THE PHOTOS
OF THE CENTURY

**EVERGREEN is an imprint of
Benedikt Taschen Verlag GmbH**

© for this edition:
1999 Benedikt Taschen Verlag GmbH
Hohenzollernring 53, D–50672 Köln

original French edition published by
Editions du Chêne – Hachette Livre
© 1999 Editions du Chêne – Hachette Livre
under the title "Les Cent Photos du Siècle"
Text: **Marie-Monique Robin**
This book was made from the audio-visual
series co-produced by ARTE and the CAPA
Agency with the cooperation of Mission 2000.

Created by: **Editions Binôme**
Edited by: **Serge Malik**
Coordination: **Angela Calvé**
Production: **La Cité**
Photo-engraving: **SNO, Ivry-sur-Seine**

Translation from the French: **Sue Rose, Wembley**
Cover design: **Catinka Keul, Cologne**

Printed in Italy
ISBN 3-8228-6512-5

Marie-Monique Robin

THE PHOTOS OF THE CENTURY

100 historic moments

evergreen

"Photography exists not to represent but to remind." **Roland Barthes**

VERYTHING (ALWAYS) begins with a meeting, real or imaginary. I was working on a report in Cuba, in 1989, when a friend told me that Kim Phuc, the little girl running down a Vietnamese road, her skin burned by a stream of napalm, was studying in Havana. Who has not shuddered at that terrible image, one of the most powerful symbols of the Vietnam war? *The Photos of the Century* was born out of the desire to meet Kim Phuc. The idea: to chart the history of the 20th century through the use of outstanding photos illustrating key events, and to travel to the four corners of the earth in search of their protagonists and photographers. This was a formidable journey through space and time, a deciphering of the traces of private and collective memory.

Five criteria governed the choice of photos: international renown; historical and symbolic significance; importance for the history of photojournalism or, occasionally, for the history of photography *simpliciter*; the possibility of our meeting the main (often anonymous) protagonists, the photographers or their relatives; and finally, the existence of a 'story' that had contributed to the creation of an icon. This was not a purely objective exercise. A degree of subjectivity was inevitable and appropriate. Certain photos were chosen because they strongly attracted or repelled me, or because I felt they were important pieces of the huge jigsaw by which the photographic memory of our century has been constituted. Some of my choices or omissions may seem surprising. If I had to justify them, I would say that they were governed by a single unifying principle: the desire to pay homage to the men and women who, camera in hand, captured a fragment of our history, and often risked their lives to do so. At a time when photojournalism is undergoing something of a crisis, this in itself was a significant criterion.

Marie-Monique Robin

The Turin Shroud

© **Secondo Pia**/Museo del Sindone

Gianmaria Zaccone: "After the photo, the Shroud became an object of scientific analysis."

Secondo Pia's original print: a negative behaving like a positive image.

Miracle

→ TIMELINE

The Turin Shroud, also known as the Holy Shroud, is one of the most carefully studied objects of the 20th century; according to Christian tradition, it was Christ's winding sheet. It is a piece of linen bearing the pale yellow imprint of a crucified man. The wounds tally with the accounts of Christ's Passion, pollen found on the shroud originated in Palestine, and the weaving technique was thought to antedate the 8th century. In 1988, however, carbon-14 dating proved the shroud was not authentic: the linen dated from the 13th century. Fresh examinations are scheduled for the millennium.

MAY 28, 1898. Leaning over the tray in which he was developing a glass plate, Secondo Pia could not contain his excitement. "A miracle!" he cried. The negative showed the positive image of a dead man, hands crossed over his pubis, wearing an expression of overwhelming serenity. This overthrew all the laws of photography: the light, shadow and spatial co-ordinates of a negative are reversed, and only in the positive print is the object reproduced as it appeared. Here, the process had skipped a stage. "If the negative shows a positive image, the object that I photographed must be behaving like a negative", wrote Secondo Pia, the amateur photographer who had been asked to photograph the relic by Archbishop Riccardi. The photos were taken in spring 1898, during an exposition of the relic in Turin cathedral. The imprint, which could be made out only from two metres away, was illuminated by two 1,000 watt lamps. Secondo Pia exposed two 21 x 27 cm plates for one and two minutes respectively. The result was indecipherable. He then exposed two 50 x 60 cm plates, the first for fourteen, the second for twenty minutes, using a 2 mm aperture stop. The first exposure entered history. "After the photo," says Gianmaria Zaccone, Secondo Pia's biographer, "the shroud ceased to be a simple object of devotion and became an object of scientific analysis." ∎

"This is the most mysterious photo of the century," says Professor Bruno Barberis, chairman of the International Centre of Sindonology. "No laboratory has been able to reproduce the image it revealed." One thing is certain: the Shroud is not a painting. No trace of pigment has been found. The phenomenon causing the characteristic yellowing of the fibres has only affected the surface of the image and cannot be detected beneath the bloodstains: "Apparently, the image formed after the fabric was stained with blood. On Pia's negative, only the bloodstains appear in photographic negative." In 1978, an American laboratory suggested that the image might have resulted from the oxidation of the cellulose in the linen, after sudden intense heat had "superficially scorched" the fibres. "The blinding flash of the Resurrection" exclaimed the Christians ... Another interesting characteristic of the image is its three-dimensional nature. This discovery was made by two American officers who placed the photos of the shroud under one of NASA's machines, the VP-8 Image Analyser, which can convert light itensity into distances. The result: a three-dimensional image of the man on the shroud. "Yet another mystery."

Professor Bruno Barberis

"Only the bloodstains appear in photographic negative."

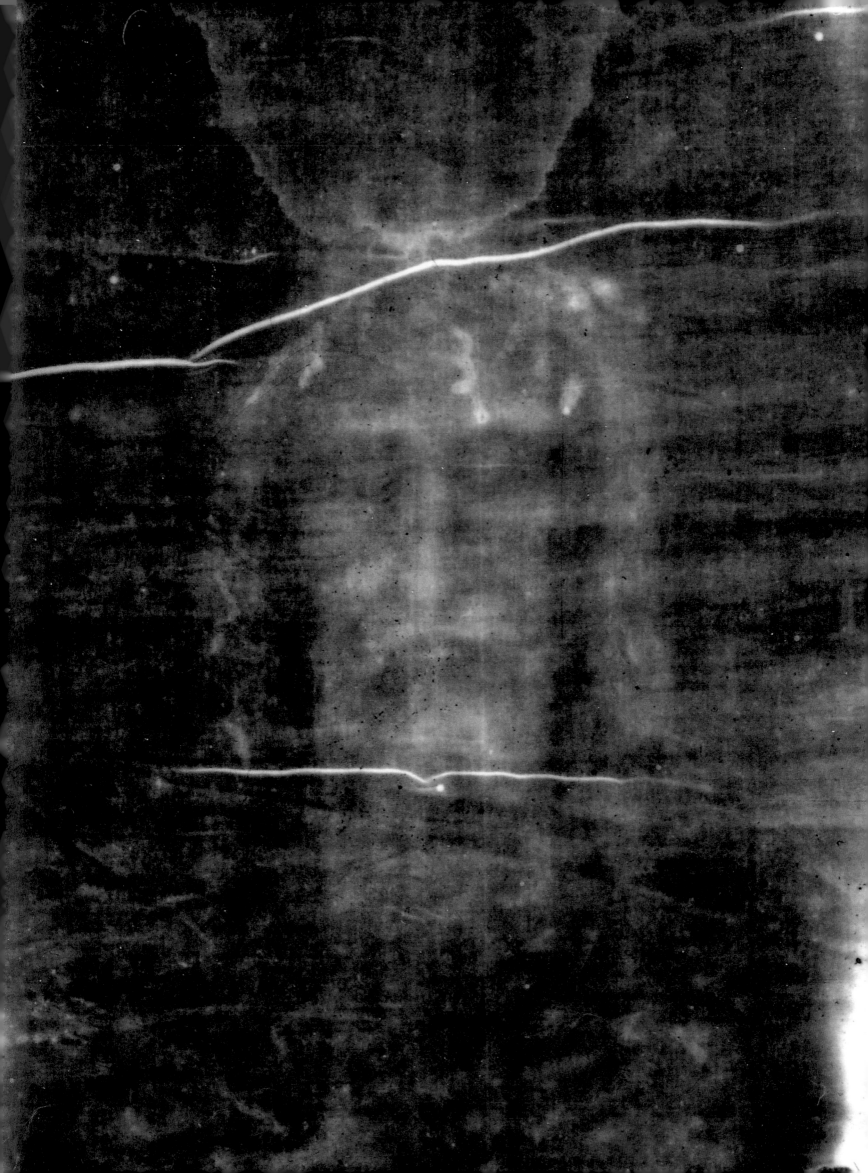

The Boxer Rebellion

→ TIMELINE

This was the first anti-colonial rebellion of the 20th century. Its instigators were the 'Boxers', originally a Chinese secret society whose members practised martial arts. Their objective was to drive out the foreigners who were exploiting the industrialisation of China. In the early months of the century, the Boxers assassinated missionaries and Chinese Christians, then, with the support of the Empire, besieged foreign legations in Peking. The subsequent crackdown was brutal: thousands of Boxers were executed by Western troops.

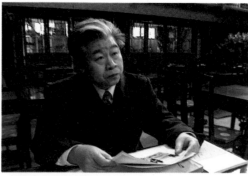

Professor Zang Haipeng: "The photos of the executed Boxers were not published in China until Mao Zedong came to power."

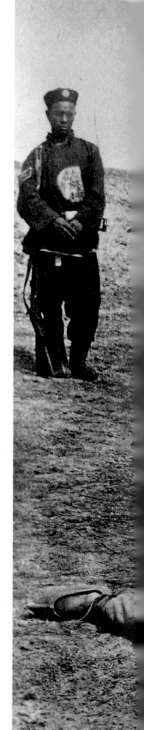

The Yellow Peril

"THIS PHOTO WAS TAKEN in August 1900," notes Professor Zang Haipeng, a historian in Peking. "The photographer was a European journalist with the Western troops: at that time, Chinese people were banned from places of execution, and few owned cameras anyway." Paris-based researcher Gilles Baud-Berthier concurs: "The newspapers immediately put their best newshounds on the case. Everyone wanted proof of the barbarity of the *Chinks*." The photos demonstrated that the missionaries had been avenged and that Western law extended to the farthest reaches of Asia. Most of the executions were photographed and Western chiefs-of-staff paid close attention to the contents of the pictures. "The photo shows only Asian soldiers," says Gilles Baud-Berthier, "the Chinese executioners are in the foreground, and behind them, the Japanese, who were allies of the West. The eight foreign powers also took part in the crackdown, but there are very few photos showing European soldiers." Taken from a standing position, with a very long exposure, the photo symbolises victory. "This is not even propaganda: in Europe, it was generally accepted that Western interests had to be defended. The policy of colonisation was rarely questioned." ∎

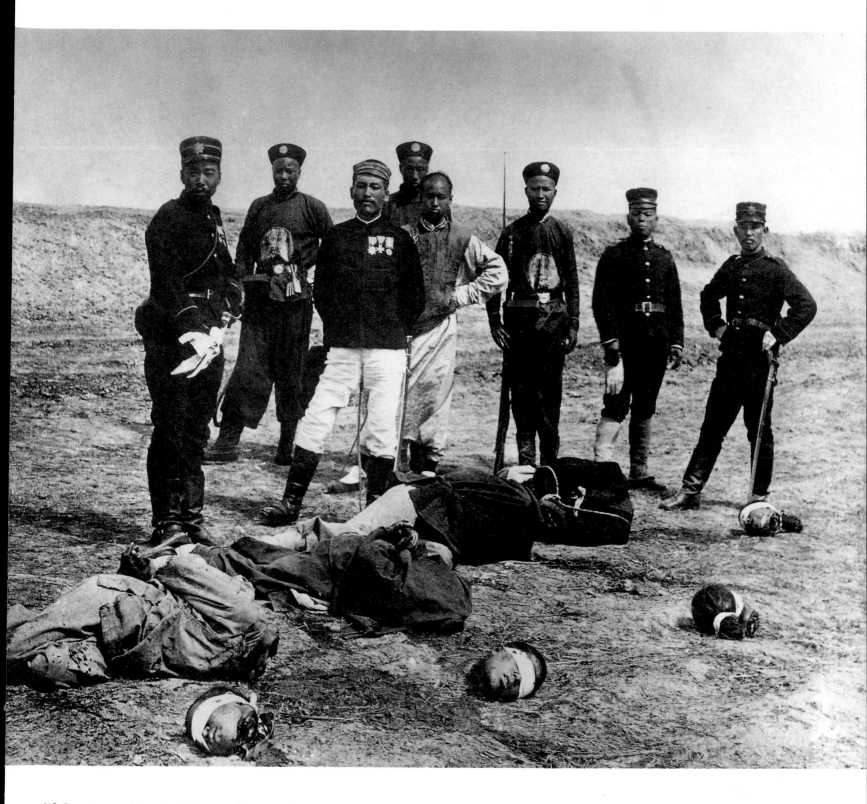

"Most racist clichés about the Chinese date from this period."

The photos of the decapitated Boxers took six weeks to reach Europe, where people were waiting anxiously for news of China. When the siege of the legations began, telegraph wires had been cut and the press, starved of information, allowed its imagination to run riot. "For weeks," explains Gilles Baud-Berthier, "the public had been regaled with horror stories about the *Yellow Peril*,

a blend of fantasy and fear. When the photos arrived, there was a feeling of relief; widely published, they fuelled the Western imagination, exaggerating the caricatural view people had of the Chinese. Most racist clichés date from this period." Likened to 'rats' (with their plait as 'tail'), the Boxers reinforced the white man's fear of all indigenous peoples. This strong undercurrent of feeling enabled the Western powers to raise funds easily whenever a further anti-colonial rebellion threatened. The feeling in China was one of

humiliation: "These photos were not published until Mao Zedong came to power," Professor Zang Haipeng notes. "They appeared in history books to show how badly the West had treated our country. Today we approve of the Boxers' anti-imperialist attitudes, but we're not about to copy them ..."

Gilles Baud-Berthier

Autochrome

© L'Illustration/Sygma

Nathalie Boulouch: "For the press, this was a revolution."

Life in Colour

"How does the autochrome process work? It's a sort of colour slide on a glass plate." A expert in chemistry at the Centre National de la Recherche Scientifique, Bertrand Lavédrine explains the process invented by the Lumière brothers. His erudition is lightly worn: "Their big idea was to use potato starch ... for the colour filter." Grains of starch were dyed blue, green and red, then mixed to form a homogenous layer on a plate coated with varnish. The spaces were filled with black carbon dust. The plate was then covered with a panchromatic emulsion: after drying, the plate was ready for use. "For the press, this was a revolution," says historian Nathalie Boulouch. "*L'Illustration* pioneered colour photography; in 1914, it was imitated by the American *National Geographic*." In the meantime, Léon Gimpel had discovered a remedy for one of autochrome's failings: the length of exposure, which allowed only static subjects to be photographed. In 1913, he demonstrated plates sensitised to a hundredth of a second. His favourite subject? The illuminated signs that pervaded the streets of Paris in the 1920s.

→ TIMELINE

Europe was the foremost power in the world and, with the exception of France, all European countries were governed by monarchies. World War One radically altered European political systems. In 1917, Tsar Nicholas Romanov was overthrown by the Russian Revolution. One year later, a Republic was proclaimed in Germany after the abdication of Kaiser Wilhelm II. The end of the Great War consolidated the victory of parliamentary democracies and the emergence of a new world order dominated by the United States.

IT WAS A "memorable sitting", wrote Léon Gimpel in his diary. "I was nervous not because of my subjects' rank but because I was afraid of failing in my task." His challenge was to produce the first portrait in 'natural colours' to be published in the press. It all started in 1904, when Gimpel, photographer to the weekly *L'Illustration,* came across the autochrome process developed by Louis and Auguste Lumière. Gimpel persuaded the brothers to give an exclusive presentation of their invention at the premises of the paper: "The chilly black and white images of old will henceforth be of minor interest," crowed the editor in his own paper. The lecture took place on 10 June 1907, and filled the Paris smart set with enthusiasm. Gimpel decided to use the 'Eighth Wonder of the World' to cover a news item: the visit by the Danish royals, Frederick VIII and his wife Louise. He photographed the royal couple's suite of rooms at the Quai d'Orsay. Fascinated, Frederick VIII suggested a formal sitting. This was how Léon Gimpel came to install his "monumental camera" on the ministry steps: "the weather was perfect, a bright milky sky without direct sunlight". It was an emotional moment; Gimpel asked the monarchs to "remain absolutely still for several seconds, as the new process did not allow instantaneous exposure". "We are entirely at your disposal", replied Frederick VIII in impeccable French. Published in *L'Illustration* on 29 June, the photo created a sensation: it was "the high point of my photographic career", Gimpel later said. ∎

Bertrand Lavedrine

"Their big idea was to use potato starch."

- - - - - - - - - - -

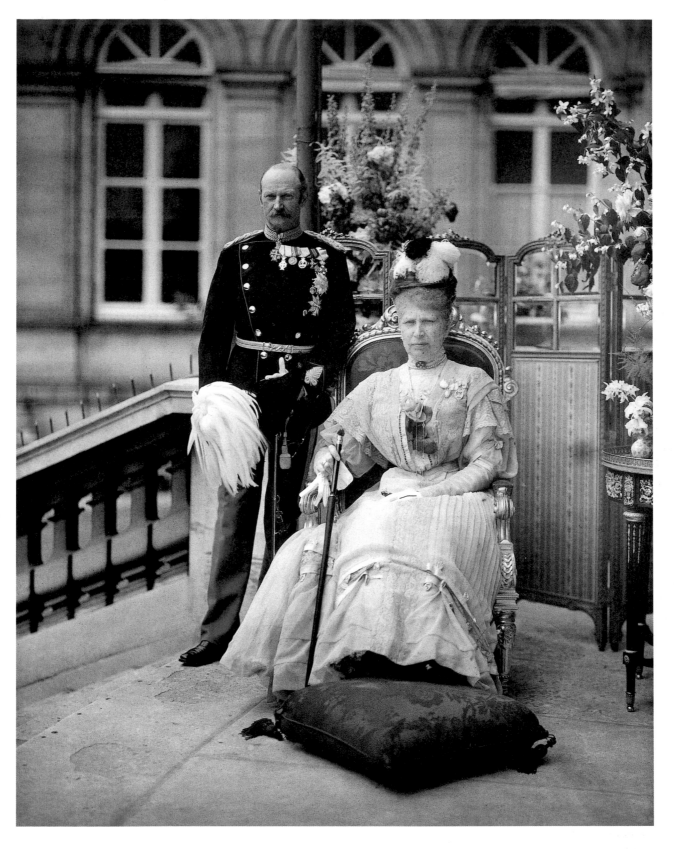

"Poor Kaiser Wilhelm II"

"Kaiser Wilhelm II of Germany was green with envy at the publication of this photo; he had posed for an autochrome in Monaco, but the photo had not come out. Poetic justice really: his grandfather, the King of Prussia, had seized a third of the unfortunate Danes' kingdom ..." One in the eye for Wilhelm! Michael of Greece is the grandson of George I, the younger brother of Frederick VIII, who became King of Greece. "In short," he says, "the man in the autochrome is my great uncle." And he adds: "I love the imitation Louis XVI backdrop, arranged on the steps of the Quai d'Orsay, with the large red damask cushion under Louise's feet. Frederick VIII was a great amateur photographer: like all the kings of the period, he owned a Kodak, and he spent his time photographing his family in his Copenhagen castle. European royalty have been excellent propagandists for photography ever since its invention. It was obviously a godsend for a king; no need to sit for hours for a portrait. One click, and the picture could make its way to the four corners of Europe. And in colour! Poor Wilhelm II ..."

Michael of Greece

Child Labour

© Lewis W. Hine/Courtesy George Eastman House

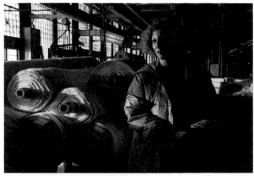

Daile Kaplan: "Hine wanted to furnish proof of child labour."

→ TIMELINE

Between 1903 and 1913, millions of European immigrants landed in New York harbour. For many of them, the American dream became a nightmare: crowded together in unhealthy living quarters, they lived in abject poverty. The entire family had to work to survive. A census of 1910 revealed that two million children aged between 10 and 15 were toiling in mines and farms, ten hours a day, six days a week. Not until 1938 was child labour in the United States regulated.

EVERYTHING ABOUT HER SMACKS of drudgery, yet she is the soul of dignity. Flanked by two rows of spindles, she stares straight at the camera. The photo was taken in 1908, in a cotton mill in Carolina. The photographer's name was Lewis Hine; he worked for the National Child Labor Committee (NCLC), an organisation that campaigned for the abolition of child labour. Evidence was needed to heighten public awareness, and photography was his means of acquiring it. For ten years, Hine travelled throughout the United States: he gained entrance to mines in Virginia, glassworks in Indiana and cotton plantations in the South. He would claim to be an insurance or bible salesman to allay the fears of the bosses. In his pocket, a little notebook in which he furtively made notes: "Mart Payne, 5 years old, gathers ten kilos of cotton a day." He often guessed the children's age by measuring their height against his jacket buttons, which he had carefully calibrated. "Such was his faith in the cause he was championing," says historian Daile Kaplan, "that he was able to forge a real relationship with children in a matter of minutes". Every one of his 5,000 snapshots, hastily taken in poor light, is imbued with this sense of trust: like this photo of a young textile worker, who evaded the vigilance of the foreman to appeal to America's conscience through the lens. ■

The American Dream

LEWIS HINE

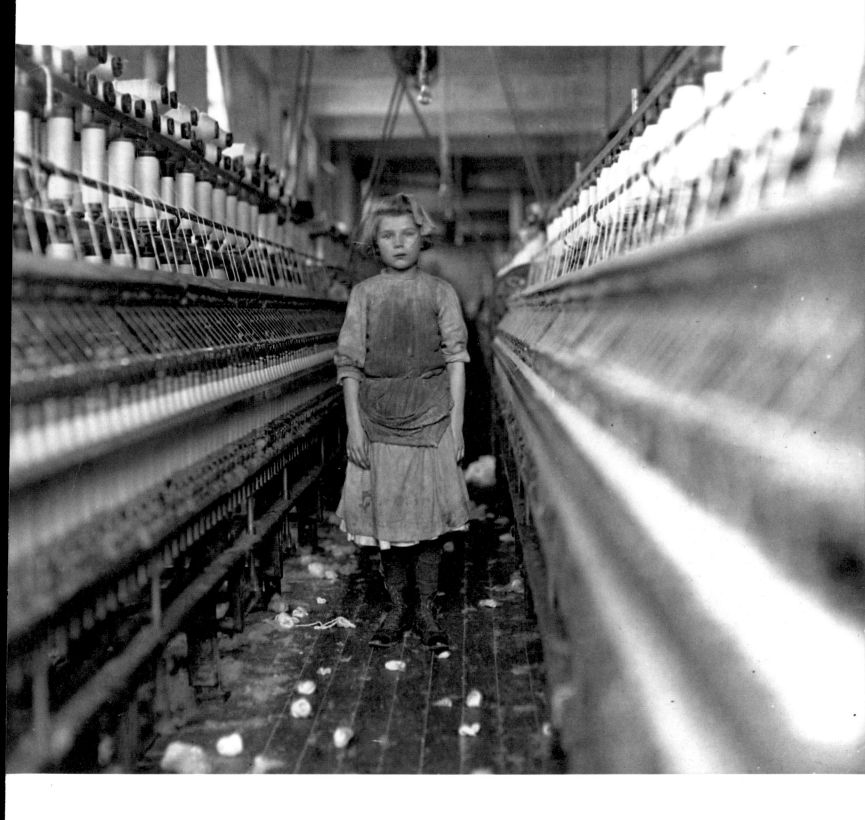

"We need a new Hine."

"Lewis Hine was the leading social documentalist of the century," says Daile Kaplan, who has written two books on him. "He wanted to make social problems more human, giving them a face to help the public to identify with the victims." In collaboration with the NCLC, Hine organised exhibitions and conferences, published articles, and developed a new form

Jeffrey Newman

of journalism: photo-reportage. "His main contribution was to combine image and text in a new type of visual medium, at a time when photography was first appearing in newspapers." In 1912, the U.S. government created an agency to investigate the information supplied by Hine. Then, in 1918, a inaugural law was passed to restrict child labour. After that, there was no stopping the process. "Now we need another Hine to denounce the exploitation of children in late twen-

tieth-century America," states Jeffrey Newman, chairman of the NCLC. "How many people are aware that most of the fruit on our tables is gathered in California by unregistered child-labour?" The Committee has not given up the fight, but its task has become harder: "We are competing with countless high-profile media events and can no longer count on the audience we had at the time of Lewis Hine."

The Suffragettes

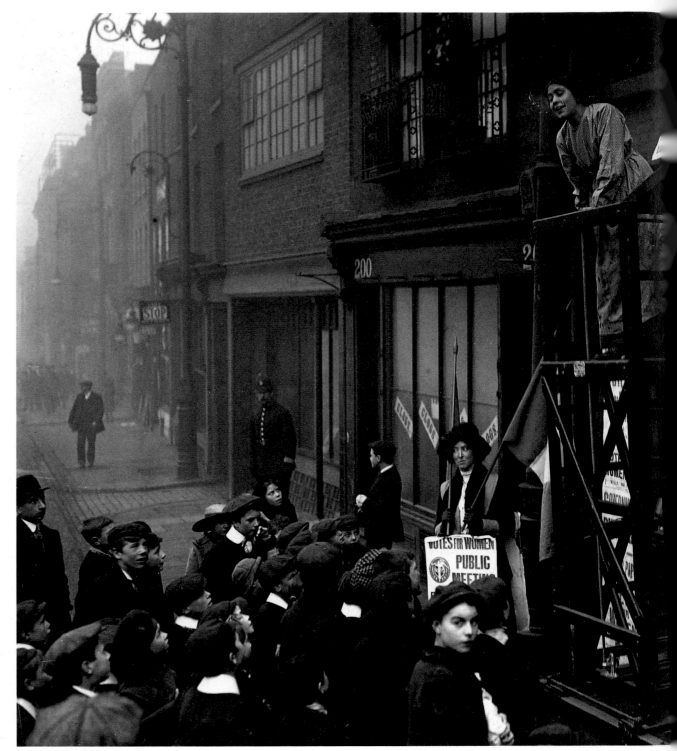

→ TIMELINE

London, 1912. Emmeline Pankhurst was one of the most famous women in Europe. With her two daughters, Sylvia and Christabel, she headed the suffragette movement, which campaigned for votes for women. Demonstrations, brawls, spectacular arrests: the Pankhursts would do anything to advance their cause. They won the first round in 1918: women over 30 who fulfilled certain social criteria were granted the vote. Ten years later, they were allowed, like men, to vote at the age of 21.

005

"The suffragettes are the most widely photographed social movement of the early 20th century; they realised that photography was a vital means of drawing attention to themselves." A professor at the University of London, June Purvis could talk forever about these women, the "first feminists", who un-

June Purvis

derstood "the power of photography" before anyone else. Photographs were just starting to replace engravings in the daily papers. From 1904, the *Daily Mirror* illustrated its pages exclusively with photographs. This was a first in Europe. "Before demonstrations," comments June Purvis, "the Pankhursts warned the newspapers, who sent along photographers". When imprisoned, Emmeline and her daughters would start indefinite hunger strikes. As a result,

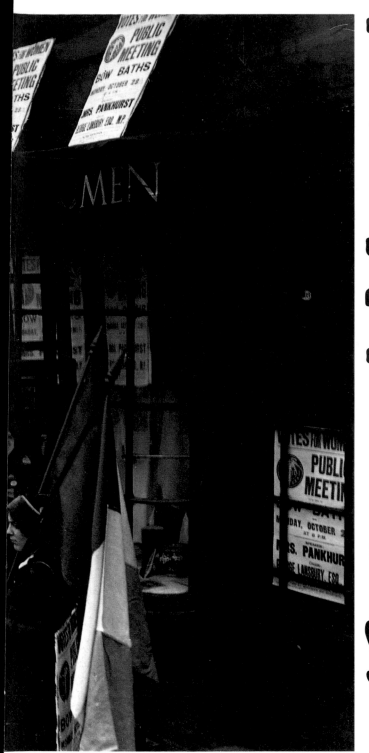

'Cat and Mouse'

Richard Pankhurst: "My mother said that one can change the world by small degrees."

" **'I'** VE NEVER FOUND OUT who took this photo of my mother," says Richard Pankhurst, Sylvia Pankhurst's son. He is holding a photo printed in all the history books: it shows a young woman perched on a makeshift stage, haranguing a crowd of passers-by, who are hanging on her every word. The scene is set in East London, a working-class neighbourhood. "My mother was opening a new branch of the suffragettes, painting 'Votes for Women' on the front of a shop that served as the movement's premises. This was her answer to Prime Minister Asquith's claim that the suffragettes were waging an elitist battle un-connected with the people." Of the many photos of the suffragettes, this is the most peaceful. It was taken in 1912, at a pivotal moment in the movement's history. Realis-ing that peaceful action was fruitless, the Pankhursts became the first terrorists of the 20th century: they planted bombs in blocks of flats where politicians lived, set fire to letterboxes and chained themselves to the railings of Buckingham Palace. At the 1913 Derby, Emily Davison committed suicide in front of the photographers by throwing herself under the hooves of the king's horse. Sylvia showed her son this photo [left], saying: "One can't change the world as much as one might like, but one can change it by small degrees". ■

a law was passed specially to prevent militant prisoners dying of inan- ition. Dubbed the 'Cat and Mouse Act', **"The first** **feminists."** it meant that the police ('cats') could free hunger-striking prisoners ('mice') till they had recovered, then again detain them for the remainder of their sentence. Press photographers were, of course, happy to immortalise each successive arrest and release.

The suffragettes' release is im-mortalised by photographers.

The Distorted Racing Car

© Jacques-Henri Lartigue/Ministère de la culture/France/A.A.J.H.L.

→ TIMELINE

Panhard, Levassor, Bugatti, Ford: powered by steam, electricity or petrol, cars were a major attraction at the turn of the century. France was the birthplace of motor racing. In 1906, the Grand Prix organised by the Automobile Club de France attracted the world's best drivers. They sped along country roads under the fascinated eye of the public. The growth of the automotive industry promoted the development of the road, steel and rubber industries, and had a profound impact on the organisation of work and leisure.

Florette Lartigue: "My husband contrived a double effect that reinforced the impression of speed."

Visual Effects

IT HAS GONE DOWN in the history of photography as the *distorted racing car*. The Delage, transfigured by speed, was competing in the ACF Grand Prix on 26 June 1912. A technical tour de force, the photo was taken by Jacques-Henri Lartigue, a moneyed 18-year-old photographer with a 9/12 plate camera. From childhood, he had compiled photo albums coupled with diaries in which he meticulously chronicled his life in words and sketches. On that day, he made a sketch of each photo taken at Tréport, to check later that each image matched what he thought he had seen. One of these photos was the *distorted racing car*, driven, he noted, by Boileau, at 180 km/h. This was followed by the annotation: "Very good". "My husband was very proud of this photo," says Florette Lartigue, "because he'd contrived a double effect that reinforced the impression of speed". She goes on to explain that the camera was equipped with a roller-blind shutter which, closing from top to bottom, created a graduated image on the plate. The result was a distorted picture in which the wheels appear oval. And, as he took the shot, Lartigue pivoted on himself, causing another distortion, that of the spectators. "An inspired idea", says the American critic John Szarkowski, who included the image in one of the first exhibitions of Lartigue's work, half a century later. ■

After each photo, Lartigue would make a sketch of what he thought he had captured on camera to check the result in his dark room.

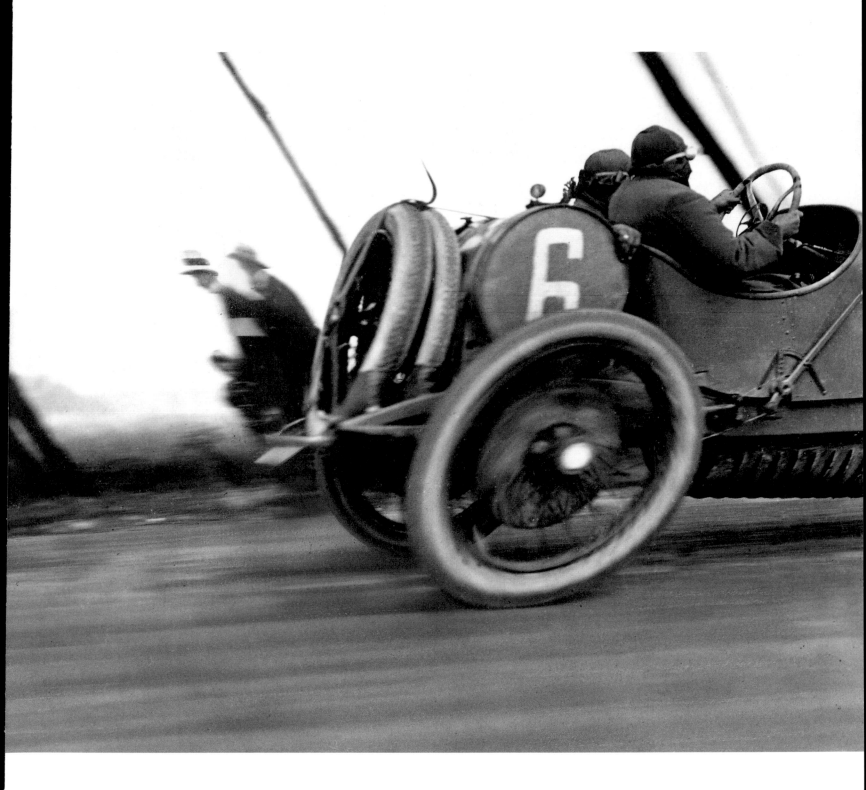

John Svarkovski

"Lartigue was the first person who took photos like a butterfly collector catching butterflies", says John Svarkowski. He was working at the Museum of Modern Art in New York when, in 1962, he discovered a treasure: some 100,000 Lartigue photos. "I'd never come across anyone with such a talent for capturing movement." Jacques-Henri Lartigue had no need to earn a living from his photography. He took photographs for his own pleasure. "My husband rarely showed anyone his photos", said Florette Lartigue, "he said they were like conserves and he preferred fresh fruit". For over eighty years, Lartigue photographed aspects of his daily life to 'conserve' something of the fleeting moment. And with a set purpose: he was in search of happiness. "The butterfly collector does not bring home slugs", he remarked in his memoirs. Fascinated by movement, he 'collected' everyday miracles with his cam-era, painting a magnificent portrait of the Belle Epoque years: fashionable women at the Auteuil races, *cocottes* in the Bois de Boulogne, the Lartigue family in a gleaming Hispano-Suiza or Josephine Baker, cigarette between her lips. "I'm a taxidermist preserving what life offers me *en passant*", he said. A fitting sentiment for the man who could make a racing car weighing over a tonne seem as light as a feather.

"I'd never come across anyone with such a talent for capturing movement."

World War One: Propaganda

Jane Carmichael with a Goertz Anschutz camera: "Ernest Brooks was first and foremost a patriot."

→ TIMELINE

On 28 June 1914, Archduke Franz Ferdinand, heir to the throne of Austria, was assassinated at Sarajevo. Thanks to the interplay of alliances, a regional crisis deteriorated into a European war. By late 1914, the Western Front was deadlocked. From the North Sea to the Swiss border, troops occupied the trenches for a war of attrition. To break the stalemate, countries involved in the war drew in neutral countries. The first world war in history ended on 11 November 1918.

A PHOTO shows him posing in uniform in a trench during the Great War. He has his Goertz Anschutz camera and a briefcase for his glass plates. Having worked as a photographer with the *Daily Mirror*, Ernest Brooks was the first photographer recruited by the British Army's photographic department in 1916. With his newly acquired military rank, he arrived in northern France where, since August 1917, two million British soldiers had been bogged down in the mud of Passchendaele. The Third Battle of Ypres cost the lives of some 250,000 soldiers. But Ernest Brooks showed nothing of that. "Official photographers had no access to the front," explains Jane Carmichael, who works at the Imperial War Museum in London. "Their mission was to reassure the home front, worn out by the duration of the war." Men playing cards in the trenches, officers drinking tea, or a line of tanks: the 40,000 photos kept at the museum are all similar, with, in the case of Brooks, a penchant for silhouettes, which were easier to reproduce than varying shades of grey. Taken against the light, his most famous photo shows "a column of anonymous men symbolising the universal soldier of World War One". Published on 20 October 1917 in *The Sphere*, this "typical propagandist photograph" was printed on thousands of postcards. ■

ERNEST BROOKS

Theatre of Operations

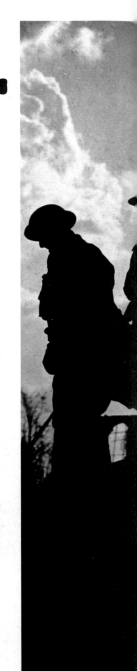

Lieutenant Colonel Aussavy

"The Great War was the first conflict in history to become a media event," says Lieutenant Colonel Aussavy, head of French military archives. "At a time when photography was emerging as a mass medium, the military authorities realised that it was of immense strategic importance." This meant that the production and distribution of images had to be strictly controlled, as photos could provide the enemy with valuable information and demoralise civilians. From 1915, European nations started to create film and photographic sections within their armies; these had a monopoly on pictures taken in the various theatres of operations. London had sixteen official photographers, France had thirty, and Germany some fifty. Photography was a formidable weapon in a positional war; it enabled the army to locate enemy lines, and direct artillery fire and troop-movements. "Everyone knew that the photos only represented a partial view of the conflict," notes historian Jane Carmichael, "but, like the official photographers, people were deeply patriotic. It wasn't until the soldiers came home that people realised the hell they had been through."

"The birth of army photographic sections."

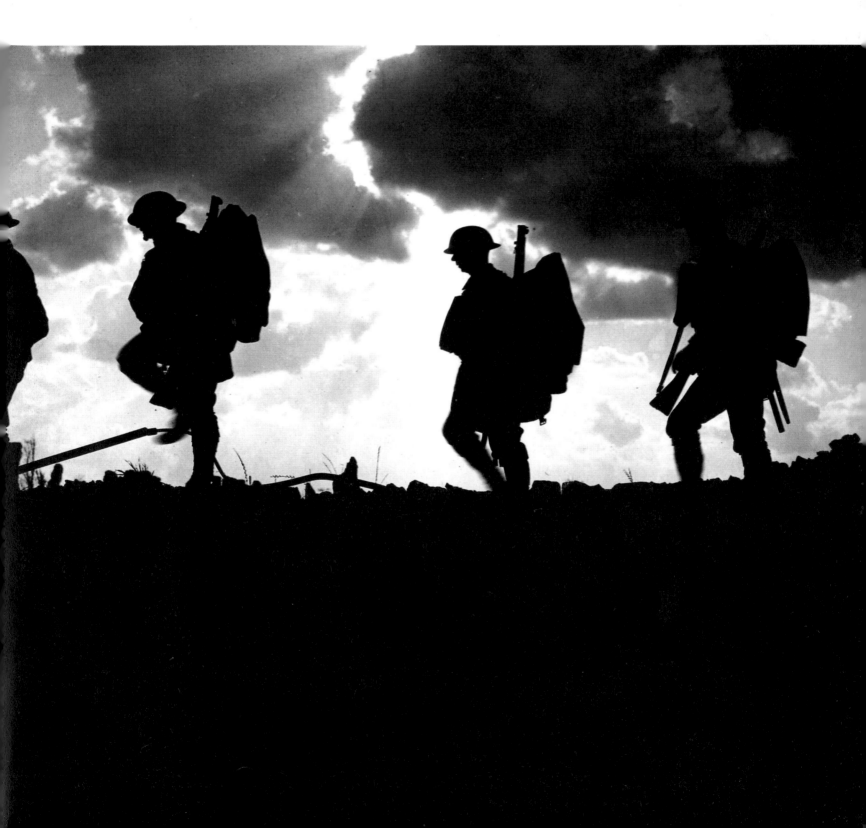

World War One: Reality

© Anonymous/L'Illustration/Sygma

Jean-Pierre Verney: "This was the first war to be photographed by insiders."

Secret Images

→ **TIMELINE**

Between 1914 and 1918, some eight million soldiers died and six million were maimed. World War One was also the first total war in history. To remedy shortages, the belligerent countries established a war economy, mobilising women and children. The length of the war and the decline in the standard of living caused rebellions and social unrest, which were quelled by authoritarian governments. By the end of the Great War, the ruins of Europe were the setting for moral and political crisis.

YOU NOTICE HIS PARTED LIPS first, then the rictus of death, framed by a muddy field. The man was a French soldier, killed in 1918 on the Verdun front and photographed by 'anon'. "World War One was the first war to be photographed by insiders," explains Jean-Pierre Verney, a historian in Paris. "Hundreds of thousands of photos were taken by soldiers who wanted to record the most traumatic experience of their lives. They compiled the true account of the war." When, in 1914, they left for war with flowers in their rifles, many also had a Kodak Vest-Pocket in their pack. "You Press the Button, We Do the Rest", boasted the ads. Simpler and lighter than its predecessors, the little camera sold millions in Europe. Photography clubs were all the rage. The photo of the buried solder was not published during the war, when censorship prevailed. And, at the beginning of the 20th century, death was not considered a fitting subject for photography. This was a matter not just of taste but of reticence. Soldiers' private diaries and letters show how hard they found it to articulate what they had lived through. After the war, their photos were mostly put away in the attic, "to avoid upsetting their families – and to forget". ■

"Soldiers were the forbears of war reporters," observes Gerd Krümeich, a Düsseldorf historian. "It wasn't until the mid-1920s that their invaluable photographs were revealed to the public. In Germany, the emergence of an influential pacifist movement hastened this process. The most famous example was Ernst Friedrich's book *War on War*, published in four languages, which scandalised the whole of Europe. Searching through the archives, Friedrich selected shots of the dead and victims of facial injuries. In France, from 1925, works such as *The Secret Images of War* left almost nothing to the imagination though no mutinies, executions or scenes of fraternisation at the front featured in the soldiers' photos. At the end of the 1920s, the rise of European fascism caused the rebirth of a genre of war literature, using the photos taken by the soldiers to fuel the flames of nationalism. In Germany, encouraged by the Nazis, the military lobby used them in its campaign to reconstitute the German army."

Gerd Krümeich

"Soldiers were the forbears of war reporters."

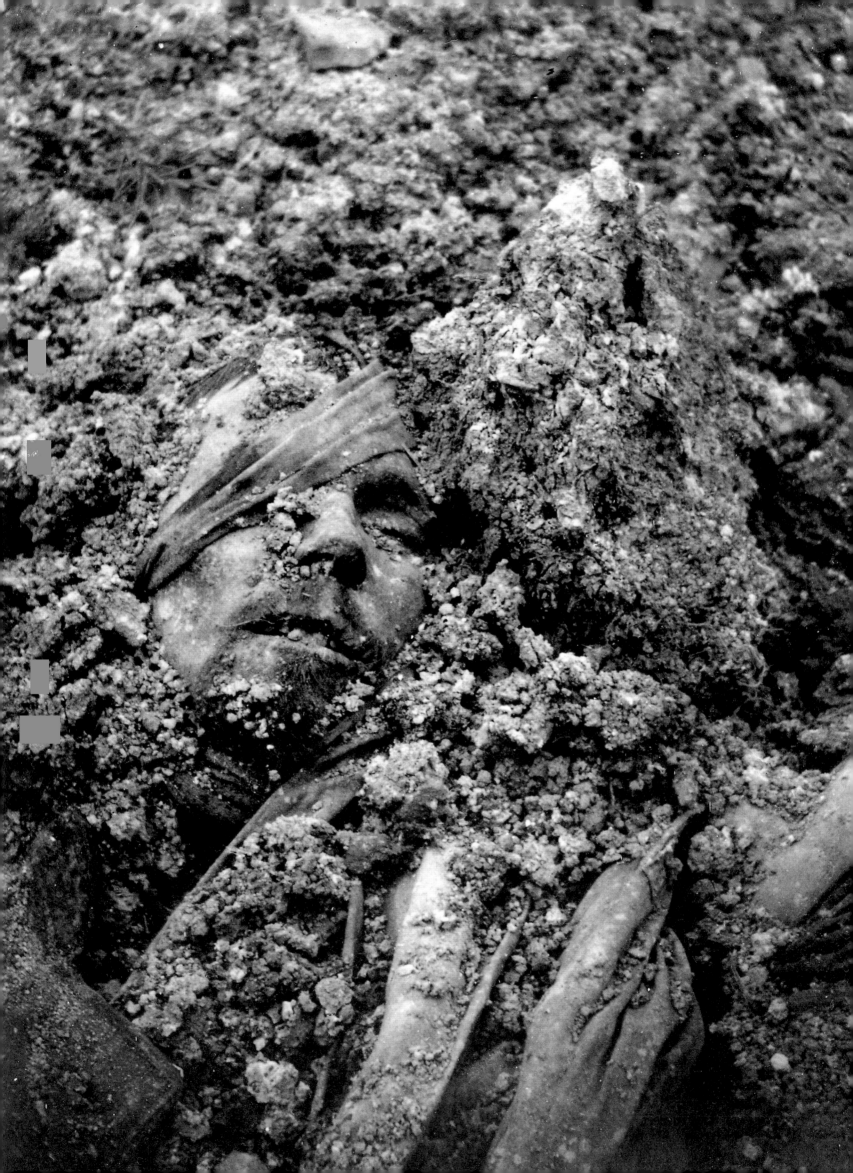

Zapata: Death of a Hero

© Agustín Víctor Casasola/Fototeca del INAH

Margarita Zapata: "This photo is a call to continue my grandfather's fight."

→ TIMELINE

This was the first Latin-American revolution of the 20th century. On 26 May 1911, the Mexican dictator Porfirio Díaz resigned after forty years of absolute power. He had been opposed by the liberal middle classes, which were calling for democracy, and the Indian peasants, led by Emiliano Zapata, brandishing the slogan 'Land and Liberty'. The new government introduced agrarian reforms and adopted a socialist and nationalist constitution. But these reforms fell far short of Zapata's expectations and he continued his fight from his southern stronghold until his murder on 10 April 1919.

"BY MURDERING Zapata, the government thought they had put an end to Zapatismo: but the photo of his death turned the hero into a legend." A woman with a steady voice and direct gaze, Margarita Zapata knows her grandfather's story by heart. "How can we ever forget how they betrayed him?" Zapata had agreed to meet Colonel Jesús Guajardo on 10 April 1919. It was a trap; Guajardo had contacted Zapata offering to surrender with all his men and equipment. The meeting took place at Chinameca hacienda in the state of Morelos. "Zapata arrived with an escort of 10 men; Guajardo had a bugle sounded. They killed him as he passed through the guard of honour." Following orders from his superior Pablo González, the "traitor" loaded the body onto a mule to transport it to the police station in Cuautla. There Jesús Mora, a local photographer, took the first photo of Zapata's corpse, surrounded by incredulous peasants staring at his blood-soaked head and chest. The next day, Agustín Casasola, who had come straight from Mexico City, took the second photo. "In the meantime, they had changed his clothes, washed his body and laid him out in a coffin. This picture was circulated throughout the country with a caption saying that Zapata had died in battle. The aim was to dishearten the peasant rebels and show the world that order had now been restored in Mexico. It was a real propaganda image." ■

Viva Zapata!

A lawyer by training, Margarita Zapata was the spokesperson for the Sandinista National Liberation Front in Nicaragua. Vice-President of the Women's Socialist International, she now lives in the Paris area. "At first, this photo symbolised defeat. But it gave rise to the legend of a national hero. Even those who killed Zapata claimed to be his followers. Former President Salinas called himself a Zapatista; he called his son Carlos Emiliano and his presidential aircraft *General Zapata*. More than 2,000 organisations in Mexico use the name Zapata. By his death, Zapata entered the heritage of humanity. While peasants are landless and Indians marginalised, this photo is a call to continue my grandfather's fight."

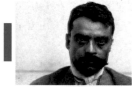
Zapata in 1914.

"By his death, Zapata entered the heritage of humanity."

009

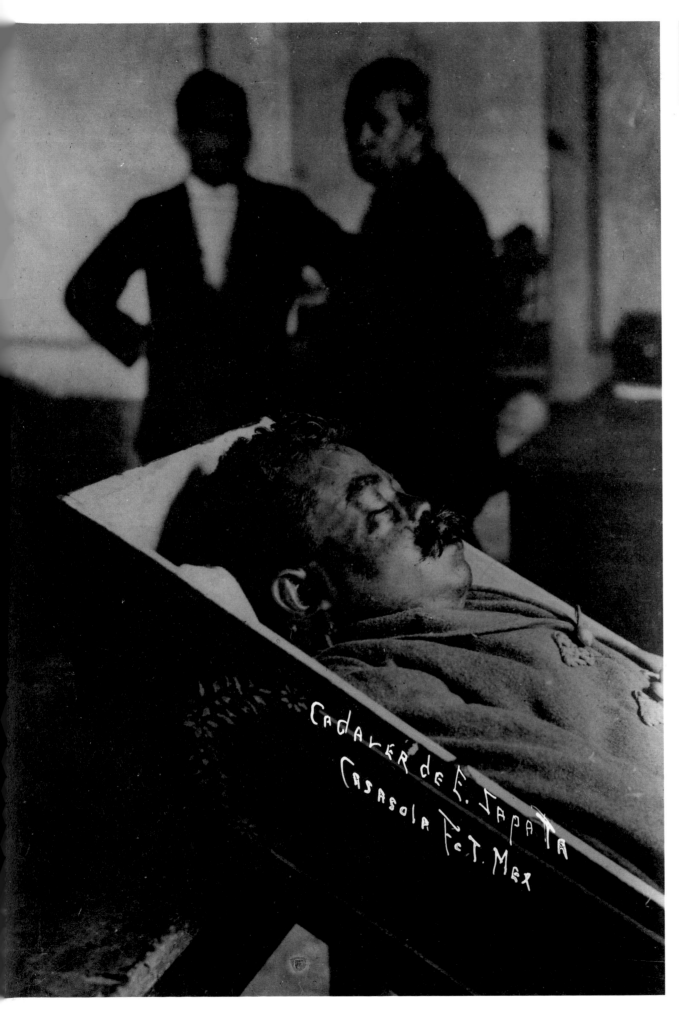

Cadaver de E. Zapata
Casasola Fot. Mex

Ignacio Gutiérrez Ruvalcaba

Founder of the first Latin-American press agency, Agustín Casasola covered the Mexican Revolution from 1910. A journalist who turned to photo-reportage in 1894, he took thousands of photos of the Zapatista rebellion: "Casasola was not a Zapatista photographer," says historian Ignacio Gutiérrez Ruvalcaba, "quite the contrary. Those who, like the reporters, lived in Mexico City, saw Zapata as a throwback; he wanted land for the peasants, while they wanted democracy. When this photo was published, the headlines read 'Attila is dead.' But in Morelos, the Zapatista stronghold, people were suspicious: many thought the picture was a fake, because the body didn't look like Zapata. The rumour went round that Zapata was alive. Books, articles, and legends reported that he had taken refuge in the mountains in the South. People will still tell you today that Zapata died in the 1950s."

"The rumour went round that Zapata was alive."

Lenin and Trotsky
© G.P. Goldstein/David King Collection

Manipulation

David King: "They didn't just vanish from the photos; they were killed."

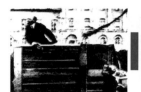
Retouched photo ...

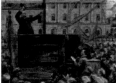
and painting

→ TIMELINE

Moscow, 5 May 1920. Lenin is haranguing a crowd of young soldiers about to leave for the Polish Front. Backed by the Western powers, who wanted to build a *cordon sanitaire* around the Bolshevik republic, Marshal Piłsudski had captured Kiev. Civil war raged between the Red Army and the counterrevolutionary 'Whites'. On the steps of the platform: Trotsky, Commissar for War, and Kamenev, a member of the Politburo. Exiled to Mexico, Trotsky was assassinated on Stalin's orders in 1940. Kamenev was shot in 1936.

T HIS IS THE GREATEST ICON of the October Revolution, and the best example of the Stalinist method of falsifying history. "As soon as Trotsky was expelled from the Party, in 1927, he systematically disappeared from the photos," explains David King, who has spent thirty years of his life travelling the world to find photos of the Bolshevik leaders in their original state, before retouching. A former art director of the *Sunday Times Magazine* he has built up a collection of 250,000 photos, meticulously filed in red metal boxes. The original photo of Lenin on the platform was last published on a postcard celebrating the tenth anniversary of the 1917 Revolution. "Afterwards," explained King, "the censors cropped the right-hand side of the photo to remove Trotsky and Kamenev. Later, the two banned figures were replaced by five retouched steps". One of the gems in King's collection is a picture painted in 1933 by Isak Brodsky, a leading exponent of 'Socialist Realism', in which the two dead men have been replaced by two studious journalists. Exhibited at the Lenin museum, it was reproduced on millions of posters. "But we should never forget," King adds, "that they didn't just vanish from the photos; they were killed". ∎

At the age of 73, Valeri Bronstein, with his bony face, moustache and round glasses, is the very image of his great uncle Lev Bronstein, alias Leon Trotsky.

"I'm his ghost, the last Bronstein in Russia."

Valeri Bronstein

"I'm his ghost," he murmurs, "the last Bronstein in Russia." When Stalin's henchmen removed Trotsky from this famous photograph, nineteen members of his family were still living in the Soviet Union, including seven children. All the men were shot, as was his sister Olga. The women were sent to the Gulag: "I was the only one in my family to survive," says Valeri Bronstein. "I was 12 and was sent to an orphanage." In the meantime, the survivors disposed of the family albums; the hunt for forbidden pictures was pitiless, and owning one resulted in immediate arrest. It was not until Mikhail Gorbachev's Perestroika that this implacable censorship was lifted. Not until 1989 did Bronstein see the original photo of 5 May 1920; it was in a book by David King, given to him by the Institute of Marxism-Leninism.

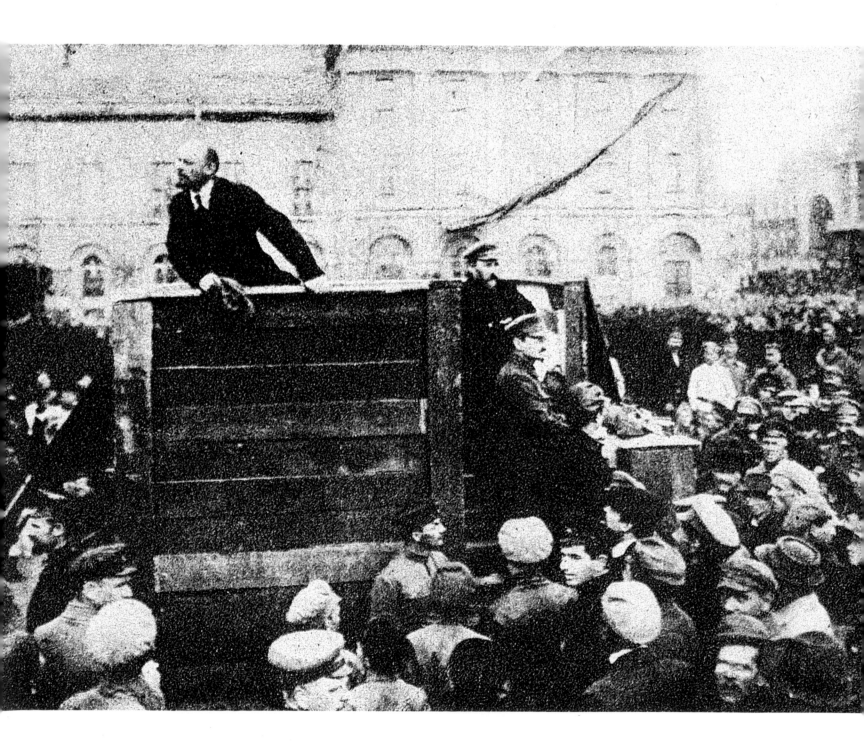

The Kid

→ TIMELINE

He was one of the most famous men of the century. Born in 1889 in a London slum, Charlie Chaplin emigrated to the United States. In 1914, he acted in thirty-five comedy shorts, revolutionising silent film. In *The Kid*, Chaplin made his debut as a director of full-length films satirising the idiosyncrasies of his time. A victim of McCarthyism, he went into exile in Switzerland with his wife Oona O'Neill. In 1972, after an absence of twenty years, Chaplin returned triumphantly to the U.S. to receive an Oscar for his lifetime's work. He died in Switzerland at the age of 88.

011

Jane Chaplin: "When I was a child, this photo made me jealous: they look so much like father and son."

THE EYES say it all: Charlie Chaplin stares into the lens, the kid ostentatiously ignores it. They both wear threadbare clothes and a truculent expression. "They look so like each other," says Jane Chaplin. "It's as if it were my father at two different ages." The photo was taken in 1921, during the shooting of *The Kid*. Its young hero: Jackie Coogan, a 6-year-old whom Chaplin had seen in a vaudeville at the Orpheum. At the end of the act, the little blond child joined his father on stage for a dance. Archive pictures show him charming his audience with complete spontaneity. "It was love at first sight for my father," related Jane. "He was going through a bad patch; his marriage with Mildred Harris was breaking down, and he had just lost his first son almost at birth. It was Jackie Coogan who gave him the idea of making *The Kid*." The former urchin of the Victorian slums wrote the story specially; it was a love story between a tramp and a little boy abandoned in the street. "My father was directing his own childhood; hence the overwhelming sincerity that makes it so magical." Shown all over the world, except in Colombia, *The Kid* became a cinematic landmark and made Jackie Coogan an international star. "He could apply emotion to the action, and action to the emotion, and could repeat it time and time again without losing the effect of spontaneity", wrote Chaplin in his memoirs. "Like my father," sais Jane. "They really were like father and son." ∎

Child of the Century

Born in 1958, in Switzerland, Jane Chaplin was the sixth of eight children born of Charlie Chaplin's marriage to Oona O'Neill. She spent her childhood in the house at Corsier-sur-Vevey, which her parents had moved into in 1952. Quick to smile, hypersensitive, she first saw the photo at the age of ten. "I was very jealous of Jackie Coogan because he seemed so close to my father. At his age, I had a nanny and I saw very little of him. I lived on the second floor with my brothers and sisters, and my parents lived on the first. During the week, we only saw him at dinner and were allowed five minutes to talk to him, because my mother was overprotective towards him. Sometimes I used to imagine that it was me acting in *The Kid*. I was so angry with him that I wanted to change my name. Now, I'm proud to be his daughter; he was a great artist and he passed on his taste for freedom and independence. All the same, I wish someone would stick me in the middle of the photo, right between them. I'd look at young Coogan and say: "He's my father, not yours!"

Family photo of the Chaplins at Corsier-sur-Vevey.

"He's my father, not yours!"
- - - - - - - - - - -

"This is Chaplin's icon because it faithfully reflects his own story."

A historian of the cinema, David Robinson has written an acclaimed biography of Charlie Chaplin. "This is one of the most famous photographs in the world, but it's not credited. In 1921, there were no set photographers in the studios. As far as I can tell, it was probably taken by Jack Wilson, the assistant cameraman, whose wife and baby were acting in the film. Between two takes, he must have come across Chaplin and Coogan sitting on the steps: 'That would make a nice photo. May I?' It was a truly magical moment. This is one of the most famous photos of Chaplin because it faithfully reflects his own background and the character he created. He was a great Dickens reader, and, despite the colossal fortune he had amassed, he never denied his poverty-stricken upbringing. Indeed, he used it. He used to say: 'I think people have taken me to heart because of the terrible humility of the penniless, which is, I'm convinced, universal.'"

David Robinson

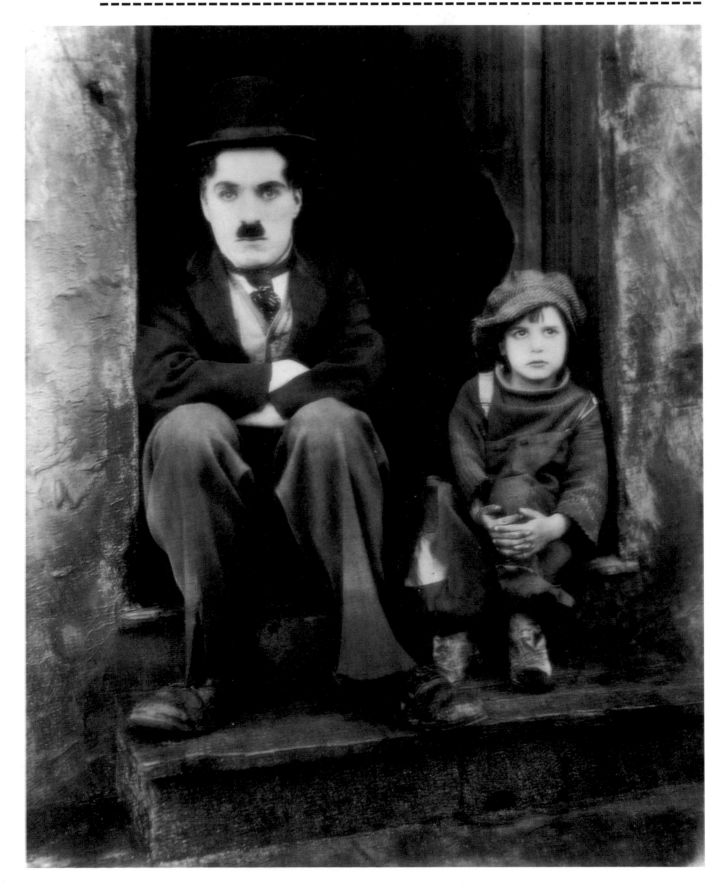

The Death Penalty

© Thomas Howard/Daily News, L.P.

Dead!

Loretta Wendt: "What I see is not Ruth Snyder's dead body, but my father's immense professional success."

→ TIMELINE

12 January 1928: accused, together with her lover, of the murder of her husband, Ruth Snyder, 33, was executed in Sing Sing Prison, New York. In her defence, she had described the torments inflicted by her husband, aged 46. A heated debate about the death penalty followed, and was exploited by abolitionists and feminists. Ruth Snyder received some 2,500 letters from women congratulating her for revolting against her domineering husband, and one hundred and sixty-four proposals of marriage ...

THIS IS THE FIRST STOLEN tabloid image of the 20th century. It is also the most famous, since it is the only photo ever taken of an execution. The photographer, Thomas Howard, was hired by the *New York Daily News*, an American tabloid. "Photographers weren't allowed into the execution, so the newspaper brought my father from Washington, because he wasn't known by the prison warders and journalists in New York", explains his daughter Loretta Wendt. The plan was to pass Howard off as a writer, and send him in with a miniature camera attached to his left ankle. This camera had a single plate, and was linked by a cable to the shutter release hidden in Howard's coat pocket. It opened the shutter gradually to prevent the sound of a click. Focusing was calculated on the information provided by an insider about the distance between the electric chair and the press seats. For a month, Tom Howard practised in his hotel room. On the big day, he contrived to be the first person into the execution chamber, and claimed a good seat. When the prisoner's body was shaken by the first electric charge, he pressed his shutter release, exposing the plate. After the second charge, he pressed again, thus creating the impression of movement on the final photo. In the newspaper's offices, the front page was already set up. All that remained was to insert the photo beneath the huge headline: "DEAD!" "Fantastic! You did it!" cried his editor-in-chief, as soon as the photo emerged from the lab. ∎

"After that," says Loretta Wendt, "my father was the most famous photographer of his time, and even today his photo is a milestone in the history of American journalism". It was also important for the history of the death penalty in the United States. For the *New York Daily News*, the scoop exceeded all expectations: its print-run of 1,556,000 copies was a world record. "The photo had an enormous impact on public opinion, because the death penalty had never been shown in such an uncompromising light", says William Styron, author of *Sophie's Choice*, who has written a stage play about the Snyder affair. The photo also gave new impetus to the abolitionist movement, which then lost momentum until the Rosenbergs' trial. Since then, the photo has appeared whenever the death penalty comes up, but, in the last analysis, it hasn't, alas, changed anything." As for Thomas Howard, he became famous overnight. He received a big bonus, and later became head of photography at the White House. "Our life changed completely," recalls Loretta Wendt, who was then 5 years old. "That's why, for me, this is not a sad photo."

"In the last analysis, this photo hasn't changed anything."

William Styron

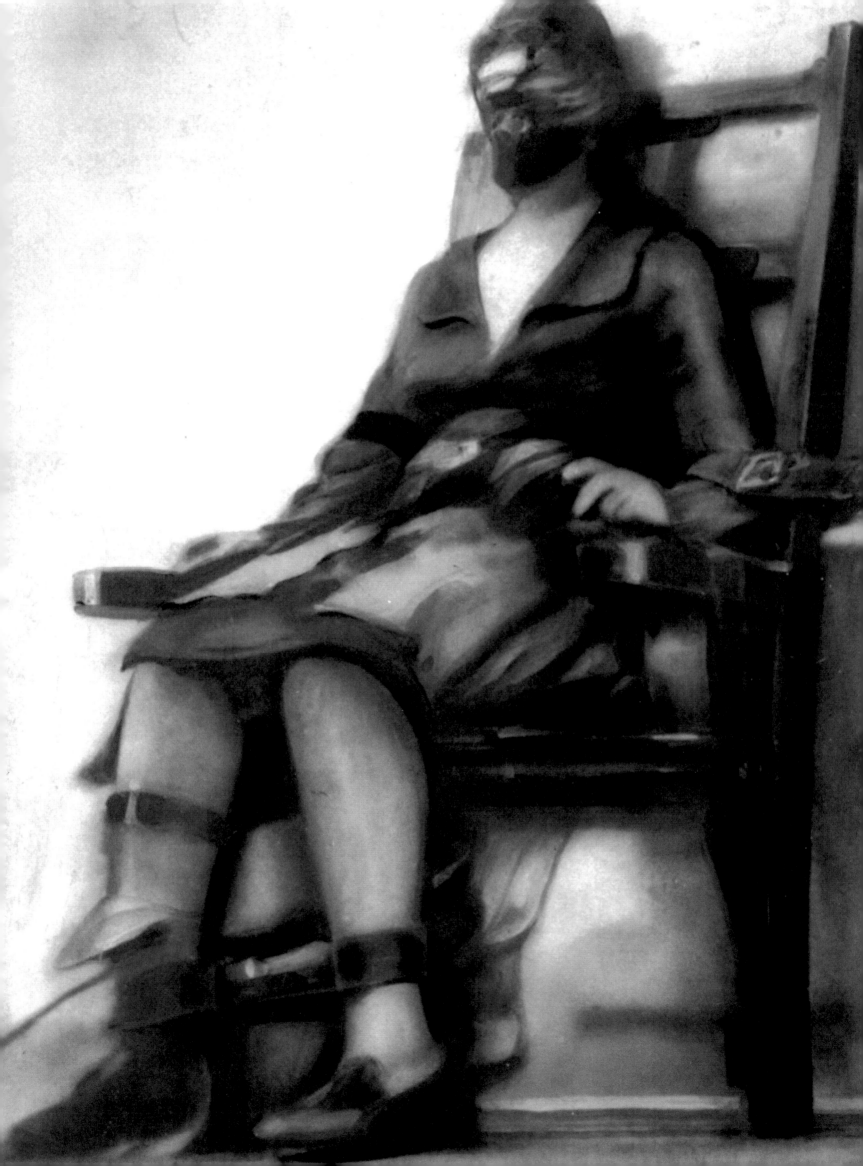

The Pastrycook

© August Sander -Archiv, Köln/ADAGP Paris 1999

→ **TIMELINE**

9 November 1918: after the abdication of Kaiser Wilhelm II, the German Social Democrats formed the Weimar Republic in August 1919. Bled dry by reparation payments to the Allies, Germany plunged into recession; unemployment was widespread and prices were spiralling. The traumatic aftermath of the war and popular unrest proved a fertile breeding ground for extremism. Those nostalgic for the German Empire relied on the new industrial magnates to weaken the Republic. In 1924, economic recovery led to a period of prosperity that lasted until the Great Depression of 1929.

Lili Bremer: This photo is my father-in-law to a T, except that, before his death, he was even stouter!"

AT THE AGE OF 84, LILI BREMER has a beguiling silvery laugh. "If it hadn't been for the war," she sighed, "my life would have been perfect. Fortunately, my father-in-law didn't live to see it, he would have been devastated to see his shop in ruins." His name was Hans Bremer and he was a master pastrycook. In 1902, he moved to the stylish district of Lindenthal in Cologne. He had two assistants and put in long hours, like his two brothers, a butcher and a hotel manager in the same area. When the 1920's recession hit Germany, he was running two establishments, with a pastry shop and a teashop that employed thirty staff. His wife worked the till, while Franz, his son, helped out. "My father-in-law was very proud of his success," said Lili, who married Franz Bremer in 1933. "His name was known throughout Cologne and the surrounding areas. I had not yet become part of the family when the famous photo in the kitchen was taken. But I knew the photographer, August Sander, very well. He lived just opposite the pastry shop." The photo shows the pastrycook, in a white overall, staring confidently at the camera. He is holding a copper basin and a whisk. "Apparently he was preparing confectioner's custard. The photo is him to a T, except that, before his death in 1936, he was even stouter! But he was a lovely man … If he had but known that his portrait would be seen all over the world! I've had postcards from everywhere, even the United States!" ■

Taxonomy

The Nazis forced August Sander to cease publication of *Man of the Twentieth Century*. He secretly added two chapters to the project, photographing persecuted Jews and political prisoners, including his son Erich, who died in a concentration camp. "What is unique about Sander's work," says historian Susanne Lange, "is that it succeeded in delivering a universal message about a particular period by focusing on a geographical microcosm. He was more interested in showing the development of a civilisation than the allocation of roles in society. He had an extraordinary gift for inspiring trust in his subjects, and so he could transcend their individuality, making them appear universal. This is why his work is seminal not only to photographic and art history, but to history itself."

Susanne Lange

"A work seminal to history."

August Sander

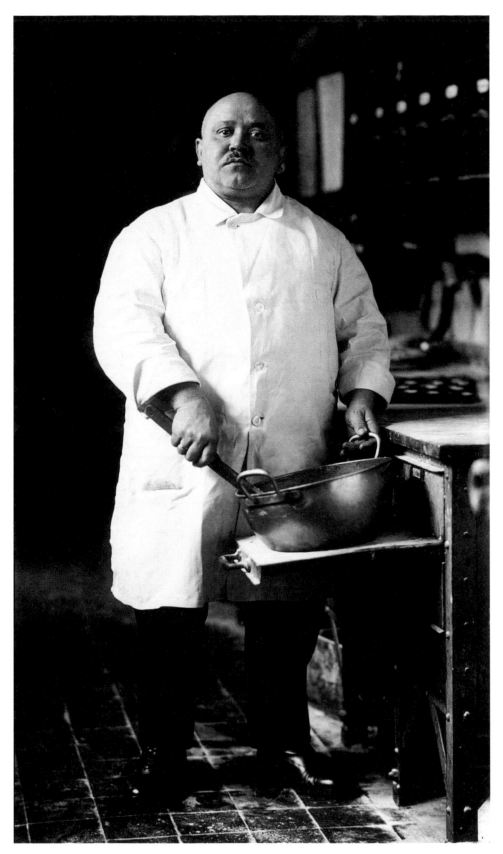

Sander's book – *Man of the Twentieth Century* – was his life's work. "An obsession", says his grandson, Gerd Sander. Born in 1876, August Sander began his career in Linz, as a portraitist. Pictorialist photography, its romantic style modelled on painting, was then all the rage. In 1909, Sander moved to Cologne, where he frequented the Progressive Artists group; he gave up 'bourgeois photography' and turned his hand to documentary. He wanted to "Paint a portrait of our time while remaining completely faithful to nature", revealing "the social structure" of the Weimar Republic. It comprised seven chapters of portraits: Farmers, Workers, Women, Occupations, Artists, The Big City, The Last Men. "My grandfather took his photos within a 200 km radius of Cologne," says Gerd Sander. "Some of his subjects were photographed in his studio, but most of them were taken at home or at work. The pose was arranged and had to be held for several seconds." The result was many thousands of photos in which Sander attempted to capture "the identity of his subjects through their physiognomy". This was a "subjective vision", in which the selected portrait "embodied a social type". Consequently the captions give no names. "My grandfather didn't want to pass judgement, but to capture the people of his time in all their variety. His credo was: 'See, observe, reflect'. The pastrycook is one of his most successful portraits."

"My grandfather wanted to capture the people of his time in all their variety."

Gerd Sander

Land of Ebony

© Albert Londres/SCAM

→ TIMELINE

The French empire was second only to that of Great Britain. Its black African colonies lay in equatorial and western Africa. An inexhaustible reserve of manpower and raw materials, they were administered all by whites, who financed infrastructure and bureaucracy by a poll tax. The only guideline for this cut-price development was French economic interests; roads and railways were built to carry exportable commodities. Independence movements brought the French empire to an end in the early 1960s.

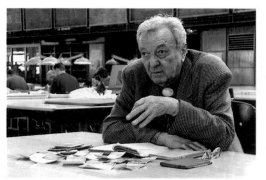

René Mauriès: "Albert Londres sought justice; he was denouncing a new form of slavery."

The Exhibits

"OUR JOB IS NEITHER to entertain nor to slander; it is to bring injustice to light", wrote Albert Londres in the introduction to *Terre d'ébène* (*Land of Ebony*). The first great reporter of the century worked for *Le Petit Parisien*. In 1928, he spent four months in French black Africa. There he discovered the subhuman conditions of the woodcutters: "The forest! The terrifying kingdom of the woodcutters! I left Abidjan in search of a lumber camp. (…) At last, I came upon a black chief. (…) I mimed my questions. Wood men? he said, Use-up men? He indicated that it was further on. (…) I walked towards the shouting. Here it was. A hundred naked negroes, harnessed to a tree-trunk, trying to drag it along.
– Yââââ! The foreman beat time with his stick. He seemed all but demented. He roared. The beasts of burden were all muscle as they strained forward. They pulled head down. A shower of blows rained on their outstretched backs. The creepers lashed their faces. Their bloody feet left a trail. (…) A white man! He stood open-mouthed at my presence. (…)
– I'm interested in the forest, I said. I wanted to watch the lumber work. (…)
He showed me his stick.
– I always have a cudgel to hand. Only way of getting them to work here. It's a shame. But I look after them. (…) In the whole region, no one kills fewer than I do. That's life; harsh words, but machines can never replace niggers. You'd have to be a millionaire. There's nothing to beat banana-power." ∎

He has the warmth of a man of feeling and the candour of a freethinker. Awarded the prestigious Albert-Londres prize in 1956 for his reports on the Rif, René Mauriès is visibly moved as he leafs through the notebooks of Londres, his inspiration. "Londres was the father of investigative journalism. After denouncing the penal colony at Cayenne, the psychiatric hospitals and the white slave trade, he attacked an immoveable object: colonial France. He was no anti-colonialist, but he was disgusted by what he saw in Africa. He thought colonisation meant emancipation for underdeveloped nations; instead he discovered a new form of slavery. Whom did it serve? The birthplace of the rights of man: France. Slaves cutting wood or building the Congo Océan Railway, on which 17,000 blacks were worked to death. After his reports were published, he continued to seek justice, lobbying ministers and parliamentarians. The reaction was ferocious. The colonial and military lobbies accused him of "lies and slander", calling him "Jew" and "traitor". Until his mysterious death in 1932, in a shipwreck on the Red Sea, Londres continued his fight for freedom of information. He was truly 'a credit to his profession', in Léon Daudet's words."

"Albert Londres was the father of investigative journalism."
- - - - - - - - - - -

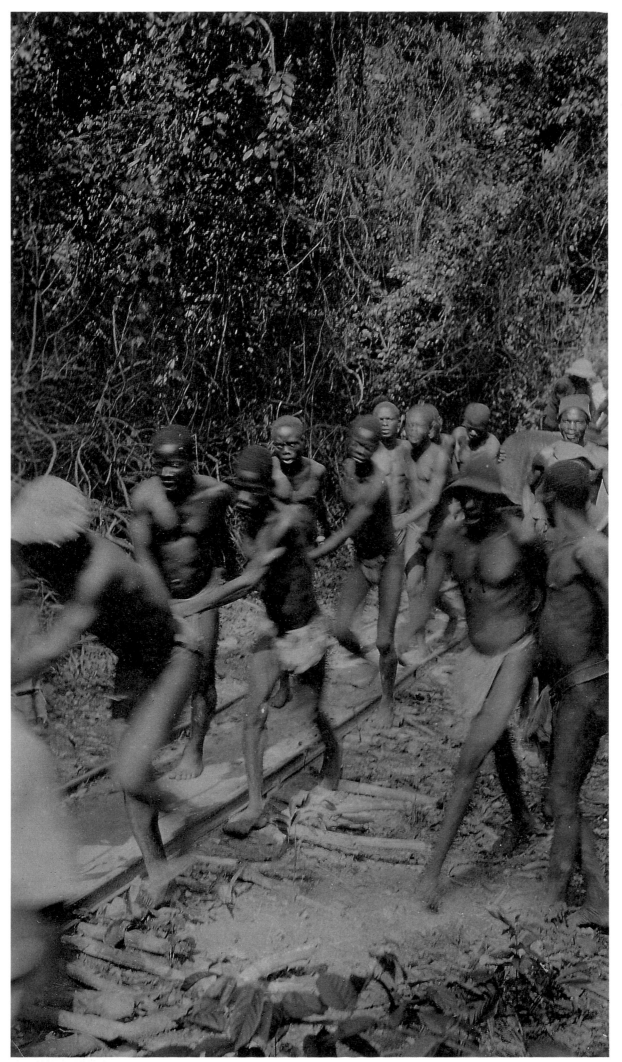

"They proved that what he wrote was true."

Didier Folléas

A teacher in a Casablanca *lycée*, Didier Folléas was bargain-hunting in a souk when he found an envelope containing some one hundred black and white photos; it was marked 'Albert Londres'. In Paris, he consulted the archives at the *Petit Parisien*: the photos were genuine. The shot of the woodcutters was published on 31 October 1928 under the title 'Four Months With Our Black Africans'. "I found a studio invoice showing Londres had the photos developed in Casablanca, a mandatory stopover for travellers on their way to Africa," explains Didier Folléas. "The photos are amazing, because they are neither ethnographic nor propagandist; at the time, these were the only ways of photographing colonial France. Londres divided his reportage into little episodes, like a film script, with descriptions and dialogues, and his photos illustrate his texts. What's more, they proved to the people he was accusing that what he wrote was true: these photos are like exhibits in a criminal case."

Albert Londres

The Hague Conference, 01.00

© Erich Salomon/Bildarchiv Preussischer Kulturbesitz

→ TIMELINE

28 June 1919. The Treaty of Versailles marked the end of the First World War. Dictated to Germany, which was excluded from the negotiations, it contained territorial, military and financial provisions: the return of Alsace and Lorraine to France, the payment of reparations, demilitarisation and the occupation of the left bank of the Rhine. Germany, humiliated, termed it the 'Diktat of Versailles'. In 1930, the Hague Conference decreed a reduction in the reparations and withdrawal from the Rhineland.

015

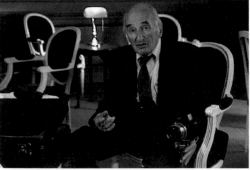

Peter Hunter: "My father was the first paparazzo of the century."

HE ARRIVED AT the India Hotel in The Hague armed with an enormous black leather attaché case, a tripod and a cardboard portfolio. Peter Hunter, 85, is the son of Erich Salomon, the most famous photographer of the interwar period. Dubbed 'the king of indiscretion' after he invented the first hidden camera in history, 'Dr Salomon' liked to ambush his prey in this luxurious hotel, where every night the international conferences taking place in the former capital of the Netherlands would adjourn. Peter Hunter unwrapped his treasure: a 1927 Ermanox. The ads proclaimed: 'Indoor and night photography without flash'. Next, out came an 8-metre cable with silent shutter-release. And finally, ultra-sensitive glass plates, allowing shutters speeds of 1/8; at the time, this was exceptional. "My father placed his Ermanox on this tripod, and discreetly moved around with his cable, so that he could photograph his subjects without them realising it. He was the first paparazzo of the century." At the end of the Hague Conference, Erich Salomon caught the European ministers dozing in the lounge of a restaurant. He hid behind a screen to take the photograph. "Finally, the French Finance Minister, Chéron, discovered my father and said to him: 'Since you're here, you may as well help us solve this thorny problem!'" ∎

'The King of Indiscretion'

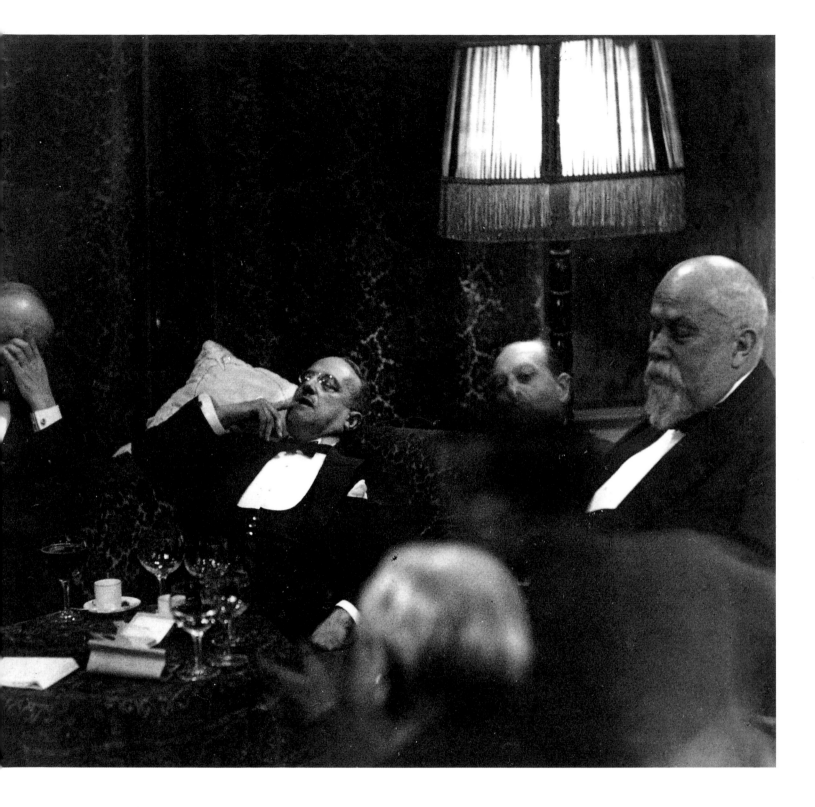

The father of photojournalism.

Born in 1886, in Berlin, to a family of Jewish bankers, Erich Salomon learned his trade with *Die Berliner Illustrierte*, the finest European illustrated magazine, which had a two-million print-run. He worked alongside several of the greatest photographers of the century: Alfred Eisenstaedt, Felix H. Man, André Friedman – alias Robert Capa – and Tim Gidal. Revelling in his title of 'Doctor', Erich Salomon became the official photographer of the higher echelons of power. But in his own manner; uniquely for the time, none of his photographs was posed.

Famous as far afield as the United States, he regarded himself as a *Bildhistoriker* (a historian in pictures), and was the first photographer to sign his pictures. He single-handedly raised the status of the photographer from technician to journalist proper. When, in 1933, Hitler came to power, the Jewish photographers left Berlin, taking their expertise with them. Alfred Eisenstaedt went to the States to work on *Life* magazine; André Friedman went to Paris, where he co-founded Magnum; Tim Gidal worked on *Picture Post* in London. Salomon's Dutch refuge offered no security. Captured during a round-up, he died in Auschwitz with his wife and second son. His eldest son, Otto, emigrated to London, where he served in the British army under an assumed name: Peter Hunter.

ERICH SALOMON

Hitler

© **Heinrich Hoffmann**/Fotografarchiv Hans Döring

Rudolf Herz: "The dictatorship was built on the cult of a leader. So the portrait was vital."

The Führer

→ TIMELINE

30 January 1933: after the Nazis' electoral victory, Adolf Hitler was appointed Chancellor. His opponents were sent to concentration camps, political parties were dissolved, and the repression of the Jews began. The Third Reich was born. Thanks to a powerful propaganda machine, Hitler was immensely popular: he reduced unemployment through a vast programme of public works and by militarising the economy. In twelve years of absolute power, Hitler established himself as the greatest criminal of the century.

SEPTEMBER 1923, Schelling street in Munich. In a courtyard, a studio bearing the sign 'Photohaus Hoffmann'. Adolf Hitler, leader of the obscure 'National Socialist German Workers' Party' had an appointment there. No one in Germany knew his face, so he asked his friend Heinrich Hoffmann to take his picture. They had met in 1920. Hoffmann's shared Hitler's extreme right-wing beliefs. This first sitting produced a photo widely distributed after the abortive *putsch* of November 1923; the Hitler-Hoffmann partnership had begun, and the myth of the 'Führer' was, in part, its creation. "Hitler was very gauche and didn't know how to present himself," says historian Rudolf Herz. "Hoffmann taught him everything." Over the course of twenty-two sittings, Hitler created his new image: clothes, hairstyle, stance, expression, everything was tested and rehearsed. "The aim was to depict him as Germany's saviour. The Nazi party's appeal was not its ideology, but faith in a leader. So the portrait was vital." The apogee of this *mise en scène* was a photo taken in 1933, entitled 'Hitler, Chancellor of the Reich'. It shows him in military coat, with First World War Iron Cross and Nazi insignia, diagonal parting contrasting with the straight moustache, intense stare enhanced by lighting, and determined set of the mouth. "Modelled on the traditional Prussian royal portrait, this was the most successful stylisation of the Führer." ∎

In May 1945, Hoffmann was arrested by the Allies. who confiscated his property and 2.5 million photos. Imprisoned in Nuremberg, where the Nazi war criminals were brought to trial, he was forced to comb his archives to provide evidence against certain figures. With other leading Nazi figures, Hoffmann was found guilty in the first degree; the verdict stated that his "photos contributed greatly to Hitler's accession to power". Sentenced to ten years' hard labour, he obtained a reduction in his sentence and became an alcohol salesman. He died in 1957, at the age of 72.

"Guilty in the first degree."

HOFFMANN
and denazification

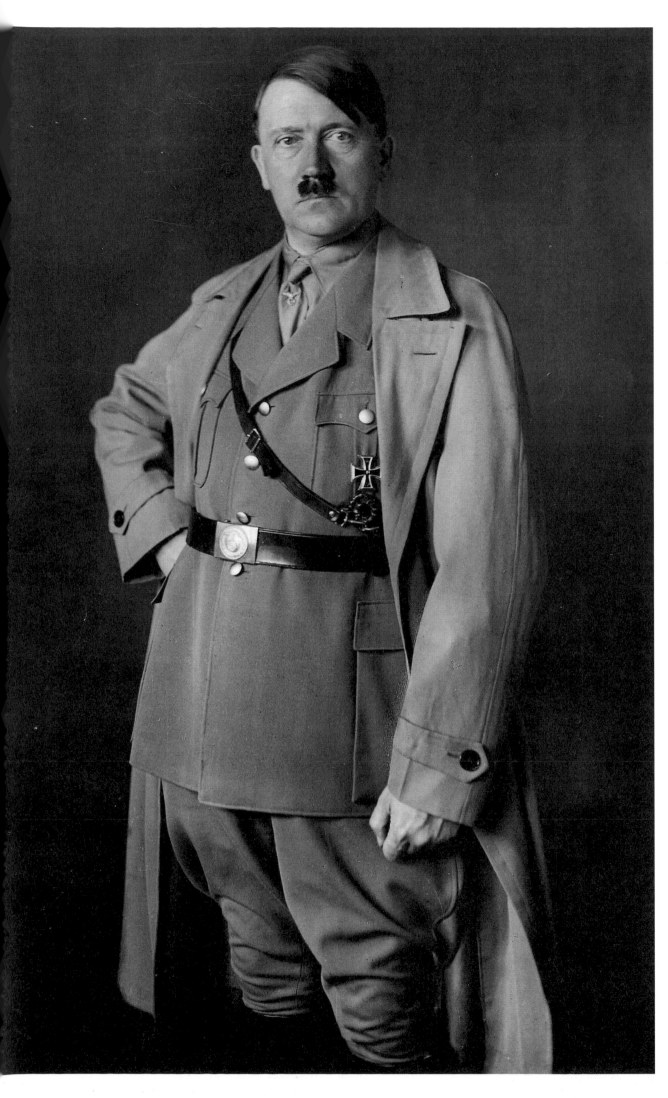

"One of the most successful companies during the Nazi regime."

Gisela Twer was 20 when she was taken on by Heinrich Hoffmann as a copywriter. Her job was to devise captions. The studio had grown to a company employing three hundred staff, with a press and publishing department. "Hoffmann was Hitler's personal photographer. He alone was allowed to photograph him at home and, during the war, in his headquarters and bunker. Eva Braun, whom Hitler had met in the studio in Munich, where she worked as a sales assistant, never appeared in the photos. The private photos were published by Hoffmann in illustrated books with print-runs in the hundreds of thousands: *The private Hitler, Hitler in the Mountains* and *Hitler and Children*. A photo like the 1933 shot was sold to every town hall, administrative office and company in the country. Most of his photos were used in the Nazi press, like *Der illustrierte Beobachter*, which Hoffmann helped to found. His company was one of the most successful of the Nazi regime."

Gisela Twer

Mexico 1934
© Henri Cartier-Bresson/Magnum Photos

→ TIMELINE

1934. Lázaro Cárdenas was elected president of Mexico. He was hugely popular; he redistributed sixteen million hectares to the peasant farmers and Indians, nationalised the oil companies, and laid the foundations for a genuine democracy. A haven for refugees from authoritarian regimes in Latin America and Franco's Spain, Mexico was then the political, social and cultural beacon of the Americas.

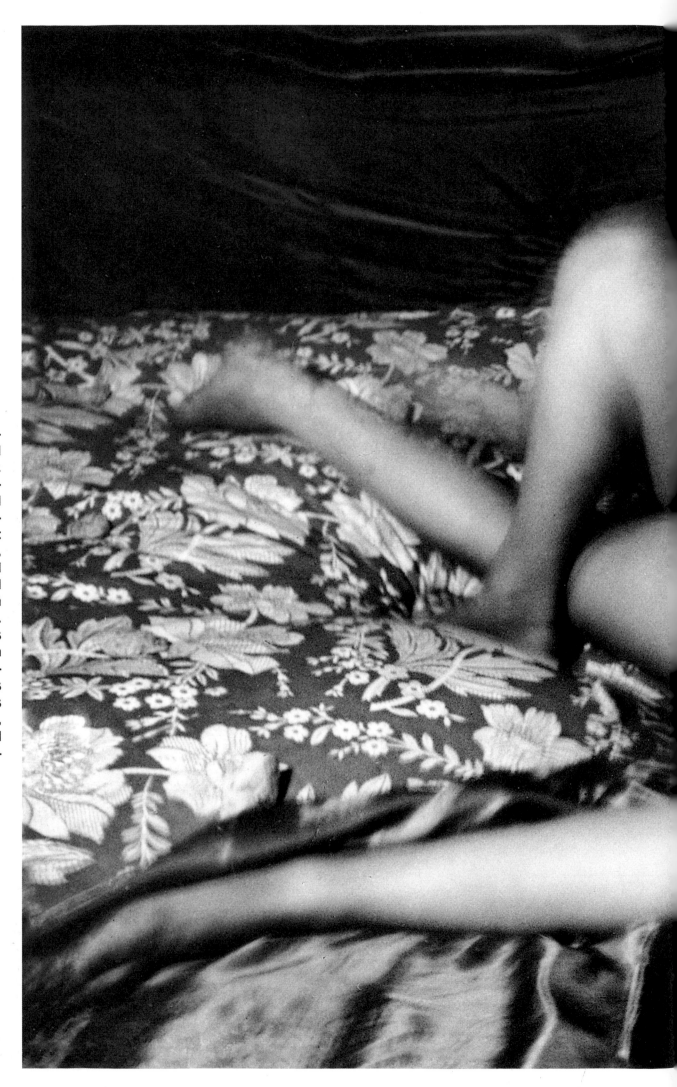

HENRI CARTIER-BRESSON

"It's like in a river, watching the trout that's watching the fly, then: snap!"

The Spider Of Love

"I CALL THIS CHARMING PICTURE 'The Spider of Love'; it shows two pretty Mexican lesbians caught, I think, unawares, using the HCB method; he relies on the instant. Here, everything but the essential is hidden, and decency is preserved amid ultimate eroticism. The eye is feasted in all innocence. What elegance, what discretion!" Written in ink at the bottom of an elegantly framed print, the text is signed by the writer André-Pieyre de Mandiargues. "He was my friend for over half a century," says Henri Cartier-Bresson. "He loved this photo." And, with obvious relish, he describes how it was taken: "It was in 1934, in Mexico, where I'd been living for a year, taking part in an ethnographic mission, which came to nothing. An artist friend had decorated the bachelor pad of a plenipotentiary minister. Everyone was drinking tequila after tequila, except me; I had amoebic dysentery … I and my friend, Tonio Salazar, explored the house; when we were upstairs, we heard a faint sound, opened the door … I always carry a Leica, Tonio had a torch, click, there you have it! I took two or three other photos – too late; the moment had passed. It isn't in the photo, but afterwards, you see, I was very ill, but my friend wasn't: he joined the girls … then all four of us went back downstairs as if nothing had happened …" ■

The world according to Henri Cartier-Bresson

"Love is blind ... I can't separate body and mind, for me the unity of physical and spiritual is entire. Puritanism's a dreadful thing: without physical pleasure and sensuality, there would be no art, no music, just aridity, a knock on the head ... I've lived with painting. Photography is a different adjunct, in my view, it's like instant drawing. It's a notebook of sketches. It's not an art. When you run, you sweat, it's like that: an emanation ... It's the photographic shot I'm passionate about ... the sensitivity, it's just the opposite of didactic thought: pleasure, geometry, intuition. De Gaulle said: 'Photographers should be like artillery men, aim well, shoot quickly, then get the hell out!' That's a good definition. You shouldn't want anything specific, it's dangerous to want something, you must be responsive and open, give and take. Even in the physical sense, bang! it's like an orgasm when the subject is there. I was brought up on Arsène Lupin, photographers are pickpockets, chroniclers: we keep a log, like a writer, and the contact sheet shows everything we've seen, second

by second, that's why it's so indiscreet ... I don't like travelling, I like being in a country, living there. Elegance is slow. Take your time. Rodin said: what takes time to make is respected by time. I'm not nostalgic. Well, perhaps for photos and events I missed, and not really even then: life is perptual change. Everything disappears and is reborn every moment ... I was a photographer for a little too long. When you do 'reportage', you can't do anything else: you're like a safety inspector, your eyes scan everything. Since I stopped, I've been free ... I'm obsessed by drawing. I draw nudes when it's rainy or cold, I draw trees, I love drawing heads, whereas photographic portraiture is the most difficult thing of all, I find. You have to guess ... It's a delicate matter, to get a Leica between the shirt and skin of a person. What does it mean to be dubbed 'the greatest photographer of the century'? I've been lucky in life, that's all. And it's good to be old. I'm alive. And an anarchist, of the non-violent variety. Long live Bakunin!"

And God Created Magnum

"Chim and Capa aren't dead," says Henri Cartier-Bresson. "They're simply on the away list. Their spirit still infuses Magnum ...". In April 1947, David Seymour ('Chim'), Robert Capa and HCB founded the agency Magnum-Photos, the first photographers' co-operative. Its aim was to keep some sort of control over the texts accompanying photos, while retaining ownership of the shots. "We wanted to stop being a magazine's flunkies and choose our own subjects, but at the time it was revolutionary! We each put 400 dollars into the business. The name? It was the promise of a bottle of champagne every time we got together." The "business" became the benchmark for photo-journalism. The jewel in its crown are the photo-essays that Magnum championed against all odds ... 1954: Robert Capa was killed by a mine in Indochina. 1956: Chim was killed in Egypt. "In this job," says Cartier-Bresson, "we go away for a long time; some have been away longer than others".

A man of his Century

"I was destined for textiles, but I scarpered to Africa!" Born in 1908 to a family of industrialists from the Paris area, Henri Cartier-Bresson had art in his blood: a father who loved to draw, a painter uncle. The little boy dreamed of becoming a painter. He always has. His influences: Goya, Degas, Cézanne, Delacroix, Matisse. He hung around with the Surrealists, then went to the Ivory Coast, where he lived by hunting. 1931: he came across a photo by Martin Munkácsi, 'Children on Lake Tanganyika'. Love at first sight; he bought a Leica and began to travel in Europe, then Mexico, his first home base. An acclaimed photographer, he tried film-making as Renoir's assistant, then made a documentary about Republican hospitals during the Spanish Civil War. Captured in 1940, he escaped in 1943. At the end of the war, the Museum of Modern Art in New York organised a posthumous exhibition of his work! Next, he travelled to the Orient, where he lived for three years: India, his second home base, China, Burma, Indonesia, and Japan. Then the USSR, the United States and Mexico again. A long-haul photographer, Henri Cartier-Bresson "gave up reportage" in 1972 to devote himself to drawing: "Now, when I get out my Leica, it's to photograph the people I love: my wife Martine, my daughter Mélanie and my friends ..."

Stalin and Guelia

© **Kalashnikov**/David King Collection

→ TIMELINE

His favourite nickname was 'little father of the peoples'. After Lenin's death, in 1924, Joseph Stalin reigned supreme over the eleven republics of the Soviet Union, systematically eliminating his opponents, sowing widespread terror and promoting his own personality cult. Millions of innocent people were murdered during his reign. A demagogue, he made much of his two great successes: his victory against the Nazis and the USSR's accession to the status of superpower. At his death, in March 1953, the entire country felt bereaved.

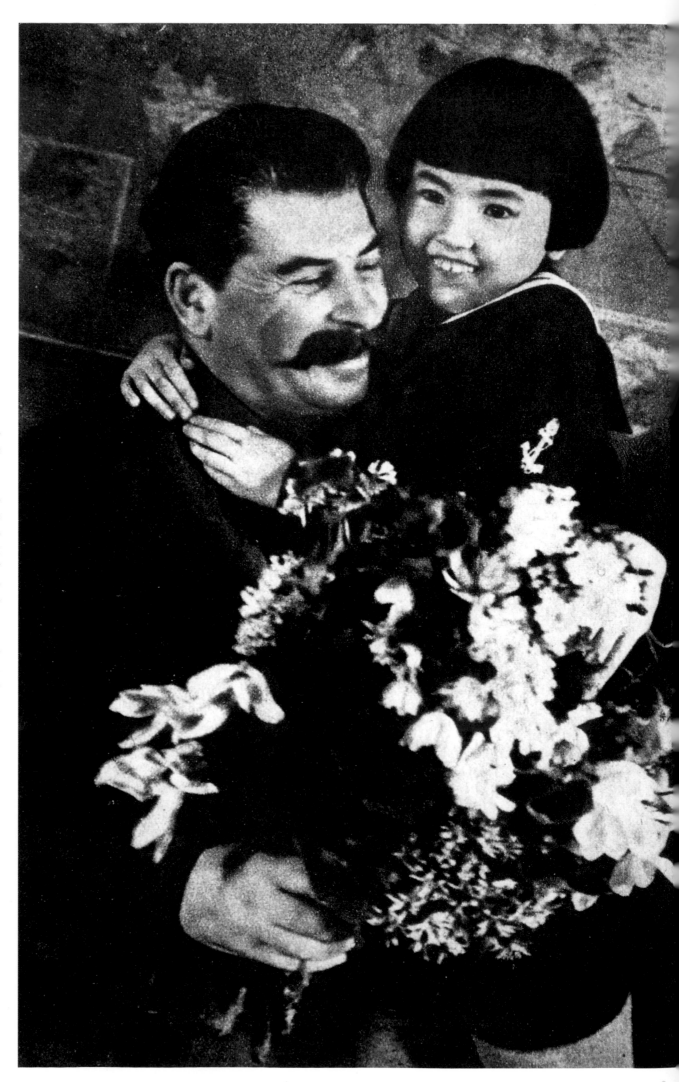

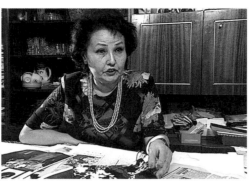
Guelia Markizova: "It was like a dream come true."

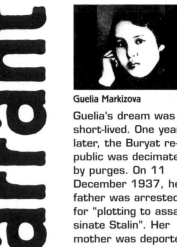
Guelia Markizova

Guelia's dream was short-lived. One year later, the Buryat republic was decimated by purges. On 11 December 1937, her father was arrested for "plotting to assassinate Stalin". Her mother was deported to Turkistan, and the photo and presents from Stalin went with her. "We continued to admire him," Guelia says sadly. "We couldn't believe he had anything to do with our tragedy." There was more unhappiness to come. In November 1940, her mother, Dominica, was found, her throat slit, in the paediatric hospital where she worked. Officially, she had "committed suicide". It was not until 1996, on consulting the KGB archives, that Guelia discovered the truth. In an eight-hundred-page file, she found a letter sent to Moscow by the head of the NKGB in Turkistan, asking what he should do about the "exile Dominica Markizova, who has a photo of her daughter with Stalin, which she might brag about". On it, a reply in blue pencil: "Eliminate her".

A Death Warrant

Yuri Borissov

"An icon of Stalinist propaganda."

The photo of Guelia and Stalin appeared in millions of posters, postcards and textbooks. The artist Georgi Lavrov sculpted it; three million casts adorned Soviet paediatric and gynaecological dispensaries. "This photo left its mark on my generation," says Russian historian Yuri Borisov, "the propagandists used it to symbolise Stalin's policy towards children. It also embodied the 'little father of the peoples': the little girl is obviously not Russian, and this was very important at a time when republics of disparate cultural and ethnic origins were being yoked together by force".

THAT DAY, SHE WAS, SHE SAYS, the "happiest girl in the world." The archive pictures show her awestruck, embracing Comrade Stalin, to whom she has just presented an enormous bouquet. The little Mongolian girl's eyes are wide with happiness, while Stalin smiles compassionately. Click: the aptly named Kalashnikov took the shot. The eldest daughter of Ardan Markizov, Second Secretary of the People's Revolutionary Party of the Republic of Buryat-Mongolia, and Dominica, a medical student, Guelia was seven on 7 January 1936. Stalin had invited a delegation of sixty-seven people to the Kremlin to celebrate the achievements of the revolution in that far-off territory. "Fascinated by the Party leader," Guelia persuaded her father to take her with them. However, in the halls of the Kremlin, the little girl grew bored. Flouting protocol, she stood up in the middle of a laborious speech in Buryat by a woman listing the achievements of her kolkhoz. "I want to see Stalin", she demanded, squeezing behind the presidium, bouquet in hand. "Stalin turned round and smiled," she remembered, "he lifted me onto the table, and I laughed with joy." The highlight of the evening: Stalin gave her a red box, engraved 'To Guelia Markizova, from the Party Leader', and containing a "magnificent gold watch" and a record player. "It was like a dream come true, how could I have imagined the nightmare to come." ∎

Migrant Mother

→ TIMELINE

29 October 1929. Sixteen billion dollars were lost in the Wall Street Crash. This was the first stock market crash of the century and it plunged America into the Great Depression: thousands of businesses went bankrupt, while thirteen million unemployed 'migrants' wandered the country in search of work. When, in 1932, Franklin Roosevelt was elected President, he announced an ambitious programme, the New Deal: a policy of public works, agricultural subsidies and fiscal restructuring to reflate the economy.

019

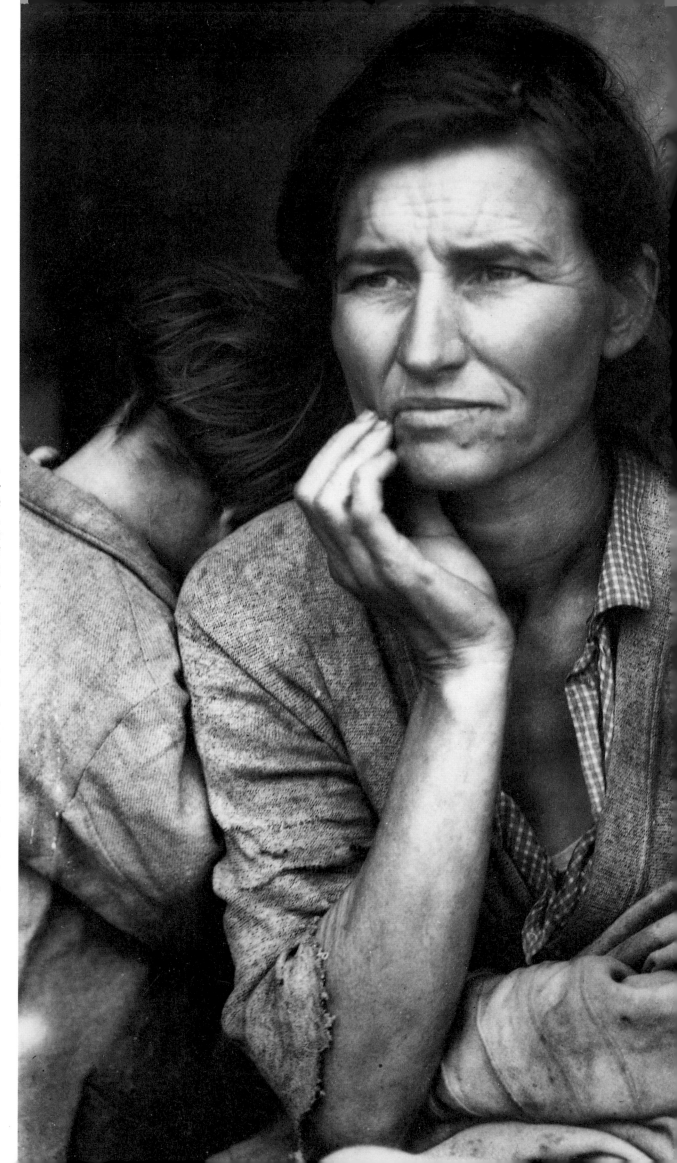

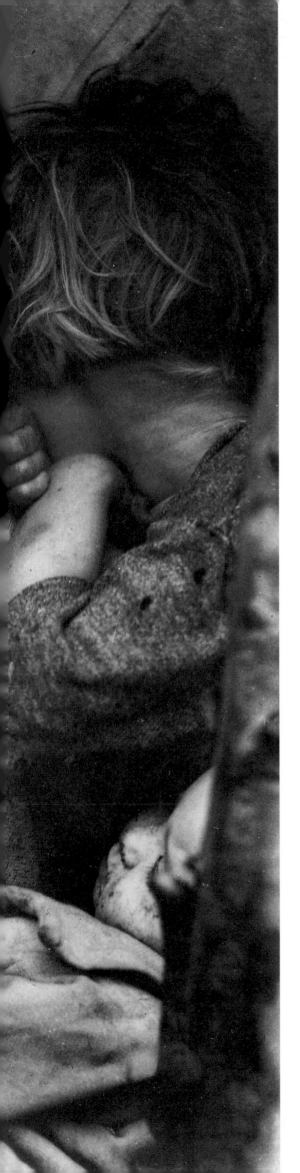

Society's Rejects

Kathleen McIntosh: "In the photo, I'm on my mother's right."

IT WAS COLD AND DAMP on 6 March 1936, when Dorothea Lange decided to return home. She had just spent a month photographing seasonal workers on the west coast of America. At the roadside, she noticed a sign for a pea-pickers' camp. Keen to see her two children again, the photographer drove past without stopping. Thirty kilometres on, she turned back. "I followed my instinct and not my logic," she said in an account written in 1960. A muddy road led to a makeshift camp overflowing with migrant families. "I noticed a starving, desperate woman and I was drawn to her like a magnet." Dorothea Lange only stayed ten minutes, time enough to exchange a few words with Florence Thompson, a thirty-two-year-old widow with six children. Thompson had just "sold the tyres on her car to buy some food". She and her family survived "by eating frozen vegetables from the fields and birds trapped by the children". "In fact," explains Kathleen McIntosh, the little girl huddled against her mother's right shoulder, "we'd stopped at this camp at Nipomo because the driving belt of our car had bust. We were waiting to be repaired before going to Watsonville, where we were told there was work." Lange took six photos. This was the last. It has become a lasting symbol of the outcasts of the American Dream. ∎

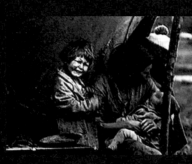
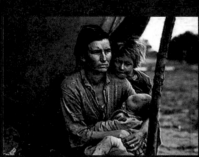
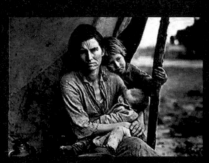
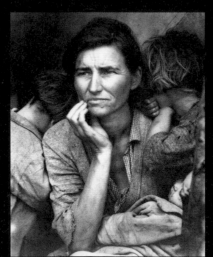

019

Vicki Goldberg: "A form of government propaganda."

Dorothea Lange

Dorothea Lange took six photos. Gradually she moved in on Florence Thompson suckling her baby. And the scene took shape: the baby fell asleep, while Kathleen and her sister huddled against their mother; only the napes of their necks can be seen. The woman's face is beautiful, despite the anxiety that furrows her brow. Her chin resting on her hand, she gazes into the distance. "The power of this photo lies in its relation to our cultural heritage, particularly the Renaissance madonna and child," notes Vicki Goldberg. "Like all true icons, it can be appropriated or exploited in other artistic disciplines." The picture was published in Republican tracts during the Spanish Civil War. Later the Black Panthers used it with the caption "Poverty is a crime, and our people are the victims"; mother and children were given black skin and afro hair. It also made the front page of the Venezuelan magazine *Bohemia*; this time the children had Amerindian features. Throughout the world, 'Migrant Mother' has become an icon of poverty.

For Dorothea Lange, it all started in San Francisco, where she had opened a studio. An acclaimed portraitist, she began reportage when she discovered the silent but dignified crowds of the unemployed at soup kitchens and employment agencies. In Washington, her photos overwhelmed Roy Stryker, an economist working for the Farm Security Administration, newly created by Franklin Roosevelt to carry out rural reform. Its aim was to help ruined farmers with subsidies. To obtain funding, the Democrat President had to convince Congress and public opinion. Photography was his weapon. At Roy Stryker's instigation, the FSA created a photographic department, which hired Dorothea Lange. For six years, eleven photographers were told to show the poverty suffered by the victims of the Great Depression. "It was a form of government propaganda," comments Vicki Goldberg, an American historian. "This was the first time that an administration had used photos as a tool of communication." The result was 270,000 photos, 100,000 of which were taken by Lange. 'Migrant Mother' remains the greatest memorial of both the FSA and Dorothea Lange. "I seem only to have taken one photo in my career ..." she used to say in old age.

At the age of 67, Kathleen McIntosh has a strong working-class accent. She lives in a small house in California. Unearthing scores of yellowed newspaper cuttings, she points at the nape of a five-year-old girl with a mixture of satisfaction and annoyance: "Our photo has appeared all over the world, but we've never received a cent. That's why I charge journalists who want to interview me 1,000 dollars." And she reads out a 1978 interview given by her mother to *Tribune*. "I'm tired of symbolising human poverty when my living conditions have improved," declared Florence Thompson, announcing that she would take legal action to prevent publication of the photo. The trial never took place; there was no evidence that she had been photographed unawares. On the contrary. Five years later, her children did not hesitate to publish the photo in the *New York Times* with an appeal for help: their mother was suffering from cancer and could not afford hospitalisation. Within a few weeks, 15,000 dollars flooded in from all over the United States. To no avail: Florence Thompson died on 16 September 1983 at the age of 79.

The photo was adapted for a Black Panthers poster.

"Poverty is a crime, and our people are the victims"

Florence Thompson

"The first time I saw the photo, I was ashamed ..."

Front Populaire

© **Willy Ronis**/Rapho

→ TIMELINE

June 1936. The French elections were won by the Front Populaire, and the socialist Léon Blum was Prime Minister. Two million employees went on strike to force the government to keep its election promises. On 7 June, the employers and the CGT union signed the Matignon agreement: in addition to pay rises, and a forty-hour week, it gave employees two weeks' paid holiday. Working-class France was overjoyed. However, the business sector's hostility coupled with a rash of administrative errors plunged the country into recession, and in June 1937, Léon Blum resigned.

020

WILLY RONIS

"A memorable day which marked the beginning of my career."

"I T WAS A MEMORABLE DAY:" no idle comment from a man who has seen so much in his ninety years. "I've never again seen such jubilation on Bastille day," insists Willy Ronis, "Everyone who sympathised with the left took to the streets". It was 14 July 1936, a month after the signing of the Matignon agreement, the greatest achievement of French social reform. The workers revelled in their first paid holiday; Paris celebrated. "They came from all over, with their wives and children," says Ronis. "I was 26 and an amateur photographer. I mingled with the crowd using my 6 x 9 bellows camera to snatch some souvenirs of this homage to the Front Populaire". Léon Blum and his ministers headed the procession, which went from Place de la Bastille up Rue Saint-Antoine, singing the *Internationale*. At 4 Rue de Rivoli, Ronis noticed a little girl perched on her father's shoulders. "She caught my eye because she was wearing a Phrygian cap and she had raised her fist. I took two photos. On one she was brandishing her left fist, on the other her right; I asked her to change hands because, in protest marches, people traditionally raise their right fist." Published the next day in a Parisian newspaper, the photo remains a symbol of the Popular Front. "And," said Willy Ronis, "it marked the beginning of my career: it was on the evening of that memorable day that I decided to become a professional photographer." ■

Bastille Day

He loves to talk about his memories. "I'm a photographer of the humdrum," says Willy Ronis. "Scoops don't interest me, neither do smart neighbourhoods. I like recording the lives of ordinary people and their everyday pleasures." He dreamed of becoming a musician, he devoured paintings (Veronese, Breughel) and became one of the greatest French photographers. For more than sixty years, Willy Ronis has regarded the world good-humouredly, camera in hand and music in his head. For him, each photo is a chord born of the harmonies of light. "However excited I am by a subject, I'm always concerned with form. I try to achieve a composition that balances masses and lines, shadow and light. I like bird's-eye views laying out a succession of spatial planes; as in a fugue, there should complementary but autonomous lines. Like in life ..."

WILLY RONIS

"Life is like a fugue."

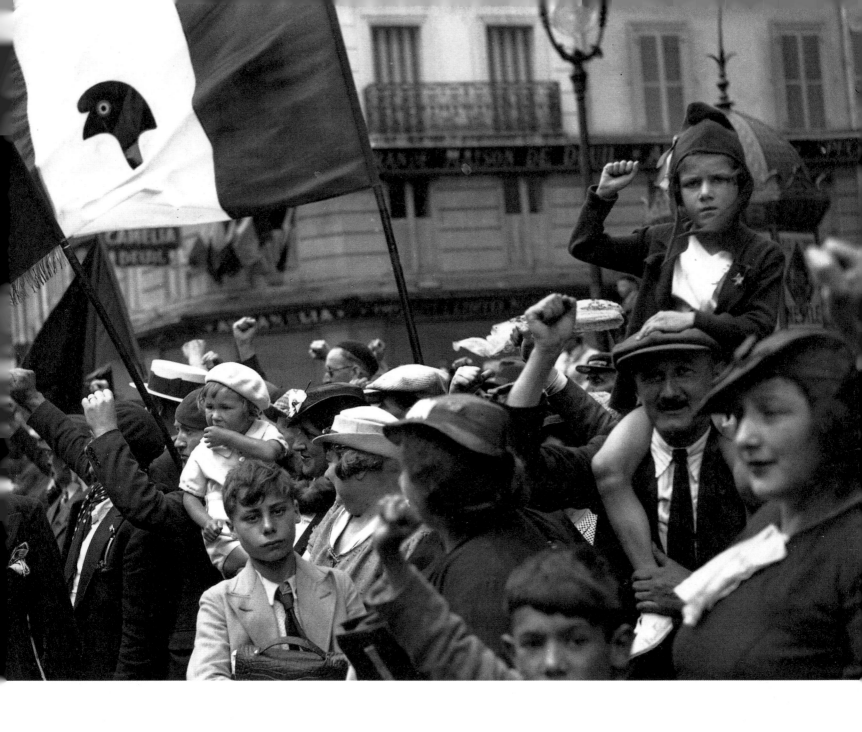

"My mother made my Phrygian cap."

"You were destined to symbolise the Republic", said Willy Ronis, when they met for the first time in a Parisian café. And the photographer gave her a watch with the photo printed on the face. "Oh, thank you!", murmured the blushing Susanne Trompette. The daughter of a railwayman, she was seven when the photo was taken. She saw the photo for the first time before the war, then again on television, on the sixtieth anniversary of the Front Populaire. "My father was delighted; it was a confirmation of the social reforms obtained by the strikes. He wanted me to take part in the celebrations, along with my two brothers, and my mother made me the Phrygian cap, the emblem of liberty. Sixty-two years later, I'm really thrilled to meet you ..."

Susanne Trompette

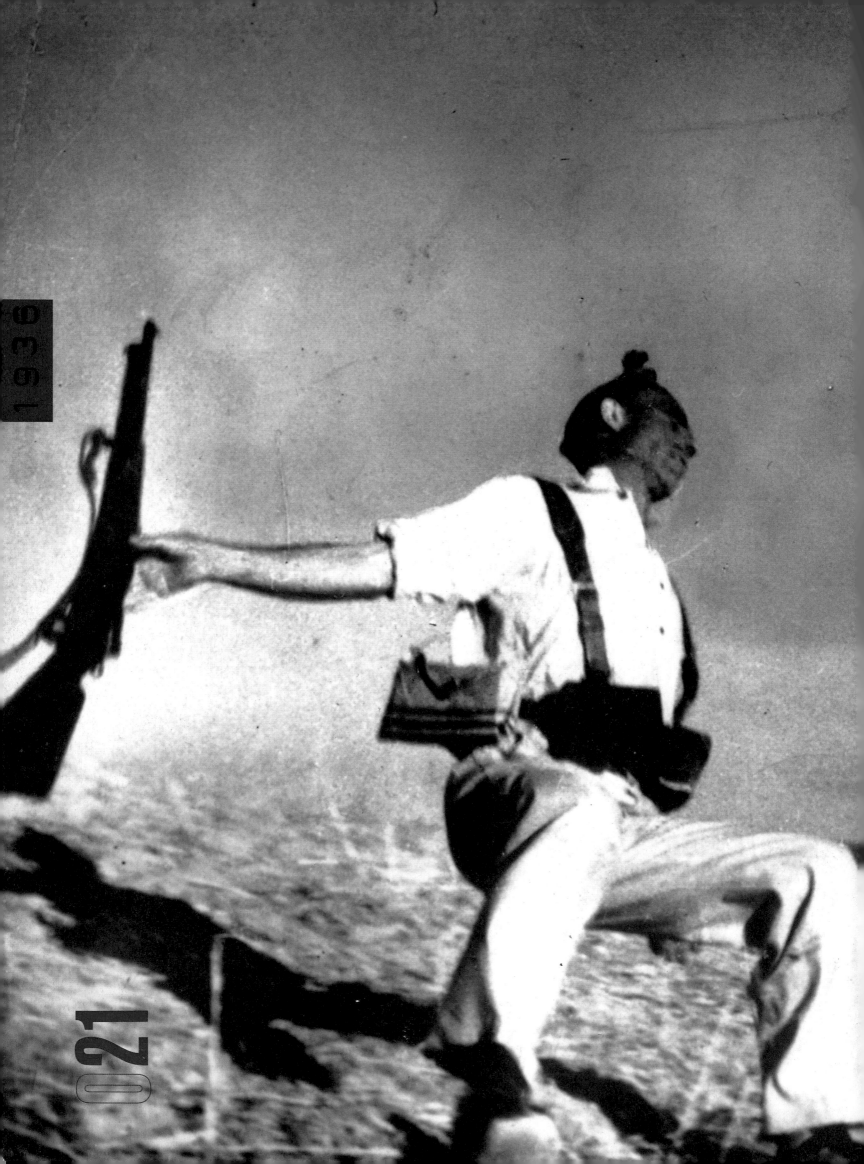

1936

021

Death of a Spanish Republican

© Robert Capa/Magnum Photos

Richard Whelan: "Robert Capa fought fascism, Leica in hand."

Published in *Vu* in September 1936, then in *Life*, in July 1937, the photo caused a sensation: the celebrated English magazine, *Picture Post*, called Capa "the finest war photographer in the world". "It was the first time that a reporter had photographed the war from within," explains John Morris, who published the photo in the United States, three years before meeting its author. The photo immediately became a symbol of the absurdity of the Spanish Civil War and of all wars. It was also a milestone in photo-

→ TIMELINE

February 1936. The communists, anarchists and socialists of the Spanish Frente Popular came to power. General Franco organised a military uprising that led to civil war. The nationalists received aid from Mussolini and Hitler, while thousands of volunteers, the International Brigades, joined the Republicans; among them were intellectuals like André Malraux and Ernest Hemingway. The Spanish Civil War ended in April 1939 with victory for Franco, whose dictatorship lasted until his death in 1975. A million people died in the war.

HE WAS 23 AND HE WANTED to fight Leica in hand. "For Robert Capa," explained Richard Whelan, his American biographer, "this little lightweight camera was a weapon with which to fight Fascism. He wanted to raise money for the Republican cause with his photos." In the summer of 1936, Capa got lucky: Lucien Vogel, owner of the magazine *Vu*, flew him to Spain in his private aeroplane. Landing in Catalonia with his lover Gerda Taro, he travelled to southern Spain where fighting was at its most intense. On the morning of 5 September, the anarcho-syndicalists in the CNT planned an offensive on the Córdoba front. Capa and Gerda joined the 300-strong Alcoy regiment. Against them were ranged General Mola's nationalist troops, who opened fire in the Cerro Muriano sector. One of Capa's photos shows a group of Republicans brandishing their rifles; on the far left stands a taller man, wearing a pale fatigue jacket with a cartridge belt slung across his chest. Several seconds later, he was killed. Photographed from a trench, as the Fascist bullet struck, he falls back, his rifle slipping from his hand, caught forever between the scorched grass and the limitless sky. ∎

Icon

"This photo inspired generation of reporters."

journalism, marking the advent of a politically committed style of photography that inspired generations of reporters."

John Morris: "That man was like a brother to me."

- - - - - - - - - - -

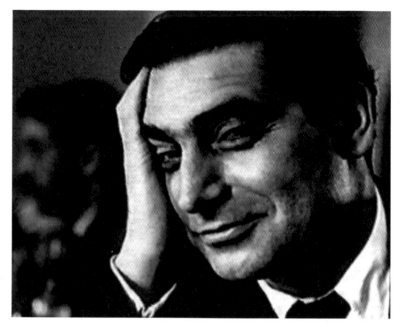

Robert Capa

Capa's last photo; he was killed by a mine in Indochina.

"A vicious rumour."

This is one of the great photos of the century. Witness the rumour that it had been "staged", and that its subject was unhurt. Robert Capa is not alone. Similar things were said of Joe Rosenthal ("His photo of Iwo Jima was faked"), Alberto Korda ("He didn't take the photo of Che") or, more recently, Hocine ("The 'Madonna' is phoney"). Great photos upset the authorities and make people jealous. When one does both, rumours abound. Suspicions first appeared in the early 1970s, after a former *Daily Express* correspondent talked about a 'secret' confided by Capa in a San Sebastián hotel. Philip Knightley cited this in his book on war reporters. The rumour was finally quashed in September 1996 by historian Mario Brotons, a friend of the Republican in the photo. His research in military archives proved what he had always known: the only soldier killed on the front at Cerro Muriano on 5 September 1936 was Federico Borrell García. The victim was twenty-four and had founded a libertarian youth movement in his town of Alcoy. A hedonist, with a fine singing voice, he was a committed antifascist, and a man after Capa's own heart.

He was handsome and brilliant, and women – notably Ingrid Bergman – loved him. A Hungarian Jew, born André Friedman in 1913, he learnt his trade in Berlin. When Hitler came to power, he went to Paris, where he met David Seymour, the future 'Chim', Gerda Taro, a 20-year-old German refugee, the love of his life, and Henri (Cartier-Bresson). In 1935, André Friedman changed his name to Robert Capa, and began to roam: China, USSR, the Normandy landings … In 1947, he founded Magnum with Chim, Cartier-Bresson and George Rodger, over a magnum of champagne. He was now rich and famous: he lived in luxurious Parisian hotels and John Huston, Picasso and Hemingway were his friends. Wherever freedom was threatened, his camera could be found. Gerda, killed by a Spanish tank in the summer of 1937, lived on in his heart. "He never recovered from that blow", says John Morris, who joined Magnum on 'Bob's' recommendation. In May 1954, *Life* sent Capa to cover the Indochina war. After the battle of Dien Bien Phu, Capa wanted to photograph French army manoeuvres in the Red River delta. His penultimate photo shows soldiers with a mine detector. In the last – number eleven – the soldiers have moved off. Then, nothing, just a black border. An anti-personnel mine had killed Robert Capa, the man who "hated war", like the hero of his most famous photo: in action and in his prime. "That man," says John Morris, "was like a brother to me."

Eugen Bentele in front of the shell of the Zeppelin: "This marked the end of the Zeppelin adventure."

Death of a Zeppelin
© Sam Shere/Keystone

→ TIMELINE

6 May 1937: thirty-six passengers died when the *Hindenburg* exploded, probably due to a hydrogen leak. Designed at the turn of the century by Count Ferdinand von Zeppelin, dirigibles were Germany's pride and joy. In 1924, they made their maiden journey across the Atlantic. Lines were opened to Brazil and New York. In 1936, amid pomp and ceremony, Nazi Germany launched the *Hindenburg*, the largest dirigible in the world. An airborne *Titanic*, it transported those who were to become the 'jet set'. Its eleventh journey to New York was its last.

"THE *HINDENBURG* HAS JUST started its descent … Oh, my God! It's broken into flames! It's flashing, flashing! It's flashing terrible! This is the worst thing I've ever witnessed". Radio announcer Herbert Morrison's commentary gave way to anguished groans. At his side, Sam Shere, a correspondent of the Keystone agency, took three photos, one of which went down in history. It shows flames devouring the Zeppelin in mid-air, before it crashed down onto Lakehurst airport. It had left Frankfurt, on 4 May 1937, with ninety-seven passengers on board; sixty hours later above Manhattan, it was greeted by crowds with sirens and motor horns. It stopped 150 metres above Lakehurst, where some thirty journalists, among them twenty-two photographers, had long been waiting. Lightning flickered through the sky, and the order came to wait until the storm had passed before landing. Three hours later, two hundred and thirty-one men, posted around the three-legged mast, rushed to the mooring cables. "Suddenly, there was an explosion," recalls Eugen Bentele, the *Hindenburg's* mechanic, "and I saw the vessel go up in flames from tail to engine. Thirty seconds later, I was on the ground, miraculously still alive." He adds: "No photographer managed to capture the precise moment when it exploded. All that remains is this photo, which marked the end of the Zeppelin adventure." ∎

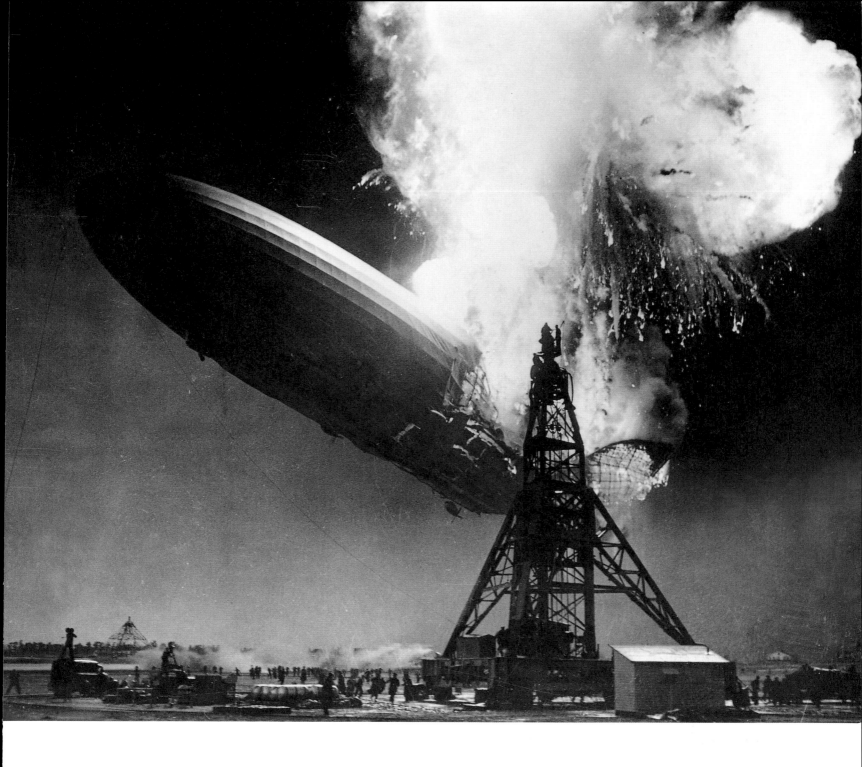

Vicki Goldberg

"The photos of the Zeppelin in flames marked the birth of the scoop," says American writer Vicki Goldberg, who has written a book on the *The Power of Photography*. "Disasters had previously been related firsthand by survivors. Now, the public wanted to 'see' the information in 'real' time. The 'news' was born, prefiguring the advent of television." Sam Shere's photos were immediately sent to Europe thanks to the diligence of Keystone's boss who, from London, called his Paris office: "If you find me clients who will pay 30,000 francs for the photo, I'll charter a plane." (30,000 francs was twenty-five times the price of a car). Three papers were interested: *Excelsior, Paris-Soir* and *L'Illustration*. "The trip is on. Buy the fuel," Bert Garaï telegrammed Dick Merrill, the only pilot who could fly across the Atlantic. On 12 May, Sam Shere's photos made the French headlines. This was Keystone's finest scoop – and the end of the dirigible industry. "This was not the first time a Zeppelin had crashed," notes Vicki Goldberg, "and they had been crossing the Atlantic for eight years without loss of life, but the impact of the photo was such that it was the death of these giant airships".

Now, the public wanted to 'see'

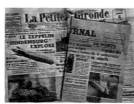 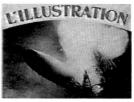

Some twenty-two photographers were present at the time of the disaster: none of them managed to capture the moment of the explosion.

Grief in the Crimea

© Dmitri Baltermants/Tatiana Baltermants

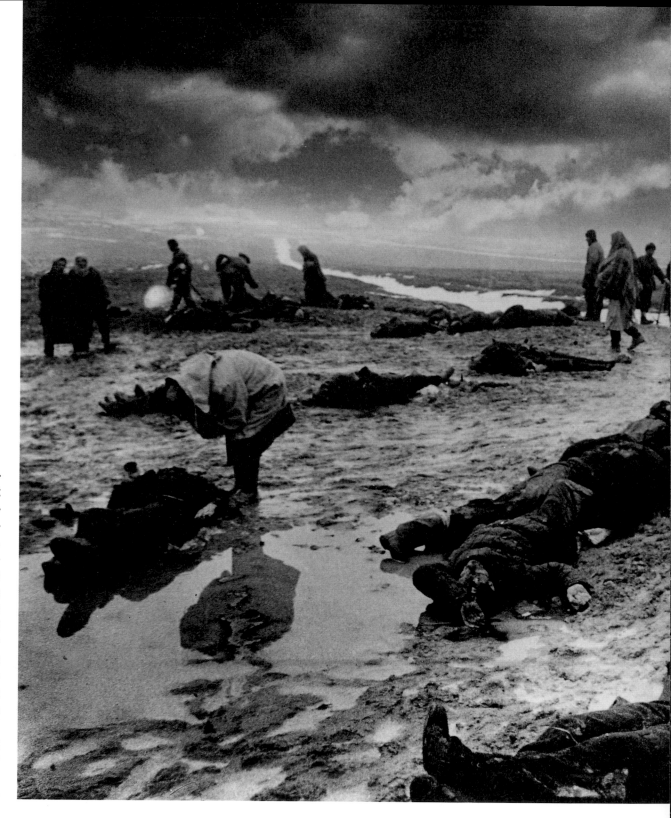

→ TIMELINE

June 1941: Hitler invaded the Soviet Union with four million soldiers. Catching Stalin unawares, the Wehrmacht advanced on three fronts: Leningrad was surrounded in the north, while Kiev fell in the south. After the Crimea, the Nazis reached the Caucasus via the Kerch Peninsula, where they massacred 7,000 partisans. But the onset of winter and Soviet resistance caused the major offensive on Moscow to fail. On 5 December, the Russians launched the first counter-offensive against the Germans. It marked the beginning of a terrible war of attrition.

Dmitri Baltermants' career began in the 1930s. Stalin was at the height of his power and only one school of art found favour with the authorities: socialist realism. Photography was no exception; its task was to "educate the ignorant masses" by kindling patriotic feeling through glorification of communism's "heroic achievements". Visual evidence of the great utopian dream, each photo was composed, produced, and even manipulated in the dark room, to fit the aims of the propaganda department. A fervent communist, Dmitri Balter-

DMITRI BALTERMANTS

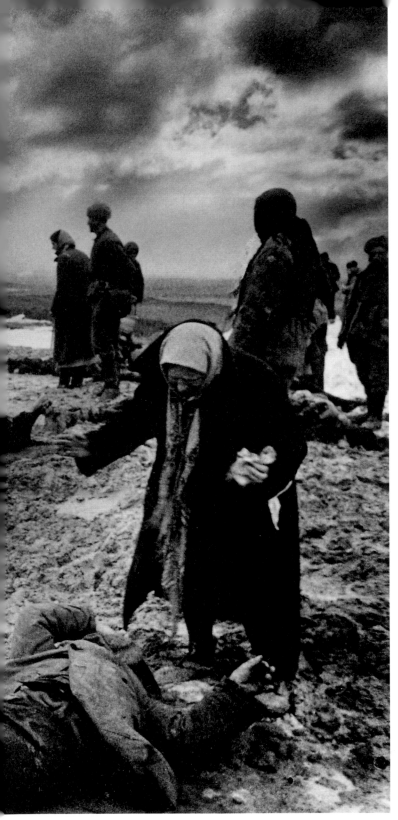

The Eye of the Nation

Tatiana Baltermants: "My father was nicknamed 'the Soviet Capa'."

F EBRUARY 1942. THE RED ARMY reached the Kerch Peninsula, where melting snow was releasing the victims of the Wehrmacht from their icy tombs. Baltermants was covering the 'great patriotic war' for *Izvestia*. Rage filled his heart, and he swapped rifle for camera at the sight of these weeping women, searching the mud for their husbands, brothers or sons. "Throughout the entire war, I only took five or six photos," he said, "you can't photograph war". In Moscow, he developed his films "out of curiosity", knowing they would not pass the censors. "The task of Soviet photographers was to boost the people's morale by showing them our victories," explains his daughter Tatiana. During development, the negative of 'Kerch, Crimea (Grief)' was damaged: there were two holes in the blank, grey sky. Baltermants created a photomontage by superimposing a stormy sky on the original, thereby heightening the dramatic impact of the photo. It was not seen until 1962 at an exhibition in Hamburg, where it was awarded first prize. All the illustrated magazines (*Life*, *Paris Match* and *Stern*) snapped it up, while Baltermants was hailed as the 'Soviet Robert Capa'. "He was very proud of that compliment," remembers Tatiana, "and often repeated it". ∎

mants established himself as the master of the Soviet icon. Published in the magazine *Ogonyok*, his photos were cut out and pinned up by his compatriots. He was dubbed 'the eye of the nation'. Baltermants was a national celebrity: "He was so popular," reports historian Lev Sherstennikov, "that the word photographer immediately suggested his name". After the discovery of 'Kerch, Crimea (Grief)', Baltermants was invited to sit on the leading international photography juries. He died in June 1990, at the age of 78, his communist dreams tumbling about him. "He wasn't a nostalgic man," states Tatiana. "My father knew that the wheel of history was bound to keep on turning."

"The master of the Soviet icon."

Child of the Ghetto

Shoah

Tsvi Nusbaum: "It's an event from my past that haunts my present."

"THE

→ TIMELINE

1941. The Nazis had occupied Poland for two years when they confined 450,000 Jews to the Warsaw Ghetto. In one year, 100,000 died of hunger or disease. Between the summer of 1942 and January of 1943, 300,000 Jews died in the Treblinka extermination camp. In May 1943, the 50,000 survivors rebelled against their executioners. The Warsaw Ghetto uprising was violently suppressed. There were no survivors. The evening of 19 May 1943, General Stroop noted in his daily report: "The Warsaw Ghetto is no more."

T SVI NUSBAUM BROUGHT two photos to our meeting in Israel: that of the little boy in Warsaw and another of him aged ten, both in the same frame. They look disturbingly alike. "I was born in Poland in 1935," says the New York doctor. "In 1942, my family were caught in a round-up and murdered in Treblinka. With an uncle and aunt, I was hidden by a Christian family in Warsaw. After the ghetto was eliminated, the Germans spread a rumour: they promised to exchange any Jews hidden in Warsaw for a colony of Germans in Palestine. This was called the 'Palestine list'. My uncle, seeing no other way out, decided to try his luck. So, on 13 July 1943, we were at the Polski Hotel, the meeting place stipulated by the Nazis. As we were about to leave, an officer read out a roll call, but I wasn't on the list. I saw my aunt and uncle getting into a lorry and I panicked. I ran towards them. That was when a soldier pointed his machine gun at me and ordered me to raise my hands. Eventually, we were imprisoned in Bergen-Belsen while we waited for the exchange, which never took place. But that's what saved my life." ■

Tsvi Nusbaum, aged 10.

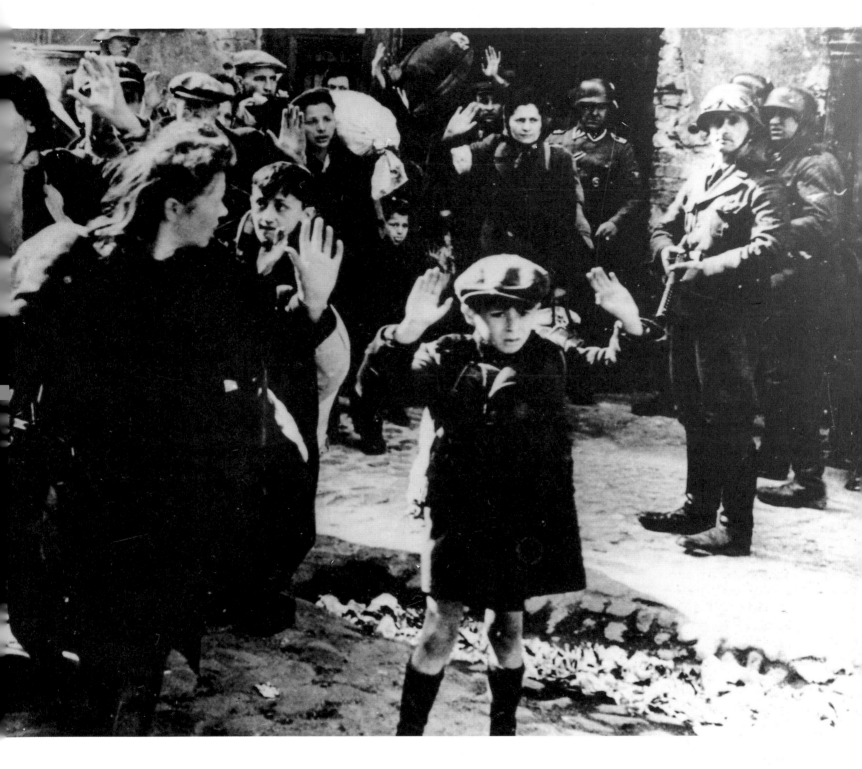

IMPORTANT THING IS THAT THIS CHILD SHOULD REMAIN ANONYMOUS."

"The founding myth of the State of Israel."

Israel Gutman

A researcher at Yad Vashem, the Israeli Holocaust Memorial, Israel Gutman confirms that the photo was taken in 1943: "It figured in an illustrated report sent by SS Major General Jürgen Stroop to his superior Heinrich Himmler, as proof that he had eliminated the ghetto. Knowing how meticulous Nazi documents were, we can rely on the date. Along with 52 other photos, the one of the little boy was intended as a symbol of victory..."

– "According to the caption, it was taken in the Ghetto, whereas by 1943 most of the children were already dead ..."
– "That's highly unlikely," admits Israel Gutman. "But it doesn't matter: this anonymous child is part of the founding myth of the State of Israel, he embodies the tragedy of the Shoah all by himself."
– "Does anyone know what became of him?"
– "Several people have claimed to be him, but his identity is not important." As for the soldier in the photo, his name was Joseph Blösche, and he was sentenced to death in 1969 in the German Democratic Republic. His leader, SS Jürgen Stroop, was hanged in Warsaw in 1952.

The Normandy Landings

© **Robert Capa**/Magnum Photos

→ TIMELINE

6 June 1944: the Allies landed in Normandy to liberate Europe from the Nazi yoke. This was the famous 'D-Day', planned in the utmost secrecy by General Eisenhower and his staff. 'Operation Overlord', the largest military operation of all time, mobilised 600,000 men, mainly British and American. The invasion took the Germans by surprise; they were expecting the Allies to land, but did not know when or where. It was the beginning of the end for Hitler.

Edward Regan: "The water came up to my nose."

Slightly Out Of Focus

"THIS PHOTO MARKED an important rite of passage in my life: the transition from adolescence to manhood." Edward Regan was just eighteen when he boarded a warship heading for 'Omaha Beach', the code name for Saint-Laurent-sur-Mer, which went down in history as 'Bloody Omaha'. That night, the sea was rough and Regan was "sick with fear". In the early hours of the morning, the order came to enter the landing craft. The flimsy vessel ran aground on a sand bank some twenty metres from shore. The fire of the 352nd division of the Wehrmacht ripped through the dawn as soon as the boats' ramps were lowered. It was sheer hell. Edward Regan jumped into the water, weighed down by 30 kg of equipment. He struggled on amid the bombs and corpses. "When I ran out of steam, I dropped down on the sand to catch my breath. The water came up to my nose. That was when the photo was taken." Published in *Life*, the photo was cut out by his weeping mother, who waited anxiously for her son to come back: "Look," she said, when he finally came through the door, "that's you, isn't it?" And Edward Regan replied: "Yep, that's me. And I'm very proud of it." ■

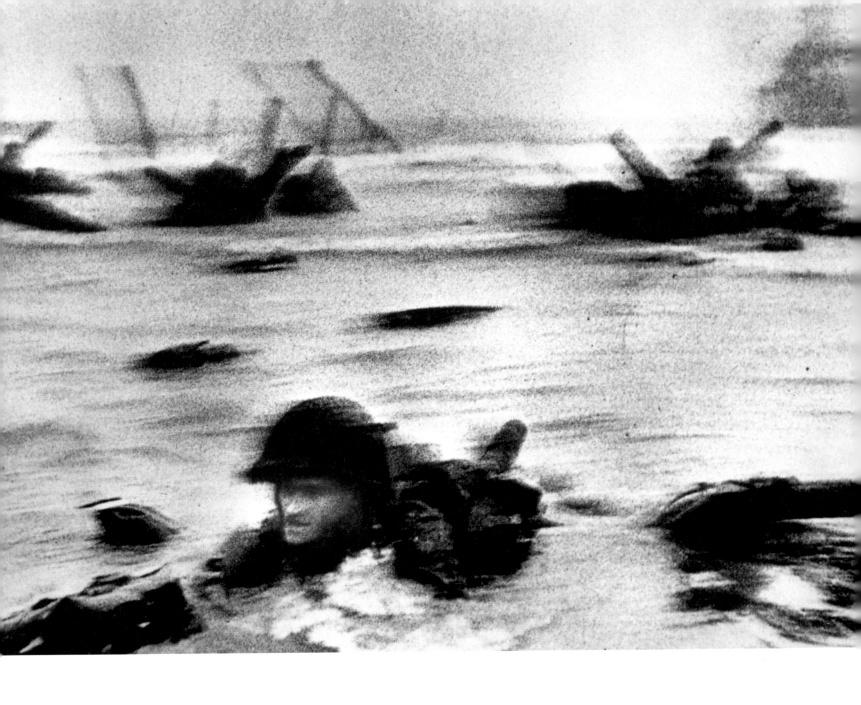

"I wept with rage."

John Morris

"As journalists, we felt an enormous responsibility in this war, which it was imperative to win," says John Morris, who ran the London office of *Life*. "The photos were to show America why its men were fighting so far from home. Capa felt it was his duty to bear witness." Three days after the Normandy Landings, Morris was on the verge of despair: "The whole world was waiting for our photos and we still had no news from Capa". As soon as the four films arrived, he rushed to the processing room and ordered them to be quick. In his hurry, the technician forgot to ventilate the drying room while raising the temperature. As a result, the emulsion melted on three of the films. On the fourth, eleven grainy and slightly blurred photos had miraculously survived. "I wept with rage", murmurs John Morris. Passed by the censors, the photos left that evening for New York, where *Life* published them with this caption: "The excitement of the moment caused the photographer's hands to shake, blurring the images". Three years later, Capa ironically responded, giving his memories of the Normandy landings the title *Slightly out of Focus*.

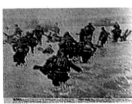

"[It] was the ugliest beach in the whole world," wrote Robert Capa. "Exhausted from the water and the fear, we lay flat on a small strip of wet sand ... but the tide pushed us against the barbed wire, where the guns were enjoying open season."

Iwo Jima
© Joe Rosenthal/Associated Press

→ **TIMELINE**

February 1945. Germany was on the point of surrendering, but Japan still controlled a great deal of Asia. The Americans needed a rear base from which to launch an offensive against the Nazis' main ally. They selected the small island of Iwo Jima in the Pacific, where the Japanese were holed up in underground bunkers. This was the fiercest battle in the history of the United States. One in three marines were killed. The death toll: 23,000 Japanese soldiers and 7,000 American marines. The survivors will never forget ...

JOE ROSENTHAL
He became famous overnight.

"THIS PHOTO OF THE AMERICAN flag is the story of a miracle. No-one who survived Iwo Jima can explain how he did it. It's like walking in the rain without getting wet, it's completely inexplicable." A photographer with the AP agency, Joe Rosenthal was 32 when he arrived on Iwo Jima.
On 23 February 1945, he was told that a patrol of forty marines had climbed Mount Suribashi to raise the Stars and Stripes flag on the highest point of the island. With a film cameraman, he hurried to the place in question, but was too late: "I've taken the photo!" cried Sergeant Lou Lowery, photographer for the marine newspaper, as the patrol came down. "We almost gave up," admitted Rosenthal later to the magazine *Collier's*. It was almost midday when they reached the summit, where a small flag, 1.37 m x 71 cm, was fluttering in the breeze. Suddenly, Rosenthal saw five marines dragging a 6-metre-long tube, while another was carrying a carefully tied flag: "This one is bigger, everyone will be able to see it!", shouted a marine. Rosenthal had his photo! "I walked back about 10 metres but the ground gave way and I was too low to frame properly." So he piled up some stones, climbed on top, and set his aperture between 8 and 11 at a speed of 1/400 of a second. Genaust, the cameraman, filmed the scene from the same angle. The photo made Rosenthal famous overnight. ∎

Reluctant Heroes

His father, John Bradley, was one of the six soldiers in the photo. James has pieced together the tragic fate of these reluctant heroes, dragged to press conferences and interviews on their triumphant return. "Three of the six flag-bearers died on the island, and three came back. Ira Hayes died ten years later, aged thirty-two. He drank himself to death; he couldn't bear the honours this photo brought. René Gagnon died at fifty-two: he couldn't take the pressure either. Only my father refused to speak to the press. He has kept quiet for fifty years. He's the only real survivor. When I was little, we didn't have a copy of that photo in the house. Our teachers talked about my father's exploit. But he told me the true heroes of Iwo Jima were the ones who didn't make it back."

James Bradley

"Only my father, who refused to speak to the press, survived the photo."

The most widely published photo in the United States

After the photo was published, millions of little flags began to appear all over the United States. In the windows of houses, factories, and banks; in schools, on buses and in cars. The photo was reproduced on 3.5 million posters, 15,000 hoardings, and on

137 million stamps, the highest-selling stamp in American postal history. Printed on treasury bills, it raised 200 million dollars to finance the war effort. In 1954, President Eisenhower inaugurated the largest sculpture in the world at Arlington National Cemetery: a replica of the photo.

Joe Rosenthal at Arlington National Cemetery.

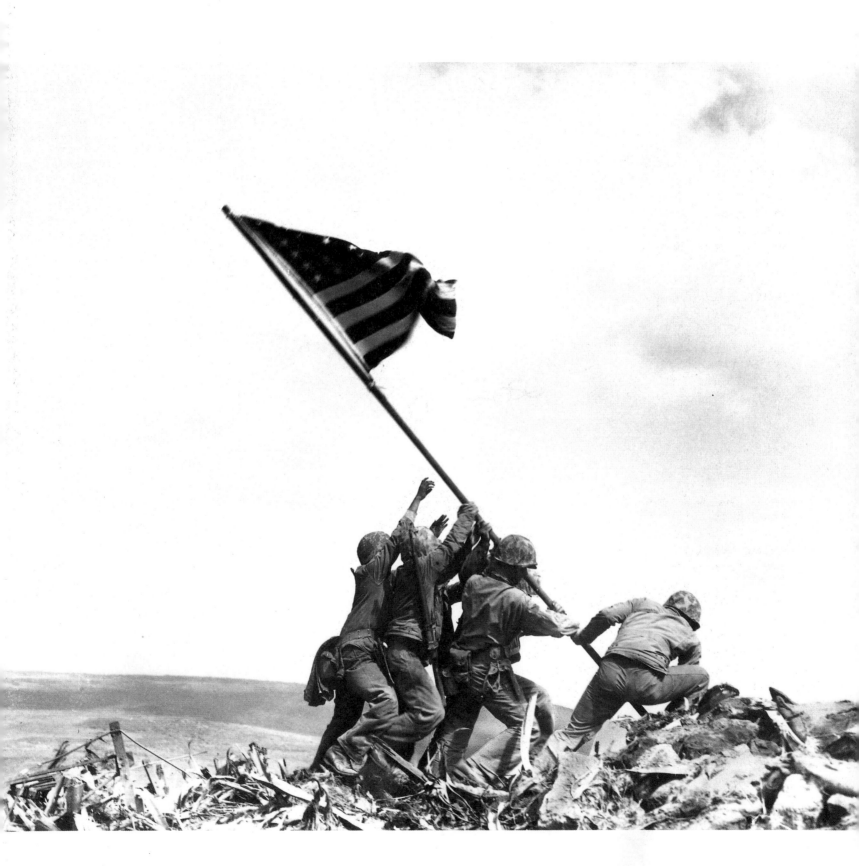

The Death Camps

© H. Miller/National Archives/ Courtesy of USHMM Photo Archives

→ TIMELINE

6 April 1945, General Eisenhower's army liberated the camp at Ohrdruf, an annex of Buchenwald: the world discovered the horror of the Nazi death camps. Built in 1933 to incarcerate homosexuals and opponents of the Nazi regime, concentration camps proliferated after the outbreak of the war. In January 1942, Hitler decided on the mass extermination of 'subhuman' races: Jews and gypsies. This was the 'final solution'. Millions of innocent people perished in the gas chambers, while the world looked the other way.

027

Elie Wiesel: "We were free, but there was no joy, no tears."

THE MAN STARING at the photographer's camera looks ageless. Elie Wiesel was sixteen when, in January 1945, the Nazis evacuated the camp of Auschwitz, soon to be liberated by the Red Army, and sent the inmates to Buchenwald. With him was his father, who did not survive this final ordeal. The teenager was in the Buchenwald 'little camp' when the American troops arrived. "This photo was taken on 12 April 1945, the day after Buchenwald was liberated. We were a group of sick, starving children in one *blockhaus*. It was a chamber of death, people were dying every night. That day, a rabbi, a Jewish military chaplain in the American army, arrived. He went from *blockhaus* to *blockhaus*, saying in Yiddish: 'Brother Jews, you are free'. I don't remember a photographer: there were officers, soldiers who came just to look, to bear witness and probably to convince themselves that it was all true. There was a tall sergeant who looked like a giant to me: when he saw us, he cried like a baby, he wept and cursed everyone and everything. We were free but there was no joy, no tears, we didn't yet know how to cry, we began crying later. I would say that on that day we gained a better understanding of the depth and intensity of the pain that had accumulated inside us for so long. Before, none of us dared to experience that pain; it made itself felt then. Later it burst out". ■

The shock

"I've never felt so shocked in all my life." This was what General Eisenhower said after his visit, on 12 April 1945, to the camp at Ohrdruf. 3,000 naked, emaciated corpses rotted in communal graves, while skeletal survivors, weakened by typhus and consumed by vermin, were tended by the American army. "Eisenhower saw things in historical terms," says the Israeli historian Itzhak Arad. "Knowing that the world would find it difficult to believe what he had seen, he asked every soldier with a camera to take pictures. It had to be done quickly: the survivors were about to be evacuated and the corpses had to be buried for

"Despite the photos, the world didn't want to know."

fear of disease." Yet the photos of the death camps did not make the headlines. They were relegated to the inside pages: "everywhere, people were celebrating the end of the war and, despite these photographic documents, the world didn't want to know. It was only years later that people really took an interest in the photos taken by American soldiers, like the one by Henry Miller, on display at the Yad Vashem Holocaust Memorial in Jerusalem."

Itzhak Arad

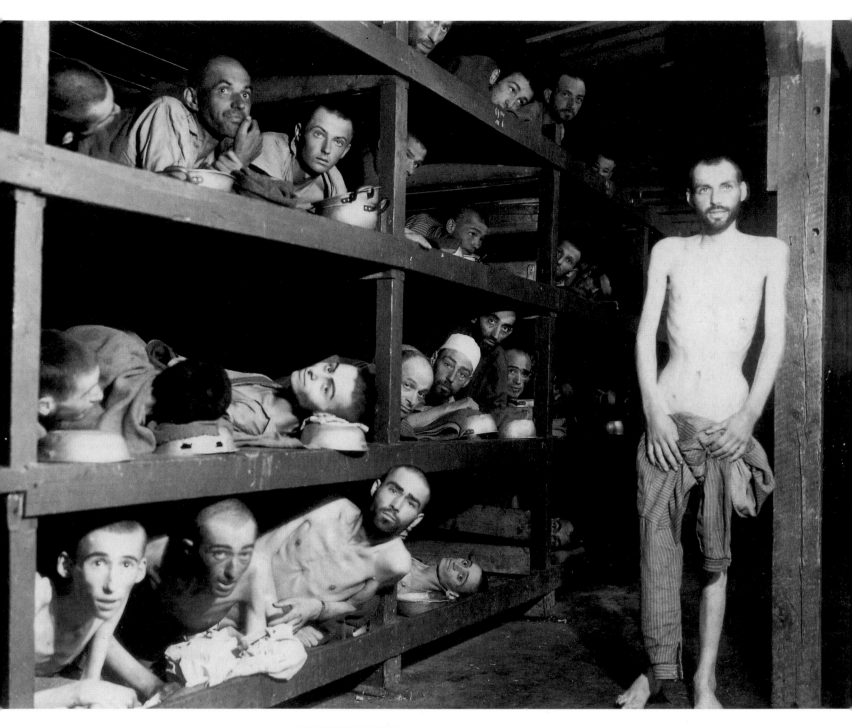

Elie Wiesel

Elie Wiesel discovered the photo in the *New York Times*. That was in the 1980s. Today, the winner of the Nobel Peace Prize pays tribute to the photographer: "I should have liked to meet him and hug him, to thank him. Personally, I place my faith in words rather than pictures. I think the people who say a picture is worth a thousand words are wrong, one good sentence is worth a thousand pictures. But not in this case. This photo is part of the collective memory. It must be distributed and preserved for the future, forever, until the end of time. Is the face I see still alive in me? I think the true Elie Wiesel, the one who saw the searing, naked truth, is him. I wouldn't want him to leave me, it would be a desertion, not by him, but by me, I wouldn't want him to reject me."

"The real Elie Wiesel is the boy in the photo."

Death of Il Duce
© Vincenzo Carrese/Publifoto Olympia

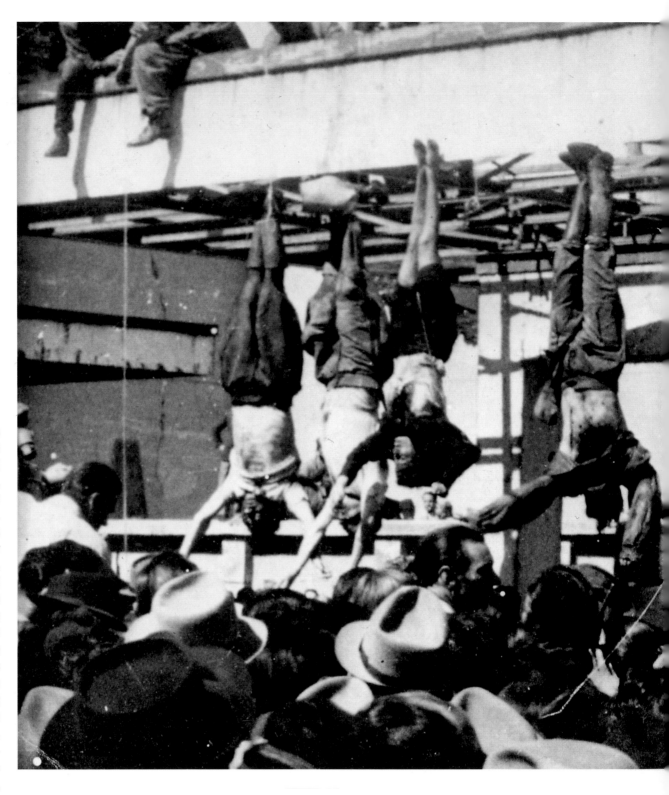

→ TIMELINE

July 1943: the Allies landed in Sicily. The Fascist Grand Council rejected Mussolini, who was arrested on the King's orders. The armistice was signed, but Germany seized northern Italy. Rescued by a Nazi commando, Il Duce became head of the Republic of Salò. On 28 April 1945, he was arrested by the Italian Resistance, in Dongo, while trying to escape amid the German collapse. Shot with his mistress and three senior Fascist officials, he was strung up by the ankles and exhibited on Piazzale Loreto in Milan.

Enrico Sturani

"You can come back now ..."

"Mussolini was the most widely photographed man of his time," observes Enrico Sturani, who specialises in fascist iconography. "Until 1938, the photos were taken by private photographers and sold as postcards to a nation bewitched by Il Duce; afterwards, when his popularity began to wane, the state took up the task. Over thirty-four million postcards were sold." Continuing Mussolini's policy, the National Liberation Committee made postcards of the Piazzale Loreto photo, captioned 'Milan. 29 April 1945. The people's justice.' One, sent to an Italian refugee in Paris, bore the laconic note: "You can come back now."

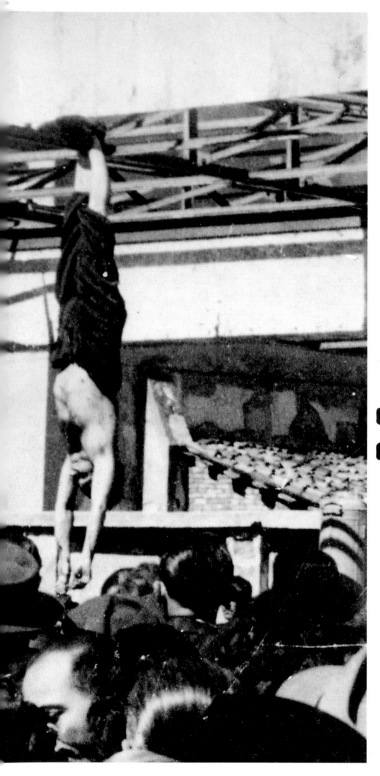

Vengeance

Gaetano Alfreta: "An incredible show of anger."

H E REMEMBERS a "glorious day, with young women joyfully cycling around in brightly coloured dresses". Gaetano Alfreta was working at the *Corriere della Sera*, which sent him to cover the scene. Armed with fire hoses, firemen were battling to hold back the raging crowd from the pile of corpses: Mussolini, bare-foot and in shirt sleeves; Clara Petacci, in a two-piece, lying next to her lover. "People were hurling insults from the balconies. It was an incredible show of anger. The memory of the fifteen martyrs killed on the same spot the previous year by the Black Shirts was fresh and they wanted vengeance: an eye for an eye." The corpses were strung up by their ankles from a petrol station frontage. A safety pin prevented Petacci's skirt hanging down. "Just look at the funny shorts she's wearing!" sniggered a woman next to Alfreta. He "was shuddering at the sight". "This scene, staged for the photographers, drew on Roman rituals celebrating the fall of a dictator," comments historian Enrico Sturani. "Their iconoclastic fury was in direct proportion to their former idolatry." ∎

Rumour. During the summer of 1946, the *Sunday Express* published news from the Nuremburg trials of Nazi war criminals; Göring had apparently told a prison psychiatrist that Hitler decided to commit suicide after seeing the photo of Mussolini strung up by the heels. "That's impossible,"

Gerhard Hirschfeld

states historian Gerhard Hirschfeld, "Hitler learned of Mussolini's execution by radio, on 28 April, in his Berlin bunker; the photo was taken on 29 April, so he can't possibly have seen it before his suicide on 30 April. This persistent rumour fills a need: unlike Mussolini, there was no photo in Hitler's case to prove that the beast was dead."

"PROOF THAT THE BEAST WAS DEAD."

The Red Flag

© Evgenii Khaldei/Ana Khaldei/Corbis/Sipa Press

Victory

Ana Khaldei: "This famous photo didn't protect my father from repression."

→ TIMELINE

30 April 1945. Hitler committed suicide with Eva Braun in his Berlin bunker. 20,000 Red Army tanks triumphantly entered the Nazi capital, capturing the administrative centre. On 7 May, Germany formally capitulated to the U. S. commanders at Rheims, and on 8 May to the Russians in Berlin. With U. S. and Russian troops facing each other in Europe, the Cold War had begun...

WHEN, ON MAY 1945, Evgenii Khaldei flew to Berlin, he had already visualised the photo he wanted. His model was Joe Rosenthal, who had immortalised the marines raising the American flag on Iwo Jima. Khaldei selected a symbolic site: the Reichstag, whose burning in 1933 had provided the Nazis with a pretext for eliminating communist opposition. The Tass agency steward had given him some red Communist Party tablecloths and a tailor friend had made him three huge flags, emblazoned with the hammer and sickle. The Reichstag was in flames; on its steps, Khaldei met three Soviet soldiers, who followed him onto the roof. Kovaliev hoisted the flag, helped by a comrade. The photographer used up an entire film and returned to Moscow that same evening. "What's that?" snapped his editor, pointing to the soldier holding Kovaliev's legs. "Didn't you spot he had a watch on each wrist? He's a looter! There are no Soviet looters!" Khaldei scratched out the watch on the soldier's right wrist with a needle … Enquiring about the identity of the flag-bearers, Stalin decided they were not politically correct. So they became Milton Kantaria (Georgian like Stalin) and the Russian Mikhail Iegorev; both were immediately made 'heroes of the Soviet nation'. The true protagonists of the photo emerged only after 1991, with the dissolution of the USSR. ∎

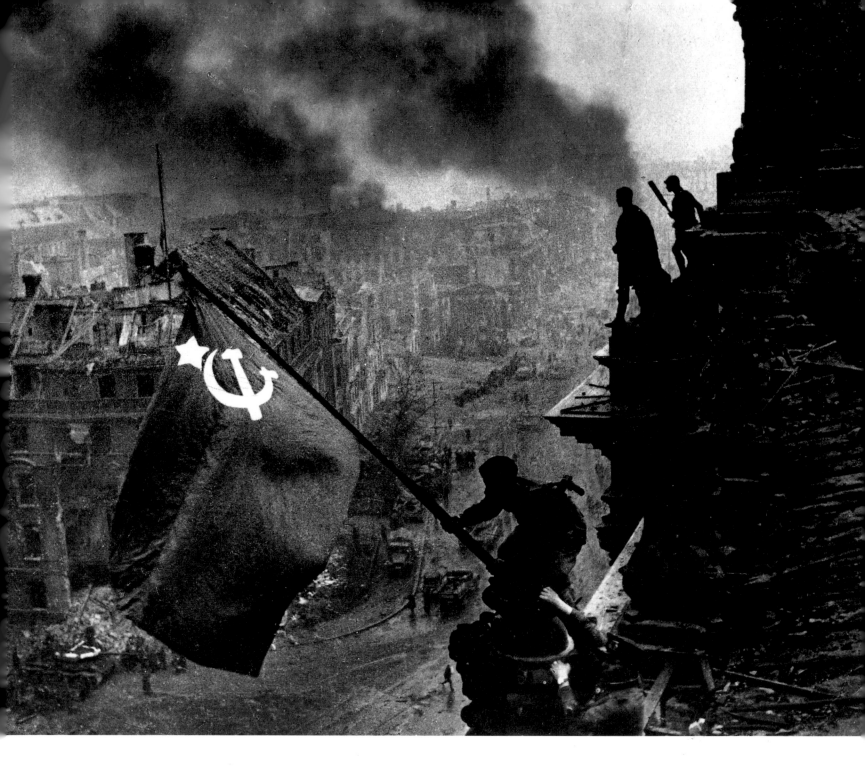

"If only Hitler knew that the two flags symbolising victory were immortalised by two Jews!"

"My father was very proud of this photo," says Ana Khaldei "though it didn't protect him from repression or poverty." Born in 1917 to a family of Ukrainian Jews, Evgenii Khaldei was one year old when his mother was killed in a pogrom. As a teenager, he cobbled together his first camera with a lens from his grandmother's glasses, then entered the Tass agency. He was nineteen, a fervent communist, and became one of the greatest photographers of the Soviet era. After the war, Khaldei was a victim of Stalin's war on 'cosmopolitanism', in other words, on Soviet Jews. Dismissed from Tass, he struggled to survive until Stalin's death in 1953. Hired by

Pravda in 1957, he was again sacked in 1972 for the same reason, and sank into obscurity. Recognition finally came from the West; in 1995, he was invited to the

JOE ROSENTHAL
EVGENII KHALDEI

Visa festival in Perpignan. There he met Joe Rosenthal, who had inspired his most famous photo. "If only Hitler knew that the two flags symbolising victory were immortalised by two Jews!" he declared, to the cheers of his audience.

Hiroshima
© George Caron/

Vicki Goldberg: "Published on the day the Japanese surrendered, this photo became the image of victory."

Apocalypse

Minaru Ohmuta

"This picture represents a turning point in the history of humanity. It symbolises the end of the world." Director of the Hiroshima Memorial, Minaru Ohmuta was 14 when requisitioned to work in an arms factory at Kuré, 30 km from the epicentre of the nuclear blast: "I saw the atomic cloud through a window and I remember thinking it was beautiful. What I didn't know was that beneath that cloud hundreds of thousands of people had been plunged into a hell on earth. But this photo shows nothing of that. The American army offered Japan a copy of the photo in 1973. The first time I saw it, I was staggered: many of my childhood friends had died in Hiroshima and behind that picture of the mushroom cloud I saw again their charred and disfigured faces. It is a nightmare without end."

"The end of the world."

→ TIMELINE

On 6 August 1945, the American army exploded the first atomic bomb over Hiroshima, a city of 300,000 inhabitants. The explosion killed 100,000 people and left tens of thousands wounded, burned or suffering from radiation sickness. The Japanese town was wiped out, and the American humiliation at Pearl Harbour avenged. On 9 August, a second bomb was exploded over Nagasaki, leading to Japan's unconditional surrender. The Japanese capitulation marked the end of the Second World War.

ON 6 AUGUST 1945, Colonel Paul Tibbetts climbed into the cockpit of his B-29, named *Enola Gay* after his mother. He was the only crewmember who knew the nature of *Little Boy* – the code name of the 'special bomb' assembled in the utmost secrecy at Tinian air base in the Pacific. 3.5 metres long, the device weighed 4.5 tonnes and contained 20 kg of uranium-235. At 02.45, the pilot took off for the Japanese coast. At the back of the B-29 sat tail-gunner George Caron, aged twenty-five, to whom the army photographic department had entrusted the task of taking pictures of *Little Boy*'s explosion with a hand-held K-20. The aircraft was also equipped with fixed, automatic K-17 cameras that took panoramic views. At 08.15, *Enola Gay* exploded the equivalent of 20,000 tonnes of TNT 600 metres above Hiroshima. Forty-five seconds later, an immense fireball filled the sky. It was engulfed by an incandescent cloud that rose to around 15,000 metres in altitude. "It looked like a mushroom", said Colonel Tibbetts. As soon as the bomb was dropped, he turned 151° to avoid the nuclear cloud. Nose pressed against the rear turret, George Caron shot an entire film. They were the only photos of the explosion: in the bomber's headlong flight, the fixed cameras photographed land and sky, but not a trace of *Little Boy*. ■

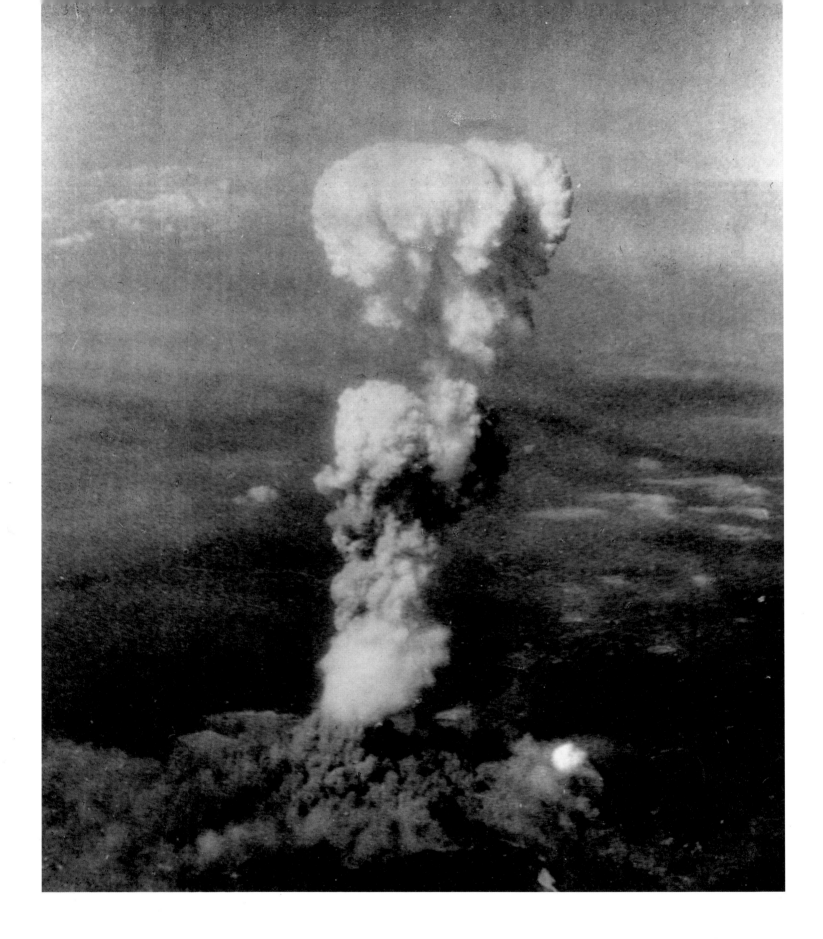

"The image of victory."

The news of the bombing was made public on 7 August, but the photo was not published until 11 August, the day the Japanese surrendered. "If the American army had circulated it beforehand, it would have been an image of destruction," says American historian, Vicki Goldberg. "By associating it with the Japanese surrender, it became an image of victory." Classified as defence secrets, photos of Hiroshima's radiation victims were not published in the United States until 1970. By contrast, the picture of the mushroom cloud was extensively used as an icon of invincibility. In 1947, fifty-five Manhattan companies modelled their logos on Caron's photo. It helped shape domestic appliances and haircuts. There was even a Miss Atomic Bomb beauty contest in Las Vegas, whose winner wore a cotton-wool mushroom cloud.

Miss Atomic Bomb

Mahatma
© Margaret Bourke-White/Life Magazine/PPCM

→ TIMELINE

People called him Mahatma ('great soul'). Born in 1869, Gandhi became a lawyer in South Africa, where he advocated non-violent resistance to racial discrimination. In India, he headed the nationalist campaigns of civil disobedience against the Raj. His weapon: the traditional spinning wheel, symbolising rejection of colonial industrialisation. On 15 August 1947, Lord Mountbatten proclaimed the independence of India and its division into Hindu and Muslim states. This was a Pyrrhic victory for Gandhi, who was murdered on 30 January 1948 by a Hindu extremist.

Sean Callahan: "Ironically, Gandhi had stopped spinning."

MARGARET Bourke-White was almost speechless when, on 15 July 1946, she gained entrance to Gandhi's ashram in Poona. "If you want to photograph the Mahatma spinning at his wheel," the secretary of the "half-naked fakir" (Churchill) told her, "you must learn how to spin!" The star reporter of *Life Magazine* had spent her life celebrating industrial progress. "She had no choice," says Sean Callahan, her biographer. A second condition followed: "The Mahatma doesn't like artificial light, you must work without flash". Margaret Bourke-White begged him to let her use two flash bulbs. In the end, she was allowed to use three, which meant three photos, and no more. "One last thing," the secretary instructed, "Monday is his day for meditation, so you mustn't speak to him." The tense photographer was admitted to the tiny room where a cross-legged Gandhi was silently spinning. Light poured in from a window behind him. "The backlighting stressed her out completely!" says Sean Callahan. First bulb: Bourke-White centred the photo and pressed the shutter release. "From the noise of the shutter and the flash, she realised the synchronisation had not worked… With the second, everything worked but, in her anxiety, she had forgotten to pull the slide to expose the film. She only had one flash left. The photo was perfect. Ironically, in the meantime, Gandhi had finished spinning and was reading the papers! On that day, Margaret stopped believing in the infallibility of technology." ■

Only Human

A photo shows her standing on the roof of a skyscraper, camera in hand. Daughter of an engineer, Margaret Bourke-White was a adept of photography from early youth. Her passion: the world of industry, which she photographed with great flair, particularly for *Fortune*, Henry Luce's magazine for businessmen. When, in 1936, the press magnate decided to launch *Life*, he commissioned the cover of the first issue from her. The subject: the construction of a dam in the American West. Telling the workers' story, Margaret Bourke-White inaugurated the genre that secured *Life*'s worldwide renown: the photo essay. "10 years later," relates Sean Callahan, "*Life* was at the height of its fame. Gandhi's entourage knew this when they organised the symbolic photo with the spinning wheel. The meeting disquieted Margaret: she was a confident woman who had extolled the virtues of industry in promotional publications, and she could not understand why Gandhi hated technology when India lived in utter poverty. Gradually, through her meetings with Gandhi, whom she often photographed (the last session was hours before his death), she came to see things differently: she describes her experiences in *Halfway to Freedom*."

MARGARET BOURKE-WHITE

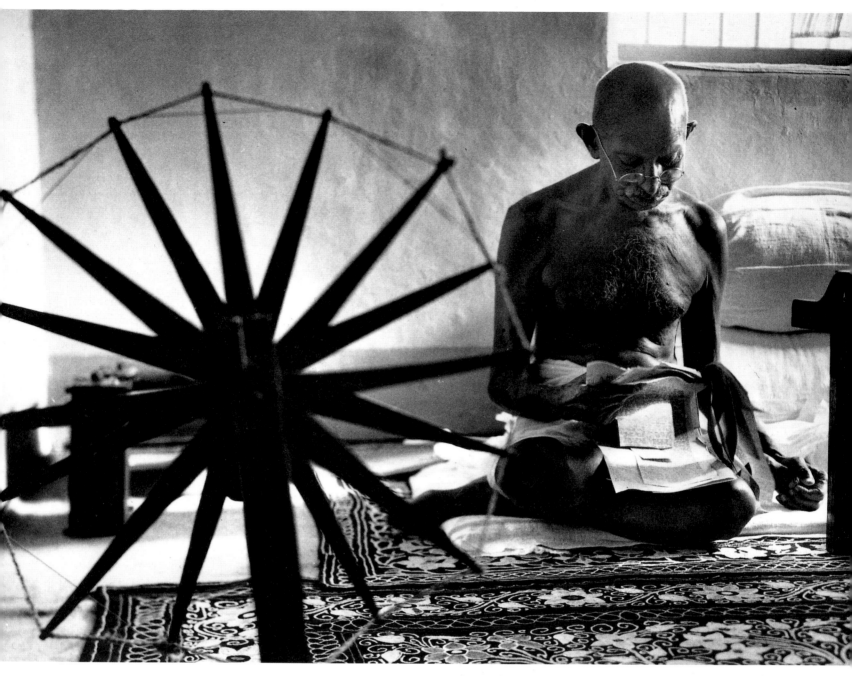

"This photo is still topical in Third World countries."

Born of the South African branch of the family, Ila Gandhi, the Mahatma's grand-daughter, speaks softly and simply. A member of the ANC, Nelson Man-

Ila Gandhi

dela's party, she met Gandhi when she was 8, a few months before his death. "This pho-to continues to inspire my political life. Its message is still topical: with the advent of economic globalisation, third-world countries more than ever need to free themselves from the yoke of the rich countries by promoting traditional crafts. Instead of exporting raw materials to buy manufactured products, we should, wherever possible, process them our-selves. Only thus can we create jobs and feed our people."

Exodus

→ TIMELINE

18 July 1947: the *Exodus*, a ship carrying 4,500 Holocaust survivors, was boarded by the British off the coast of Haifa. At that time, there were 650,000 Jews living in Palestine, under British mandate since 1917. In 1939, London restricted immigration to the Jewish homeland, where Zionist attacks were on the increase. In 1947, fifteen boats chartered by the clandestine organisation Mossad were intercepted, and their passengers deported to camps on Cyprus. The Exodus was the largest operation ever mounted by the Mossad.

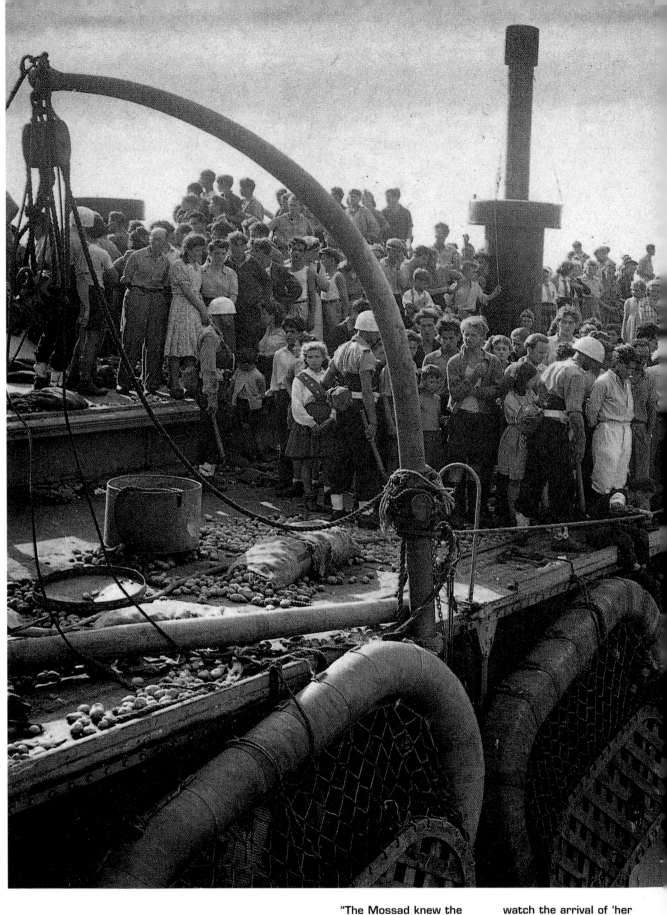

"The Mossad knew the boat would be intercepted: *Exodus* was primarily a communications exercise," says Jean-Paul Aymon, who was working for the Zionist newspaper *La Terre retrouvée* at the time. Photos of the boarding operation were printed all over the world, causing an international outcry, while in Marseilles, scores of journalists came to watch the arrival of 'her Majesty's prison ships'. When the floating prisons neared Port-de-Bouc, smpathisers showed their solidarity with the 'undesirables' by taking them food in small boats. Informed by the government spokesperson, François Mitterrand, that they would be granted asylum by France, the passengers replied by banners: "We

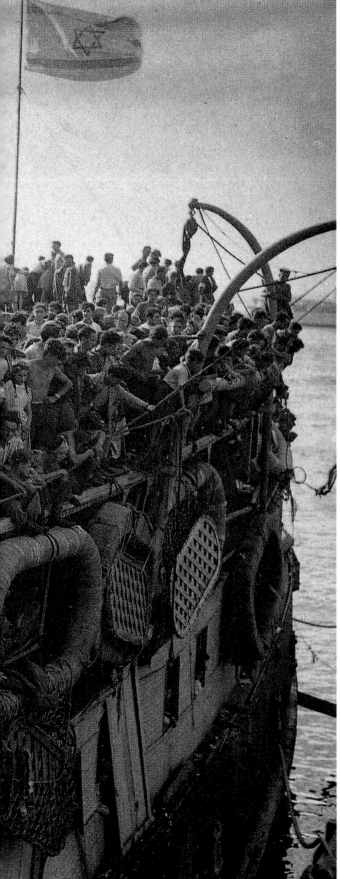

The Caged

Meir Cohen: "Our faith was unshakeable."

"I'M GOING TO Eretz Israel," murmured Meir Cohen, aged 22, to his elderly father, when he left his native Morocco. In Paris, the Jewish agency sent him to a camp in the South of France where a militant member of the Mossad gave him "a false passport in the name of Goldberg, and a forged visa for Colombia". That night, with the collusion of the French authorities, two hundred lorry-loads of immigrants headed for the port of Sète. On 11 July, Meir boarded the *Président Warfield*, an old tub designed to carry seven hundred passengers. It was crammed with 4,500 people, including 655 children; twenty-three different languages could be heard. "It was like a holiday: we sang for seven days!" They were trailed by five British warships. As they neared the Palestinian coast, the passengers hoisted the blue and white flag emblazoned with the star of David and renamed the boat *Exodus 1947*. On 18 July, it was rammed seven times by the British navy, who prevented it from landing at Haifa. Two people were killed and one hundred and thirty injured. "That was when the photo was taken, probably by one of the photographers from the Jewish National Homeland organisation waiting for us on the dock." On 20 July, the passengers were transferred to three ships bristling with barbed wire and sent back to France. ∎

want to go to Palestine!" The British finally decided to transfer the passengers to camps in Germany: "This was an enormous psychological error," remarks Jean-Paul Aymon. "although it accelerated the course of history". Four months later, the UN voted to partition Palestine into two independent states, one Jewish and the other Palestinian. In

"The photos accelerated the course of history."

April 1948, Ben Gurion proclaimed the foundation of the State of Israel.

Le Baiser de l'Hôtel de Ville

© Robert Doisneau/Rapho

→ TIMELINE

1950. Ground down by poverty, France was rebuilding itself and everything was rationed. The Marshall Plan was pumping dollars into its exhausted economy. It was discovering American consumer society; vacations, white goods and LPs, which broadcast a new world of jazz and pop. In Paris, the euphoria of liberation brought a new adventurousness in the arts, while in Saint-Germain-des-Prés, partying and politics went hand in hand.

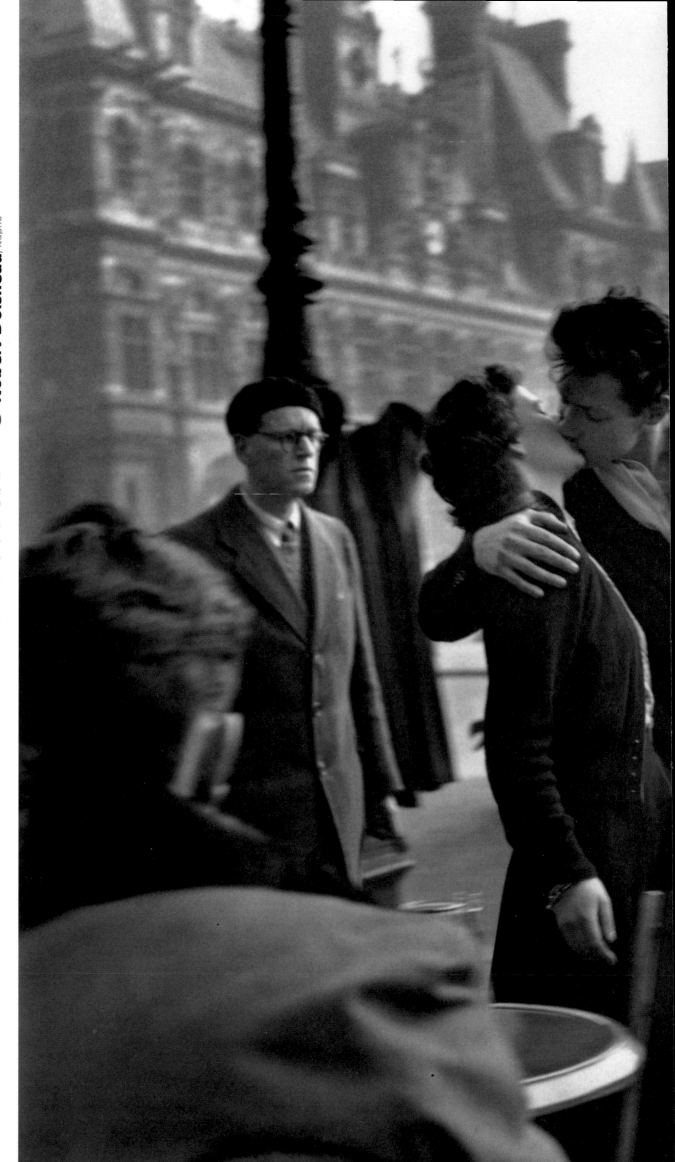

Casting

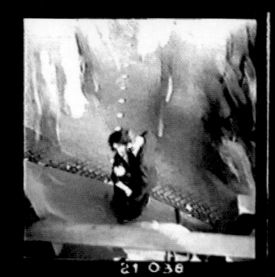

21 038

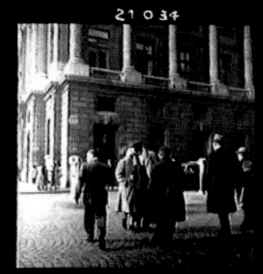

21 034

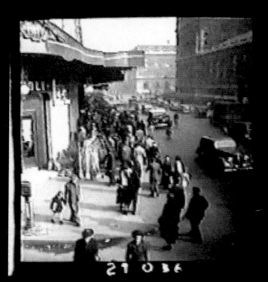

21 036

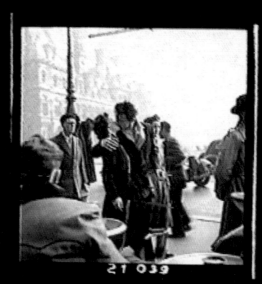

21 039

Robert Doisneau

"Paris is a theatre where the price of a seat is wasted time," said Robert Doisneau, a *flâneur* such as Baudelaire dreamed of. Born in 1912, in the southern outskirts of Paris, the city where he spent his life, he spent his childhood wandering through the suburban wastelands. "In that humdrum environment," he wrote, "I sometimes glimpsed fragments of time in which the everyday world seemed suddenly weightless. Recording those moments could take a lifetime." It did. Camera in hand, always on the lookout for "the quotidian fantastical" (like his friend, Jacques Prévert), Doisneau took more than 350,000 photos. They form a panorama of his time, warm-heartedly depicting the rich and poor of the Paris region. "My father didn't particularly like the photo of the kiss," says Annette Doisneau. "He thought of himself rather as a fisher than a hunter of images, he preferred to wait for photos to come, rather than making them happen. At the end of his life, he often said: 'It's sad to think that's the only photo I'll be remembered for'."

"The quotidian fantastical".

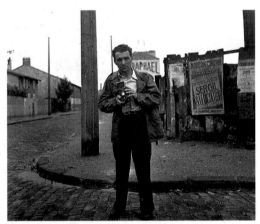

"The inveterate *flâneur*" in the Paris area in 1949.

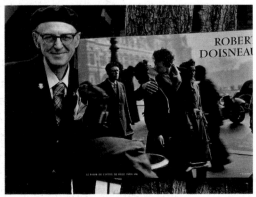

The man in the beret was a lawyer in Montreal: he saw the photo in a neighbour's house.

Annette Doisneau: "My father compared himself to a fisher rather than a hunter of images."

SPRING 1950. *Life* ordered a 'lovers in Paris' report from the Rapho agency. Speed was essential; actors were to be used. Robert Doisneau therefore asked for volunteers among his friends. He recruited two drama students, Jacques Carteaud and Françoise B. The contact sheet shows the couple strolling around the Hôtel de Ville in Paris. *Life* published six kisses, including *le baiser de l'Hôtel de Ville* in a quarter-page format. The photo languished in Doisneau's archives until 1986, when a Parisian publisher made a poster of it. It was a worldwide success. "Immediately," says Annette Doisneau, "my father received scores of letters from people who said they recognised themselves". First, there was the man in the beret, a lawyer from Montreal, who saw the poster in a neighbour's house. He sent Doisneau a photo of himself posing with the famous poster in hand. And then there were the innumerable lovers who claimed to be the couple in the photo. Now things turned nightmarish. A French couple asked to meet the photographer. A dinner was arranged: "Unfortunately," says Annette, "my father didn't say they were the couple, but he didn't say they weren't, either. He didn't want to shatter their dream." The couple sued Doisneau for damages. When their case was dismissed, they took it to appeal. As for the actress in the photo, she sued for royalties and lost. "These lawsuits really spoiled the last year of my father's life," comments Annette. "In the end, he didn't like the photo at all." ■

"This photo reminds me of what I call the visceral world: a man and a woman, two mouths, two bodies, desiring each other, wanting love to last forever." Under the corduroy cap, his eyes glitter as he searches for the right words. Firmly ensconced in his home

"The visceral world"

in the Midi, where he lives "like a peasant", Jacques Carteaud had "come up to Paris to act". It was 1945, he was 18. The handsome young man lived by modelling for photo-novels, ads and fashion shows. "Which is how I came to be paid for kissing the woman I loved! It was the stuff of dreams!"

Jacques Carteaud: "Being paid to kiss the woman you love: the stuff of dreams!"

The Rosenberg's Kiss

→ TIMELINE

5 July 1951. Accused of betraying nuclear secrets to the USSR, Julius and Ethel Rosenberg were sentenced to death. This was the most important politico-juridical affair of the post-war period. The Cold War, then at its height, led to a virulent anticommunist campaign in the United States. The anti-Red witchhunt was orchestrated by Joseph McCarthy. The Rosenbergs, communist sympathisers, protested their innocence but were sent to the electric chair on 21 June 1953, despite a huge show of international solidarity.

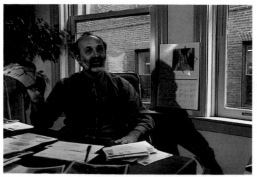

Robert Meeropol: "I've never found out who took that photo."

"IF AMERICA HADN'T BEEN in the grip of the hysteria caused by McCarthyism, my parents would still be alive today. That's why my brother Michael and I are fighting to reopen their case." Sitting in his small office in Springfield, Massachusetts, where he keeps the family archives, Robert Meeropol was called Rosenberg until the age of 6: he was adopted by the Meeropols after his parents were executed. He now runs the Rosenberg Fund for Children, which assists the families of victims of political violence. His emblem: the most famous photo of the Rosenbergs, taken in early autumn, 1950. "It was after a hearing at which the prosecutor had informed my parents of the charges against them; they were then taken to Sing Sing prison in a police van. They hadn't been together for several weeks. The other prisoners spontaneously left a space for them at the back of the van. It was dark. All of a sudden, a bright flash lit up this scene." The couple were locked in a last, intense, embrace. "I've never found out who took this photo and the negative has disappeared. As if, by causing this photo to vanish, they could bury my parents' memory for good." ∎

The most important politico-judicial affair of the post-war period.

Witch-Hunt

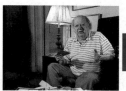

William Reuben

"The photo had a big impact because it suddenly gave the Rosenbergs back their humanity," recalls William Reuben, then working for *The National Guardian*. "During the trial, the press had depicted a Machiavellian couple who had sold their souls to the great Red Satan." Reuben organised a support committee, and an international campaign was launched, calling for the couple to be pardoned. Thousands of protesters demonstrated outside the US embassies in Paris, London and Rome. On their placards: this photo. In France, two petitions collected more than 500,000 signatures, including that of President Auriol. Even the Pope intervened. In vain. President Eisenhower rejected two appeals for pardon, citing "deliberate betrayal of the entire nation". "We are innocent," the Rosenbergs replied, "If we die, all America will have our blood on its hands". The day after their execution, their bodies were laid out in a Brooklyn synagogue. 10,000 people paid their respects.

"The photo gave the Rosenbergs back their humanity."

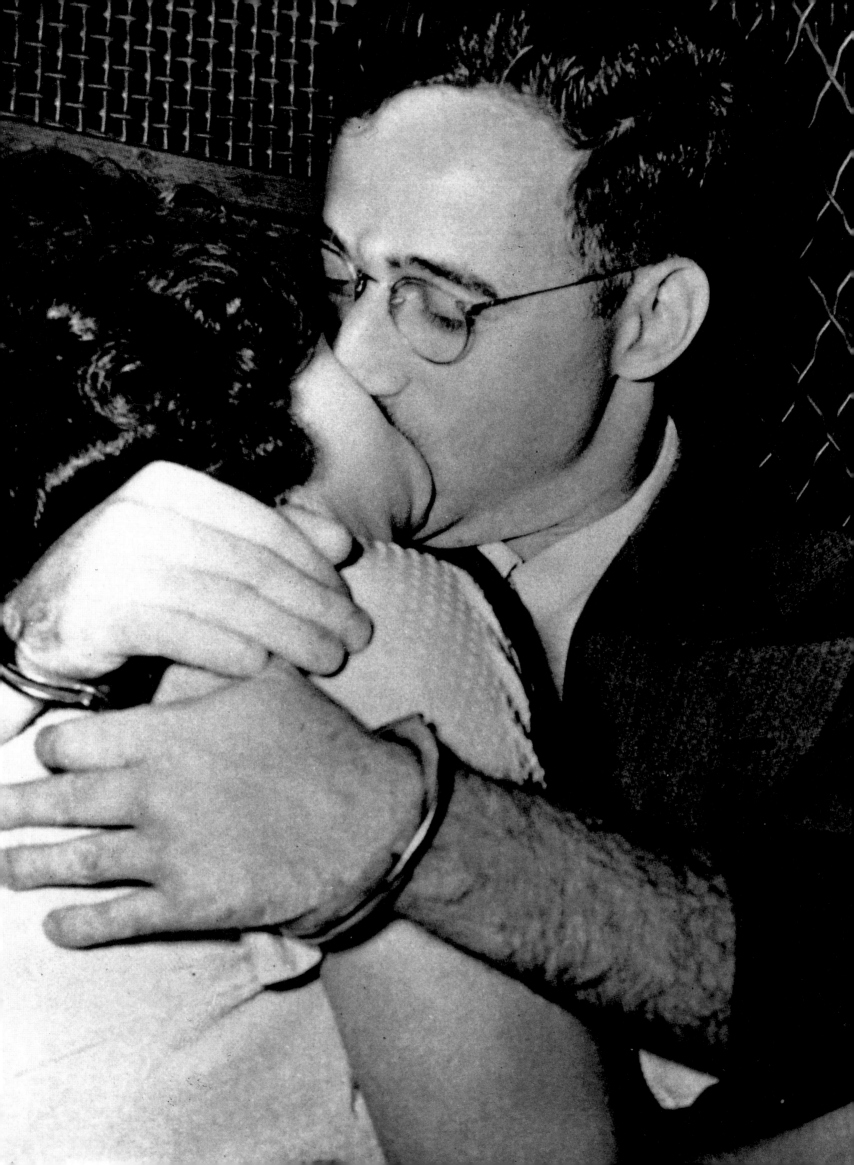

Birth on the Kibbutz

© **David Seymour**/Magnum Photos

Saga

Eliezer Trito: "Myriam was the first baby born in our settlement."

→ TIMELINE

14 May 1948: David Ben Gurion proclaimed the creation of the State of Israel. The neighbouring Arab countries immediately invaded Palestine. In five years, Israel's Jewish population doubled with the arrival of 700,000 immigrants, including 100,000 survivors of the Holocaust. A million Palestinians were exiled. The Jewish immigrants made their homes in settlements; economic development and national defence were the priorities. Based on collective ownership of the land, kibbutzim embodied the dream of the founders of the Hebrew state.

THE YOUNG FATHER'S FACE is radiant with joy. He holds up a newborn baby in a spotless christening robe: "We'd brought it from Italy," Eliezer Trito tells his daughter Myriam. "We never imagined it would become the symbol of Israel." This was 1951, three years after the creation of the Hebrew state. A peasant from south of Naples, Eliezer Trito arrived in the promised land with fifteen families from the small village of San Nicandro Garganico. Theirs was a shared destiny: they had converted from Christianity to Judaism, following their spiritual leader Donato Manduzio. A paralysed World War One veteran, he had discovered the Old Testament while bedridden. Captivated by the story of the Chosen People, he asked the Rabbi of Rome to convert him, and half the village besides. In 1950, the community emigrated to Israel, where they settled in Alma, northern Galilee, with Jews from Tripoli. "It is perhaps the most remarkable saga in the history of Israel," wrote David Seymour in his report. "It's fascinating to see how Italians and Arabs have joined forces to build their new homeland." The settlers of Alma never forgot Seymour, whose parents had died in the Shoah. "He spent several days photographing our community," says Eliezer Trito. "But the most important event was the birth of Myriam's birth, she was the first baby born in our settlement." ∎

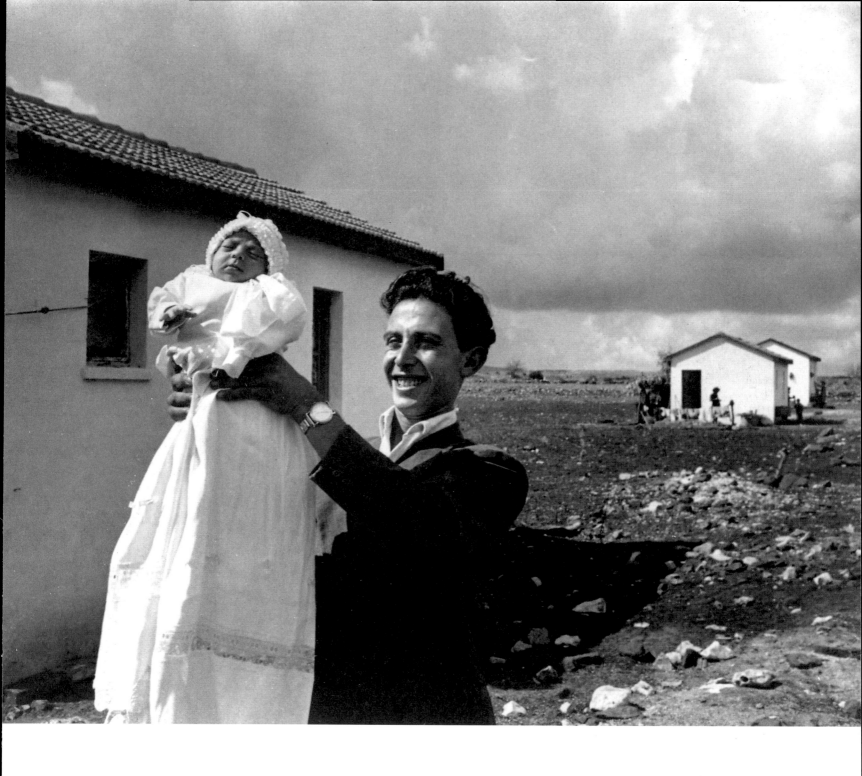

"Chim was the brains behind the Magnum agency."

David Szymin (Chim)

Born David Szymin, to a Jewish family in Warsaw, Chim was haunted by the tragic fate of the Jews of Eastern Europe. No sooner had he obtained his degree than he emigrated: first to Leipzig, where he studied graphic arts, then to Paris, where he took up photography. An oenophile and gourmet, the young man in the black silk cravat was the darling of Montparnasse in the 1930s. There he met André Friedman – later Robert Capa – and that wealthy aesthete Henri Cartier-Bresson, who shared his dreams of changing the world. "Chim had the intelligence of a chess player," says HCB. "Photography was a pawn that he moved across the chessboard of his intelligence." After covering the Front Populaire and the Spanish Civil War, Chim emigrated to the United States when Hitler invaded Poland. Taking the name "Seymour", he joined the American Army and worked on the interpretation of aerial photographs. In April 1947, Chim, Cartier-Bresson and Capa founded the prestigious Magnum agency. "They shared the same humanist approach and aesthetics of political involvement; these were the fundamental values of our co-operative," says photographer Burt Glinn. "But Chim was the brains behind Magnum. In the 1950s, television was in its infancy

Burt Glinn

and there was an enormous demand for photos. We felt invincible. Naturally, most of us covered the creation of Israel. The photo of baby Myriam was typical of Chim's work: he took a lot of photographs of children, right up to the end." In 1956, Chim went to Egypt where the Suez Crisis had broken out. One of his last photos shows a bare-footed child facing a tank, in a street in Port Said. Afterwards, he drove towards the Egyptian lines. Under a hail of machine-gun fire, his jeep turned over, plunging into the Canal.

The Cuzco Trail

→ TIMELINE

Travel was the prerogative of the wealthy until after World War Two. Mass consumption and the spread of holiday pay led to the birth of the tourist industry with the first charter flights and tour operators. During the 1960s, a new market was created by the beat generation, which headed off to California, Ibiza or Kathmandu. The tourist industry began to focus on Third-World countries and exoticism. Tourism now brings in five hundred billion dollars every year.

Marco Bischof: "This photo symbolises what each of us is looking for: the lightness of being."

THERE IS ONLY one person on the contact sheet: the little Indian boy in a poncho is surrounded by Machu Picchu, the narrow streets of Cuzco or details of carved stones. "It's impressive," says Marco Bischof. "I've always wondered how my father brought off that photo with a single shot". It was 1 May 1954. A photographer with Magnum, Bischof toured north and south America. He left his pregnant wife in Mexico and flew to Chile, then Peru. A humanist and aesthete, he immersed himself in the memories of Inca civilisation: architecture, spectacular sites, and the customs of Andean peasants, with their cult of *pacha mama*, the earth mother. A Magnum commission accompanied him in his wanderings; as part of a collective project on the children of the world, he wanted to photograph a young shepherd. It was a chance encounter between Pisac and Cuzco, in the Sacred Valley. "I've frequently imagined the scene," says Marco Bischof: "my father in his jeep, stopping to admire the rolling landscape with its harmonious terracing. Then the boy – in the family we call him 'The boy with the pipe' – passed by. The beauty of this child, spontaneously making music as he walked, captivated him, and he took only one photograph. For me, it symbolises everything we look for in life: the lightness of being. It's effectively father's testament: two weeks later, his car plunged into a ravine in the Andes, and he was killed." ■

An Invitation to Travel

Marco Bischof, as a child.

A week after Werner Bischof's death, his second son Daniel, Marco's brother, was born. The photo is intimately connected with the family's history: "I was 4 at the time, and didn't realise that my father was dead; my mother told me he was staying with the Indians and wouldn't be back. Later, the photo was hung in our dining room. For me, it symbolised my father's death. Since then, I've been to Peru with my brother and we visited the places where he worked, the place where he was killed, and his grave. We also found the place where he took the photo: it hadn't changed. Naturally, we tried to find the child in the photo … but, when it comes to it, I prefer not to know his identity and never to meet him. The photo is best if he remains anonymous."

WERNER BISCHOF

"I prefer not to know the child's identity."
- - - - - - - - -

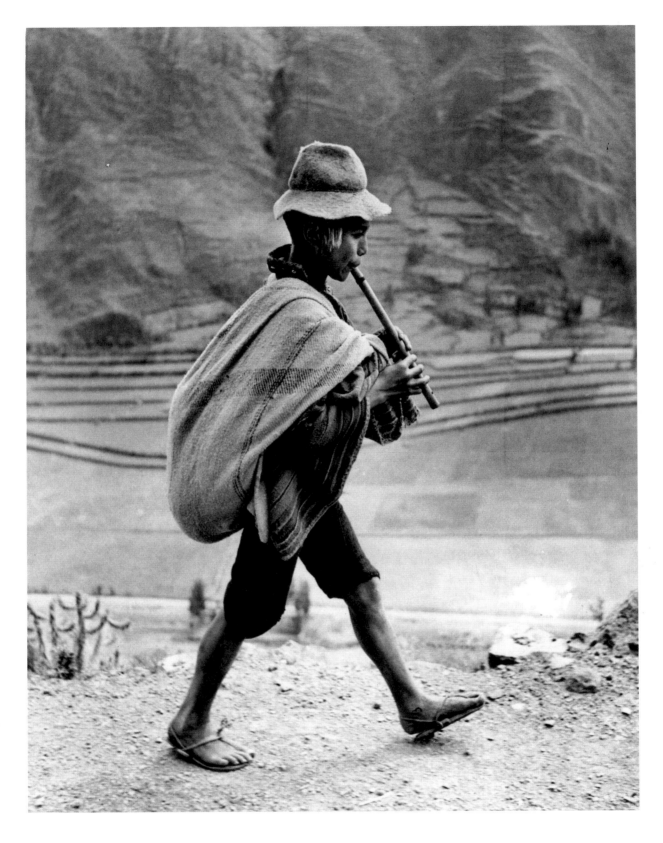

"The emblem of a generation, of its dreams and illusions."

He wanted to be a painter; he became a photographer. Born in Switzerland in 1916, Werner Bischof made his photographic debut with still lifes. He was close to the Neue Sachlichkeit movement, which proclaimed 'The World is Beautiful', examing the fine detail of that world: shells and plants. Such meticulously composed abstract works allowed him, after the Second War, to reconcile aesthetics and ethics. "In 1945," says the Swiss writer Hugo Loetscher, "Bischof photographed the refugee camps in Eastern Europe. There he discovered suffering. After that, he covered the famine in India and the Indochina war, focusing on the fate of children. The boy with the pipe manifests Bischof's desire to restore order to a world he considered topsy-turvy. The child embodies the pride of the Indians; he is walking towards his future. Ten years after it was taken, this photo fascinated an entire generation. It was an invitation to travel, it symbolised the return to nature, far from the consumer society, at a time when the Third World was asserting itself politically. This is the photo of a generation, of its dreams and illusions."

Hugo Loetscher

Che
© Alberto Korda

ALBERTO KORDA
"I've never received any royalties."

→ TIMELINE

6 March 1960: A million people paraded through Havana for the burial of those who died in *La Coubre*. Loaded with arms bought by Cuba from Belgium, the French cargo had been blown up, allegedly by the CIA. The final toll stood at 80 dead and 200 wounded. *"Patria o muerte* [Fatherland or death], we shall overcome!" cried Fidel Castro from a podium near Colón cemetery. This was one of the great slogans of the Cuban revolutionaries who had overthrown the Batista dictatorship in January 1959.

"THIS PHOTO was not planned, it was pure chance!" A onetime fashion photographer who had started a new career taking portraits of the revolutionaries, Alberto Korda was working for the newspaper *Revolución* when, by chance, he created one of the great icons of the century. Armed with his Leica, he was snapping Fidel Castro, who was giving one of his legendary speeches. At his side, lapping up his words, were Jean-Paul Sartre and Simone de Beauvoir. "I had not noticed Che, who was at the back of the podium," says Korda, "until he came forward to take in the crowd, which stretched away for miles. I just had time to take one horizontal shot, then a second one, a vertical one, with a 90mm lens. Then Che stepped back. I'll never forget his gaze, its mixture of resolve and suffering." Only the photos of Sartre and de Beauvoir were published. Those of Che went unnoticed. Korda made an enlargement of the first photo: "I preferred the vertical one, but a man's head came over Che's shoulder. At that time, we had no computers to correct it." He cropped the horizontal one instead, cutting out a profile to the right and a palm tree to the left. "I thought it was the best portrait of Che ever taken." Seven years later, the photo was published all over the world, uncredited. ∎

037

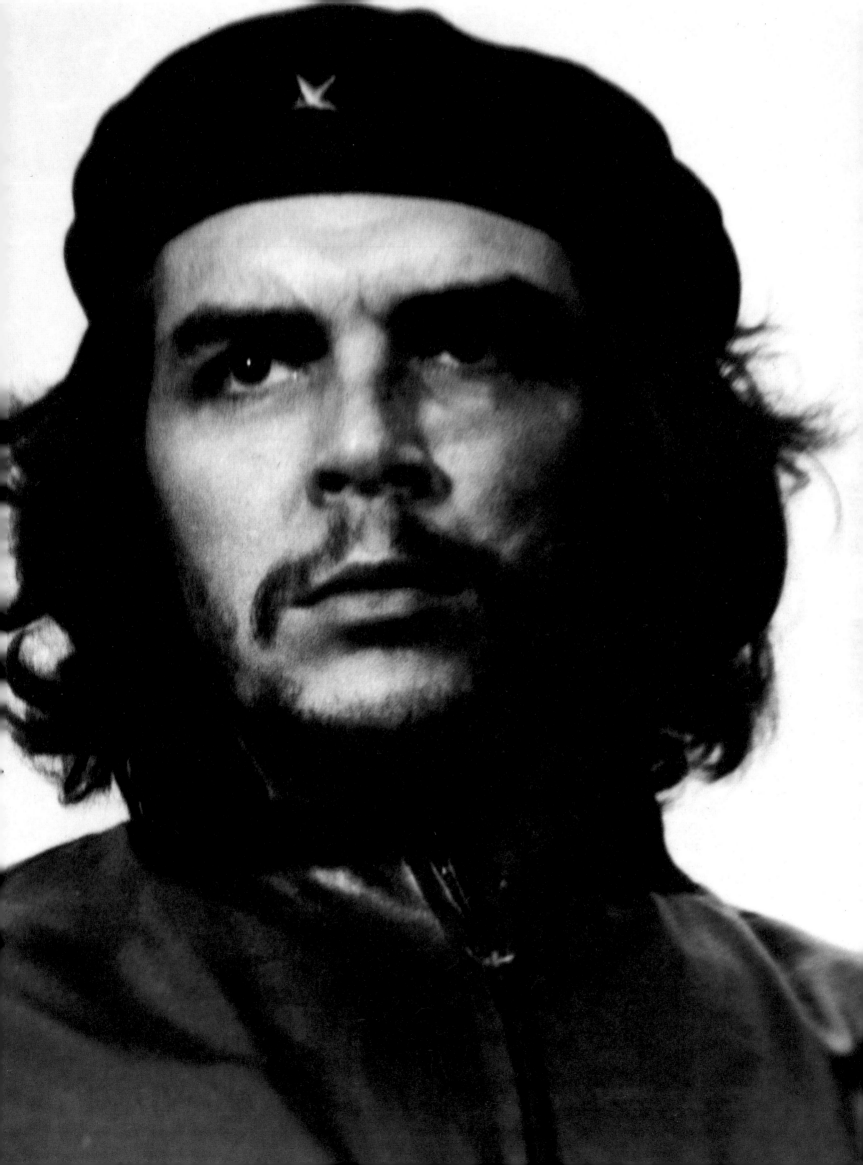

This is the most widely published photograph of the century. A virtual billionaire, Alberto Korda decided to get himself a lawyer: "As a matter of principle; it's already too late."

Ernesto Che Guevara

He was one of the most emblematic figures of the Cuban revolution. Ernesto Guevara, known as 'Che', met Fidel Castro when he was in exile in Mexico. A fervent Marxist, the young Argentine doctor had won his military stripes in the maquis in the Sierra Maestra. When, on 1 January 1959, the Barbudos triumphantly entered Havana, he was immensely popular. He was successively made roving ambassador and minister of industry. Fiercely intelligent, the dark, handsome revolutionary became the prophet of voluntary work and worldwide revolution. He was murdered on 8 October 1967, when fomenting guerrilla war in Bolivia.

October 1967: Che was shot by Bolivian soldiers aided and abetted by the CIA. Grief was universal. A Milan publisher and fervent admirer of the Cuban revolution, Giangiacomo Feltrinelli, printed a poster of Korda's photo. A million copies at five dollars apiece, credited 'Copyright Feltrinelli'. "I'd given him a print during one of his trips to Cuba," explained the photographer. "I never received a cent." A supreme icon of youth, Korda's portrait of the man in the starred beret became the most widely published photo of the century. From the barricades in the Latin Quarter to American campuses, from Libya to Ireland, he everywhere symbolised the idealistic rebel, eternally young and handsome, who gives his life for his beliefs. "He is the new Christ on the cross," comments Oliviero

Toscani, artistic director of Benetton. For years, Alberto Korda kept silent; he was happy to see his photo serving the revolutionary cause. However, when it was appropriated by concerns like Swatch, Fischer skis or Sony as a trendy 'label', Korda got himself a lawyer. He was, after all, a virtual billionaire. As he says: "I've forgotten about the money I could have made, what matters is that his example should not be forgotten."

"He is the new Christ on the cross."

Oliviero Toscani

"TOGETHER WE SHAL BUILD A NEW LIFE"

Marilyn
© Eve Arnold/Magnum Photos

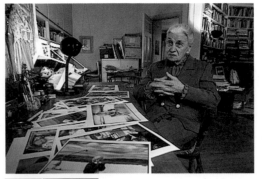

EVE ARNOLD
"This photo is a cry for help."

Photogenius

→ TIMELINE

She was one of the most photographed women of the century: Marilyn Monroe, alias Norma Jean Baker, born in 1926 in Los Angeles, became the ultimate sex symbol in 1953 after the legendary film *Gentlemen Prefer Blondes*. Her photo was on every worker's toolbox, she was the darling of intellectual circles; she was everyone's dream. Her private life was a fiasco, all bitter divorces and scandalous affairs. She left Hollywood to marry New York playwright Arthur Miller, but this marriage too failed. Her tragic death in 1962 only confirmed her legendary status.

038

THE NEVADA DESERT, 1960. Monroe was filming John Huston's *The Misfits*, alongside Clark Gable and Montgomery Clift, with a script by Arthur Miller. Magnum was given exclusive coverage and Eve Arnold stayed two months. "I'm 34. I'm exhausted. I don't know where I'm going," Monroe confided. Her marriage to Arthur Miller was in crisis. The shoot was becoming a nightmare. "She would disappear, sometimes for an entire day," recalls Eve Arnold, "She was having difficulty learning her lines." Monroe overdosed on sleeping pills and was hospitalised; then filming resumed. Shooting during rehearsals and between takes, Arnold took nearly 1,000 photos. One became famous in its own right. "She was rehearsing her lines before a difficult scene involving a violent confrontation with Clark Gable. She was focused and seemed calm." This was the most dramatic scene of the film, the one in which the heroes circled the wild horses destined for dog food. "Murderers!", screams the heroine, walking off into the desert. When, in Manhattan, the two women examined the contact sheets, Monroe 'killed' 15% of the photos. But not *the* photo: "She liked this picture of a solitary woman immersed in her work. She was tired of being treated as a sex symbol. It's as if she were crying out: 'Help me! I'm in danger!' But nobody was listening." ∎

"HELP ME, I'M IN DANGER."

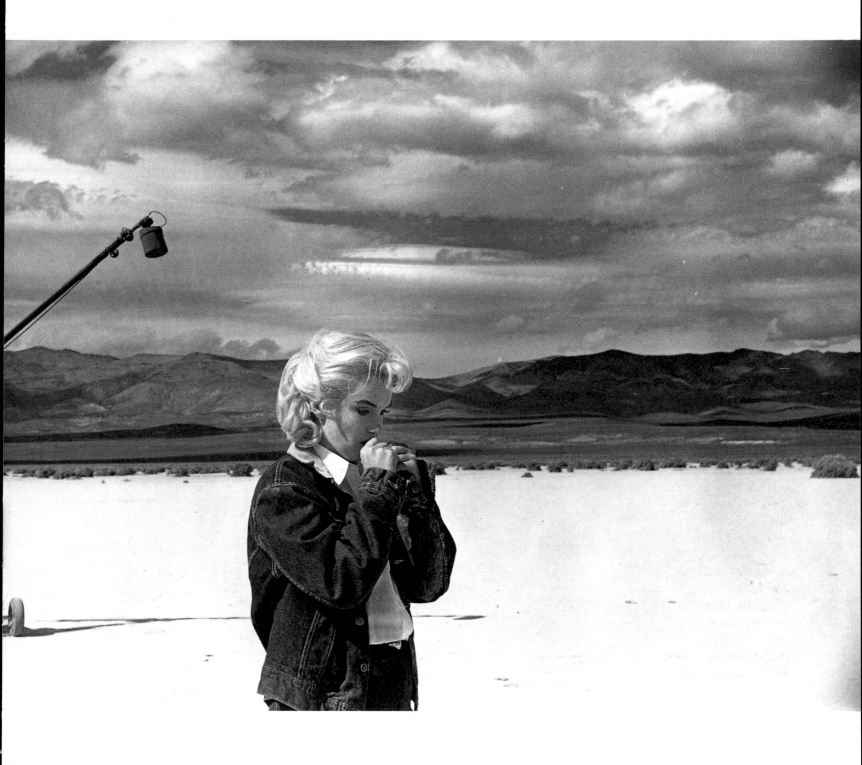

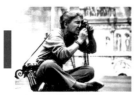

EVE ARNOLD

The meeting took place at a party in honour of John Huston. One was a Hollywood starlet, the other an up-and-coming photographer who had just finished a piece on Marlene Dietrich. "If you could do so well with her," said the ambitious pin-up, "just think what you could do with me!" Norma Jean Baker, a brunette, started early.

Captivated by the Hollywood myth, she devoured the glossy magazines. Its legends were Marlene Dietrich and Clark Gable. Stubbornly, she spent hours imitating their poses in the mirror. "God gave her everything," said Billy Wilder, who directed her in two films. "The first day a photographer took her picture, she was wonderful." She was then 18 and working on an assembly line. She became a model, then a starlet. Marilyn the blonde was born. She used the camera to build her career. "It wasn't me she chose, but Magnum," says Arnold, "she knew the agency distributed all over

the world and that to become a star she needed to catch the public's eye." Arnold had six photo sessions with her between 1950 and 1960. "She was a photo genius, she posed instinctively and set her own pace. The photographer was her object and had merely to follow her lead. Her gift for projecting herself in a visual medium meant that everyone understood her."

"God gave her everything."

Lumumba
© Dietrich Mummendey/Corbis/Sipa Press

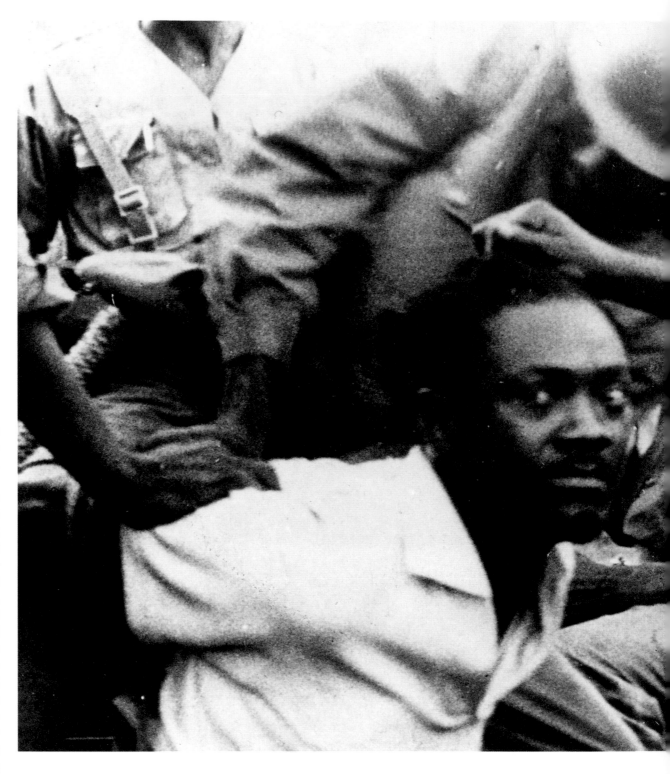

→ TIMELINE

30 June 1960: the Belgian Congo gained independence. Patrice Lumumba was appointed Prime Minister, declaring to King Baudouin I that this was "a decisive step towards the liberation of the entire African continent". On 18 August, the U.S. Security Council decided to remove him, while the Belgian army supported Moise Tshombe, who announced the secession of Katanga province. Backed by the CIA, Colonel Mobutu organised a military coup. Under house arrest, Lumumba escaped, but was re-arrested and imprisoned. Handed over to his enemies in Katanga, he was murdered on 17 January 1961.

After the Congo attained independence, Bashir Ben Yahmed met Patrice Lumumba to discuss the creation of a magazine devoted to Africa and the Third World. He made the same suggestion to Che Guevara, but the two friends refused. "They had other things on their mind," says the founder of the magazine *Jeune Afrique*, a Tunisian intellectual who has lived in Paris for many years. "This

Bechir Ben Yahmed

photo had a tremendous impact. For the first time, an independence fighter who had become Prime Minister, travelled widely and met heads of state, was suddenly thrust back into the status of a fighter, of someone who could be locked up and beaten up. This photo depressed me for years; I thought 'we'll never succeed. Our enemies are too strong and the people fighting the system are too weak, too inexperienced and too isolated.' This photo told us that independence was no gateway to paradise, just a stage in a battle that is still being fought. Yes, I wept at Lumumba's death, as I did

Forerunner

Horst Faas: "The soldiers yanked his hair so we could photograph his face."

"WHY ARE they yanking his hair? To raise his face to our cameras." Director of the London office of Associated Press, Horst Faas is not a man given to remorse: "In this job, there's no place for sentiment. For me, Lumumba was just that year's news. Full stop." The AP correspondent in the Congo, he learnt of Lumumba's arrest on 2 December 1960. With him was another German photographer, Dietrich Mummendey, who was working for United Press. On the run since 28 November, the Prime Minister was arrested by Mobutu's men at Port-Francqui. He was taken to Léopoldville on a DC-3, which landed at Ndjili airport at 17.00. "Gilbert Pongo, Mobutu's security chief, triumphantly disembarked," says Horst Faas. "Then came Lumumba: barefooted, his hands tied behind his back with a thick rope, he was shoved brutally into a lorry, with Maurice Mpolo, one of his ministers. The soldiers started beating him. For several minutes, we shot the lorry from all angles. Lumumba was hunched down; a soldier jerked his head up so we could photograph his face." The two photographers both took one photo, but Mummendey's was the decisive one. "I'll never forget his frightened eyes," Mummendey wrote in his memoirs. "He stared at my camera with infinite sadness. It was the last time that any journalist saw Lumumba alive: his ghost will haunt the Congo and the continent for a long time to come." ∎

"This photo is an indictment," says François Lumumba, the eldest son of the man who pioneered African independence. "But it shows only the Congolese soldiers, the local perpetrators of my father's murder. There's no sign of the external players, particularly the CIA agents and certain Belgian conservatives." Born in 1951, Lumumba long lived in exile, in Egypt, with his mother and four brothers and sisters. Today he runs the Congolese National Movement in Kabila's Congo, the former Zaire. "The years have gone by, and we have learned to control hatred and revenge, which lead nowhere. This photo strengthens my resolve to continue my father's struggle. I am reminded of the letter he wrote to my mother Pauline, just before they tortured him to death: 'Without dignity, there is no liberty, without justice there is no dignity and without independence men cannot be free'."

François Lumumba

"It shows only the local perpetrators of his murder."

- - - - - - - - - - - -

"This photo is tragic and beautiful at once."

when Guevara died. I was not alone. Millions wept, all over the world. Of whom could you say that today? They were universally mourned because they were pure, because they were strong, and because they were weak. They were fighting a battle they couldn't win. That's the beauty of that period, of that moment, and that photo: it's tragic and beautiful at once".

- -

1961

The Wall of Shame
© Peter Leibing

Konrad Schuman and PETER LEIBING
"We've become best mates."

Freedom!

→ TIMELINE

13 August 1961: the tanks of the Warsaw Pact sealed off the frontier between East Berlin, the capital of communist Germany, and the western part of the city, while barbed wire and concrete blocks were being put up. Guarded by the Vopos – frontier-guards ordered to shoot refugees – the 'wall of shame' separated entire families. Its official role: to stop the exodus of East Germans to the Federal Republic. Since the creation of the German Democratic Republic, three million refugees had already escaped to the West.

THIRTY-SEVEN YEARS later, he still can't get over it: "I was just starting out in the profession – and I took a photo that was published all over the world!" Peter Leibing has kept the looks he had when he was 20. On 13 August 1961, he arrived in Berlin at around 13.00. A trainee photographer with Conti Press, a small Hamburg agency, he made his photographic debut at the horse races. This was his first current affairs report; taking the advice of policemen, he headed for Bernauerstrasse where about one hundred people had gathered, along with photographers and a film-cameraman. "Get ready, he's going to jump" a local declared. Peter Leibing saw "a Vopo, smoking one cigarette after another, a few metres from the demarcation line". Leibing readied his Exacter, an East German camera, focused on the barbed wire, then waited, his eye glued to the 200 mm lens. "Suddenly, he jumped. It was a matter of seconds. I could only take one shot; camera-motors didn't exist then. I was the only one who got the shot. You know why? Because I'd practised shooting horses jumping over hedges!" It was *the* photo of 'the wall of shame'. Leibing has never earned a cent for it; the negative belongs to the agency he was training with. ∎

040

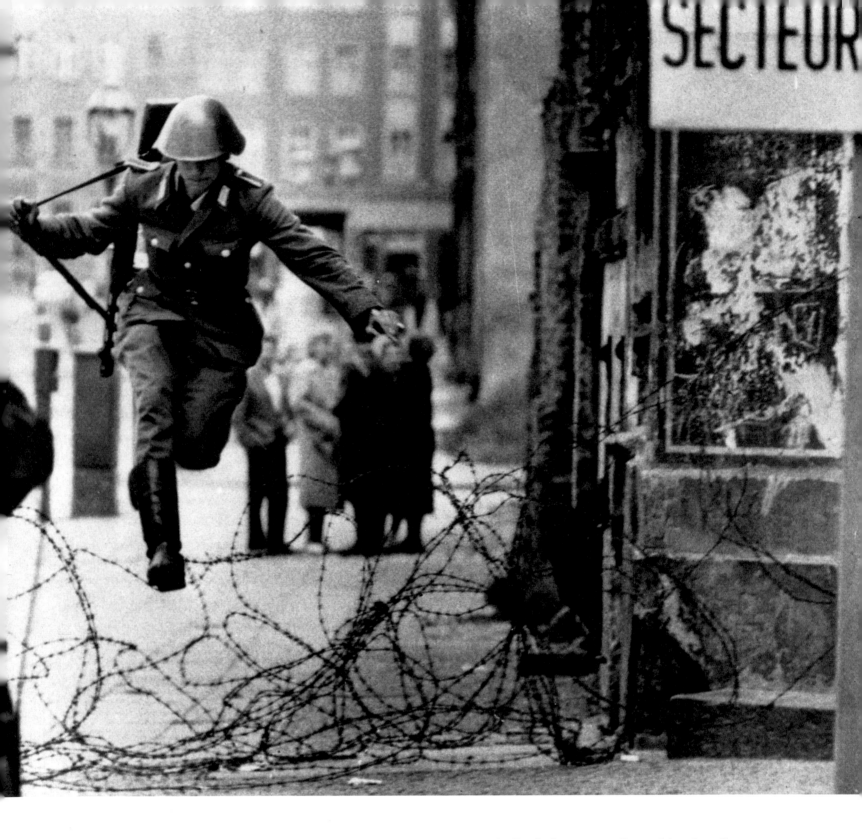

"Proud to be a symbol of liberty."

Konrad Schuman

He was 19 and a recent recruit. A communist by conviction, Konrad Schuman did not think twice when he was told that "the border was to be closed to prevent sabotage". He was stationed at Bernauerstrasse, with weapons and ammunition. On 14 August, he began to "have serious doubts". A group of young East Germans seemed to be trying to cross over in a car; they proved to be members of the Stasi, the secret police, testing the Vopos' vigilance. A second incident was the last straw: a little girl holidaying with her grandparents in East Berlin wanted to go back to her parents in the West. "I stopped her crossing, but it was unbearable: I realised that a regime happy to do that was capable of anything at all." 15 August was an ordeal: "I was at my wit's end. I couldn't make up my mind to jump; I was scared of getting caught in the wire and shot down by my colleagues. Then I saw a police van, doors wide open. That gave me the guts, I made straight for the van!" Schuman met Leibing 25 years later on a television show. Schuman was distrustful at first: "I was convinced he'd made a fortune out of me. But he hadn't, and we've become best mates. And I'm proud, now, to have gone down in history as a symbol of liberty."

PETER LEIBING was 20 when he took the photo of his career.

Lei Pheng

© Zhou Jun/*Xinhua*

→ **TIMELINE**

1958. Breaking with the Soviet model, Mao Zedong launched the second 5-year plan, defining the path of Chinese communism. This was the 'Great Leap Forward'; people's communes were to be established with the aim of restructuring the economy on collectivist lines. The results were catastrophic: between 1961 and 1962, fifteen million Chinese died of famine, and all sectors, from agriculture to industry, ground to a halt. It marked the most serious crisis since Mao Zedong's accession to power in 1949.

ZHOU JUN

"I squatted down to make Lei Pheng look taller."

HIS NAME WAS LEI PHENG and he was the most famous man in China after Mao Zedong. For this dimunitive soldier, it all began in 1961. Elected elite worker, Lei Pheng had just brought an article into the North East militia newspaper, where he was met by Zhou Jun, an army photographer. "I asked: Why don't I take a photo?" says the retired 68-year-old photographer, who still lives 600 km north of Peking, in Shenyang, the city where the photo was taken. "He looked awkward, so I offered to lend him a hat and a machine gun." The name of the hat-owner has been forgotten, but the machine gun belonged to Hu Youfen, on guard at the entrance to the building: "I was proud to lend my weapon to a model soldier". The photo session lasted around 20 minutes; time for Zhou Jun to take five photos, squatting down: "I had to make Lei Pheng look taller, he was barely 5 foot". One shot made the grade; it was published in the North East militia newspaper, then in the Peoples' Army daily. The authorities made nothing of it until Lei Pheng was run over by a lorry and killed on 15 August 1962. Then, on 5 March 1963, Mao Zedong came up with an epitaph that spearheaded mass publicity campaigns: "Comrade Lei Pheng is an example to us all." The retouchers added a fir tree to the newly coloured photo: a "symbol of eternity in China", Hu Youfen tells us. ■

Myth Or Reality

It is difficult to sort fact from fiction in Lei Pheng's biography. "What we know," notes Sinologist Jean-Philippe Béja, "is that he was a model worker from Wang-Cheng district". Lei Pheng was just 9 when Mao Zedong came to power. An orphan, he joined the communist youth movement before entering the army as a driver. The legend of Lei Pheng, model soldier, was born. "The life of man is short, but service of the people is infinite," he said. Always ready to share his rations, he wore his socks threadbare to spare the "people's property"; he exemplified communist morality, the Maoist version of Christian altruism. After the failure of the Great Leap Forward, he was the ideal hero. "The myth of Lei Pheng was created to restore a sense of values to a demoralised country," explains Béja. In 1962, pictures of the diminutive soldier were distributed to all schools and offices, and appeared in books, photo-stories, and even a film. Over the years, the legend accrued new details and new photos. "I want always to be the revolutionary screw that never rusts": such are the sentiments ascribed to the best known 'unknown' citizen of China.

Jean-Philippe Béja

Mao's Hero

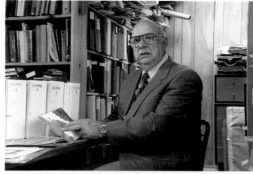

Dino Brugioni: "Photography determined the course of the entire missile crisis."

The Cuban Missile Crisis
© CIA

→ TIMELINE

22 October 1962. Kennedy imposed a blockade on Cuba: "We have evidence that Soviet nuclear missiles are stationed there", declared the President of the United States. The strained situation reached breaking point when the Russians and Americans confronted each other in the Caribbean. Eventually, the Soviets backed down. On 28 October, Khrushchev and Kennedy signed an agreement stipulating that the Soviet missiles would be dismantled on condition that the United States undertook never to invade Cuba. This was the closest the world had ever come to global nuclear conflict.

042

"THIS PHOTO REPRESENTS the CIA's greatest success in terms of photographic information." Dino Brugioni was working in the Agency's photographic department when they received "an extremely serious report: one of our agents had noticed suspicious Russian activity in the west of the island, while at the same time the Cubans were evacuating the area. We decided to find out what was going on." On 14 October, President Kennedy authorised a reconnaissance flight by the famous U-2, a spycraft capable of flying at an altitude of 22 km and equipped with two moving panoramic cameras. On 15 October, stupefaction: "The films showed objects 19 metres long. In our photo archives, we found a photo of a medium-range missile of identical size exhibited in the streets of Moscow. The object in Cuba was an SS-4, capable of reaching the United States in six minutes!" The CIA agents also identified launch pads, erectors, and fuelling vehicles. They sought an immediate meeting with Kennedy. "We had no difficulty in convincing the president" says Dino Brugioni. "A written report you can question, but not photos. Indeed, photography determined the course of the entire missile crisis." ∎

Alexander Alexeyev

25 October 1962: dramatic revelations on the United Nations Security Council. "Do you still deny there are missiles in Cuba?" asked Stevenson, the American Ambassador, of Zorin, his Soviet counterpart. "OK, bring on the photos!" "The photos made a considerable impact," says Dino Brugioni, "they proved the Russians were lying. Thanks to those photos, Kennedy could command unconditional national and international support." Alexander Alexeyev, former Soviet ambassador in Havana, tells a different story. A KGB colonel, he had been sent to Cuba to spy on the Castro revolution. He was subsequently appointed Ambassador in May 1962. It was he who told Castro about Khrushchev's plan to site forty-two nuclear missiles on the island. He found out about the photos on the radio: "In fact," he confirms, "Zorin *didn't* know anything about the missiles. Only three people were in the know at the foreign ministry: Gromyko, myself, and Kuznetsov, my assistant. But it's true: the photos were a warning and forced our two countries to negotiate over nuclear disarmament." His view is shared by Brugioni: "These photos saved humanity from nuclear war."

"The photos saved humanity from nuclear war."

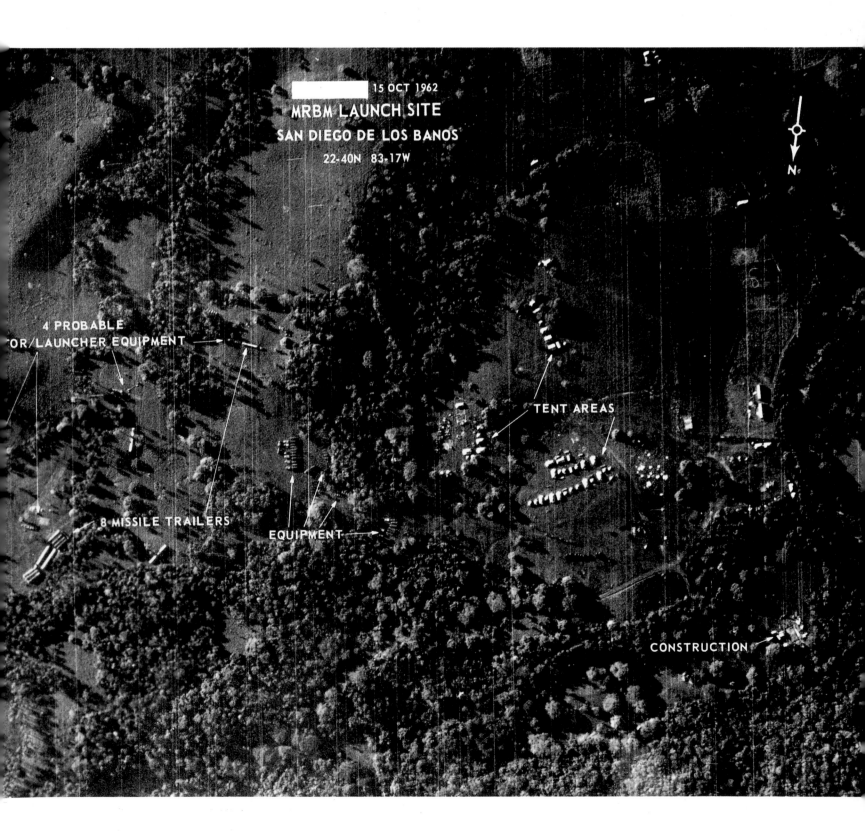

15 OCT 1962

MRBM LAUNCH SITE
SAN DIEGO DE LOS BANOS
22-40N 83-17W

N

4 PROBABLE
OR/LAUNCHER EQUIPMENT

TENT AREAS

8 MISSILE TRAILERS

EQUIPMENT

CONSTRUCTION

JFK Assassinated

© James W. Altgens/Associated Press

→ **TIMELINE**

22 November 1963. During an official visit to Dallas, President John Fitzgerald Kennedy, aged 46, was assassinated as he, his wife Jackie, and John Connally, Governor of Texas, were driving through the town centre in an open-top limousine. The police immediately arrested a suspect, Lee Harvey Oswald, who was killed two days later by Jack Ruby. The news shocked the whole world. The assassination of the youngest president of the United States is still beset by rumour and controversy. Who was behind the killing?

Richard Trask: "This photo symbolised the end of American innocence."

O N 22 NOVEMBER 1963, James Altgens was supposed to stay in his office at Associated Press, in Dallas. The 42-year-old photo enthusiast was employed to distribute other people's photos to the agency's subscribers. But that day, he wanted to be part of things. Camera in hand, he walked to a subway where there were no photographers, but the police sent him back to the carpark of the Texas School Book Depository. A few minutes later, five shots were fired from the building. When the presidential limousine was level with him, just before Dealey Plaza, James Altgens pressed the shutter release: JFK was smiling and Jackie was protecting her hat from the wind. "I was going to take another photo," Altgens told Richard Trask, who wrote two books on the assassination, "when I heard a noise that sounded like a car backfiring. Then everything became rather nightmarish: fragments of the president's head splattered at my feet. I was paralysed, I couldn't press the shutter release. Afterwards, people made fun of me for my lack of professionalism." He saw Jackie climbing on the seats of the limousine crying: "Oh, no!" "Stupefied by the shock, she was trying to gather up the pieces of her husband's head", says Richard Trask. Altgens took another shot: it shows Clint Hill, the secret service agent, trying to protect President Kennedy. He was too late. JFK died 30 minutes later. ∎

"Oh, no!"

"Ironically," says Richard Stolley, editor-in-chief of *Life*, "none of the professionals there could photograph the assassination, because they were all on a bus following the limousine. Suddenly, there was a rush to find amateur photographers." These included Abraham Zapruder, a Dallas tailor, who bagged an excellent scoop: he had filmed the killing with his 8-mm camera. The exclusive rights to the six seconds of film were bought by *Life* for 150,000 dollars. "At the time, that was a fortune," says Richard Stolley, who negotiated the price. "We published a special edition with a selection of those frames. And Altgens' photo made the front page of thousands of newspapers and won a World Press Photo award." Over the next hour, news of the assassination spread through the world. "This was the first planetary event of the century and the beginning of the end for the illustrated press. Television really asserted its status at Kennedy's funeral at Arlington. For the first time, it broadcast live throughout the day. Afterwards, nothing was the same for the press or for America."

"This was the first planetary event of the century."

Richard Stolley

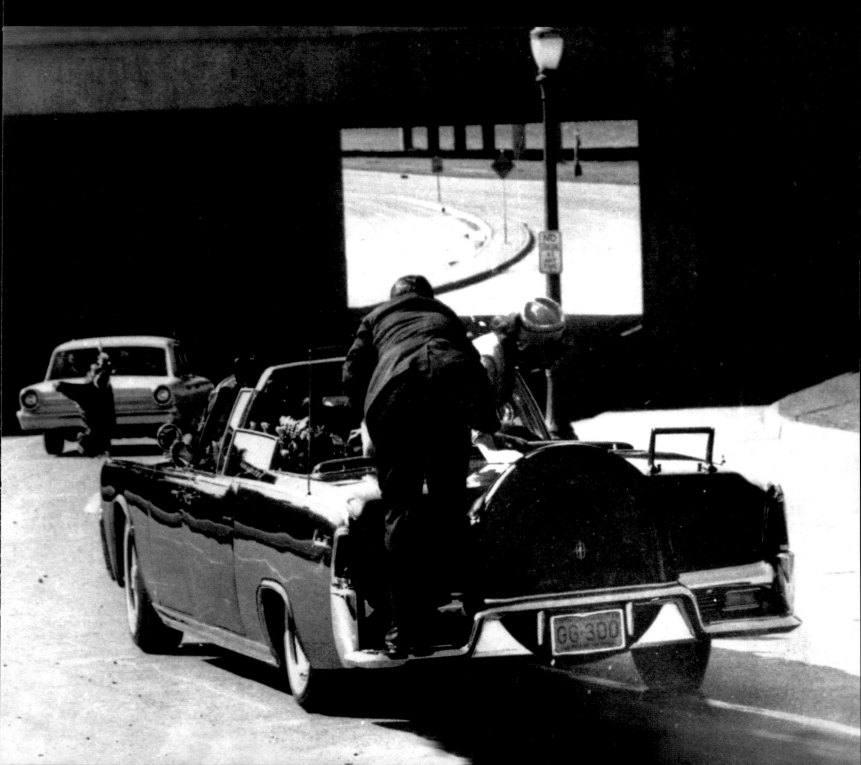

Paul VI in the Holy Land

© Georges Ménager/*Paris Match*

Father Adib Badawi: "I was third to the right of the Father!"

Roger Thérond

Spreading the Word

"With this trip, the Vatican discovered the importance of communication."

→ TIMELINE

Friday, 4 January 1964. "I come in a spirit of peace and harmony", declared Pope Paul VI when he arrived in Jordan. It was a historic event: the first time a pope had visited the Holy Land since Saint Peter. Promoting ecumenicalism and religious dialogue, Paul VI made his peace with the Eastern Orthodox Church and met Jewish and Muslim leaders. Mingling willingly with the crowds, John XXIII's successor created a new image of the papacy.

"THEY WERE the finest days of my life!" Born in the Lebanon, Father Adib Badawi belongs to the Catholic Melchite community, a branch of the Eastern Orthodox Church. He was just 36 when the Vatican made him master of ceremonies on the occasion of Pope Paul's visit to the Holy Land. "Six hundred photographers covered the voyage, including Georges Ménager of *Paris Match*, who didn't let me out of his sight!" Frenzied crowds jostled to touch Saint Peter's heir as soon as he set foot on the Way of the Cross in Jerusalem. Ashen-faced, Paul VI was almost "crushed to death". Father Badawi suggested they take refuge in a chapel at the sixth station of the cross, occupied by the Little Sisters of Jesus. "Your Holiness, may I take photos?" asked Georges Ménager, the only photographer there. "Of course, my son, you have a very difficult job," replied Pope Paul VI. "So do you, Your Holiness." And the pope kneeled on the ground to pray with the orthodox priests surrounding him. "It was a historic moment," says Father Badawi. "This photo is Paul VI to the life; he stepped down from his pedestal to share his faith with mankind". Also in the shot is a short bearded man with a Byzantine hat, holding some books: "That's me! I was third to the right of the Father!" ∎

"The impact of words, the shock of photos". Faithful to its slogan, *Paris Match* organised one of the biggest media campaigns of the 20th century for the Pope's visit: sixty special correspondents, including twenty-five photographers, climbed on board a passenger jet converted into an editorial office. This was the era when *Paris Match*, like *Life*, prided itself on "making and unmaking events", in the words of its boss, Roger Thérond. "It was a real challenge: we put the magazine together on the flight home." When they arrived, Sunday 6 January at midnight, the magazine was ready for the printer. It hit newspaper stands throughout the world in the early hours of Wednesday morning. This was quite a coup: sales topped 2 million. "The Vatican was happy," observes Roger Thérond. "I was received by Paul VI himself, and gave him a boxed copy of all the prints." Rome, too, had learnt something. "After this trip," concludes Father Badawi, "the Church realised it needed the press to spread the word. Pope Paul VI paved the way for John Paul II, the first universal apostle of the Gospel."

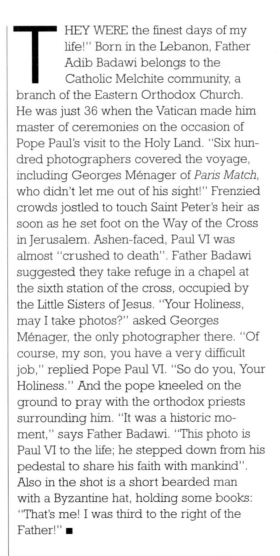

GEORGES MÉNAGER

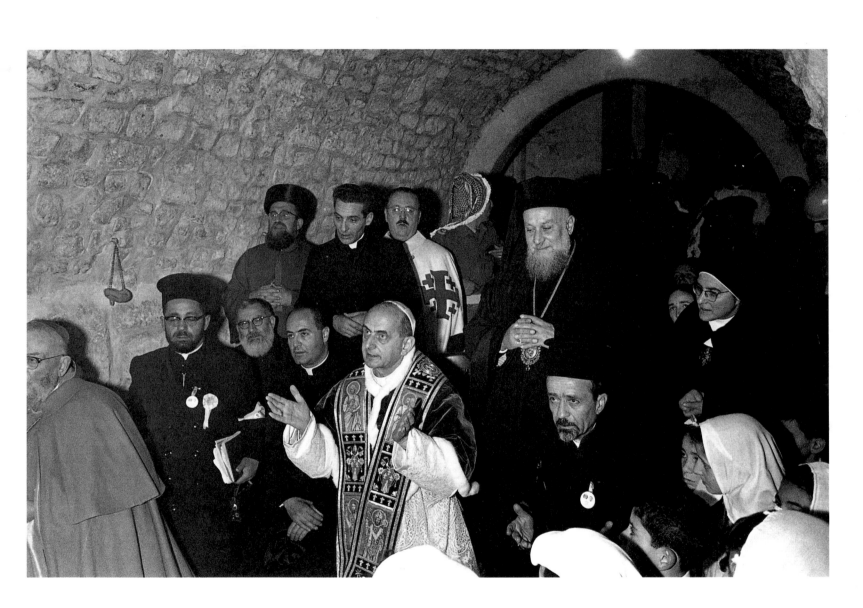

The Mysteries of Life

© Lennart Nilsson/Life Magazine/PPCM

In Vitro

LENNART NILSSON

"I was very proud, because it was a first."

"Lennart Nilsson is not just an artist, he's also a scientist: we at the Carolinksa Institute awarded him an honorary doctorate." A renowned obstetrician, Professor Lars Hamberger displays a range of instruments: ultra-compact endoscopes, macro-optical equipment, scanning electron microscopes capable of examining molecular structure. "All this was specially designed for Lennart, who is in close contact with German and Japanese manufacturers." In 1990, the two friends performed an astonishing feat: they filmed the *in vitro* fertilisation of an egg by a sperm. The film received an Emmy, the American television award. "Thanks to the development of new types of images, we will be able to show much more, not only for the joy of seeing, but to help medicine; foetal surgery is the next step."

→ TIMELINE

1895: the German physicist Roentgen discovered X-rays. A major advance in diagnostics, for more than 50 years, X-rays were used to detect high-risk pregnancies. Eventually, it was realised that they harmed the foetus. Invented in 1958, ultrasound became widespread in the early 1970s. Enabling doctors to detect foetal abnormalities, it provided greater protection for mothers and babies. The magical aspect of these prenatal pictures altered people's perception of maternity: the baby became a person whose history began in the womb.

AS A CHILD, he collected insects; he was given his first microscope when he was 12. The son of Swedish farmers, Lennart Nilsson is, he says, "passionately interested in the mysteries of life". Sitting in his laboratory at the Carolinska Institute, Stockholm, he tells the story behind his most famous photo.
"I began my career photographing celebrities. Then I grew interested in things invisible to the human eye: marine life, anthills, and the incredible process of human fertilisation. In 1953, I took photos of human embryos kept in various Stockholm hospitals. In 1964, I managed to photograph an embryo in its mother's womb using an endoscope with a wide-angle lens and an electronic flash. The end result was mediocre; visibility was obscured by the amniotic sac. A year later, doctors phoned to say they had a sixteen-week extra-uterine pregnancy. When they opened up the mother's abdomen, the foetus was lying against the intestines. It was not viable, so they removed it and put it in a saline solution. I put the foetus in an amniotic sac and placed it in a special aquarium. I positioned four lights and took some twenty photos, varying the exposure so that I was sure to get the photo. It was first published in *Life*, which sold eight million copies in three days, and created a world wide sensation. I was very proud, because it was a first." ∎

"Foetal surgery is the next step"

LENNART NILSSON

and Professor Lars Hamberger

- - - - - - - - - - -

"The caption is what makes us laugh or cry."

"A taboo has been broken", declared *Paris Match* on 12 February 1966, in the introduction to the report on "the mysteries of life". It went on to explain that, before publishing Lennart Nilsson's photo, it had obtained the go-ahead from "religious authorities". Like *Life* and *Stern*, *Paris Match* failed to tell its readers that this was a dead foetus. "This was no accident," states Bettyan Kevles, author of a book on medical imagery. "This photo was published just as the women's liberation movement was calling for the right to contraception and abortions. Nilsson realised that, in the 20th century, we have become dependent on images and that what we feel is based on what we see. When people saw this 'living' foetus, which resembles an angel, they came to believe that children were individuals in their own right from the moment of conception. The image was used by anti-abortion groups to show that the foetus is a self-sufficient organism that scarcely needs its mother.

Why didn't the newspapers say this baby was dead? This picture proves that photos

Bettyan Kevles

don't speak for themselves. Our perception is conditioned by captions. If we are told this is a live baby, we are delighted; if we are told it's an aborted foetus, we feel sad. The caption is what makes us laugh or cry."

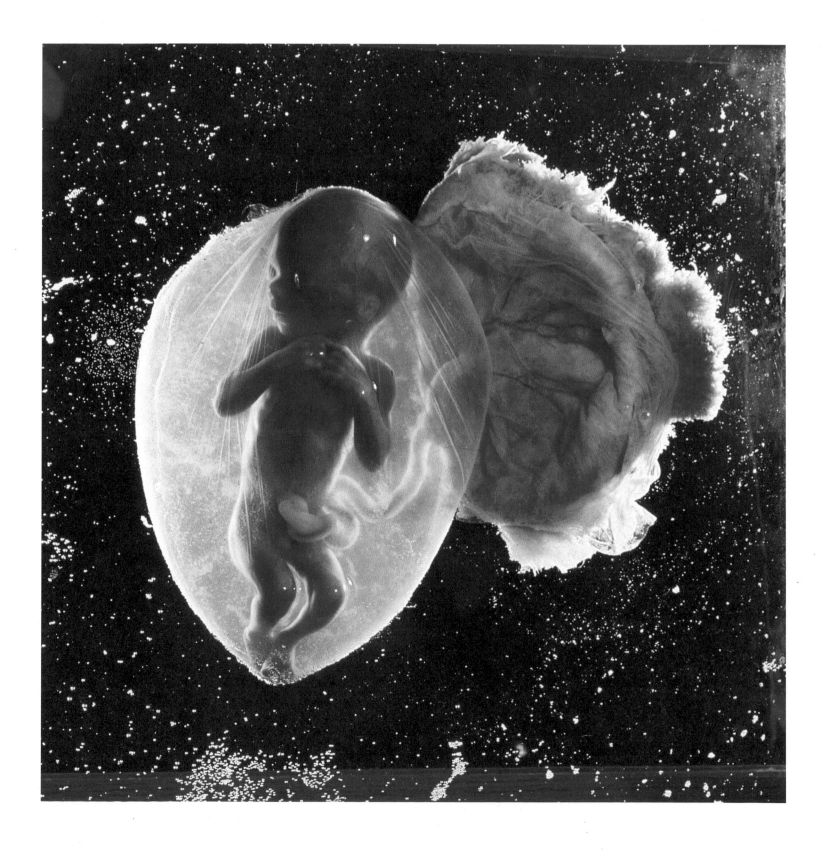

Figurehead

Mao Swims
© Quian Sije/*Xinhua*

QUIAN SIJE
"I was anxious not to miss this symbolic event."

→ TIMELINE

1965. Backed by students organised into Red Guards, Mao Zedong launched the 'Cultural Revolution' to combat 'revisionism and individualism'. Its target: 'conservatives' within the Communist Party and intellectuals. Millions of families were deported to the countryside, while Mao's personality cult was at its height. The result: at least two million dead. After a dramatic rapprochement with the United States, the dictator died in 1976 at the age of 83. His thirty years of power had claimed the lives of millions of victims.

IT WAS THE FOURTH TIME he had swum in the Yangtze River for the cameras. But that particular 16 July 1966 was a red-letter day in the Maoist annals. "That morning, the President was in a very good mood," says Quian Sije, one of Mao's four official photographers. "He was carrying out an inspection tour of Hunan province, which was organising its eleventh swimming competition. He announced that he wanted to swim." This was not lightly undertaken: the Yangtze, China's 'mother river' since time immemorial, was renowned for its dangerous currents. "It was very brave of him to jump into those tumultuous waters," says Quian Sije, "it proved that the President felt in fine physical form." Accompanied by some fifteen Red Guards, Mao boarded a motor launch. The rest of his cortege following in 'two wooden boats'." They headed for a place identified as 'safe' by his bodyguards, close to the vast Changjiang bridge. Crowds lined the riverbanks, on which red flags had been planted. The 'Great Helmsman', a tubby figure in elasticised trunks, climbed into the water from a ladder, while his bodyguards dragged the bottom. "The president swam for sixty-five minutes. I took at least two films using a 200 mm zoom. I was anxious not to miss this symbolic event. It would have been irremediable: I couldn't exactly ask the President to do it again…" ■

'National Bathing Day'

When Quian Sije's photograph appeared in the *People's Daily,* the caption called Mao "the blessing of the worldwide revolution". He was not, it said "afraid of heaven, or hell, or imperialism, or revisionism, or reactionaries...". "Distributed all over the world by the New China agency, the photo became the symbol of the Cultural Revolution. The Party's revisionists were being attacked, and it was important to show that Mao Zedong, despite his 73 years, was still able to govern," explains the Sinologist Jean-Philippe Béja. In fact, as his personal doctor noted in his memoirs, Mao could no longer swim: he merely used his enormous stomach to float. After the photo, 16 July became 'National Bathing Day': every year, people jump in all the rivers, lakes and seas in China. Throughout the country, swimming competitions are organised, particularly in the Yangtze. After Mao's death, the photo inspired Deng Xiaoping, who similarly had himself photographed swimming when he launched the 'Four Modernisations' programme."

Jean-Philippe Béja

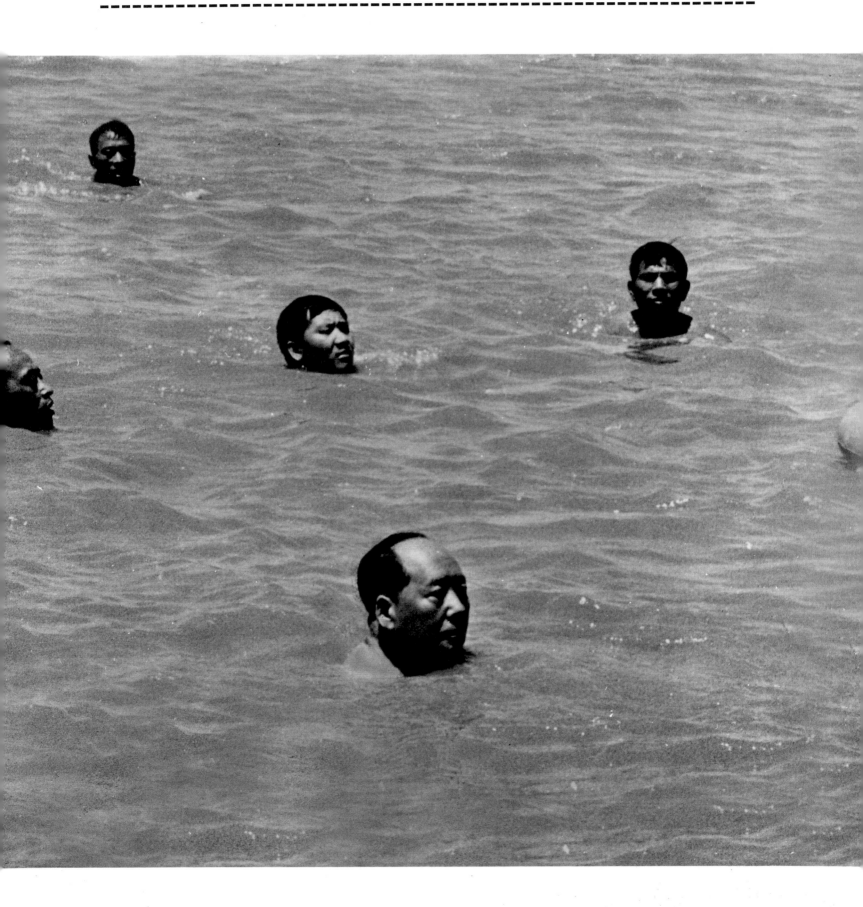

Hill 881
© Catherine Leroy

→ TIMELINE

1965. United States intervention in Vietnam reached new heights. Vietnam had been partitioned since 1954: communist Vietnam, led by Ho Chi Minh, in the north, and Diem's dictatorship, supported by the Americans, in the south. Since 1960, the Saigon regime had been at war with the National Liberation Front, whose support came from the north. In 1968, the American force numbered 580,000 soldiers. By February 1973, when the last GIs left Vietnam, the toll was heavy: 55,000 American dead and 300,000 wounded. The cost of the war: 150 billion dollars.

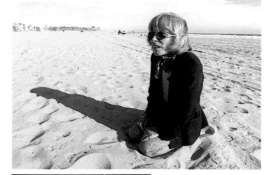

CATHERINE LEROY
"I was operating on adrenaline."

C ATHERINE LEROY had just turned 21 when she flew to Vietnam. "I wanted to be a photographer: you went there to make a name for yourself or confirm your reputation." She arrived at the office of the AP agency in Saigon, with a Leica and 100 dollars in her pocket. "I said I knew how to parachute jump and was immediately accredited." The young Frenchwoman earned a reputation as an inveterate daredevil: "I was operating on adrenaline. After each mission, AP paid me fifteen dollars a photo. I would collapse with exhaustion, happy just to have survived." That day, Catherine had accompanied a marine unit dropped by helicopter on Hill 881. Shells were falling all around. "It was hell on earth: there were dead and wounded soldiers everywhere." From the top of the hill, a Vietcong machine gun was raking the area. "I was flat on my stomach behind some branches, when I saw a marine fall. An orderly rushed over. I took four photos: on the first, the orderly leans over his friend, thinking he's still alive; then he listens for a heartbeat; finally he looks up at the sky in fury. Then he charges off up the hill, shouting: 'I'll kill them all!'" Shortly afterwards, Catherine was seriously wounded, but went on working in Vietnam until 1969. An acclaimed photographer, she was commissioned to cover the hippie festival at Woodstock: "I hung up my cameras for a couple of years…" ■

Death in Vietnam

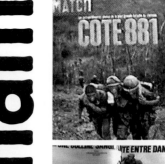

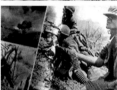

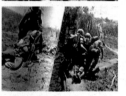

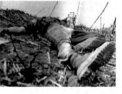

Never before had a war received so much media coverage: the American army, sure it was in the right, encouraged the press. There was no censorship. A press card was easy to obtain, ranked its holder as a captain, and provided access to the front. Result: seventy journalists were killed, mainly photographers.

"The most widely covered war of the century."

"I have a lot of pain, I don't answer the phone and I don't open the door" runs the note on the door of the cabin where he lives. "Only solitude brings me any peace," says Vernon Wike. At the age of 51, the Vietnam veteran took refuge in

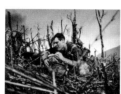

Vernon Wike

an Arizona forest. Catherine Leroy's four photos are pinned up on the wall opposite the armchair where he does macramé to soothe his nerves. "This was my first mission as an orderly and I could no nothing to save Rock's life. Since then, I've been haunted by that failure." The photos were widely published and aroused deep feelings. Thinking they recognised their sons, mothers wrote to AP, which asked Catherine to identify the dead man. And so Wike met the photographer. Wounded shortly afterwards, he was repatriated. He has never really recovered, and lives on a disability pension. As for Leroy, she travelled widely before giving up photojournalism. "She is more than a sister to me," says Vernon. "The photo has united us forever." Leroy agrees: "I photographed hundreds of soldiers but they were all anonymous heroes. You are a hero with a name."

"The photo has united us forever."

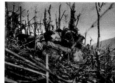

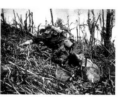

The dead soldier's name was Rock. He was 19, like orderly Vernon Wike.

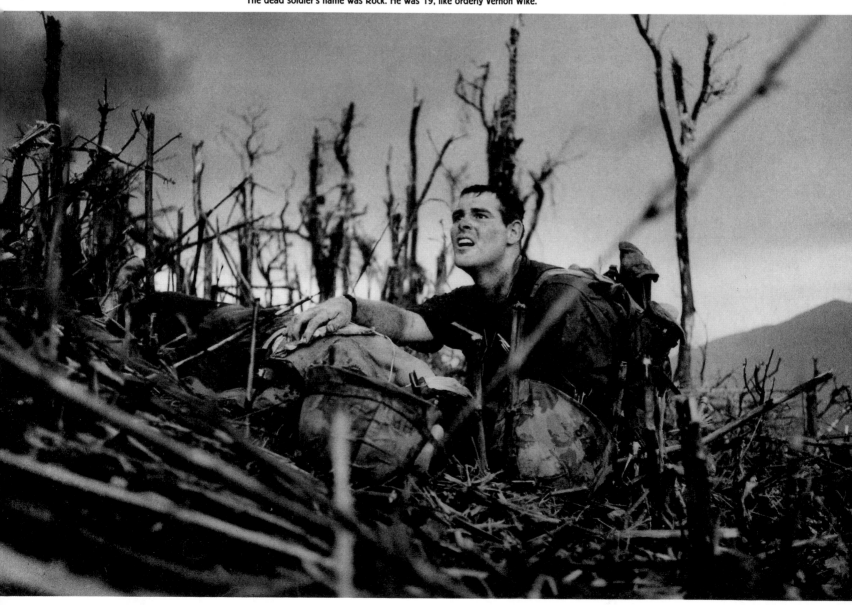

1967

Demonstration for Peace in Vietnam
© Marc Riboud/Magnum Photos

Jane Rose Kasmir: "For me, there was a before and an after."

Love and Peace

→ TIMELINE

"Bring back our GIs": 20 October 1967, a million demonstrators marched to Washington to protest against the Vietnam war, which had vitiated the youth of 525,000 Americans. That evening, demonstrators tried to enter the Pentagon, which was surrounded by the national guard. The final toll: one hundred injured. Never had a war been so unpopular.

APPROPRIATELY ENOUGH, her name was Jane Rose. She was 17 when she came to personify "flower power" contrasted with gun power. "That photo was the Gordian knot of my life," she says, "there was definitely a before and an after." 'Before' was the 60s, when this U. S. baby-boomer wanted to "change the world." Her heroes were Martin Luther King and Gandhi, her war cry was rock and roll, and her cause was Vietnam. When the "Washington demo" came up, she put on her party clothes. "Someone offered me a chrysanthemum. I took it." 'After' was steady disillusionment. The hippie movement ended, she took drugs, suffered a gang rape. She dropped out. Rescue came in the form of a daughter, Lisa Ann. What remained of 'Before' was the photo, which she found "eight years later" in a Magnum book her father had brought back from Scotland. "I wept when saw it." In 1992, she wrote to Marc Riboud: "When I was young, I thought I could change the world big time. Now I just try to share the love I have inside with my family." ∎

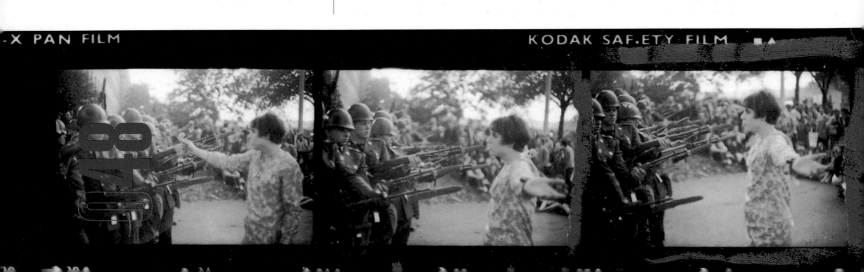

-X PAN FILM KODAK SAF.ETY FILM

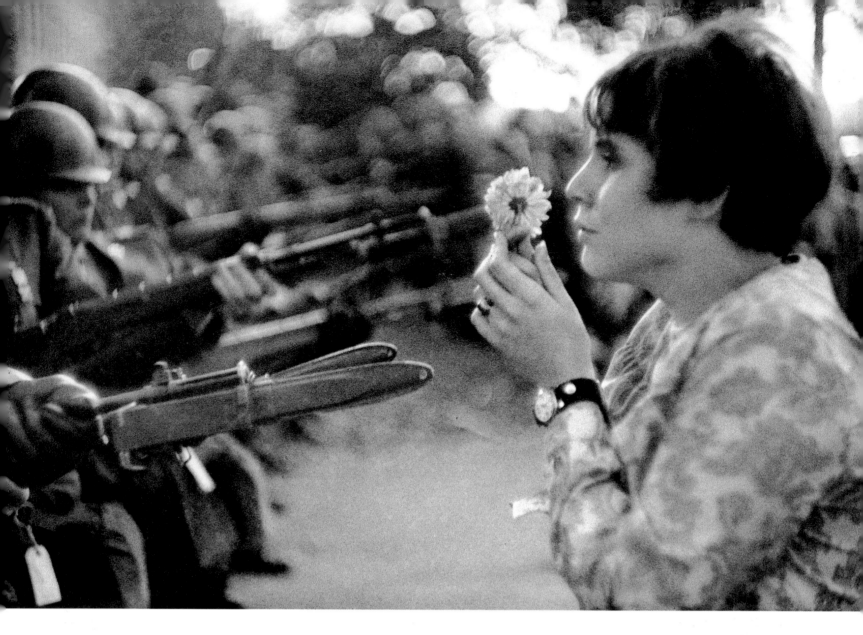

It was, he says, a "state of grace". A photographer with Magnum, Marc Riboud was reluctant to go to Washington; his wife was about to give birth. By nightfall, he had used up film after film, and he "still didn't have a picture." Just as he was leaving for the airport, out of the blue, the scene occurred. "In my viewfinder, I saw the emblem of that magnificent day!" And thanks to "The girl with the flower", he was able to take the last portrait of Ho Chi Minh, one year later. It was quite a scoop: "When Pham Vaon Dong, the North-Vietnamese Prime Minister, found out I had taken that photo, he arranged everything for me. Sometimes a photo can be a passport." And a landmark: his son Alexis was born just as Riboud was taking his most famous shot.

MARC RIBOUD

"In my viewfinder, I saw the emblem of that magnificent day."

- -

"I didn't intend to be provocative," she says, "I just wanted to talk to them about love." Her eyes fixed on the soldiers, who looked away, the young woman gently put her hands together as if in prayer. This photo, the last on the film, will symbolise non-violence forever.

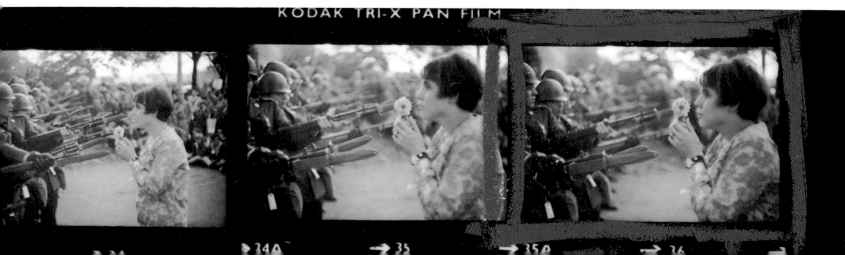

KODAK TRI-X PAN FILM

Martin Luther King Assassinated

JOSEPH LOUW
"It was as if I were firing a weapon, retaliating."

I Have a Dream

→ TIMELINE

"I have a dream..." said Martin Luther King, black pastor and champion of non-violence, who fought for the abolition of racial segregation in the United States. King, charismatic leader of the movement for civic equality, was assassinated on 4 April 1968. Violent rioting immediately broke out in the major American cities. A white extreme right-wing militant confessed to the crime and was sentenced to ninety-nine years in jail after a lightning trial. One week later, President Johnson passed the first law against racial segregation.

THERE WAS ONLY ONE SHOT, a sharp, dry sound that startled Joseph Louw. He was standing on the balcony of the Lorraine Hotel in Memphis: "I saw Martin Luther King collapse; his body was thrown backwards. I saw him fall as if in slow motion and I was afraid he would hit his head against the corner of the balcony. Then his aides rushed to his side and one of them, Andrew Young, sobbed: 'He's gone'." The South-African journalist dashed into his room, seized his Nikon and began frantically shooting. "It was as if I were firing a weapon, retaliating. I was in a state of shock, only anger kept me going. I wanted to record everything, the panic, the tears, the position of the five people on the balcony, their fingers pointing in the direction of the shot. I wanted to bear witness for history, so that the whole world knew what had happened." Louw was making a documentary about Martin Luther King; he was the only journalist at the scene. That evening, his photos were selling like gold dust, while the black townships were going up in flames. "I was accused of stirring people up with my photos, but a barbaric act like that was bound to provoke anger. It didn't even occur to me to do a close up of face, which was torn apart by the bullet. Even when he was dead, you couldn't treat him disrespectfully and behave like a paparazzo." ■

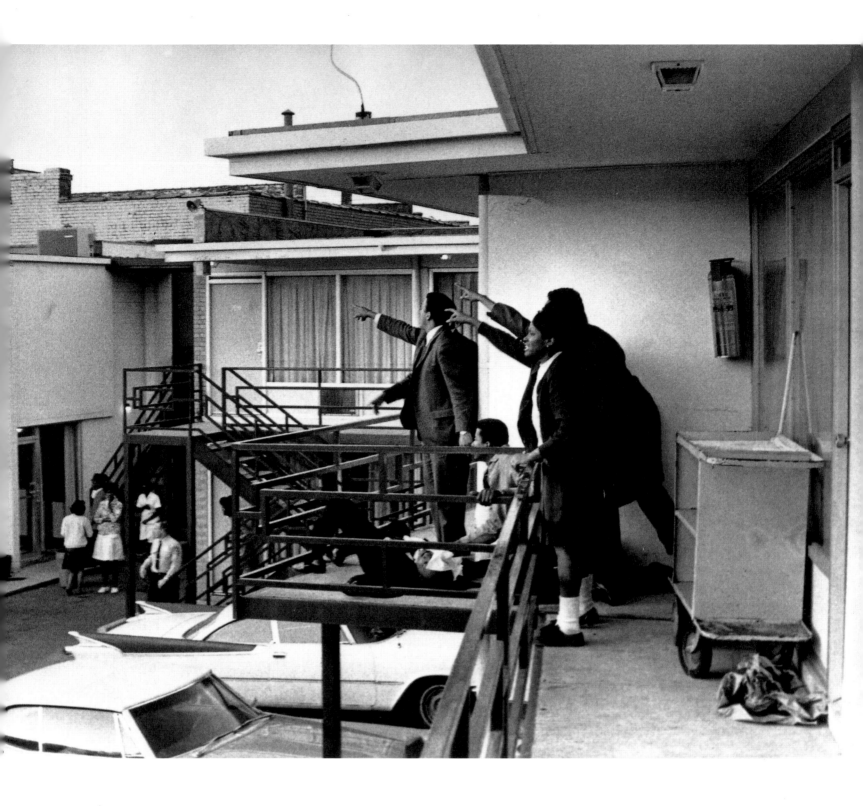

He called him Doc; he was Martin Luther King's right-hand man. In the photo, he is in the group around King, pointing in the direction of the shot. After becoming US Ambassador to the United Nations, Andrew Young was elected Mayor of Atlanta, King's native city. Seizing the photo, he points to a young black man, kneeling behind Martin Luther King's body: "To this day, we don't know who he was and how he came to be on the balcony. Some people say he was a U. S. secret service agent. Which is why we still believe that James Earl Ray was not the brains behind the crime and that it was a much larger conspiracy. As far as America is concerned, the case is closed, but Martin Luther King's family and friends feel differently."

Andrew Young

"For us, this case is not closed."

May '68
© Gilles Caron/Contact Press Images

Daniel Cohn-Bendit: "This picture imprinted me on the collective imagination."

→ TIMELINE

3 May 1968: the 'fanatics' of Nanterre University occupied the Sorbonne: May '68 had begun. The baby-boomers ripped up cobblestones for barricades, found sand beneath, and cried 'under the cobbles, the beach'. Barricades, demos, a general strike: by mid-May, the authorities were paralysed and France at a standstill. After five mad weeks, reality prevailed. Fervour declined into factionalism and extremism. General de Gaulle was returned with a crushing majority, on a wave of popular support. But things would never be the same again.

JACKET OPEN OVER a check shirt, Daniel Cohn-Bendit marched along singing the *Internationale*. With a faint smile on his lips, he came up to a group of *gardes mobiles* waiting in front of the Sorbonne. French television pictures also show a young photographer, walking backwards, never letting Cohn-Bendit out of his sight. On 6 May 1968, 'Dany the Red' had been summoned before the disciplinary council of the Sorbonne, along with six other students. Expecting trouble, the police sealed off the quarter with 1,500 men. The young redhead found himself face to face with a helmeted policeman. Gilles Caron found room to circle the two protagonists, who were staring each other down. "The funny thing was," says Cohn-Bendit, "the cops wouldn't let us in. I told the policeman: it's your job to let us in, not keep us out! He didn't say a word!" With a cheeky grin, the student mockingly outfaced the policeman. Click! Gilles Caron's photo symbolises the insolence of a movement that nearly toppled the Fifth Republic. "I'm deeply indebted to Caron," says the modern Till Eulenspiegel, "thanks to him, I'm imprinted on the collective imagination". ∎

The Merry Month of May

GILLES CARON

Co-founder of the Gamma agency, Gilles Caron had just returned from Biafra, where he was covering the famine. He threw himself heart and soul into the student rebellion. His photos memorialise May '68. One emblematic photo shows a riot policeman pursuing a student, truncheon in hand – also on the night of 6 May. Another celebrated shot shows a black flag in a deserted street just after dawn. "He was passionate," recalls his wife Marianne, "first and foremost about people, then about photography". His passion led him to Cambodia in 1970. On 4 April, he was killed in the Phnom Penh area, shortly before his thirty-first birthday.

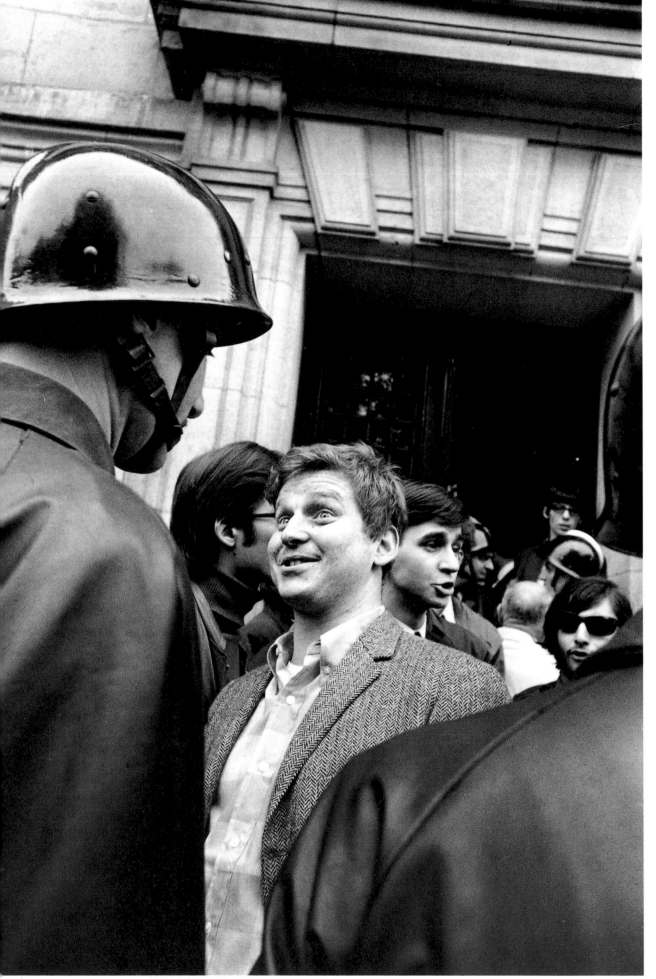

"The most reasonable of fanatics"

Maurice Grimaud, Paris Police Chief in May '68.

It proved impossible to locate that implacable policeman. "I never knew who he was," says Maurice Grimaud, who was in charge of the Paris police at the time. "It's a shame because he appears on a historic document: this photo is worth six theses about May '68. It shows the true spirit of the movement: how young its protagonists were and how hungry for dialogue." A remarkable man, this police chief, who, at the head of 25,000 policemen, kept his head while the unrest in Paris was at its height. Today, when he talks about Cohn-Bendit, he calls him 'Dany' and confirms that he was "the most reasonable of fanatics". "Because of this photo," he says, smiling, "his face has gone down in history."

WHAT HAS BECOME OF OUR EXEMPLARY CHILDREN?

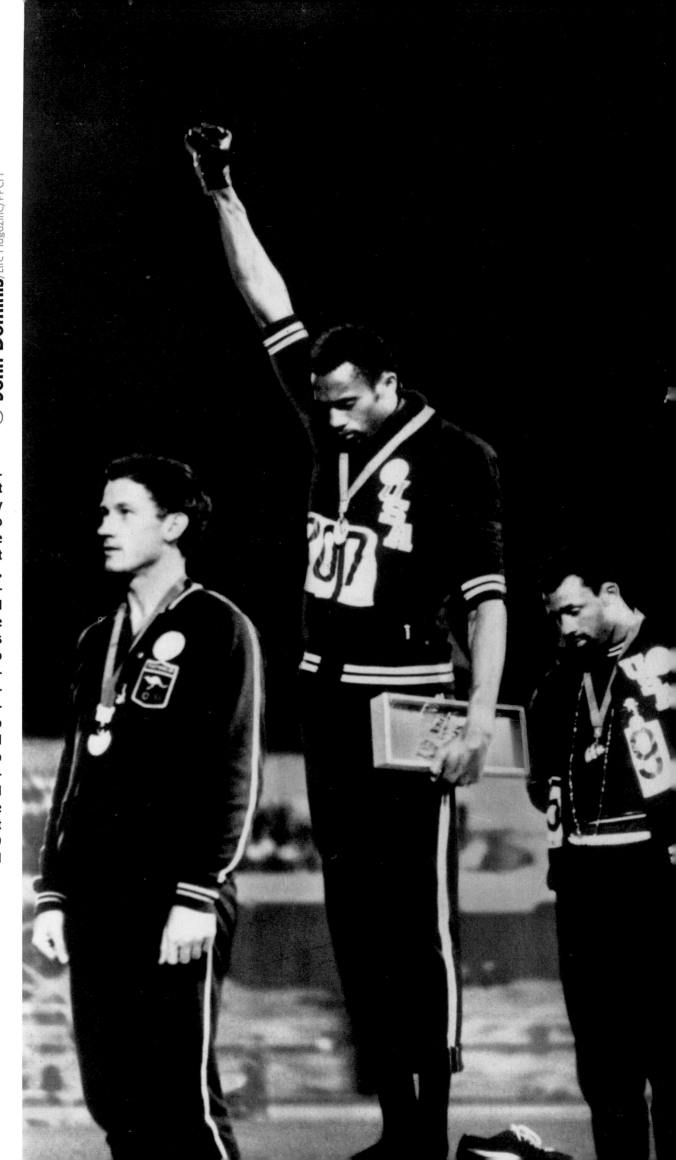

Clenched Fists in Mexico

© **John Dominis**/Life Magazine/PPCM

→ TIMELINE

27 October 1968. Black America's fight for civic equality marked the Mexico Olympics. Tommie Smith, gold medallist in the 200 metres, and John Carlos, silver medallist, raised gloved fists to the American flag. This political gesture also symbolised the triumph of black athletes at the Olympics. American Bob Beamon pulverised the world long jump record, Africans dominated the long- and middle-distance races, while the eight finalists in the 100 metres were all black.

Podium

"That gesture ruined my life."

"I was a hero and I became a pariah." Tommie Smith describes his *via dolorosa*: expulsion from the Olympic village, death threats, promises of employment that vanished into thin air, marginalisation and loneliness. His wife sued for divorce; John Carlos' wife committed suicide. One of the greatest athletes of the century – the holder of eleven world records – was reduced to "washing cars for three dollars an hour". Finally, a Californian college hired him as a coach. "Today, future athletes come into my office and see the photo: 'Is that you, sir?' they ask. Then I explain the whys and wherefores of that gesture, which ruined my life but helped to build my country."

-- -- -- -- -- --

JOHN DOMINIS

John Dominis was working for *Life* when he took his most famous photo. "At the time, I didn't understand the historical aspect of the gesture at all. Like all Americans, I thought that blacks who protested were just agitators. Now I realise how brave it was."

-- -- -- -- -- --

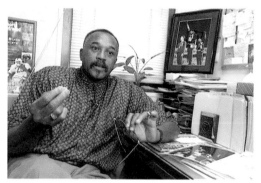

Tommie Smith: "Everything had been thought out and calculated."

TOMMIE SMITH talks about himself in the third person, as if to stress that the gold medal-winner at Mexico was someone else. His words tumble over themselves as he tries to describe the gesture of his life. "With aching muscles and a heavy heart, he climbed the finest podium any athlete could dream of. For two years, he had given his all for this. He wanted integration, but all America saw was a 'negro' whom they could start despising again as soon as he pocketed the medal. His gesture would show the world the love he felt for his people. It would show black America's determination to make Martin Luther King's murdered dream a reality. Everything had been thought out and calculated. His wife, Denise, bought the black gloves, symbols of black solidarity. The scarf around his neck represented the lynching of blacks in the South; his bare feet, the poverty of the black American community; in his hand, as a sign of peace, he held the olive branch he had been given with the gold medal. The cameras were filming him as he turned to face the Stars and Stripes. It was a historic moment that would, he was sure, change the future. As the American national anthem began to play, he bowed his head and raised his clenched fist to the sky." ∎

The End of the Prague Spring

© Ladislav Bielik/Agentura Oko

→ TIMELINE

21 August 1968. Soviet tanks invaded Czechoslovakia. Liberalisation of the press, political democratisation: socialism with a human face was the demand of the country, guided by Communist Party Secretary, Alexander Dubček. Crowds of young people confronted the Warsaw Pact soldiers, haranguing them about socialism and pacifism. Riots broke out. Soviet-enforced 'normalisation' followed. Censorship was restored, and Husák, a Kremlin hardliner, replaced Dubček. The Prague Spring was buried and forgotten for twenty years.

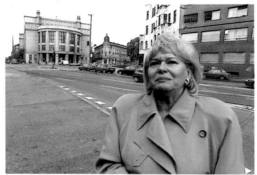

Alicia Bielikova: "Shoot! cried the man, hurling abuse at the Russian soldiers."

Appropriation

WE SEE THEM IN A PHOTO as happy lovebirds, perched on the steps of a bus, the young bride leaning towards her laughing husband. It was 17 August 1968, three days before the Soviet invasion of Czechoslovakia. "Don't be afraid," joked Ladislav, "the Warsaw Pact is celebrating our wedding with a grand parade of tanks!" She will never forget that morning, says Alicia. There are tears in her voice: "We couldn't believe it, it was like a bad dream." In Bratislava and Prague, the streets were teeming: some were weeping, others shouting, while groups of young men shouted at the soldiers sitting bewildered on the tanks. Paving stones flew. A photographer on the paper *Smena*, where Alicia worked as a journalist, Ladislav Bielik had taken film after film all morning. Around midday, near the Philosophy Faculty, he saw "a young man in overalls standing in front of a T-55 tank. Suddenly, he bared his chest to the tank crew: shoot! he cried, hurling abuse at them. At that moment, a group of young people came down Stefanikova Street, chanting the national anthem. The Russians could do nothing about it." The man's name was Emil Gallo. A municipal plumber in Bratislava, he committed suicide three years later, leaving four children orphaned. ∎

"This photo was our undoing," says Alicia Bielikova, flanked by her two sons. "Nothing was ever the same afterwards." On the afternoon of 21 August, the Russians banned *Smena* and occupied its premises. Journalists and photographers took to an apartment to produce a clandestine edition. The photo by Ladislav Bielik was on the front page. "The regime never forgave him. After 'normalisation', my husband was dismissed; to survive, he became a school photographer. Later, he specialised in motor racing. He was killed in an accident at a race in Budapest." In 1989, the 'Velvet Revolution' drove the Communists from power, and Slovakian television showed the illegal edition of *Smena*. "They contacted me for a print of the photo. But I didn't have one. In fact, I thought Ladislav had destroyed the negatives to protect himself. But when I searched the cellar, there it was. It now graces a monumental wall in Bratislava."

LADISLAV BIELIK

"This photo was our undoing."

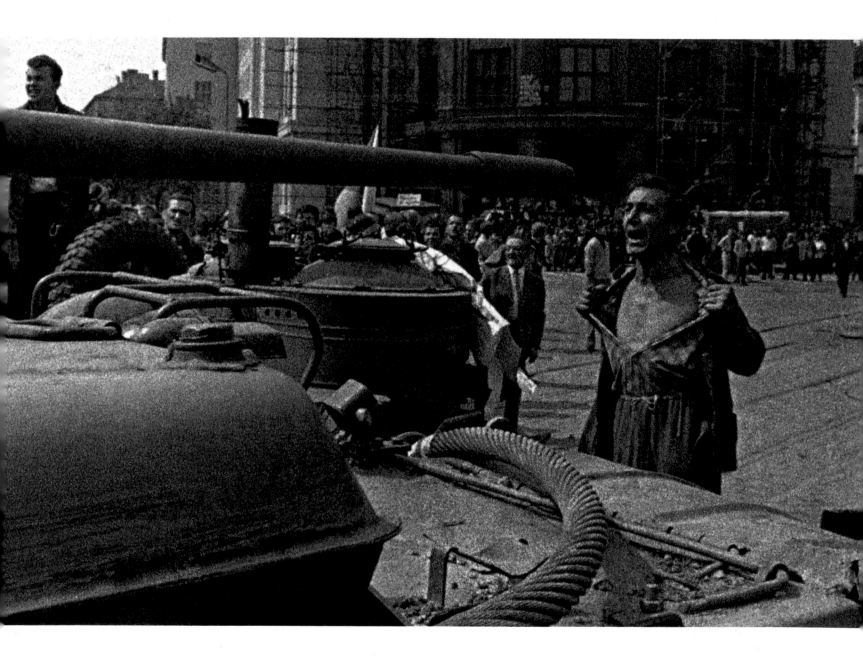

"I received the royalties."

Ladislav Bielik's photo has been published all over the world. But his name never appeared. It was credited to 'Peter Stephan Lutz' by the German press agency DPA. A philosophy student at Munich University, Lutz was visiting his Slovakian fiancée when the Russians invaded. Thirty years later, the businessman is "no longer sure" how he came by the photo. "I arrived in Bratislava on 21 August, around 16.00. Through a third person who knew I was interested in photography, a stranger gave me a roll of negatives with a visiting card. The encounter took place in the street; given the circumstances, everything happened very quickly, and I never saw the photographer again. Mr Bielik must have made several duplicates, which he deposited in safe places. In Munich, I gave the photos to the DPA agency. There were six or seven interesting pictures, but this was the most striking. I received the royalties, but Bielik's name was given to the agency, the World Press Photo foundation and at the Vatican when an exhibition was held there."

Peter Stephan Lutz

De Gaulle

© Jean-Pierre Bonnotte/Gamma

Retirement

JEAN-PIERRE BONNOTTE

"I took a photo that was so perfectly centred that I was afraid I'd taken his head off."

→ TIMELINE

28 April 1969: accepting the verdict of the referendum in which 53% of French citizens voted against him, General de Gaulle resigned. On 10 May, he flew to Ireland with his wife Yvonne. This was a private trip to the country of his maternal forbears, far from the presidential campaign won by Georges Pompidou. From his appeal to the French of 18 June 1940, which earned him a place in history, to his death on 12 November 1970, General de Gaulle was one of the most often photographed men of the century. But the photo that captured him best was taken in Ireland.

"I WAS IN THE MIDDLE OF MY LUNCH when I saw Bernard Charlet, from *France-Soir*, leap up, flash in hand. I thought to myself: car coming out!" "Get a tip-off?" I asked. "Yeah, the old boy's coming out in ten minutes." And so Bonnotte dropped everything. Working for Gamma, he had spent twenty-four hours trying to get into the manor house where De Gaulle was staying. Deep in a "petrified forest" on the Connemara coast, the house was cordoned off by security personnel. "I hired a boat, I slept in bogs: nothing doing!" The General's large black Humber shot out of the gates. "The buffer vehicle was about to lose us, when I saw the BBC's estate car flashing its lights at us. I thought: locals! They know the area!" Bonnotte "tucked in behind the British", who turned down a steep track leading to a vast stretch of moorland. Suddenly, the miracle: "Policemen everywhere, then three small silhouettes walking along the beach: the General, his wife Yvonne, and his aide Flohic!" Bonnotte lay flat, and was shooting with his 300 mm lens when De Gaulle started to climb the hill straight towards him. "I took a photo so perfectly centred I was afraid I'd taken his head off! I've never felt so excited in my life: I had the General all to myself!" ■

They all dreamed of it: a single photograph of General de Gaulle in his country retreat of La Boisserie. No one had succeeded, not even Henri Cartier-Bresson. But the trip was worth it: "Whatever the photograph, it was bound to be published," says Jean-Pierre Bonnotte. "So I regularly made the short trip to attend mass at Colombey-les-deux-Eglises, then kept watch in a small thicket, opposite La Boisserie." At 12.55 sharp, five minutes before the news on ORTF, Bonnotte saw the General walking along the walled garden of his house. "Nine seconds, four pictures a second, I had my film. But the best photo was the one that just came to me, in Ireland."

"Whatever the photograph, it was bound to be published."

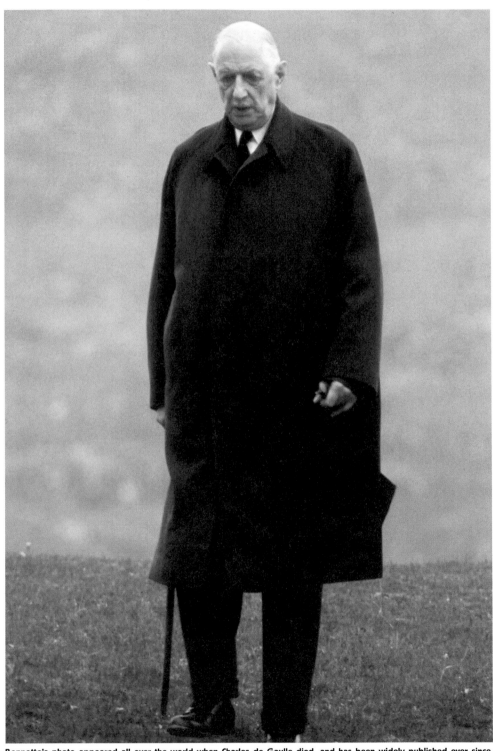

Bonnotte's photo appeared all over the world when Charles de Gaulle died, and has been widely published ever since. "It's the perfect expression of the great dramas that made up his life," says Alain Peyrefitte, who several times served as minister under De Gaulle. "It captures the rebellious, solitary man who didn't hold onto power for power's sake, who savoured independence and leisure."

Biafra
© Don McCullin/Contact Press Images

DON MCCULLIN

"This little Biafran boy appeals to our consciences to end barbarism."

→ TIMELINE

30 May 1967: the eastern province of Nigeria, with its fourteen million inhabitants, seceded. The predominantly Ibo 'Republic of Biafra' was proclaimed. The Nigerian army immediately invaded the region. To end the rebellion, the government imposed a blockade that caused one of the worst famines of the 20th century. Two million Biafrans died of starvation in refugee camps. The genocide ended in January 1970 with the capitulation of the Biafran army.

DON MCCULLIN, 63, has a penetrating gaze and a sorrowful voice. He lives in the depths of Somerset. "I try to go on living amid the ghosts who haunt me, like this little Biafran boy, whose eyes obsess me." Brought up in the London suburbs, he became a war photographer when his brother Michael opted for the French Foreign Legion. "I was looking for adventure and I wanted to show I could keep fear at bay." An inveterate daredevil, he sought out images in the midst of shell fire and rockets: Cyprus (World Press Photo award, 1964), Israel, Pakistan, followed by the Vietnam war, where he took senseless risks. Today, he admits there was something suicidal about that overwhelming passion. "I lived on adrenaline rushes, taking real pleasure in extreme situations." Until his experience in Biafra, which "was a turning point" in his life. "After that photo," he says, "I became politically involved: my sole purpose was to reveal injustice and suffering." Cambodia, the Lebanon, El Salvador, despite injuries and death threats, he continued to cover wars, attempting to take photographs "looking through the eyes of that little Biafran boy, who was appealing to our consciences to end barbarism." These remarkable photos, in the words of John Le Carré, "haul you out of your armchair". One such is the Lebanese woman howling with grief after losing her entire family to shelling. That was Don McCullin's last war photo. He turned his hand to landscape photography to "cleanse himself". "And even then," he murmurs, "people tell me my landscapes look like battle fields." ∎

Bernard Kouchner, founder of Médecins Sans Frontières.

This photo caused an international outcry and hastened the end of the war. In Paris, it stunned Bernard Kouchner, who founded Médecins Sans Frontières, bringing a new concept to the fore: humanitarian intervention. "This photo," observes Kouchner, "marked the start of a collaboration between press and medics, without which humanitarian efforts are doomed to fail."

"Intervention is a duty."

He was nine and – ultimate ignominy in Africa – albino. Working for the *Sunday Times Magazine*, Don McCullin met him in an International Red Cross camp where eight hundred young war orphans were dying of starvation.

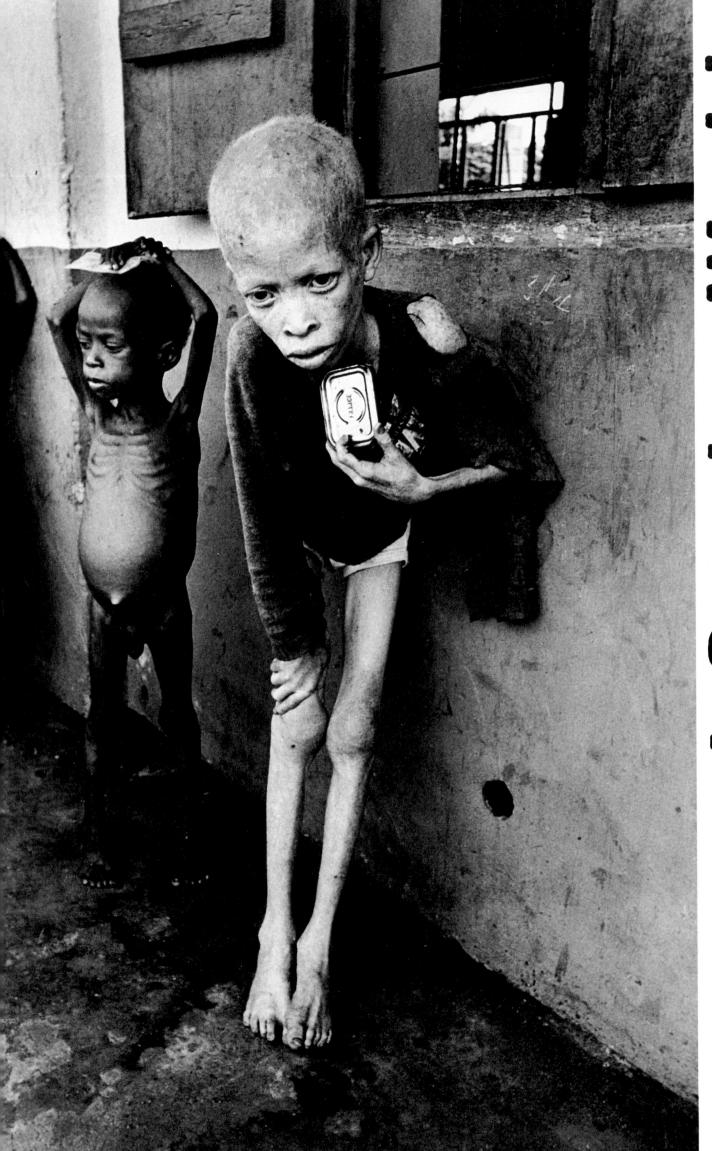

A Starving World

Man Sets Foot on the Moon

1969

© Neil Armstrong/Nasa

→ TIMELINE

21 July 1969, at 03.56 (British Summer Time), Neil Armstrong, Commander of the Apollo 11 mission, set foot on the moon: "That's one small step for a man, one giant leap for mankind!" exclaimed Armstrong. He was followed by 'Buzz' Aldrin, the pilot of the lunar module. The astronauts spent two and a half hours setting up scientific instruments, collecting rock samples and taking photos. The United States had a triumph to match Soviet Union's achievement in putting the first man into orbit. A Cold War victory of sorts ...

BUZZ ALDRIN

"Proof that it wasn't a dream."

A JOURNEY TO THE MOON has consequences. The space adventurers are not unscathed. Neil Armstrong could not be contacted; Buzz Aldrin suffered severe depression before "recovering his will to live". "I dismounted from the capsule nineteen minutes after Neil and I brought down the camera on a pulley. While we were walking around the lunar module, I took a photo of my bootprint on the moon's surface. Then Neil Armstrong took my photo next to the Stars and Stripes flag. Everything happened very quickly, we were very unsteady on our feet. The other problem was keeping the flagpole planted in the ground, which was covered with a fine layer of volatile dust. We crumpled the flag so that it seemed to be fluttering in a breeze, although of course there is no air on the moon! We wanted this photo to be a homage to our nation's supremacy in front of the hundreds of millions watching us live. Thirty years later, you ask if the photo is a true reflection of what I experienced. That would mean digging deep in my memory to recall what I really saw, and without the photos, I just couldn't do it. They are the only tangible proof I have that it wasn't a dream." ∎

Destination: Moon

Jim Ragan was one of the engineers who spent two years perfecting the camera used by the two astronauts. "We modified a Hasselblad, a Swedish make, in line with NASA's specifications: we had to take account of the zero-gravity environment and climatic fluctuations. We built up all the control buttons, because the astronauts would be wearing extremely thick gloves. It was an automatic camera that they attached to their space suit; all they had to do to take a photo was face in the right direction and press the release. One of our major concerns was to keep moon dust, about which we knew nothing, off the lens and film. We designed a special brush, and it worked well. Ironically, they had to leave the camera on the moon. The samples took priority, and there wasn't much room in the module. The magazine was all that came back!"

Jim Ragan

"The camera stayed on the moon."

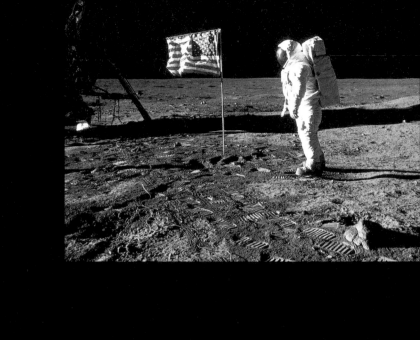

The Survivors of the Century
© Jean-Pierre Laffont/Sygma

→ **TIMELINE**

13 October 1971. A plane carrying forty-five Uruguayan students crashed on the Chilean side of the Andes. Seventeen passengers were killed on the spot. Seventy-one days later, Roberto Canesa and Nando Parado managed to alert the emergency services. Only sixteen survivors were left. The 'Miracle of the Andes' stunned the world. But then the survivors confessed the unthinkable: they had eaten the bodies of their dead companions to survive. Their conduct gave rise to bitter controversy and a spate of books and films.

Roberto Canesa: "Even when things are going badly, you can always stop and smile for the camera."

"WE ARE A TRIBE, closer than brothers, closer than lovers ..." A man with a frank gaze and eloquent turn of phrase, Dr Roberto Canesa is the spokesman for the 'sixteen survivors of the century', or more maliciously 'the cannibals of the Andes'. Quietly, he talked about their distress at cutting up the corpses, the tears that flowed when they could not bring themselves to swallow, and their determination to survive come what might: "For our mothers, for our fiancées, we didn't have the right to let ourselves die". This was the thirtieth day of their ordeal. The photo shows the shadow of Vicentín, an amateur photographer who spent his time experimenting with his friends' cameras. On the left, Fernando is wearing plastic bags inside his rugby boots to keep out the snow. In profile, Roberto Canesa. On his right, Jorge, trying to connect up the wires of the radio. "At the time, we'd lost some twenty kilos. But it was a good moment: the sun was warm, and we were full of energy. We didn't know if we would survive this photo, but for us it represented the future. When it was published, the world realised what we had been through. That was very important in view of the way we were attacked. If you are in despair, this photo reminds you: never give in. Even when things are going badly, you can always stop and smile for the camera." ∎

Survival

A photographer with the Sygma agency, Jean-Pierre Laffont arrived in Santiago, Chile, the day after the survivors had been reunited with their families. He decided to take a twin-engined plane to view the wreck; ironically, caught in severe turbulence, the pilot was forced to make a crash landing on a motorway. "We thought we were goners," he recalls. "But, in the end, I was very lucky: without realising it, we had landed a few metres from the field hospital where the survivors had been taken!" There he struck up a friendship with Nando Parado, who gave him the four films taken by Vicentín. Four precious rolls, three of which proved to be blank; the cameras had frozen. The fourth, processed at Sygma, contained six photos, which were immediately printed in *Paris Match*, *Stern*, *Life* and many international newspapers. It was a great scoop for the agency. "These were amateur photos," notes Jean-Pierre Laffont, "but they were valuable documents. In our profession, we frequently use photos taken by other people, because, logically, we always arrive after disasters have happened, in other words, too late."

Jean-Pierre Laffont

"These amateur photos are valuable documents."
- - - - - - - - - -

Massacre in Dhaka

© Christian Simonpietri/Sygma

CHRISTIAN SIMONPIETRI
"The hardest thing of all is not to intervene."

→ TIMELINE

December 1970: the Indian army invaded East Pakistan to support the Bengali rebels, who were demanding independence from Pakistan. In March 1971, the provisional government of the Republic of Bangladesh took refuge in India, while thousands of Bengalis were killed by the Pakistani army. On 14 December, Dhaka, the capital of East Pakistan, was seized by Indian parachutists. Bangladesh was born. The victorious Bangladeshis then took their revenge on the 'Razakars' who had collaborated with Pakistan. The purge was pitiless.

"WHEN I SEE THIS PHOTO again, twenty-six years later, I can still hear the screams of pain, the spectators' laughter and the cries of excitement: everything the photo doesn't show and that I have tried to forget." Christian Simonpietri was a photographer with Gamma when he arrived in Pakistan in November 1971. After the liberation of Dhaka, the Bengalis were celebrating their victory at a stadium in the east of the city. "Long Live Bengal!" shouted the jubilant crowd, showering the Indian parachutists with jasmine, then started to pray. General Abdel Khader Siddik, the 'Tiger of Tangai', was presiding over the celebrations from the grandstand, wearing a splendid Tyrolese hat. When the parade was over, Christian Simonpietri noticed "five men, sitting on the grass, their hands tied behind their back. The General stepped down from the grandstand and, with several soldiers, began to beat them. They proceeded to torture them to death with fixed bayonets. It was horrible; mass hysteria. The crowd formed a circle and was pushing, we had to fight to keep our distance from the slaughter. In the face of atrocities like this, you take refuge behind the camera. You're no longer in the field of vision, you're no longer even alive, you look with one eye, you keep the other tightly closed." ∎

Dilemma

Should he take the photo or not ... You have to take it, says Christian Simonpietri; the journalist's role is to bear witness. "The hardest thing of all is to stay put and remain as passive as possible. That's what's so terrible: you can't intervene. You can't stop a massacre, or a war. This conflict between your duty to bear witness and your inability to help people in distress is harrowing. Every time you take dangerous shots, you leave a piece of yourself behind, you get drained ..." After ten years of photojournalism, "memory overloaded and head messed up", Christian Simonpietri turned to show business: shooting films, photographing stars, "because I'm the one setting the scene for the photo; not this General."

"We are there to bear witness."

057

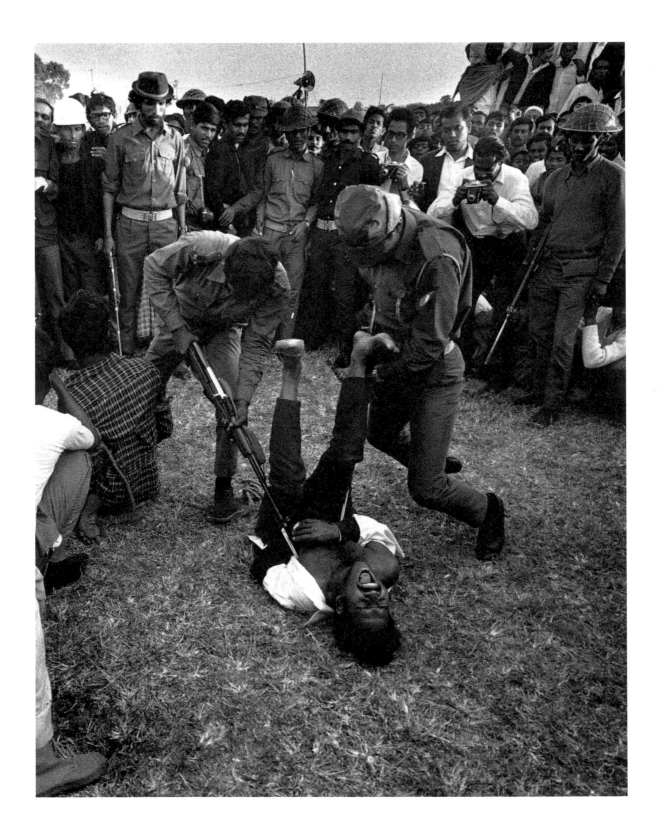

Marc Riboud, from Magnum, was the only one of the five photographers at the Dhaka racetrack who did not photograph the executions. "Photographers work largely by instinct, but I think disgust comes into it too. I was physically unable to stomach it. It wasn't a moral or ethical reflex that stopped me, it was the sight of blood spurting from eyes of the tortured men. I also think that torturers are often excited by the presence of cameras, which is why, if I had my time again, I still wouldn't take that photo. It's also true that, because of this photo, Indira Gandhi put a stop to the atrocities, as she told me some time later. That's the ambiguity of these extreme situations."

MARC RIBOUD

"I still wouldn't take that photo."

War in Northern Ireland
© Christine Spengler

→ TIMELINE

31 January 1972: 'Bloody Sunday' in Northern Ireland. Fourteen civilians were killed by British soldiers during a demonstration in Londonderry. Irish Republican Army (IRA) attacks escalated while repression intensified. Ireland, acquired by the British crown in the 17th century, had been partitioned since 1921: in the south, the (Catholic) Republic of Ireland, and in the north, Ulster, dependent on the United Kingdom and largely Protestant. The Northern-Irish Catholics, regarded as second-class citizens, have waged the longest war for independence in history.

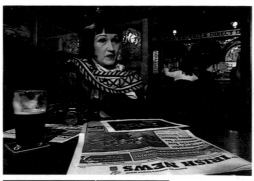

CHRISTINE SPENGLER

"It's so moving to meet people you photographed thirty years ago."

T HE STREET that cuts through the heart of Bogside, Londonderry's Catholic neighbourhood, remains unchanged. The group of friends solemnly advances, their eyes fixed on a horizon of blue slates.
"How wonderful!" murmurs Christine Spengler, her voice choked with tears.
"I recognise the one who stuck his tongue out at me!" His name is Paul McGinley and he is met with hugs and laughter.
– "It was six months after 'Bloody Sunday'. There was rioting all over Northern Ireland. Shortly before this photo was taken, the British soldiers had come into our street to drench us with water cannons."
– "They wanted to put out our fire and destroy our barricades," says Jim.
– "Several weeks earlier, my brother had been killed by British soldiers," says Vincent. "He was 15 and it happened at a football match. I hated them and I never missed a chance to throw stones at them."
– "We all had stones," says Dorothy, "like my brother in the photo: he died just two years ago."
– "We were children," says Seamus, "but we wanted the British to leave: we still do."
– "I remember exactly when the photo was taken," says J. J. Doherty, "but I don't remember you. At the time, there were photographers all over Derry."
And Christine Spengler, Nikon in hand, tells them "After the clashes with the soldiers, I decided to stay in Bogside for a while: that's when I met you, but you didn't want to be photographed. That's why Paul stuck his tongue out at me!" ■

Heartbreak

She has jet-black hair and red lips, and says she was born the day she took her first photo. It was in 1970, in Tchad, when Christine Spengler and her young brother Eric were captured by Tubu guerrillas. "When I saw these bare-foot fighters shooting at French helicopters, I said to him, lend me your Nikon! And I decided I'd be a war reporter to defend just causes and the oppressed. When I did my first report on Northern Ireland, I was naturally on the side of the Catholics." 1973: Vietnam: Christine Spengler was photographing the Americans' departure when a telegram informed her of Eric's suicide. "After that tragedy, I headed straight for the international hotspots: Cambodia, Nicaragua, Iran, the Lebanon, Eritrea, I was suicidal, like all war photographers, they all have some terrible secret wound. My personal grief became a universal grief: my photographs and clothes were black and white. I was the sister of all the widows and the mother of all the orphans in the world. I knew that I wouldn't get married, that I wouldn't have children and that I might die doing my job. Now, I'm cured of that grief and I can capture the beauty of the world. I've come to like colour again; I'm like the arenas of my childhood in Madrid, half shadow, half sun."

"A terrible secret wound."

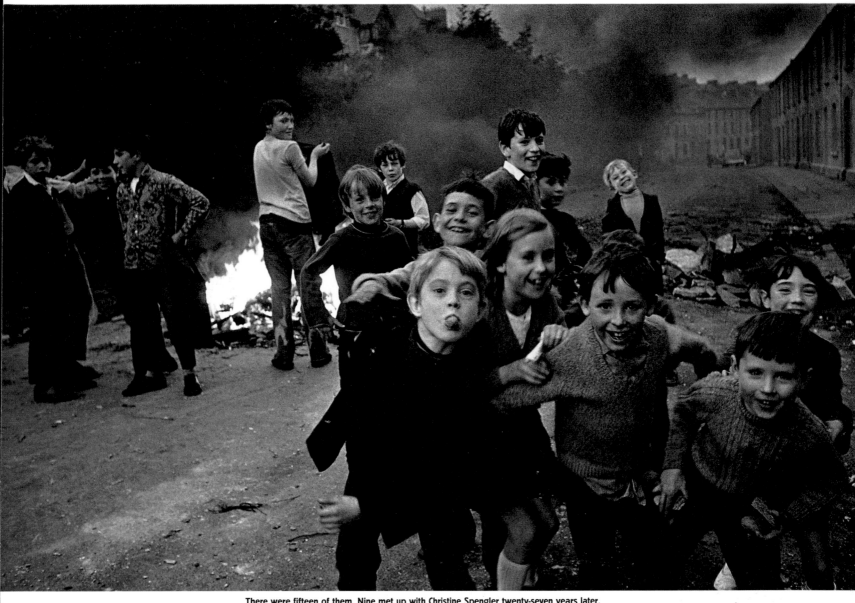

There were fifteen of them. Nine met up with Christine Spengler twenty-seven years later.

Patrick Campell

Jim Friel Vincent Derry Dorothy Campbell Seamus McIntyre JJ Doherty Michael Doherty Joseph Mayes Paul McGinley Majella Sheerin

The group repeating the composition of 1972.

Napalm

© Nick Ut/Associated Press

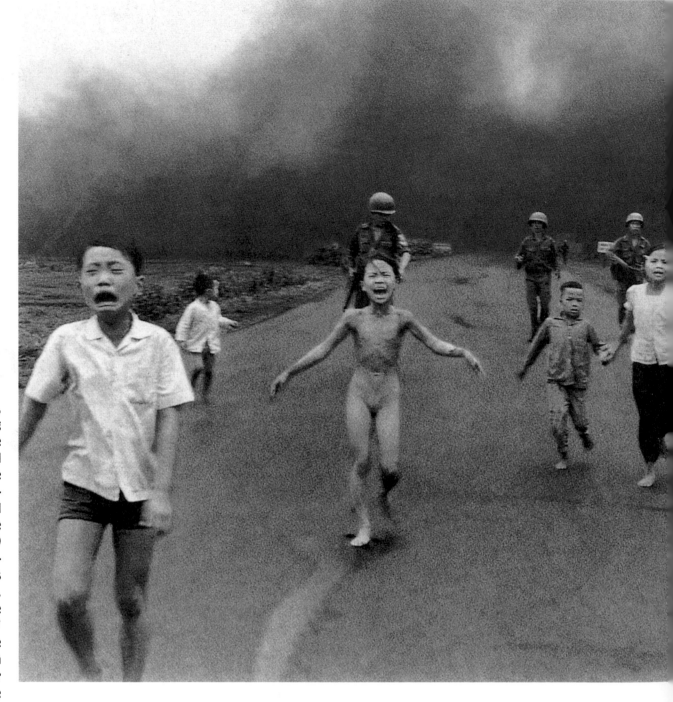

→ TIMELINE

Defoliants, napalm, phosphorus: during the Vietnam war, the American army and its South Vietnamese allies made extensive use of chemical weapons. When the war ended, on 30 April 1975, the reunified country was one huge battlefield. In fifteen years, the war had claimed 1.7 million lives. Entire regions had been contaminated for decades. Twenty-five years after the end of the war, children continue to be born with genetic defects caused by the defoliant Agent Orange.

"My life was turned upside down."

"Nick Ut saved my life," says Kim Phuc. "That's why I call him Uncle Ut." Taken to a hospital in Saigon by the Vietnamese photographer, the little girl had seventeen operations in fourteen months. In 1982, she started medical college, but had to break off her studies; ten years after publication of this photo, two hundred journalists flocked to Vietnam to interview her. "The government asked me to devote myself to the international press. This is how, in 1986, I came to be in Cuba studying Spanish and pharmacy." A resident of Los Angeles since the fall of Saigon, 'Uncle Ut' came to visit her. She introduced him to Buy Huy Toan, a Vietnamese student whom she married in 1992. After a honeymoon in Moscow, the couple took advantage of a stop-over to request political asylum in Canada. Now the mother of two small boys, Kim Phuc has moved heaven and

Kim Phuc

earth to "spread the Gospel". On 11 November 1996, in Washington, she preached reconciliation in front of two thousand Vietnam veterans. Deeply moved, a man called John Plummer approached her. Ex-Captain Plummer had given the order to bomb Route 1. He had become a priest to get over the nightmare of the photo. Kim Phuc forgave him: "Thanks to Uncle Ut's photo, I've become a messenger of peace". She was appointed Goodwill Ambassador by Unesco in 1997.

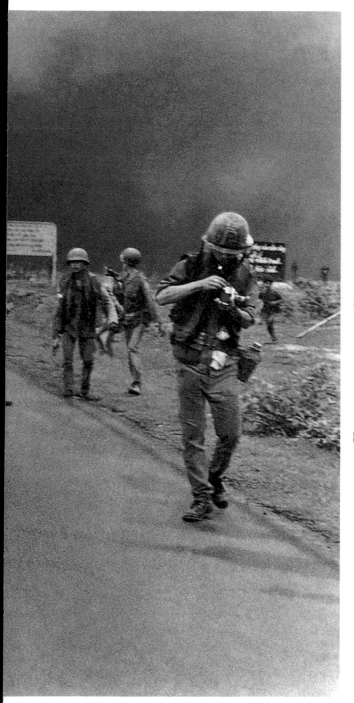

Indictment

NICK UT

"It was a horrific sight."

"The photo hastened the end of the war."

Awarded the Pulitzer Prize, the photo galvanised public opinion, and opposition to the war was immeasurably strengthened. "I've often been told that it hastened the end of the war," says Nick Ut. The symbol of the most unpopular war of the century, it is now one of the most widely published photographs.

"HER MOTHER called her 'Golden Joy' when she was a little girl. At thirty-five, Kim Phuc lives up to that pretty nickname. "I believe," she says smiling, "that, without God's help, I would never have overcome my hatred and suffering". And she displays the broad, deep scars of third-degree napalm burns. It happened on 8 June 1972. Kim Phuc's family lived in the village of Trang Bang, 65 km north of Saigon, and close to Route 1, which links the South Vietnamese capital with Phnom Penh. It was the most bombed road in the war. Here the Viet Cong had hollowed out 200 km of tunnels with a hospital and dormitories. One evening, someone knocked at the door: it was a North Vietnamese communist, who announced that the area was occupied. Her father took refuge in the village pagoda, with five other families and some South Vietnamese soldiers. On the third day, two American planes hedge-hopped over Trang Bang. An air-raid siren indicated that the temple was about to be bombed. "Run down the road!" shouted Kim's mother, and the little girl dashed for the road with her six brothers and sisters. Suddenly, the sky was ripped apart by explosions. The planes had dropped four napalm bombs. "Nong Quá! Too hot!" screamed the little girl, her clothes burnt off. The skin on half her body was hanging off in strips. "It was a horrific sight," recalls Nick Ut, a photographer with the Associated Press agency. "She rushed towards me, I pressed the shutter release, then she fainted in my arms." ∎

Tomoko in her Bath

© W. Eugene Smith/Magnum Photos

Aileen Smith: "It was our moral duty to condemn industrial pollution."

A Picture of Love

→ TIMELINE

Minamata, south Japan. In the early 50s, the inhabitants noted a strange disease affecting first animals, then humans; it caused neurological lesions and physical malformations. The cause was the mercury discharged into the sea by the Chisso chemical factory. The whole food chain was contaminated. It took twenty-five years of fierce legal battles to bring those responsible to justice. To this day, legal proceedings are still being brought to obtain compensation. The Minamata disease officially affected 14,000; a thousand of them died.

"HER NAME IS Tomoko Uemura. She was poisoned by mercury in her mother's womb." This was the caption to the photo 'Tomoko in her Bath', published in *Life* in June 1972. "I speak for those who have no voice", said W. Eugene Smith, who found out about the pollution in Minamata in 1970. "We decided to support the resistance of the inhabitants," says Smith's widow Aileen, "we felt it was our moral duty." The couple moved into a mud hut, near Tomoko's family. "Every day, we saw her mother go by, carrying her on her back. Eugene felt this conveyed a powerful message." The photographer offered a photo session and suggested bath time. Tomoko's mother agreed, in order to "show the whole world what pollution had done to her daughter". The session took place at midday, the traditional time for ablutions. A shaft of light filtered through a side window. The photographer added two flash units to enhance the interplay of shadows. Slowly, Tomoko's mother climbed into the bathtub holding her inert daughter. "His eyes brimming with tears, W. Eugene Smith took five or six photos: he knew what he wanted." The photo is heart-wrenching: with her deformed limbs above the water, her face turned towards her mother's tender gaze, Tomoko seems to be smiling. "It's a picture of love", said the photographer. ■

Ralph Nader

Kimiyo Itoh: "Eugene Smith spoke from the heart."

"That photo finally gave industrial pollution a face," says Ralph Nader, a Washington lawyer. "It's a thousand times more effective than any scientific report." A sworn enemy of the abuses of the industrial society, he launched a public campaign, in 1972, in favour of the victims of mercury poisoning. The result: in Minamata, things began to move. As for W. Eugene Smith, he promised to stay until Chisso was brought to book. "He was involved in all the battles," recalls Kimiyo Itoh, who runs an organisation for the victims. "He came to meetings with the sick and drank rice wine with them. He spoke from the heart; that's why his photos are so compelling." On 7 January 1972, the photographer was attacked by Chisso 'security-guards' during a demonstration. He never recovered: his right hand shook and his vision was impaired. But, with the help of his wife, he kept his promise: the publication of three years' work in a volume. Meanwhile, the photo had been seen all over the world. Tomoko's parents found it hard to bear: "Their daughter had died, but the photo lived on," says Aileen. "It's a heavy burden for that family to embody the suffering of Minamata indefinitely."

"Industrial pollution finally had a face."

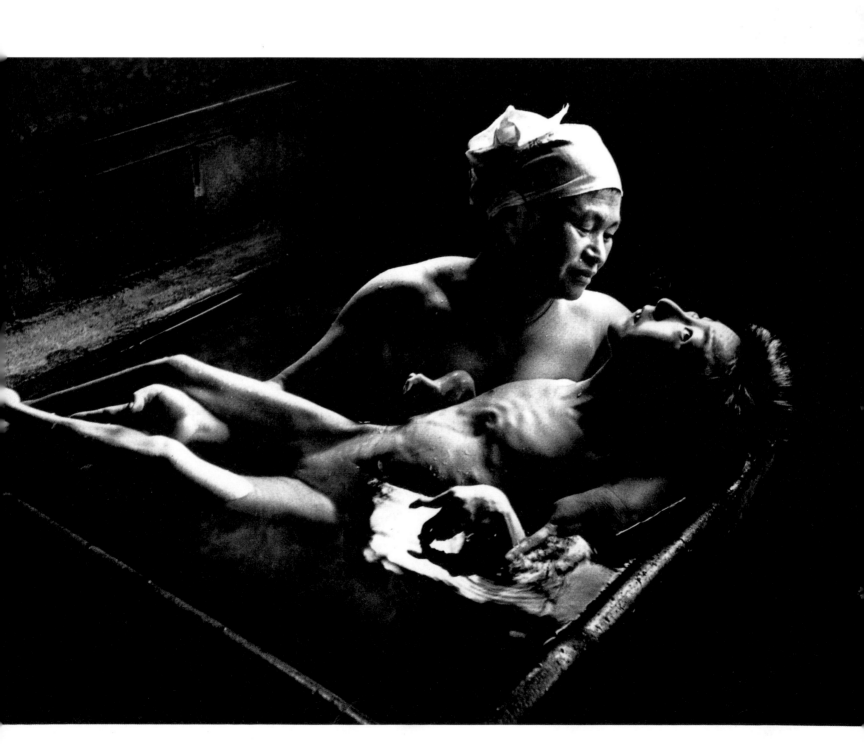

The Last Picture of Allende

© New York Times

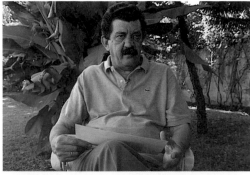

Danilo Bartulín: "We knew that President Allende wouldn't surrender."

Coup d'État

→ TIMELINE

"I believe in the vote not the gun," said Socialist leader Salvador Allende, who was elected President of Chile in September 1970. His Popular Unity coalition launched a programme of agrarian reform. Nationalising the copper mines alienated the United States. On 11 September 1973, General Pinochet staged a military coup, supported by the CIA. After his attack on the Moneda Palace, he announced Allende's "suicide". Ferocious repression followed: summary executions, widespread torture, disappearances. Chile suffered one of the most vicious dictatorships in Latin America.

AT 61, HE HAS the same moustache and impassive expression as in the photo. President Allende's personal doctor and head of security, Danilo Bartulín moved to Cuba after exile in Mexico. On the morning of 11 September 1973, he arrived at the Moneda with Salvador Allende. Around 09.00, tanks surrounded the capital, while planes flew low over the palace. Allende put on a helmet and seized a Kalashnikov he had been given by Fidel Castro. At 10.15, he addressed the nation on the only radio station not silenced by Pinochet's henchman: "The process of social change cannot be stopped by crime or violence. I will pay with my life for my loyalty to the people". The photo was taken just after that final speech. "We were organising our defence; the Hawker Hunters were intensifying their activity," says Bartulín. "We knew the president wouldn't surrender." At 11.00, the putschists granted a 10-minute cease-fire; Allende asked everyone without a weapon to leave the Moneda. This left a small nucleus of loyal supporters. Rocket bombardment started. Danilo Bartulín was arrested, tortured, and deported to a concentration camp in Chacabuco. When, at 14.00, the soldiers invested the ruined palace, Allende was dead. "As to Felipe and Mauricio, the two bodyguards in the photo, they are among *los desaparecidos,* the 'disappeared' of Chile." ∎

061

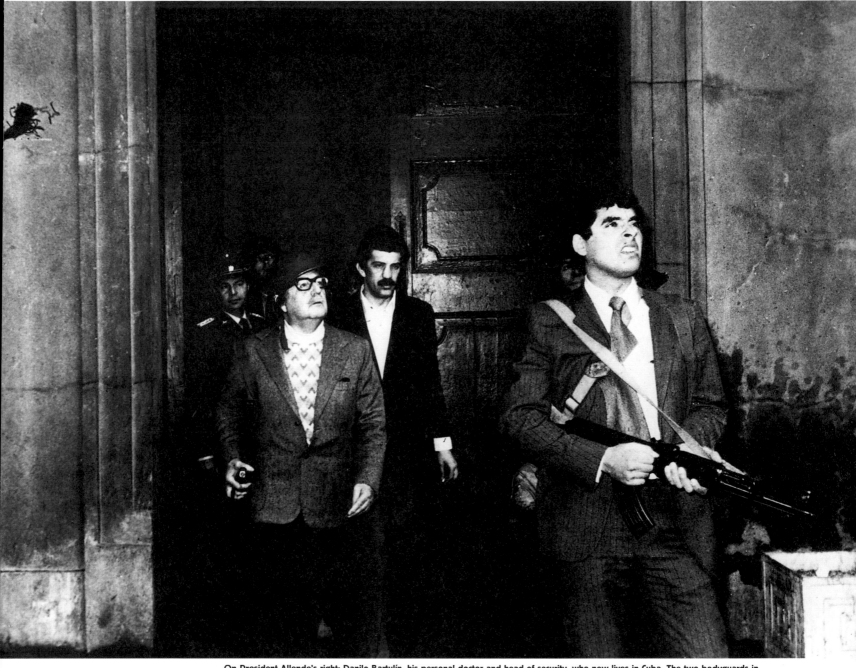

On President Allende's right: Danilo Bartulín, his personal doctor and head of security, who now lives in Cuba. The two bodyguards in the photo, Felipe and Mauricio, are among the Chilean 'disappeared'.

"25 years later, I still don't know who David is."

"Is David alive? French journalists wish to pay tribute to him." Published in January 1998 in a Chilean newspaper, the advertisement has still not received a reply. 'David' was a pseudonym; one day in 1973, he telephoned Frank Manitzas, the CBS News correspondent in Santiago. "I have the last photos of President Allende alive. Can you help me sell them?" Sitting in his villa in Miami, the journalist has never forgotten that "frightened" voice. "It was three weeks after the military coup and I realised that he needed money to leave the country. Of course, I agreed to help; the repression was unbelievably brutal." So Manitzas met 'David', a 40-year-old with greying hair and a thin moustache, who gave him six 35mm photos, one of which was of overwhelming "historical intensity".

He called the *New York Times*, which signed a contract with 'David' to distribute the photos. "I learned that he had made 12,000 dollars in three months." Twenty-five years later, the newspaper continues to sell the photo (winner of the World Press Photo award in 1973), but the photographer remains anonymous. "The *New York Times* won't tell me his name. There was a clause in the contract he signed," explains Frank Manitzas. "Perhaps 'David' is afraid that the events of 1973 will be repeated."

Frank Manitzas

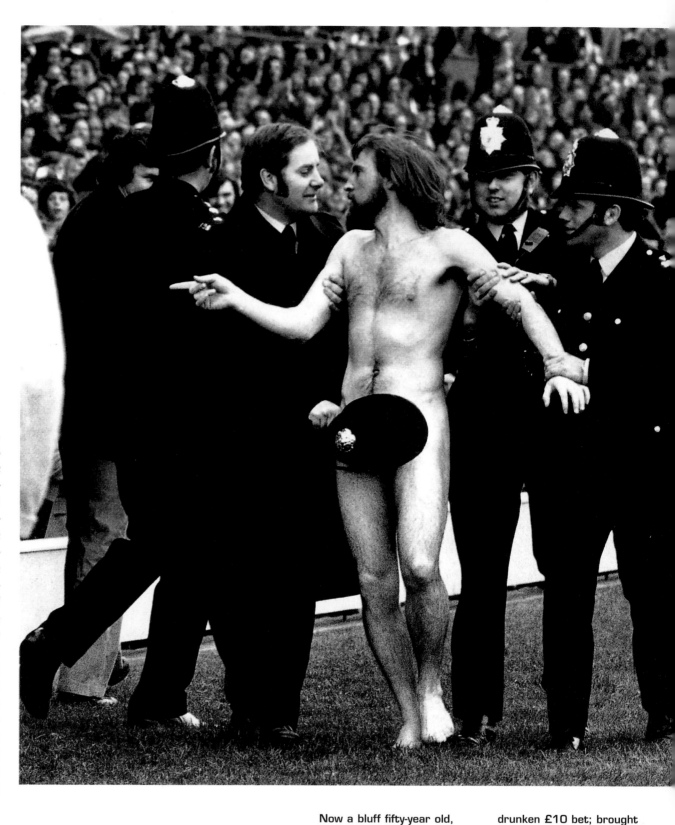

1974

The Streaker
© Ian Bradshaw/Mirror Syndication International

→ TIMELINE

20 April 1974. 53,000 spectators were watching the rugby match between England and France at Twickenham in the presence of Princess Alexandra. Only one picture of that match endures: this photo of the streaker. No one in England had ever seen anything like it. 'Streaking' emerged in the United States in the early 1970s as part of the post-hippie movement. Its object: entertaining the public by running naked through public places!

062

Now a bluff fifty-year old, Bruce Perry was the policeman who saved Princess Alexandra's honour. "It was my finest hour as a policeman! As we ushered him towards the touch-line, the streaker turned to me and said: 'Give us a kiss!' I burst out laughing!" He remembers the details of the story: the streaker's name was Michael O'Brien and he was Australian. By appearing in nothing but his birthday suit, he won a

Bruce Perry

drunken £10 bet; brought before the magistrates at Twickenham, he was sentenced to a £10 fine for offending public decency. "It was difficult to keep a straight face," chuckles Perry, who attended the trial, "because in the end that photo was the best publicity the British police have ever had!" As head of security for three major London football stadiums, he uses the photo in police training sessions: "This is how the police should be, firm but cheerful!" Having become a celebrity, he donated

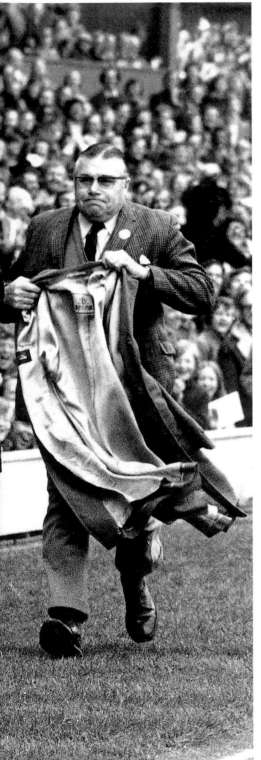

"Shocking"

IAN BRADSHAW
"I am a virtual billionaire."

his helmet to the Saint James rugby club in London: a life-size reproduction of the photo graces the wall of this exclusive bar, with the legendary helmet hung in its rightful place. As for Michael O'Brien, in 1995 he told the *Sunday Mirror* that he wanted to "put the past behind him." A computer specialist working at the Sydney Stock Exchange, he lies low when journalists are looking for him.

"It was my finest hour as a policeman!"

"THIS IS THE ONLY FAMOUS PHOTO I've ever taken," smiles Ian Bradshaw. "If I had a penny for every time it was published, I would be a billionaire!" On 20 April 1974, he was working freelance for the *Sunday Mirror* and had no claim on his photos. "It was half-time, when I saw a naked man running on the pitch." "Shocking!" declared the police chiefs, "*Lèse-majesté*", and set off in pursuit of the bearded brazen to the amused cheers of the spectators. "Three policemen caught the streaker and were escorting him from the pitch. One of them had taken off his helmet to hide the man's privates. I shot frantically, hoping to God that the helmet would stay in place!" On the fifth shot, everything was perfect: the position of the bodies, the intersecting glances, holding the helmet, not to mention the grim rugby official running after them, coat in hand. Having been published all over the world, the photo was reused by the admen for Canon, Nikon, and Paco Rabanne, but Ian Bradshaw cannot put his name to it. Imperturbably he keeps track of his virtual fortune. The latest money-spinner: the English lottery used his photo on a scratch-card. "I scratched," he sighed, "but I didn't win. I'm doomed never to earn a penny from this photo!" ■

In 1998, the English lottery used the photo on a scratch-card.

Muhammad Ali
© Howard Bingham

→ TIMELINE

He was fourteen times world boxing champion. Joining the Black Muslims or- ganisation, Cassius Clay converted to Is- lam and became Muhammad Ali. In 1967, he defied the draft for the Vietnam War, was stripped of his title and barred from the ring for three years. 1974 marked a remark- able sporting achiev- ment: he won back his title in Zaire. After retiring from boxing in 1981, the multimillionaire Ali developed Parkin- son's Disease. But he continues to be a boxing legend.

HOWARD BINGHAM

"When Ali knocked Foreman out, I didn't take a photo: I was jumping for joy!"

"ALI BOUMEYE! Ali Boumeye!" Twenty-five years later, the shouts in Swahili still echo in Howard Bingham's memory. "Kill him, Ali!" shouted the crowd of fans when, on 30 October 1974, Muhammad Ali and George Foreman climbed into the ring in Kinshasa. Organised by General Mobutu to bolster the prestige of his dictatorship, this was the match of the century. "We'd been waiting for this for two months," says Bingham. "Foreman had injured his eyelid when train- ing, and the match had been postponed." This was Ali's big chance. The experts declared him "finished" and thought that "Foreman was going to pulverise him". Making the most of the favourite's convales- cence, Muhammad Ali and his supporters travelled around Zaire. "It was an incredible triumph," says Howard Bingham. "Every- where we went, Ali was treated like a demigod". When the big night came, the atmosphere was electric. Journalists and photographers from all over the world fought tooth and nail for seats, while George Foreman literally threw himself at his opponent. "He showered Ali with blows, I was sick with worry. Caught on the ropes, Ali looked as if he wasn't defending himself. In fact, he had everything worked out. He waited for the storm to blow itself out, then delivered the fatal blow. Just when everyone had stopped hoping, he knocked him out. It was so masterful, I didn't take a photo: I was jumping for joy!" ■

Comeback

An affable man with the shoulders of an athlete, George Fore- man greets his con- gregation, all in their Sunday best, as they flock into the small Evangelical church he has founded in the suburbs of Hous- ton. After his first retirement in 1977, the boxer climbed back into the ring ten years later for a dazzling comeback; in 1994, he won back the title that Muhammad Ali had snatched from him in Zaire. The preacher is devoted to his cause: using sport to rescue those who have gone off the rails. "That match was the high point of my life. Until Ali knocked me out, I was convinced I was going to win. I thought each punch I threw was going to be the last one. In the seventh round, when I really bat- tered him, he said to me: 'That all you got?' When I see this photo, that's what I hear: 'That all you got?' And it was! This photo has a message: even when everything is going against you, what really counts is not giving up, that's the only way to get what you want. And that's what I try to get these young people to understand."

"It was the high point of my life."

George Foreman

0 63

Muhammad Ali and Howard Bingham

"I'm not Muhammad Ali's personal photographer, I'm his friend."

The meeting took place in 1962 on a street corner in Los Angeles. One was a young boxer, the other a photographer for a local newspaper: "Ali was eyeing up the girls with his brother," says Howard Bingham. "They ended up in my car for a short drive around the city." The two men have been inseparable ever since, and Bingham has become the star's "personal photographer". "No," he corrects me, "his friend". For over thirty years, he has photographed Ali's life: victories and defeats, meetings all over the world (with Elvis, the Beatles, and others), Ali's four marriages, the birth of his eight children, and his conversion to Islam at the side of Black Muslim leaders. "Magazines like *Life* or *Paris Match* have offered me a fortune to publish my photos of Ali with Malcolm X or Elijah Muhammad. But I never would, because, at the time, it would have harmed Ali. Money soon goes, but friendship is truly a precious thing."

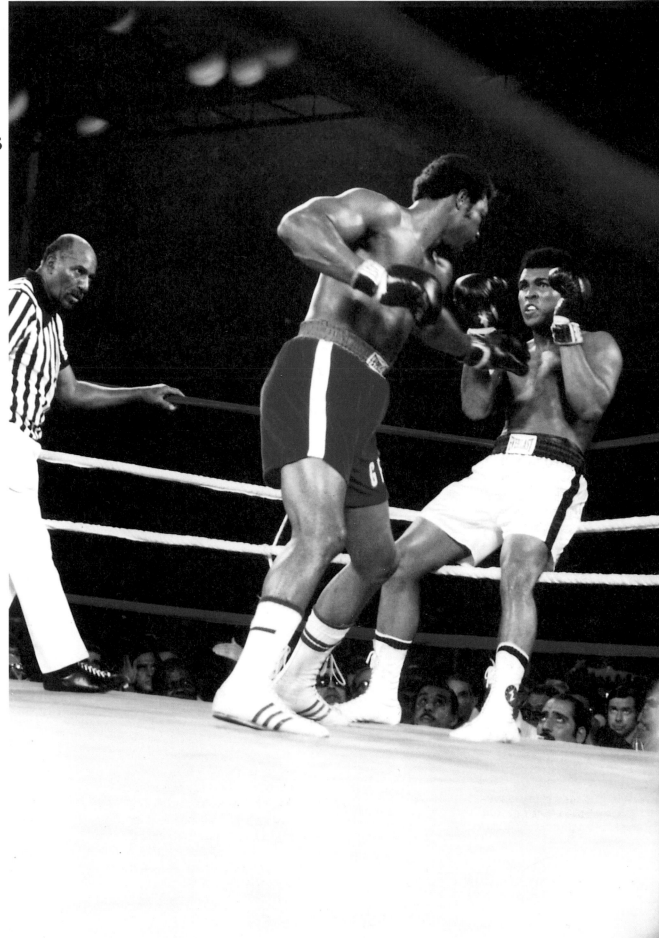

Carlos the Jackal

© Nik Wheeler/Sipa Press

NIK WHEELER
"I didn't know I'd photographed the future public enemy number one."

The Gamble

→ TIMELINE

21 December 1975. A terrorist commando invaded the Vienna headquarters of the Organisation of Petroleum Exporting Countries (OPEC). Eleven ministers were kidnapped in a plane. The 'armed branch of the Arab revolution' claimed responsibility for the attack. At its head: Illich Ramirez Sanchez, alias 'Carlos', a pro-Palestine militant who advocated armed combat against 'imperialism'. Born in 1949, in Venezuela, the terrorist had been identified six months earlier, after killing two French counterespionage agents in an apartment on Rue Toullier, in Paris.

064

IT WAS ONE OF THOSE GAMBLES that Goksin Sipahioglu loves. "No one knew where the terrorists were taking the hijacked plane," says the owner of the Sipa Press agency. "People thought it would be Iraq, Libya or Algeria. Time was of the essence, and I couldn't send a photographer to each of the countries, so I chose Algeria. I asked Nik Wheeler to go, because he was very good and shrewd." Now living in California, and married to a *Dynasty* star, Wheeler admits that he was as surprised as anyone. "Almost as soon as I arrived at Algiers airport, I was confined to a building overlooking the runways. I was bored to death; nothing was happening!" Suddenly, a movement on the tarmac caught his eye: some ten officials flanked by bodyguards strolling along in conversation with a stranger. Witnesses identified Abdelaziz Bouteflika, the Algerian Foreign Minister. "I figured the stranger must be one of the hostage takers," says Nik Wheeler. "I ran to the toilets and climbed onto the pan. After cleaning the window, which was black with dirt, I took about ten photos with a 500 mm telephoto lens. I thought I should at least photograph the back of Bouteflika's neck. I had no idea I was taking a photo of Carlos, the future public enemy number one." ∎

"How did I recognise Carlos in the photo? It was very simple," says Goksin Sipahioglu, the owner of Sipa Press. "I examined his nose, chin and ear under a magnifying glass and compared them with a photo given to us by the police department, after the murders in Rue Toullier." Thinking he had drawn a blank, Nik Wheeler handed his contact sheet to Sipahioglu who went wild about the stranger in the centre of the main photo. "I asked them to enlarge his profile several times. Now, with a computer, it would take no time at all, but then it took several hours." With his famous accent, that of a Parisian Turk, he adds: "I wasn't 100% sure it was Carlos; that was another gamble!" The scoop was announced by the press; it made the cover of *L'Express*, and later *Stern*, looking rather grainy due to the successive enlargements. But the quality was irrelevant; for a long time it was the only photo of Carlos, and it was published countless times.

"This photo is one of the Sipa agency's assets."

Goksin Sipahioglu

The OPEC attack enabled Carlos to extort fifty million dollars from Saudi Arabia. He then moved to Hungary, to head an international arms-dealing operation. After a stay in Syria, he was kidnapped in Sudan, in August 1994, by order of the French security services. From his prison in the Paris area, he conveyed to his lawyer, Maître Coutant Peyre, his observations on the photo. "Carlos saw the photo the very day it was published. Division Superintendent Saleh Hijeb carried out an immediate enquiry: he confirmed that it had been taken by Nik Wheeler at Algiers Airport. Flanked on the far left and right by security police, the photo shows:
– Abdelaziz Naed, future head of the Sûreté Nationale in Tizi Ouzou,
– the Minister of the Interior, Colonel Abdel Ghani, who is speaking to Carlos,
– the Minister for Industry and Energy,

Belayid Abdessalam, and the head of national security, Colonel Draia,
– Abdelaziz Bouteflika, the Foreign Minister, a courageous militant and shrewd diplomat,
– finally, the deputy head of the Sûreté Nationale, the future Minister of the

Mᵉ Coutant Peyre

"Carlos' identification did not interfere with his revolutionary activities or compromise his safety."

Interior. Carlos' identification did not interfere with his revolutionary activities or compromise his safety. On the contrary, the worldwide publication of this photo generated a wave of revolutionary solidarity."

Massacre in Lebanon
© Françoise de Mulder

FRANÇOISE DE MULDER

"The photo haunted me for years."

Torture

→ TIMELINE

Beirut, January 1976. The Christian militia razed the Quarantania district in Palestine. The Lebanese civil war entered its second year. On the one side, the Palestinians, supported by the progressive and Muslim parties, who dreamed of destroying Israel; on the other, the Christian militia, who wanted to drive the Palestinians from the country. By the time the war ended in 1990, the Palestinians had lost their base in the Lebanon and the Christians their power. The Israelis occupied the south of the country and Lebanon was under Syrian political control.

LEATHER BOOTS, combat fatigues and a gloved hand brandishing a machine gun: Françoise de Mulder never saw the soldier's face, only his eyes through his hood. But she never forgot the "insane hatred" and the trail of corpses he left behind him. How many? "I don't know, it was total butchery." Arriving in Beirut on Christmas Day, Françoise de Mulder was taken to the general headquarters of Pierre Gemayel's Phalangists. On the morning of 18 January, she accompanied a group of militiamen who took part in the attack on the Quarantania district. The pitiless "cleansing" had begun the night before: "They went from house to house, and street to street". Françoise dogged the heels of a young soldier whose cruelty knew no bounds. "He regularly gestured to me to stop taking photographs. Then came the gunshots." Women, children, old people: no-one was spared. Fire devoured the hovels of the shantytown. By early afternoon, the Quarantania district had been wiped off the map. Françoise de Mulder reached the rear of the camp, where some fifty Palestinians gave themselves up waving a white flag. The scene that followed symbolises the Lebanese civil war forever: hands outspread in a final plea, an old Palestinian woman begged the soldier to stop the massacre. Soon after, the "refugees were lined up against the wall of a factory and machine-gunned". ■

Taken to Amman by courier, Françoise de Mulder's rolls of film reached Paris two weeks later. Too late: "Brilliant reportage", telexed Gamma, "but we've missed the American market". On her return to France, however, Françoise de Mulder discovered that *the* photo had never been published. Under-exposed, the photo had been overlooked on the contact sheet. She and the photo were vindicated; it won the World Press Photo award in 1977 (a first for a woman photographer), and was published all over the world, coming to symbolise the Lebanese tragedy. "It changed people's perceptions, it was no longer a question of good Christians and bad Palestinians; the Phalangists never forgave me." Plastered on the walls of Beirut, the photo angered the Christian militia, who harassed the photographer, forcing her never to return to East Beirut for fear of "serious trouble". Françoise de Mulder tried to locate the people in the photograph. "According to my information, only the mother and her baby survived. The soldier killed himself playing Russian roulette."

The first World Press Photo award won by a woman.

F. de Mulder in the field.

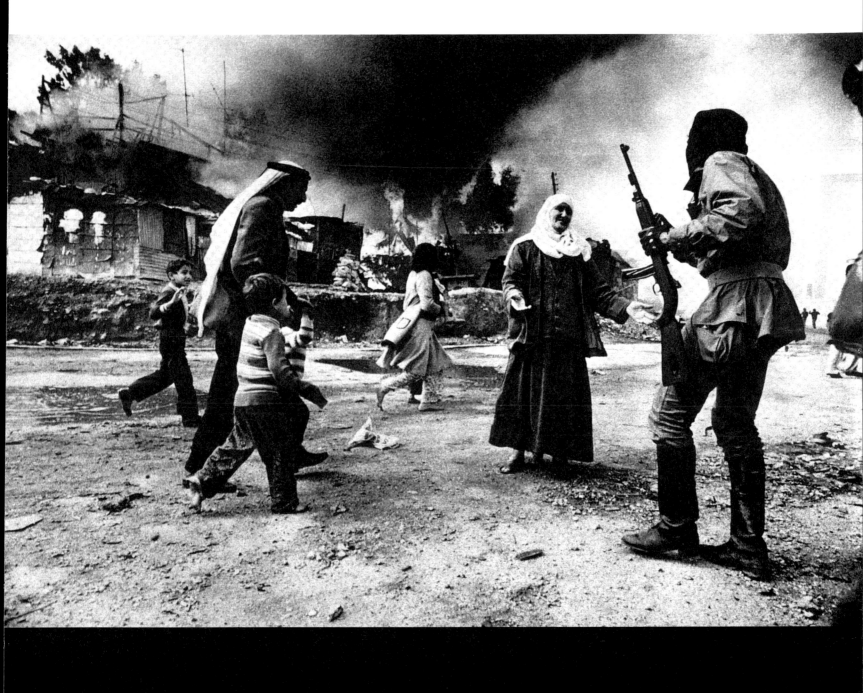

1976

Bob Marley
© Kate Simon

→ TIMELINE

Twenty years after his death, Bob Marley is still one of the best-selling artists in the world. The only third-world superstar, the reggae singer had his first international hit in 1975. A follower of the Rastafarian religion, which advocates non-violence and marijuana, he preached universal harmony. In Jamaica, his concert was dedicated to reconciling the warring factions of Jamaican politics. An emblem of the struggles of oppressed peoples, he denounced racial discrimination, singing until the end of his short life. The 'Jah Rastafari' died of cancer at the age of 36 in 1981.

Black is Beautiful

"The best photos are always the ones people want you to take."

Not a museum, but a temple; it takes up the entire basement of his villa in the hills above Los Angeles. A voluble, enthusiastic man, Roger Steffens introduces himself as an actor-photographer-DJ-collector-historian. His passion: Bob Marley. For twenty years he has collected everything associated with the reggae star. The result: 9,000 records, 11,000 tapes, miles of filmed interviews, 10,000 posters and badges. A Japanese magnate offered him a million dollars for his collection, but he refused. The same goes for Rita, Bob Marley's widow, a frequent visitor. "I don't do this for the money," he says, "but for him: he was one of the greatest figures of this century". So, naturally, Roger Steffens knows everything about Kate Simon's photo, chosen by Chris Blackwell in 1977 to illustrate the cover of Marley's album *Kaya*. "It was just after Bob's European tour, which established his status as an international superstar. The idea was to cast the net wide: instead of the smoking joint that attracted the hippies and frightened off ordinary people, this was a photo you could show your mother. He looked almost like a boy-scout, with his neat hair. This photo now appears on badges, T-shirts, stickers, flags, postcards, and plastic buttons. I've seen it at the top of the Grand Canyon, at the entrance to an Indian reservation, in the coffee shops of Amsterdam and on Japanese rugs. The foremost pop critic with the *New York Times* recently said that in 2096, when the former third-world countries have outstripped and colonised the old superpowers, people will commemorate Bob Marley as a saint. And Kate Simon's photo will appear on the medallion of Saint Bob Marley!"

"A picture you could show your mother."

Roger Steffens

IN A PHOTO, she is sitting on a bus, grinning at the Rasta King. Kate Simon was 27 when she met Bob Marley for the first time; it was in 1975, after a concert at London's Lyceum that made the singer an international star. A year later, Kate Simon was sent to Jamaica to photograph Bunny Walker and Peter Tosh. She was staying at the Kingston Sheraton, the haunt of all the reggae professionals. In the hotel swimming pool, she met Chris Blackwell, chairman of Virgin's Island Records. They had a wild breaststroke race. "Chris had just won when I saw Bob sitting under a parasol. He was wearing a blue tracksuit, with white stripes down the sides. I wasn't expecting to see him there. We hugged each other in delight. I then measured the light level near his neck: it was a wonderful light, very bright but reflected. I took two rolls, circling around him: Bob changed expression, he smiled, looked serious, thoughtful, or stared into the distance. The best photos are always the ones people want you to take and, that day, I couldn't have asked for more. It's rare to meet someone so photogenic: his generosity fills the film. You only get good photographs of people you like. In that respect, Bob was one of the great loves of my career." ∎

The Victims of Pol Pot

→ TIMELINE

1975. Pol Pot, alias 'Brother Number One', founded Democratic Kampuchea. His obsession: to eradicate the after-effects of capitalism by re-educating the people. In three years, 1.5 million Cambodians starved or died of exhaustion in the 'killing fields' and over 200,000 were massacred. When, in December 1978, the Vietnamese entered Phnom Penh, the head of the Khmer Rouge escaped with his troops to the borders of Thailand, where he formed a guerrilla force. He remained there until his death in April 1998.

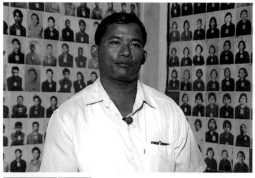

NHEM EIN

"I knew that the prisoners I was photographing were doomed."

" I ALWAYS KNEW that the prisoners I was photographing were doomed." Nhem Ein, 38, adds: "Day and night, you could hear the cries of the tortured prisoners, but what could I do?" By way of excuse, he holds out a tiny identity photo: it shows a young boy in the uniform of the Khmer Rouge. "I was sixteen when I was press-ganged by the Khmer Rouge." The son of a peasant family of eight children, Nhem Ein was sent to Shanghai to learn photography. In May 1976, he was appointed head photographer at Tuol Sleng prison. This centre of repression, a former French school, was renamed 'S-21' by Pol Pot's henchmen: S for 'security office', '2' for 'second division' and '1' as in 'Brother Number One'. This was where all 'enemies of the country', 'agents of the American, KGB or Vietnamese invaders' and disgraced officials ended up. With the help of six assistants, Nhem Ein worked from 07.00 every morning, photographing the prisoners as they arrived. Full-face and profile: on some days, he took as many as 600 photos. Eyes dazzled by the flash. Some had been beaten. Exhausted, terrified or simply bewildered, every man, woman and child had a sign round the neck, with a number, sometimes pinned to the skin, signalling their order of arrival. "These portraits were sent to Pol Pot as proof that his enemies had really been eliminated," says Nhem Ein. ∎

Lest We Forget

He was no. 55 on 7 January 1978. An artist, Vann Nath, 31, had been deported to an agricultural co-operative as a woodcutter, before being arrested for 'counterrevolutionary activities'. "I arrived at Tuol Sleng around midnight, blindfolded and roped by the neck to other prisoners. After interrogation, I was made to sit on a chair and they took off my blindfold: I found myself face to face with a photographer." The rest was pure hell. Out of 14,000 prisoners interned here between 1975 and 1978, including 1,200 children, only seven survived. Seven artists, spared, like Vann Nath, by the torturers so that they could produce monumental paintings and sculptures in praise of the dictator. "Survival is a burden that only my determination to testify allows me to endure. The only way to do all my companions justice is to make sure that their memory lives on." And he shows us the thousands of portraits lining the walls of the former prison, converted into a memorial to the genocide perpetrated by the Khmer Rouge. "Unfortunately, Pol Pot died before he could stand trial for his crimes."

Vann Nath

"Unfortunately, Pol Pot died before he could stand trial for his crimes."

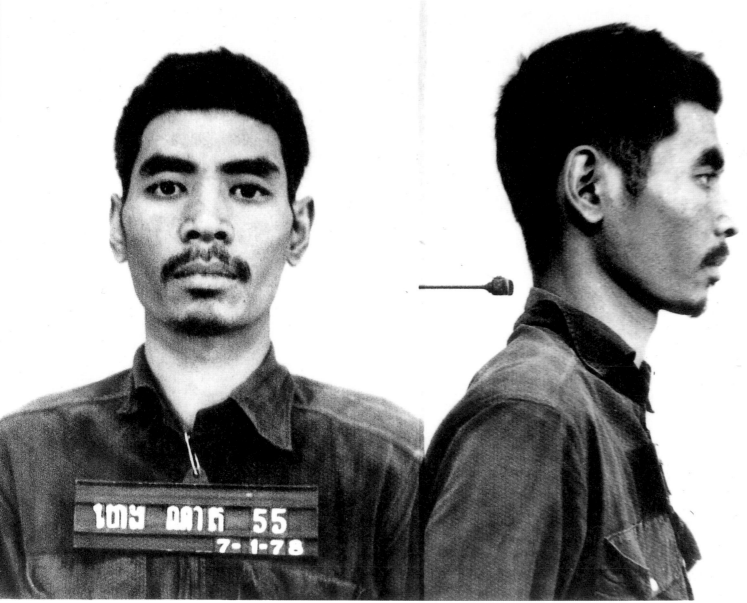

Vann Nath survived because he was an artist.

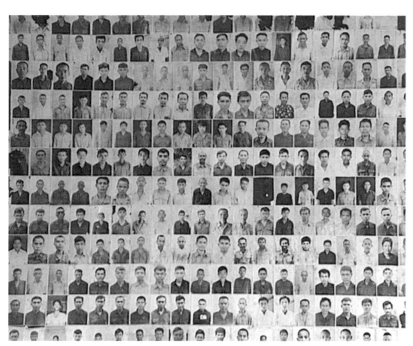

Of the 14,000 prisoners interned at Tuol Sleng, only seven survived.

Nhem Ein's photos were rescued from decay by two Americans who discovered them on a visit in 1993, ensuring that Pol Pot's victims will never be forgotten. "These photos are unique in the history of photography," says Chris Riley. "They form an illustrated history of the genocide. Written accounts cannot match their particularity; each victim remains a unique individual." With journalist Doug Niven, the photographer came up with a plan to preserve the negatives, damaged by damp and insects. Having compiled a catalogue of 6,000 photos, enabling people to identify family and friends who had

Chris Riley: "These photos are unique in the history of photography."

disappeared, they mounted an international exhibition with some one hundred photos. Then they published a book with a preface by Vann Nath: "It is not just Cambodians who have a duty to remember. The whole world must remember these faces; they are a call to conscience for humanity."

"Rescued from oblivion."

The Murder of Aldo Moro

© Gianni Giansanti/Sygma

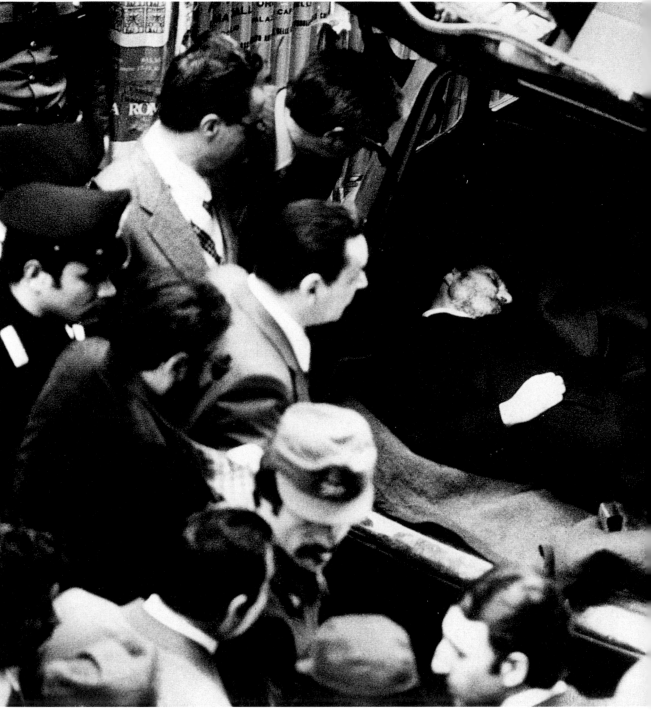

→ TIMELINE

Rome, 16 March 1978: Aldo Moro, former Prime Minister and elder statesman of the Christian Democrat Party, was kidnapped and his escort massacred. The Red Brigade claimed responsibility for the kidnapping, demanding the liberation of fifteen terrorists, including Renato Curcio, the movement's first leader. Italy was in shock but the State refused to negotiate. On 9 May, Aldo Moro was murdered. There was talk of petty rivalries within the Christian Democrat Party and of an alliance between the Mafia and the Red Brigade. These issues were never clarified.

His expression is shy but candid. Giovanni Moro was twenty when his father was killed. Disillusioned with politics, he works for an organisation that defends civic rights. "I first saw the photo in the newspapers; it was a terrible shock for my whole family. My father used to shave every morning, we'd never seen him with a beard, and he was still wearing the suit he had worn on the morning he was kidnapped. In my view, the photographer had the right to take that photo. In a case like that, the right to know takes precedence over the right to privacy. By contrast, my family took legal action against the photos that were probably taken by the police during the autopsy at the morgue. They were completely gratuitous and needlessly offensive. We won the case. This photo is a historical document, it shows what our country was like at the time: a weak, scheming state, in the grip of compromise and cowardice, a democracy in danger. This photo is an indictment."

"The right to know is more important than the right to privacy."

Giovanni Moro

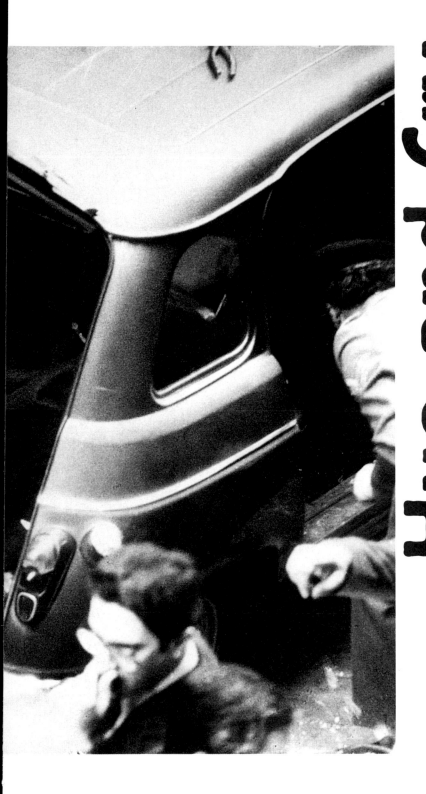

Hue and Cry

GIANNI GIANSANTI

"I knew I had an international scoop."

I T WAS THE SCOOP of his career, the photo that made his name. A miscellaneous news reporter for a small agency in Rome, Gianni Giansanti, aged 22, had already won attention on the day that Aldo Moro was kidnapped: he took the first photos of the five murdered bodyguards. Since then, he had focused on the 'affair'. His equipment: a scanner tuned to police frequencies and a big motorbike. On 9 May 1978, he was waiting outside the headquarters of the Christian Democrat Party when police cars shot past in the Via Del Gesù. Giansanti gave chase, following them to Via Michelangelo Caetani, where a roadblock had been set up. Guided by "instinct alone", he dived into an apartment block and knocked on a first-floor door. He found himself on a balcony above a swarm of *carabinieri* crowding around a red Renault 4. And he started taking photographs. Of what? "I didn't know what I was photographing, until I heard on the television of the apartment I was in that they'd found Aldo Moro's body!" In the meantime, the bomb disposal experts had broken into the car. In the boot, Aldo Moro lay huddled up, his head lolling. He was thin, bearded, and long-haired. Colour photos for the magazines, black and white photos for the newspapers. Using a single camera, Giansanti loaded film after film. "In those situations, you don't feel anything, you just take photos as if you were possessed. I knew I had an international scoop." ■

South Africa

© **Abbas**/Magnum Photos

ABBAS
"I realised my photo was sheer dynamite."

Colonel Malan

"This photo did us more damage than an enemy unit", said the South African Ambassador in Paris. Malan, the colonel in the photo, finished his career as a general, before retiring to the outskirts of Pretoria. "I was disappointed, because abroad the photo became politicised. Certain publications insinuated that this was a prison or even a concentration camp.

→ TIMELINE

1948. The white South African government instituted Apartheid: "separate development" for different racial groups. Segregation was enforced in every sphere of daily life; interracial marriages were prohibited, and there were separate buses, schools, and housing areas. Condemned by the United Nations as a crime against humanity, the policy of apartheid intensified during the 1970s. South Africa became an international pariah, as efforts intensified to free Nelson Mandela, the black leader incarcerated since 1962.

WHEN THE MINISTER of Information in Pretoria suggested this report, Abbas nearly refused. What on earth was he going to do in a training centre for black policemen, a centre therefore singled out for attention by the rascist authorities? "Finally, I decided to do it on a 'you scratch my back' basis; I'll do the report, but there are things I want." So there he was, under escort, in the brand new centre of Hammanskral, a small town near Pretoria. Gymnastics and ball games: around a hundred black youths, all bare torsos and shaved heads, were training under the supervision of Colonel Malan. Nothing to interest Abbas, in short. "Could I photograph the students lined up?" he suggested. The young men complied and, perched on a podium, Abbas shot. Out of the corner of his eye, he glimpsed the impeccably uniformed Colonel watching the scene. "Could you pose with your pupils?" he asked. Hesitating, Malan glanced questioningly at the surveillance officer present, who nodded. Malan took his place, his stick under his arm, while the student policemen stood to attention, their dark eyes directed towards the lens. Suddenly jubilant, Abbas took several rolls of film, first in colour, then in black and white. Finally, he had what he wanted. "I realised that I had caught a powerful symbol of apartheid. It was sheer dynamite." ∎

"This photo became politicised." The students had their shoulders back, which made their bones stand out, so that they looked undernourished. The same photo could have been taken in a white college with white students, in Durban with Indian students or in Cap Verde with mixed race students. But it is true that the commanders were always white. When I see this photo again, I realise that my finest years were spent at Hammanskral."

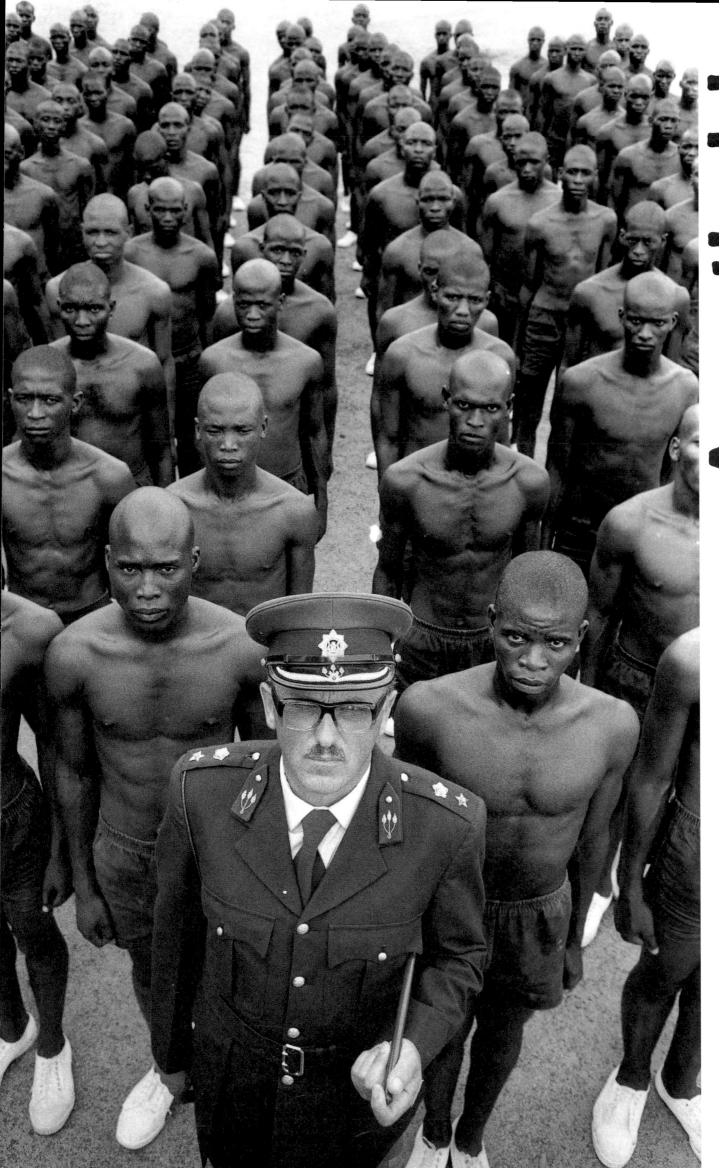

Apartheid

Revolution in Nicaragua
© Susan Meiselas/Magnum Photos

→ TIMELINE

19 July 1979. The Sandinista National Liberation Front overthrew the dictator Anastasio Somoza, who was supported by the United States. Daniel Ortega's government instituted a programme of agrarian reform, launched a literacy campaign, and nationalised foreign trade, while maintaining a mixed economy. In 1980, Ronald Reagan imposed an embargo on Nicaragua and armed the 'Contras', anti-Sandinistas based in Honduras. After a landslide victory in the 1984 elections, Daniel Ortega was defeated in the 1990 elections by Violetta Chamorro, the White House candidate.

070

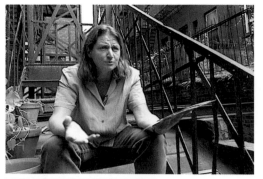

SUSAN MEISELAS

"It was a time of hope."

WHEN SUSAN MEISELAS arrived in Nicaragua in 1978, she little thought that her experience would change her life. "I discovered that my country was supporting a bloody and corrupt dictator up to the hilt. I was ashamed to be American. I decided to stay and testify, hoping my pictures would start a debate in the United States." Photographing demonstrations, the sinister National Guard on exercises, and the mutilated bodies of dissidents, Meiselas roamed Nicaragua for months, driven by a "sense of duty". Then, in June 1978, a journalist from the opposition paper *La Prensa* took her to Monimbo, in the suburbs of Masaya, a hotbed of Sandinista resistance. Here, a year later, the insurrection against Somoza arose. "I was taken to a small wood where masked men were training. I didn't know their names or see their faces. They led a double life: by day they worked, by night they organised operations against the Somocista Guard. To conceal their identity, they used traditional folk masks, which also protected their faces from the shrapnel of the contact bombs: grenades made with sugar, metal, fragments of glass, and nails. This photo was taken at a key moment, when urban guerrillas and village militia units were being created. It was a time of hope. The masks and the contact bombs became symbols of the Nicaraguan revolution." ■

Compañeros

Justo was twenty when he joined a secret cell of the Sandinista Front in Monimbo. The central figure in the photo, he had first proposed arranging a photo session. "Our aim was to publicise our struggle at the international level and give the lie to Somoza, who was always proclaiming that the Sandinistas were finished. I trusted Susan but it wasn't easy to convince my comrades. Some of them said: 'If you want to die, bring in the Yankee, you know the CIA has eyes everywhere'." Today, Susan is the godmother of my daughter, who bears her name. When I see that photo now, I just feel sad. Then I dreamed that peasants would no longer be driven from their lands, that children would go to school and the poor have access to medicine. Today I feel bitterly disillusioned. For my own part, because I have trouble supporting my six children. And because the revolution was blown out of the air in mid-flight."

"The revolution was blown out of the air in mid-flight".

Justo

The Boat People

© Alain Dejean/Sygma

→ TIMELINE

30 April 1975. The communists of North Vietnam entered Saigon, renaming it Ho Chi Minh City. In former South Vietnam, which was mainly pro-American, people panicked. Fleeing the new regime, which nationalised companies and businesses, and economic crisis, thousands of Vietnamese 'boat people' tried to reach the shores of south-east Asia on improvised craft. Against them were ranged the sharks, pirates and storms of the Gulf of Siam. In fifteen years, 1.5 million people sought exile in this fashion.

Bertrand Vannier: "It was the first time that an exodus of this size had been organised."

"WHEN I THINK ABOUT IT, we were a bit like Tintin and Snowy!" A journalist with France Inter, Bertrand Vannier flew to Malaysia in October 1978. "There was talk of a freighter stranded off Port Klang with 2,566 boat people on board. It was the first time that such a massive exodus had been organised." The *Hai Hong* set off in secret from a South-Vietnamese peninsula, and was driven out of Indonesia before reaching the Malaysian coastline, where it was forbidden to land. For three weeks, the government of Kuala Lumpur prohibited the supply of food and medication to the boat, which had now run out of fuel. Vannier met Alain Dejean, who was working for Sygma. "He was trying to get to the *Hai Hong*, but the anchorage was sealed off by the police, who threatened to imprison fishermen who approached it." The two accomplices decided to rent a boat and row. "We left in the middle of the night from a little port some way off; the sea was very rough and it was pouring with rain; the boat was taking in water: one of us rowed while the other bailed. I've never been so frightened in my life." It was 04.00 when they arrived alongside the freighter and were thrown a rope by the refugees. "It was quite a climb: the hull was covered in shit. We finally came on board filthy and stinking to high heaven!" On board, 2,566 starving, thirsty refugees were packed "like sardines" from bridge to hold under makeshift tarpaulin shelters. "Dejean took several flash photos. Then he waited for daybreak, when he took this photo. Immediately afterward, we gave ourselves up to the Malaysian soldiers who had spotted us and given chase." ∎

Tintin and Snowy

Slowly, Mme Phu, aged 98, adjusts her glasses. Silently she contemplates the photo: "We were at the bottom of the hold, weren't we?" Around her, the fourteen members of her family agree: "Yes," says her son, "there were three holds packed to overflowing". And Jessica, 30, adds: "The main thing I remember is that we had nothing but biscuits to eat". Most of the *Hai Hong* refugees, unlike the Phu family, are Hoas, Vietnamese of Chinese origin. The Hanoi government wanted rid of them, because they owned most of the country's shops and businesses. "In fact," says Jessica, "the *Hai Hong* is supposed to have had official permission to leave. We each had to pay eleven ounces of gold, or 2,000 dollars. The problem was that Malaysia had been flooded by refugees and it didn't want any more." After the photo was published, France, Canada and the USA accepted boat people. The Phu family moved to Los Angeles, where they still live.

Fourteen members of the Phu family were on board the *Hai Hong*.

"Were it not for this photo, the children and old people would probably have starved to death."

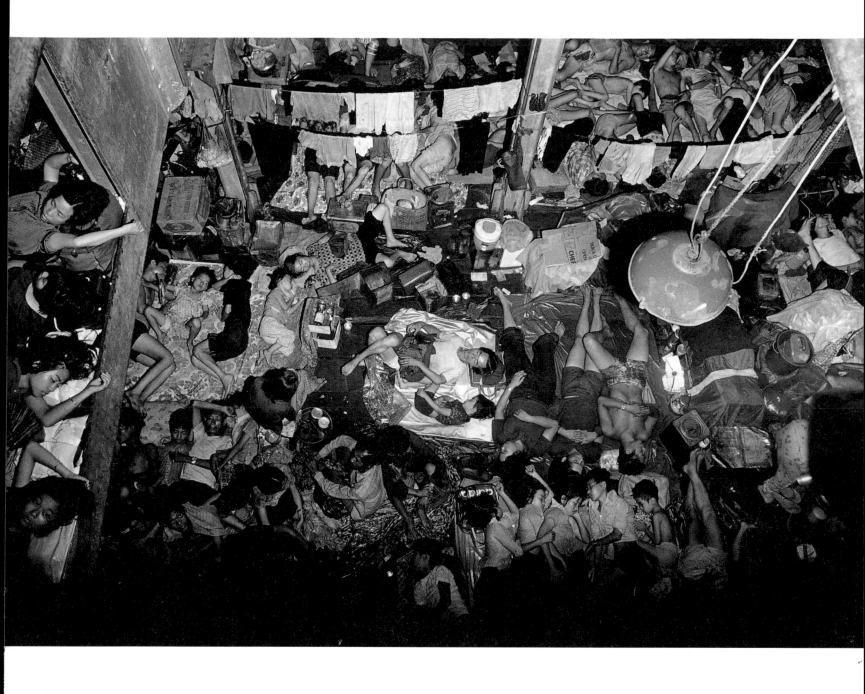

"That photo prompted the HCR to take action over the *Hai Hong*."

Now a member of the High Commission for Refugees, Sadato Ogata represented Japan at the UN in 1978. "That photo prompted the HCR to take action over the *Hai Hong*. At the time, my colleagues were already involved in the cause of the boat people, but this dramatic photo forced them to act more quickly and save as many lives as possible. Before the boat people, most refugees fled across land borders, and we knew how to help in those cases. Learning how to help water-borne refugees marked a turning point in our ability to intervene. This photo accelerated that process."

Sadato Ogata

Ayatollah Khomeini
© Michel Setboun

→ TIMELINE

1 February 1979. After fifteen years of exile, Khomeini returned in triumph to Iran, where a popular uprising had overthrown the Shah's dictatorship. Supported by the mullahs and the Guardians of the Revolution, Khomeini imposed Islamic law with a reign of terror. Summary executions were commonplace. During the war with Iraq, the Supreme Leader of the Revolution eliminated his opponents, while supporting Islamic terrorism abroad. When the dictator died in 1989, he left a country completely isolated on the international stage.

MICHEL SETBOUN

"I was terrified by Khomeini's lack of compassion."

"**I**'D NEVER SEEN such universal rejoicing. Who could imagine the disaster to come?" On the morning of 1 February 1979, Michel Setboun was a tired but happy man; he had fought hard to board the plane that brought Khomeini back to Iran. This was the first sleepless night. The future Supreme Leader of the Revolution was immediately carried off by a human tide to the Behechte Zahran cemetery (renamed 'Martyrs' Cemetery'), to shouts of 'Allah Akbar'!" Then he disappeared. Another sleepless night: "We looked for him everywhere until we learned that he had taken up residence in the Alavi School near the Iranian Parliament. There he received mullahs, soldiers and government ministers." From daybreak, tens of thousands of people waited to enter the school courtyard. One line for women, another for men: everything was organised by the Islamic stewards. The doors opened, and people rushed forward. "Sometimes we waited an hour and suddenly the Messiah appeared at the window! The crowd went absolutely wild in their devotion; thousands of hands were stretched towards Khomeini, who seemed utterly indifferent. He looked like a statue. I recall being terrified by his lack of compassion." A basketball net, much favoured by the international press, was Setboun's platform for the photo. "We took turns on top of the pole! It lasted a week: there Khomeini prepared the revolution that led to the Islamic Republic." ∎

True Colours!

Political commitments led him to photography. "I was a Leftist," says Michel Setboun, "and I was passionately interested in the struggles of the Third World. When I learned of the Shah's fall, I cracked open a bottle of champagne, and decided to go and bear witness, camera in hand. The Iranian revolution was extremely visual: women in black *chuddars*, turbaned mullahs; the people had a sense of drama, theatre, movement, and colour. It was incredibly beautiful. Also, the people supported us. People would come up to me, saying: 'Take photos, show the world what is happening here!' With my foreign looks, I could easily pass for Iranian. That's a big advantage in our job. The photos we took for the foreign press soon reappeared on placards carried during demonstrations! For me, this photo represents lost illusions. I thought we could change things, I'm not so sure now. And it also marked the onset of professionalism. The difficult thing now is to work passionately on stories just as important as that one, without getting too involved."

"This photo represents lost illusions."

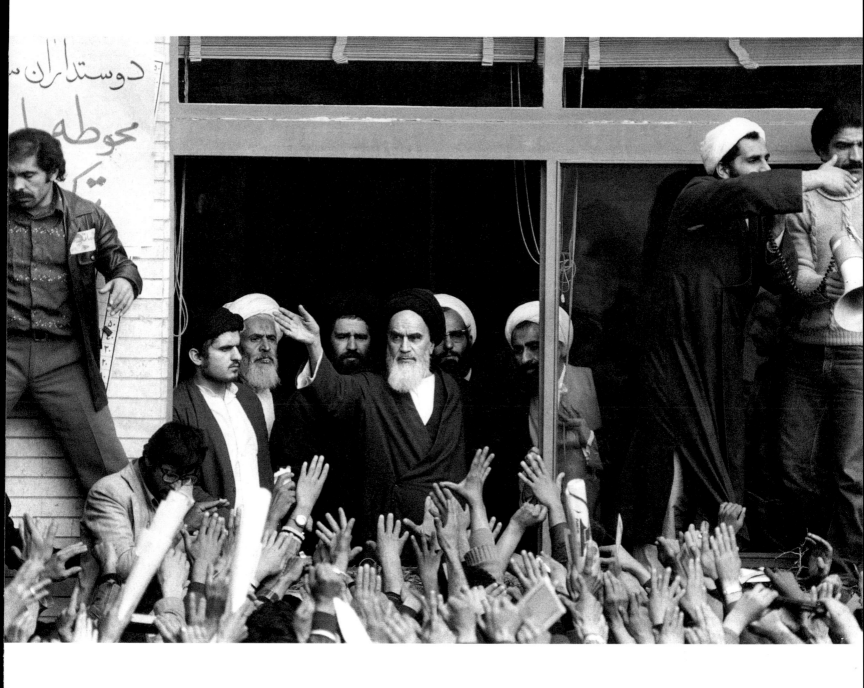

"The mullahs took the place of the intellectuals who surrounded Khomeini in Paris."

An intellectual friendly with Khomeini when in exile in France, Bani Sadr became the first President of the Islamic Republic. Denouncing the regime's totalitarian tendencies, he went into self-imposed exile in 1981. Since then, he has lived as a recluse in the Paris area. "This photo prefigures the coming dictatorship because you can see that the mullahs have taken the place of the intellectuals who surrounded Khomeini in Paris. They monopolised the new government, which devoured its own children. All the figures in this photo are dead, except Hussein, Khomeini's grandson, on the far left, who fled to Italy and, on the far right, the current President of the Parliament. Ahmad, Khomeini's son, behind him on the left, died in suspicious circumstances. At his side is a mullah from Shiraz, who was murdered. Finally, on Khomeini's right, one of the leaders of the Guardians of the Revolution; he died in a plane crash, said to be no accident. This regime is a complete failure. It thinks it can postpone its fall through murder and crime. But it will never silence the people's cry for freedom."

Bani Sadr

War in Afghanistan

© Alain Mingam/Gamma

→ TIMELINE

27 December 1979: the Red Army invaded Afghanistan to uphold the communist regime, instituted after a military coup. Supported by Pakistan and the USA, the resistance fighters waged 'holy war' on the 100,000 Soviet soldiers. The USSR was mired in the Afghan conflict, which accelerated its fall; it withdrew in 1989. The war claimed 13,000 Soviet lives, and left a quarter of the Afghan population living in exile. In April 1992, the mujaheddin liberated Kabul, but the victors now fought their own civil war. In September 1996, the Taliban captured Kabul, enforcing Islamic law with a reign of terror.

073

ALAIN MINGAM

"All the hatred of the Afghan people for the reigning communists was focused on that man."

The Call to Arms

"FOR SOMEONE LIKE ME, who didn't cover the Vietnam war, the mujaheddin's battle against the biggest army in the world was David versus Goliath: those bearded, turbaned men fascinated me." It was July 1980, six months after the Russian invasion. A photographer with Gamma, Alain Mingam arrived in Afghanistan pretending to be a tour operator's representative. His aim: to report on the resistance being organised all over the country. In a carpet seller's shop, the Islamic Jihad suggested that Mingam go to the village of Farzac, 30 km from Kabul: a strategic place, close to the Salong road used by the Soviet supply convoys. "I'll never forget my arrival in that remote valley. The mountain was covered with turbaned men who materialised suddenly from thickets like an army of ghosts. They only had one large calibre weapon: a *duchaka*, captured from the enemy." In conversation with the commander, Mingam learned that the resistance fighters were about to execute a 'traitor', sentenced by an Islamic court for betraying nine mujaheddin who had died by firing squad in the Pol-e-Tcharkhi prison. "He was presented to us. He arrived with his hands tied behind his back and surrounded by angry, menacing fighters. I had to take the photo: it was powerful testimony about the start of a civil war that is still raging. All the hatred of the Afghan people for the reigning communists was focused on that man." ∎

Should he have photographed an execution? Alain Mingam is faintly exasperated: "Of course. It's my job to show these things. With or without a photographer, that man would have been executed." He went on to recount the last minutes of the condemned man: "They took him to the riverside. He turned towards Mecca and started to pray, which the firing squad found hilarious. The volley echoed through the mountains. They began to hack at the corpse with a sabre. Then the commander intervened, saying 'Stop, that's enough', probably because I was taking photographs." His series of photos was given a World Press Photo award.

ALAIN MINGAM

"With or without a photographer, the man would have been executed."

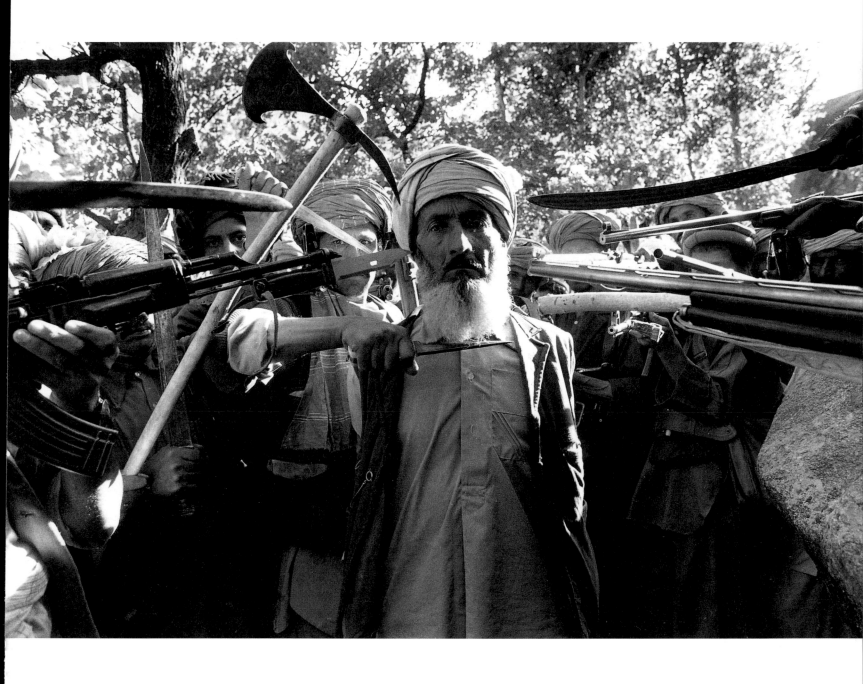

"Without the support of the Western press, military aid would never have been sent."

He lives with his family in a small two-roomed apartment in the back courtyard of a dilapidated building. 'Embassy of the Islamic Republic of Afghanistan', reads the sign. Cultural attaché until the advent of the Taliban, Mehrabodin Masstan is now the representative of Colonel Massoud, whom he joined in 1980. "This photo is dated," he tell us, in impeccable French, "it symbolised the start of the Afghan resistance movement, which was armed with what it could find: picks, medieval sabres, knives, and Lee Enfields left behind by the English in the 19th century. There were also two Kalashnikov rifles taken from the enemy or from a deserter. At the time, it was difficult to draw the world's attention to our battle. Everyone thought it was a lost cause, that Afghanistan was now irrecoverably part of the

Soviet sphere of influence. The Western press played a vital role in countering communist propaganda, which portrayed Afghans fraternising with the Russians. It is obvious from this photo that the mujaheddin are posing for the photographer. The message for Afghanistan was: 'No mercy for informers' and for the world at large: 'We are fighting the communists'. When, in 1984, the West realised there was Afghan resistance, massive military aid followed."

Mehrabodin Masstan

Strike in Gdańsk
© Alain Keler/Sygma

ALAIN KELER
"It was a completely surreal scene!"

→ TIMELINE

14 August 1980. The 17,000 workers at the shipyards in Gdańsk came out on strike. On 31 August, Solidarność, the first independent trade union of the communist era, was officially born. At its head, Lech Wałęsa, a devout Catholic, supported by Pope John Paul II and the Polish church. On 13 December 1981, General Jaruzelski proclaimed a state of war and the Warsaw Pact tanks invaded Poland. Solidarność was prohibited and Wałęsa arrested. Awarded the Nobel Peace Prize in 1983, the former electrician was elected President of the Polish Republic in 1990.

WHEN HE TALKS ABOUT the scene, the enthusiasm in his voice is catching: "I was walking in the Lenin Shipyard when I saw two cars driving through the entrance gates. The workers immediately formed a guard of honour and began cheering. Two priests sat down on low stools and began to hear the confessions of the crowd. It was completely surreal!" A photographer with Sygma, Alain Keler arrived in Warsaw without a visa. He got in by pretending to be a salesman. A holiday atmosphere reigned in the shipyards, under the sympathetic eye of the people pressed against the railings of the shipyard, which had been declared a "free territory". Everywhere, portraits of John Paul II, the former Archbishop of Krakow, had replaced Party posters. And here the confession took place. On the left of the photo is Wałęsa in his work clothes, his head bowed and his hands crossed. "He led the prayer of the rosary, and seemed very shy," Keler notes, "I would never have imagined his subsequent destiny". Nor did any of the newspapers that published the photo; they re-centred it, cropping out the founder of Solidarność. "At the time, no-one knew who he was; twenty years later it's amusing to see he was cut out of the photo." And he adds: "In any case, the priests are what made the photo interesting; they tell you a lot about Poland today." ∎

Solidarity

Lech Wałęsa

He says "he's not interested in the past" and that he "has never seen this photo". Speaking from his Gdańsk fief-dom, once again his home after he lost the presidential elections of November 1995, Lech Wałęsa adds, a little testily: "It's true that it was a historic moment and that we no longer go to confession like that. Without the Western press, I would never have become a hero and we would never have won: you can do amazing things, but if no-one talks about them, there's no point."

"The press made me a hero."

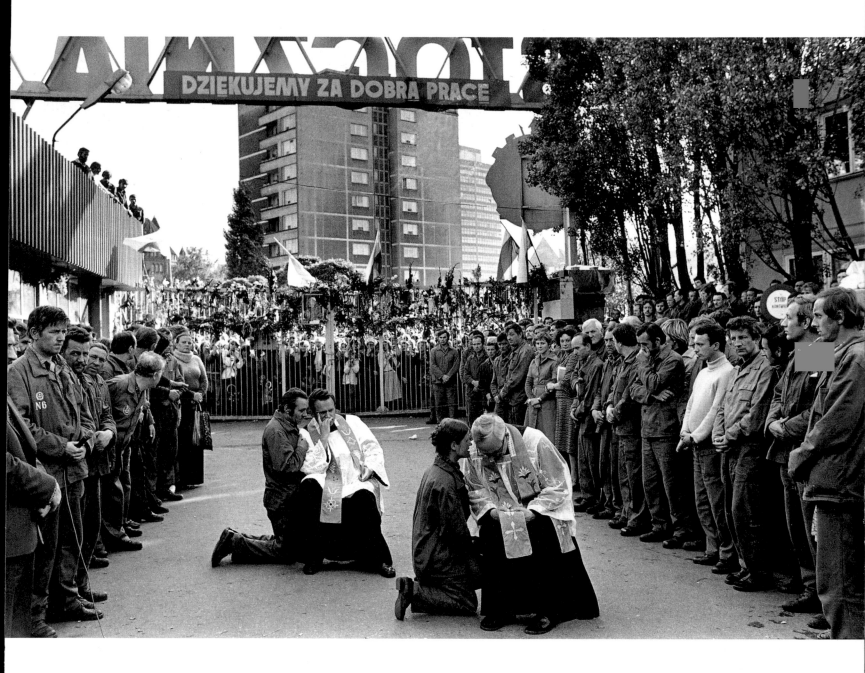

DZIEKUJEMY ZA DOBRA PRACE

"I organised the confession."

Jan Jankowski

He is the priest in the centre of the photo. Having become Lech Wałęsa's confessor, Jan Jankowski was summoned to Rome, in 1997, for making anti-Semitic remarks from the pulpit. But the black-frocked priest refuses to discuss that. "As soon as I was told about the strike, I decided to support it spiritually – and physically. Before joining the strikers, who wanted me to celebrate mass, I made my will in case things turned out badly. In the Lenin Shipyard, the workers had erected an altar on the back of a tractor. Some threw their Party cards in the gutter; others were wearing a cross or medallion of the Virgin on their bare chests. This was where I met Lech Wałęsa for the first time. After the mass, I suggested we organise an open-air confession, which became one of the great rituals of the strike. Like Mr Wałęsa, I thought that faith could liberate Poland."

The Iran-Iraq War

© Henri Bureau/Sygma

HENRI BUREAU

"I waited twenty years for this photo."

The Oil War

→ TIMELINE

22 September 1980. Saddam Hussein's Iraq invaded Ayatollah Khomeini's Iran. This was the First Gulf War. The main area of conflict: the border region along the Shatt al-'Arab river, the site of half the world's oil resources. The war was ferocious; three million soldiers took part in trench warfare that degenerated into butchery. When, eight years later, a cease-fire was declared, there was no outright winner. The war had claimed a million lives and ruined both economies.

"PEOPLE HAVE CRITICISED me for setting the photo up. Well? How does that detract from it?" A former photographer with Sygma, Henri Bureau stands by his actions. He arrived in Iraq on the third day of the war. Escorted by two Iraqi army jeeps, he was driving along the road by the Shatt al-'Arab river when he saw "enormous plumes of smoke rising from the desert". The Iranian oil refineries of Abadan were in flames. "Stop!" he shouted, suddenly realising that night was about to fall. "I saw my driver walking, machine gun in hand. Something extraordinary entered my viewfinder. He smiled at me making the V-for-victory sign. But I didn't want his nationality to be visible. I wanted a photo that symbolised the oil war, so I asked him to turn round. That's all! It's not a staged photograph: I didn't start the war or bomb the refineries of Abadan! There was no manipulation. In my career, I've missed thousands of photos that I simply didn't see in time. I waited twenty years for this photo, and when it came, I didn't miss it. It's my pride and joy…" ■

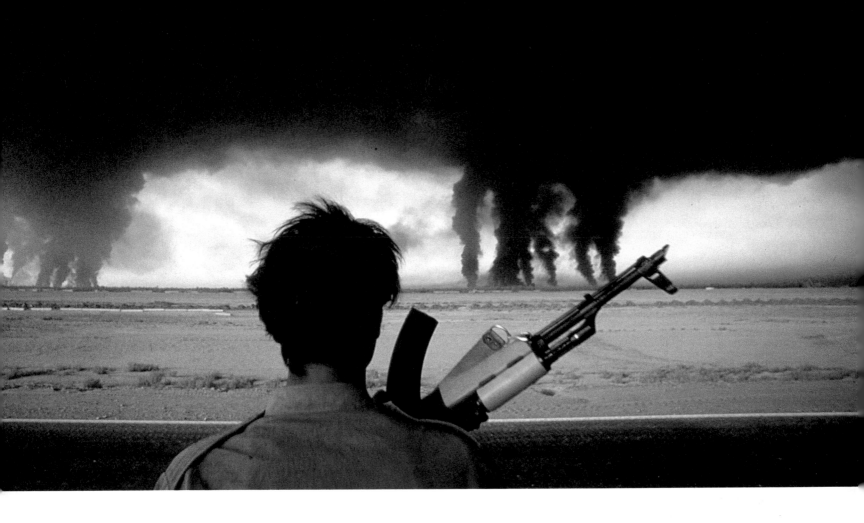

"The ultimate icon of the Iran-Iraq war."

"The photo has been published again and again. It completely transcends the specifics of the Iran-Iraq war, that is why it's so powerful", explains Frank Mueller-May, who ran the New York office of *Stern* at the time.

Published in the German magazine in 1980, the photo reappeared in 1991, a month before Operation Desert Storm was launched in the Second Gulf War. "It needs no caption; all the key issues are in the picture. It's the ultimate icon of the Gulf War and, given the economic and political importance of oil, it has a great future!"

Frank Mueller-May

Putsch in Madrid
© Manuel Perez Barriopedro/Agencia Efe/Sipa Press

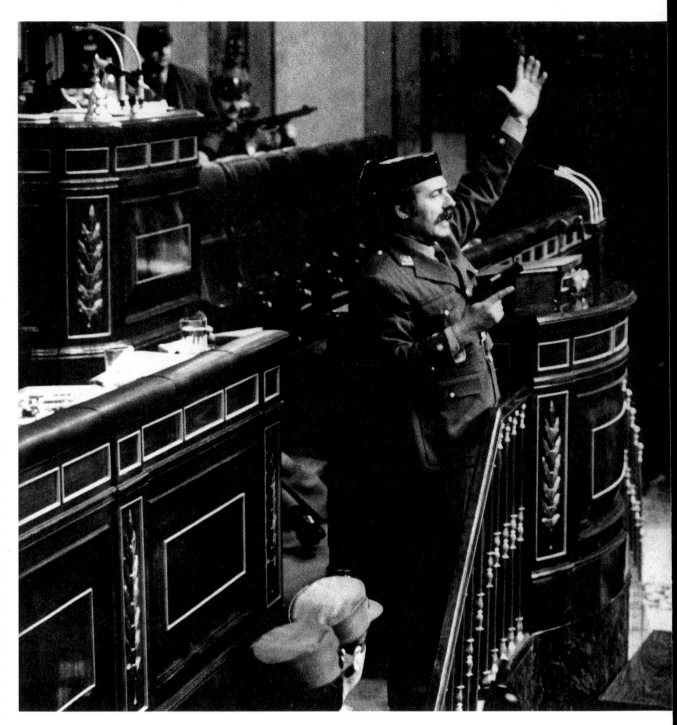

→ TIMELINE

23 February 1981. A plenary session of the Spanish Parliament was convened to elect a new Prime Minister. On 19 January, Adolfo Suárez had resigned, after leading the first democratic government since the death of General Franco in November 1975. As tanks invaded the streets of Valencia, Lieutenant Colonel Tejero and three hundred Guardias civiles stormed the Cortes. The military coup was firmly condemned by King Juan Carlos, the supreme commander of the army, who emerged as a key player in Spain's nascent democracy.

Santiago Carrillo

Secretary-general of the Spanish Communist Party, Santiago Carrillo was one of the four hostages who refused to throw themselves flat on the floor. Returning from exile in 1976, he had been one of the main opponents of Franco's dictatorship.

"I decided to defy the orders of the rebels; I thought it was undignified for a representative of the nation. Besides, I thought, if the military coup succeeded, they would shoot me anyway. So I might as well not let them cast me as a coward. When I see that photo, I'm ashamed of my country. That night, Spain was like a banana republic." The photo won a

World Press Photo award, and appears in many Spanish history books. "For me," says Manuel Perez Barriopedro, "it symbolises the victory of the Spanish people over the soldiers".

"I'm ashamed of my country."

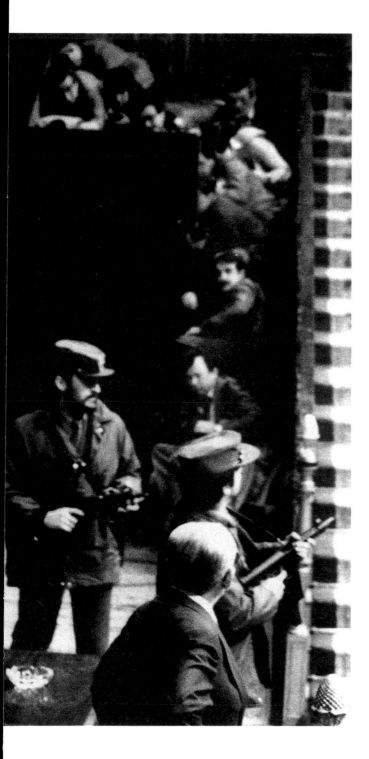

MANUEL PEREZ BARRIOPEDRO

"It was one of the blackest days in Spanish history."

"PEOPLE SAID MY PHOTO helped defeat the military coup, and I'm very proud of that." A photographer with the Efe Agency, Manuel Perez Barriopedro will never forget the long night of the '23F', as it is known in Spain. At 18.20, when the parliamentary vote was in full swing, uniformed men burst into the chamber firing automatics. "Everyone on the floor! Stay calm!" bellowed Lieutenant Colonel Tejero. All but four of the deputies and ministers threw themselves down. Manuel Perez Barriopedro managed to take eleven photos. "I just had time to hide my film in my shoe, when I saw the Guardias civiles seizing film from my colleagues. At 21.30, all the journalists were allowed to leave." The next morning, a photo was splashed across the front page of the European newspapers: it showed Tejero vociferating, pistol in his hand, on the presidential tribune of the Cortes. The picture was Perez Barriopedro's. "My photo electrified the country and became the emblem of resistance to the putsch." Thousands of Spanish citizens took to the streets to defend democracy. This vast upsurge of feeling, combined with King Juan Carlos' intervention, determined the outcome of the attempted putsch. At 12.00, the hostages were released and Tejero gave himself up. He was sentenced to thirty years in prison and released in December 1996 for good behaviour. ■

Attempt on President Reagan's Life

© Ron Edmonds/Associated Press

Ron Edmonds: "If you blinked, you missed the photo."

Point-blank

→ TIMELINE

30 March 1981. President Ronald Reagan was wounded in an assassination attempt in Washington. A former member of a neo-Nazi group, John Hinckley, aged 21, fired six shots. A bullet hit President Ronald Reagan in the left lung; James Brady, head of the White House Press Office was seriously wounded in the head, and two security agents were slightly injured. This was the seventh attempt to assassinate a US president in the 20th century. The affair sparked off a national debate about the constitutional right to carry arms.

ACCORDING TO the American secret services, it all happened in 1.9 seconds. "If you blinked, you missed the attack," confirmed Ron Edmonds, the Associated Press correspondent at the White House. The day started uneventfully. On the agenda: a lecture by Ronald Reagan to an audience of industrialists at the Hilton Hotel. As soon as the speech was over, Ron Edmonds rushed to take up a vantage point outside the hotel entrance. He photographed the President waving to the crowd as he moved towards his limousine: "Suddenly, I saw him grimacing in the viewfinder. I kept shooting, without realising what was happening." As his motor-driven Nikon only took six pictures a second, he got only four photos. But what photos! Boxed in by the crowd, the other photographers looked on in despair; Edmonds alone caught the incident. As soon as his negatives were developed, they were sent to AP's 4,000 international clients. A feat which made it possible for 2,000 newspapers to make room for his photo that evening. "It was the most exciting moment of my career," confesses Edmonds, who received the Pulitzer Prize and a World Press Photo award. "On the other hand, from a financial point of view, this photo earned me almost nothing." Standard procedure: AP holds copyright on the photos of its employees. ■

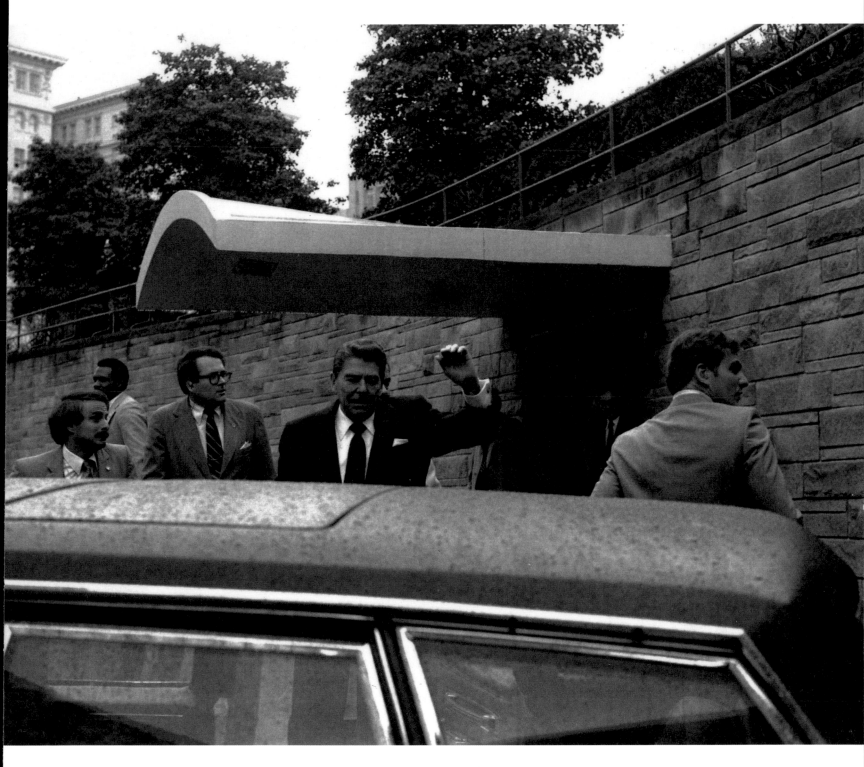

SEBASTIÃO SALGADO

A photographer with Magnum, Sebastião Salgado returned from Australia to execute a commission from the *New York Times*. His brief: to shadow Ronald Reagan for a week and illustrate the first hundred days of his presidency. "This was not exactly my cup of tea, but it was exciting to be close to the most powerful man in the world." Before going to the White House, he borrowed a jacket, tie and shoes. He was not accredited for the Hilton seminar, and argued hard and long to be allowed into the security vehicle, "a small van containing some fifteen men". When the first shot was fired, Salgado went into action alongside the security team, which was trying to immobilise the gunman behind the presidential limousine. The result: seventy-six photos telling the other side of the story. A godsend: published in the leading in-

"A godsend."

ternational magazines, his photos brought in around 250,000 dollars. Unlike Ron Edmonds, Salgado owned his negatives. The Magnum co-operative took only a percentage of the proceeds: "I can't remember how much I earned, let's just say I bought a big car and an apartment in Paris!"

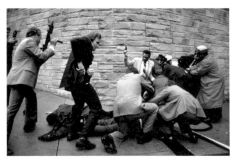

Sebastião Salgado's seventy-six photos tell the rest of the story.

DOUGLAS KIRKLAND

"It was the best scoop of my career."

1981

Princess Di's Kiss

© Douglas Kirkland/Contact Press Images

→ TIMELINE

29 July 1981. Prince Charles, heir to the throne of England, married Lady Diana Spencer, watched by a television audience of 720 million. The Windsors had planned everything but this kiss, which marked the climax of the most lavish wedding of the century. But the fairy tale did not last. In 1996, the couple divorced and, on 30 August 1997, the Princess of Wales died in a car crash in Paris, trying to escape the press.

078

DURING CHARLES AND Diana's wedding ceremony, some fifteen photographers were bustling about a press stand beside the Queen Victoria Memorial opposite the Buckingham Palace balcony, where the royal family was due to appear. Among the photographers was Douglas Kirkland, who worked for the Contact agency. Armed with a battery of cameras, he set up his 400 mm on a tripod and waited. Suddenly, enthusiastic cheering began and he "shot like mad". "The appearance lasted about fifteen minutes", he says, "and, thinking it was all over, the photographers started to put away their equipment. I saw the couple glance at each other, and then came that wonderful kiss!" "Attaboy, Charlie!" cheered the crowd. The photographer had time for three photos: the first shows the couple leaning towards each other, with the royal family looking the other way; then, the kiss, followed by a third photo, which shows the half-amused, half-embarrassed reaction of the family. Filmed by the BBC, the scene was examined in minute detail. A deaf and dumb expert pieced together the conversation, and gave this account of it: "Why not give her a kiss?" whispered Prince Andrew. "May I, mother?" asked the groom. And the Queen assented. ■

Princess of Hearts

"This photo marked a turning point in the history of the British monarchy," remarks Michael Rand, head of photography at the *Sunday Times Magazine*. "We'd never seen such an informal and intimate photo." In other words, no-one had ever seen a royal couple kissing in public. He adds: "That photo created the myth of the Princess of Hearts". Everyone praised the naturalness of the young Princess, who broke with rigid Palace protocol so gracefully. After this "young and glamorous" image, the 'royal pack' thrived. Princess Di was assigned some ten tabloid photographers, who followed her every movement. The frank young woman developed a taste for this, exploiting the pack to create the image of the 'rebel princess'. "She learned how to manipulate photographers with great subtlety," says Michael Rand. "She hated the more sinister aspects of the pack, of course, like the paparazzi, but, generally speaking, she encouraged it. This snowballed until her tragic death."

"Lady Di learned how to manipulate photographers with great subtlety."

Michael Rand

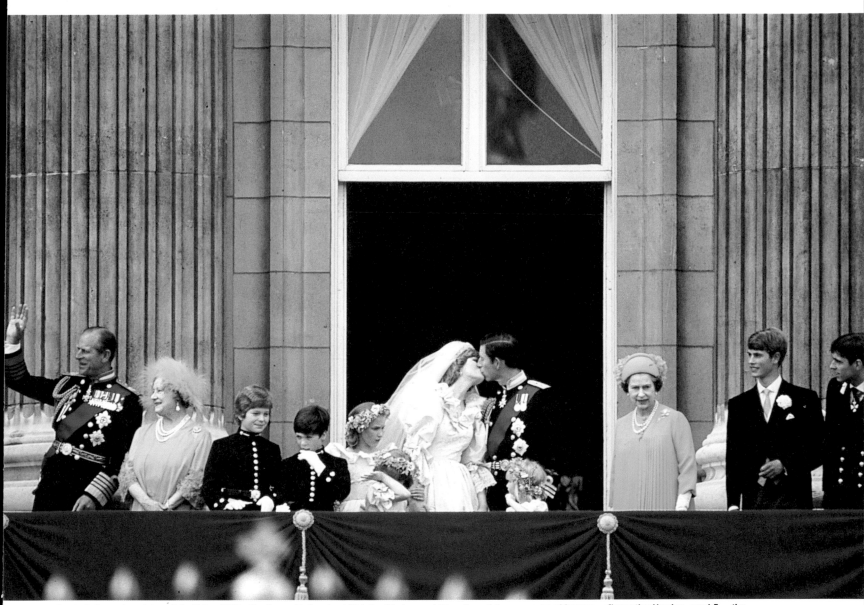

On the balcony, from left to right, Prince Philip, the Queen Mother, Lord Nicholas Windsor and Edward van Cutsem – pages of honour –, Clementine Hambro, aged 5, – the great granddaughter of Sir Winston Churchill – and Catherine Cameron, aged 6, holding Princess Diana's hand. Beside Prince Charles stands Queen Elizabeth and Princes Edward and Andrew.

François Mitterrand

© Guy Le Querrec/Magnum Photos

GUY LE QUERREC

"Everything struck a chord."

→ TIMELINE

10 May 1981. François Mitterrand was elected President of the French Republic. General de Gaulle's most consistent opponent wanted to make history. At 30, he had been the youngest minister since the First Empire. Juggling his convictions, he represented the French Left for twenty-five years. He was a consummate politician, and a master of rituals and symbols: he abolished the death penalty, promoted European unity, and launched a programme of large-scale building projects. Till his death in January 1996, François Mitterrand remained the architect of his own image.

The Sphinx

ON 8 MARCH 1982, the music room of the Elysée Palace was bathed in light. "It was good for photos," says Guy Le Querrec, "but bad for Daniel Druet: he prefers northern light, it's more revealing". The two men are old friends. For six years, they worked together for the Musée Grévin: one photographing celebrities, the other making wax models of them. At the Elysée Palace, the commission included a presidential bust. "I was a bit in awe," smiles Guy Le Querrec, "it was the first time I'd been inside the private apartments of the Head of State. And François Mitterrand did nothing to put us at ease." For that fourth sitting, the President arrived half an hour late, "as always". Silently he sat down on the dais, put on his glasses and immersed himself in *Libération*. The front page was perfect for International Women's Day: "Mitterrand: Women, Our Friends", read the headline. At his side, Nil, his Labrador, a key character in this "avant-garde play". The sound of pages turning, the sculptor's hands moulding the clay, delicate clicks from the Leica. Like a choreographer, Daniel Druet circled his subject, took a few steps back. "Then, happily, Danièle Mitterrand crossed the room," Le Querrec recalls. "It was a magical appearance in a completely surreal scene. At the same time, Nil decided to raise his right paw slightly. Everything struck a chord…" ■

"I'm don't much like that photo; it reminds me of a very painful time." In his Paris studio, Daniel Druet chooses his words carefully. "I couldn't capture Mitterrand's true personality. He refused the intrusive gaze of the sculptor in his own home and jealously defended his inner self. Everything exacerbated the ordeal: dreadful light, the coming and going of ministers, the dog and Mme Mitterrand, the President's changes of mood, by turns cheerful and haughty. Result: the bust was dreadful and at the eighth sitting I simply destroyed it. Mitterrand was so surprised that his mask slipped a little. Having caught him off balance, I made the most of his discomfiture to capture his true self and finished the final bust in two hours. I have the only bronze cast: the President never had any others made, probably because I had wrested from him things he preferred to conceal."

Daniel Druet with the completed bust.

"I destroyed the bust at the eighth sitting."

079

This bust was destroyed at the eighth sitting. The final bust was completed in two sittings, but only one cast made.

"The 'Venice temptation'."

The photo was published all over the world in 1988, when François Mitterrand was pursuing a second term. "The portrait was an immense success because it embodied the many facets of the man," explains writer Jean Lacouture, author of a posthumous biography. "On the one hand, it shows Mitterrand's desire for immortality; he is having a bust made, and stages his desire for a place in history by being photographed posing. On the other, it shows what I would call the 'Venice temptation': his taste for masks and secrecy. He hides behind his glasses and his paper, and even behind his wife, one of the vital people in his life. The interplay of sculpture and photo is a further distraction; this is the epitome of the sphinx."

Jean Lacouture

The Falklands War

© **Rafael Wollman**/Gamma

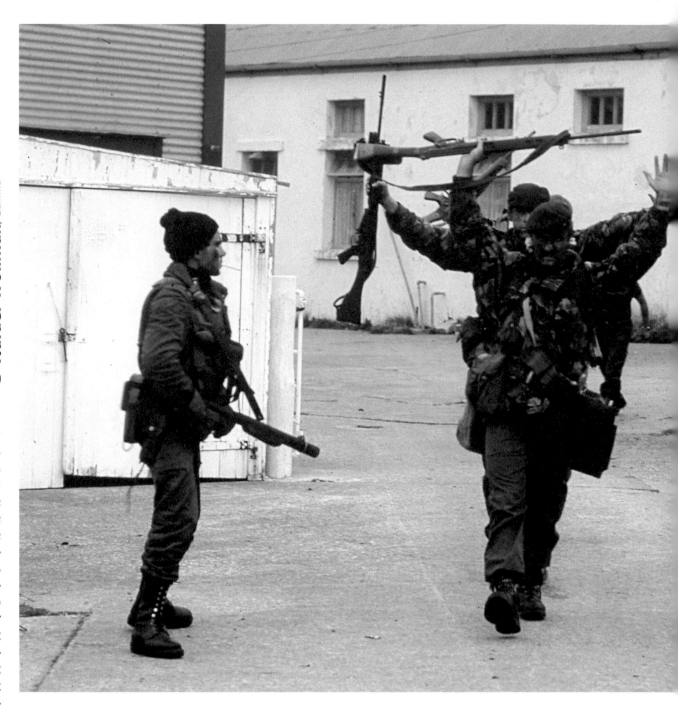

→ TIMELINE

2 April 1982. 5,000 Argentine soldiers seized the Falklands Islands, a British possession since 1832; they lie some 500 km from the mainland. The Argentine Generals had headed a ferocious dictatorship since 1976; they hoped this exploit would play on nationalist sentiment and end domestic stagnation. They reckoned without the determination of British Prime Minister Margaret Thatcher, who resolved to retake the islands. After a high-tech war, the Argentine army surrendered. The war ended the Argentine dictatorship and led to the triumphant re-election of the 'Iron Lady'.

"These were the most expensive photos we'd ever bought."

When he tells us "what happened next", he still can't get over it. On his return to Buenos Aires, Rafael Wollman was besieged by representatives from all the world's photo agencies: "I've never been so stressed in my life. I hadn't even developed my photos, and people were already urging me to sell them at prices I would never have imagined in my wildest dreams!" Gamma finally landed the shots for the small matter of 50,000 dollars. In Paris, the agency immediately sought the highest bidder. In France, two clients made the running: *Paris Match* and *VSD*. "The negotiations lasted all night," recalls François Siegel, who was working for

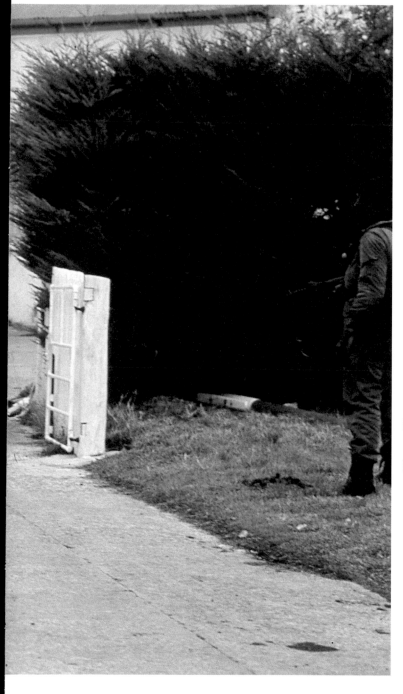

Humiliation

RAFAEL WOLLMAN

"I've never been so stressed in my life."

THAT'S LUCK FOR YOU. On 23 March 1982, Rafael Wollman arrived in the Falkland Islands to report on the lifestyle of the Falklanders, the descendants of English pirates who conquered this archipelago of the Roaring Forties. "I had spent a week photographing them when I heard a speech by Rex Masterman Hunt, the British Governor, on the radio. He announced that the Falklands had been invaded by the Argentine army. It seemed unbelievable." At dawn on 2 April, 5,000 soldiers captured Port Stanley, the capital of the Falkland Islands. They were confronted by eighty British marines, entrenched around the Governor's house. After exchanges of gunfire and grenades, in which an Argentine officer was killed, Vice-Admiral Gilabert advanced waving a white flag, ordering the unconditional surrender of the British. One by one, the marines gave themselves up, holding their weapons above their heads. Which is when the photo was taken, symbolising the most humiliating experience ever suffered by the United Kingdom. It shows three English soldiers covered by a proud, threatening Argentine, before being disarmed and searched on the ground. Rafael Wollman kept shooting till the British were evacuated: "I knew I was the only journalist, because the Argentines had sealed off the island: it was the biggest scoop of my career!" ■

VSD at the time. "The Gamma representative trotted to and fro up the Champs-Elysées. We finally obtained the documents for 400,000 Francs,

François Siegel

having started at 150,000. It was a record figure for our magazine." And it gives some idea of the profit made by Gamma around the world. Wollman himself makes a quick calculation. "I had just founded a small agency with three Argentine colleagues. Thanks to my scoop, we fitted out our studio, and each of us bought an apartment or paid off a house."

Arafat in his Bunker

© **Reza**/Sipa Press

→ TIMELINE

1982. Israel invaded the Lebanon, which Yasser Arafat, the leader of the Palestine Liberation Organisation, had chosen as his base after being driven out of Jordan in 1970. After the massacres in the Palestinian camps of Sabra and Chatila, the PLO were evacuated to Tunis. In 1983, Arafat secretly arrived in Tripoli, north Lebanon, where he was besieged by the Syrians and dissident Palestinian factions. After many years in the wilderness, he made a triumphant return to Palestine in 1994, after the Oslo Accords.

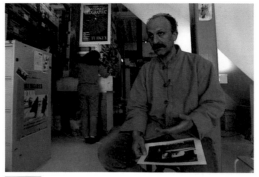

REZA

"I'll never forget the intensity of his expression."

"I'D NEVER PHOTOGRAPHED Arafat looking that intense: it was a moment of truth that revealed his isolation and his determination, and it was very moving." An Iranian living in Paris, Reza was an old acquaintance of Arafat's; working for the Sipa agency and *Time*, he had followed him from Beirut to Tunis in his headlong flight to save his people and himself. In late October 1983, he was working in the Lebanon and decided to travel to Tripoli, where the PLO *fedayeen* had been under siege since late September. On arrival at the Palestinian headquarters, he was told that the 'Old Man' would hold a press conference and that afterwards "there would be a surprise". "It was always like that," says Reza, "for security reasons, they told us Arafat's schedule at the last possible moment". Their destination: the Palestinian camp of Bedawi where Fatah loyalists were entrenched. "There were about fifty of us, including fifteen journalists. As Arafat and Abu Jihad, his Defence Minister, were inspecting the front, the Syrians started to shell the camp from the surrounding hills. Their guards immediately bustled them into a nearby bunker. All the journalists followed, except me. In this job, I have a principle: never run where everyone else is running. Bullets were ricocheting above my head. It took me a few seconds to get round the bunker. Then I spotted Arafat peering through a slit. I took five shots. I'll never forget the intensity of his expression." ∎

The Phoenix

"Some photos don't need a caption: this is one." Now retired to the coast of Florida, Arnold Drapkin was head of photography at *Time* for over thirty years. "I remember when that photo arrived at the magazine. We had almost completed the issue and we didn't really have any good photos. I knew Reza was in Tripoli, and I was impatient to see his films, which were arriving from Paris by Concorde. When I saw the photo on the slide table, I was so excited that I summoned all my staff to show them how the perfect picture looks. Not only does it sum up the historical situation, but it was an excellent portrait of Arafat who, like a phoenix, always rises from his own ashes. I published it in our annual supplement as one of the best photos of 1983."

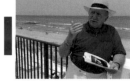

Arnold Drapkin

"One of the best photos of 1983."

"The symbol of the military leader."

"President Arafat likes this photo very much," says Leila Shahid, President of the Palestinian Delegation in France. "Reza presented him with a print at the Palestine National Council organised shortly afterwards in Jordan. But to illustrate our president's nine lives, we would need several photos: Arafat as a student, Arafat at the UN, a pistol in his belt and an olive branch in his hand, Arafat shaking Yitzhak Rabin's hand, etc. This photo symbolised the military leader, the man whose courage set him above all the other Palestinian fighters. Going back to Tripoli in 1983 was a very reckless thing to do. This photo is ultimately a reminder that diplomacy was only reached by armed force."

Leila Shahid

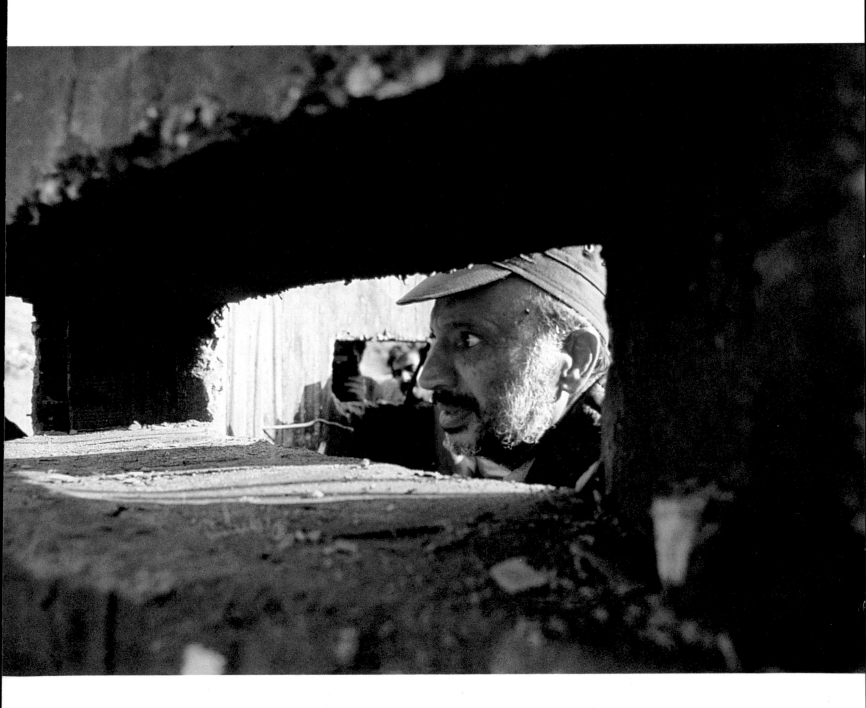

Sicilian Chronicles
© Franco Zecchin

→ TIMELINE

September 1982. General Dalla Chiesa, the Palermo Police Chief, was murdered by the Cosa Nostra. Italy passed its first anti-Mafia law. Its weapons: in camera interrogations and the with drawal of bank confidentiality. In 1986, the 'maxi-trial' opened, with a pool of judges including Giovanni Falcone. The evidence of supergrasses led to the conviction of 474 people. In May 1992, Falcone died in an attack ordered by Tino Riina, who was arrested a year later. Meanwhile, 300,000 Italians demonstrated in Palermo: the end of the *omertá* led to popular mobilisation against the Mafia.

FRANCO ZECCHIN

"The people watched this slaughter in fear and silence."

O N 15 NOVEMBER 1983, Franco Zecchin, on standby for the newspaper *L'Ora*, intercepted a police message about a homicide in an outlying district of Palermo. "It was at the height of the war between the Mafia clans," he says, walking up a winding alley. "At the time, there were as many as two murders a day. People watched the slaughter in fear and silence." Reaching the scene of the crime on his Vespa, Zecchin found some ten people gathered round. "It was here," he says, "against that stone wall. In the foreground lay the body of the victim, Benedetto Grado, covered with a white sheet, beside a pool of blood; behind him, his mother and two daughters, dressed in black, prostrate with grief, with the police and the magistrate. I realised there was a very powerful picture there if I could simplify it, and I walked around the scene until only the three women, with their resigned, silent grief, were in the frame." Zecchin immediately rushed to the paper to catch the evening edition, placing the developed photos on the editor's desk. "He took the first, cut it, and that was the photo that went in." But it was not *the* photo. "Later, in the dark room, I took my time examining the contact sheet, and discovered this utterly unique photo, with the woman's face reflected in the pool of blood." ∎

An Eye for an Eye

"One day, everything suddenly fell into place," says Franco Zecchin. "Along with my girlfriend, Lettizia Battaglia, a journalist at *L'Ora*, I and a group of friends decided we could no longer stand by and watch this slaughter of people whom we respected for their commitment to society: magistrates, journalists and politicians. So, in 1979, we formed the first anti-Mafia centre in Palermo." Its name was 'Impastato', in honour of an activist murdered for denouncing the Onorata Società's stranglehold on his village. Its aim: to make people think about the Mafia, revealing 'its true face' by mounting itinerant exhibitions. "We gathered all the photos of murders published as and when in the press, like that of Grado. Shown together, they made a big impact. Some people didn't even dare stop and look at them; they knew that, if they did, they would be forced to condemn the Mafia. That's what we wanted: to break the esteem in which the Mafia was still held, and the code of silence on which its power was based. Photography is a direct language, it speaks to everyone, whatever their social or cultural level. Gradually, it brought about an anti-Mafia culture, which now, twenty years later, has become a powerful civic movement.

"It brought about an anti-Mafia culture."

"As if 100 or 1,000 people were speaking."

She still speaks of it with emotion. In 1992, Benetton launched an advertising campaign called 'The Shock of Reality', using Zecchin's now colourised photo. Michela Buscemi joined Women against the Mafia in 1986, when she lost two of her brothers. She saw the photo on a huge wall-mounted hoarding: "The moment I saw it, I felt enraged, overcome by a sense of furious revolt I didn't know I had in me. What really got me was the face reflected in the dead man's blood. It was as if I could see myself standing by my brothers as they lay dead on the ground. This photo has become the voice of those fighting the Mafia: it is as if 100 or 1,000 people were speaking."

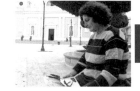

Michela Buscemi

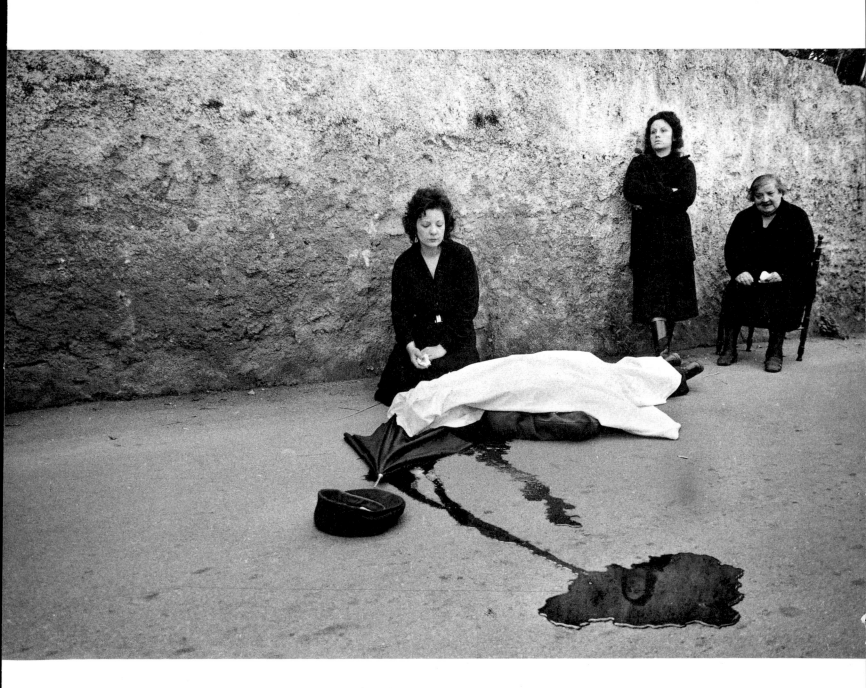

The Los Angeles Olympics

© **David Burnett**/Contact Press Images

→ TIMELINE

July 1984. The Olympic Games opened in Los Angeles, boycotted by the Eastern bloc. After her triumph at the World Championships in Helsinki the year before, Mary 'Divine' Decker was America's great hope. Running the 3,000 metres alongside Zola Budd, she tripped halfway through the race. The Rumanian Maricica Pulka won the gold medal, with a time of 8'35"96. A young sprinter, Carl Lewis, dominated the games, pocketing four gold medals in the absence of the Soviet Union.

DAVID BURNETT

"I couldn't believe what I saw in the viewfinder: Mary Decker had fallen."

H E WAS NOT A SPORTS photographer, luckily for him. "Always watch where Burnett positions himself," says a colleague at the Gamma agency, "he never gets the angle wrong. Quite simply, he's the best." On 10 August 1984, the atmosphere at the Los Angeles Coliseum was electric for the final of the women's 3,000 metres, one of the great track events of the Los Angeles Olympics. Hundreds of photographers massed at the finishing line. "Some of them had been there since five in the morning," says David Burnett. "They had set up six tripods, one for each camera and lens. One thing was sure, it was no use competing with them." The photographer decided to find a "comfortable spot, fifty metres away." On the fifth lap of the race, he saw Zola Budd starting to pull away from the rest of the runners. Flanked by Mary Decker, the young South African moved towards the outside lane. "I changed camera to use the short lens," says David Burnett. "As she came nearer, I couldn't believe what I saw in the viewfinder: there was a collision of sorts and Mary Decker fell over. I grabbed my telephoto lens just as the nurse arrived. Everything happened in the space of fifteen seconds: with my motor-driven camera, I just shot continuously. That evening, I called my wife. I told her: 'I've got good news and bad news. The bad news is, Mary Decker fell. The good news is, she did it right in front of my camera'." ■

Heartbreak

She was 18 and had been nicknamed the "bare-foot runner". The apartheid State of South Africa, where she was born, was banned from the Olympics. Zola Budd acquired British nationality in two weeks; a 'fiddle', shouted her detractors, who accused her of tripping Mary Decker. Disqualified, then reinstated to sixth place after an appeal, Zola Budd gave up international competition. "That was the toughest moment in my life. Mary was a model for me, and to be suspected of tripping her was unbearable. To be honest, I have no idea what happened. My only memory of that time is the one evoked by that unforgettable picture: I see the anger on her face and I still feel it's directed at me."

"I still feel her anger."

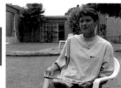

Zola Budd

Mary Decker

This is the first time she has agreed to talk about that day. Mary Decker is wearing a tracksuit. Her voice is frail as she admits that she "couldn't look at that photo for years": too much pain, too much disappointment and anger. "You can't turn the clock back. I felt so impotent." Her Olympic dream ended on the Coliseum track. In 1976, leg injuries meant she watched the Olympics on TV. Four years later, the US boycotted the Moscow Games. In 1984, her time had come at last. Several times world champion, Mary was 25 and America was cheering her on. "There was a lot of pressure, and so, when you fail, it's even harder. All I can remember is wanting to get up, but this wrenching pain in my hip stopped me. And the race going on without me … Afterwards, when the photo was seen all over the world, I was criticised for crying, but now I'm proud of it. Athletes are not machines, they're human beings like everyone else. This photo at least served to break the taboo; since then, I've seen football, baseball and basketball players crying. So why not me?"

"Athletes are human beings like everyone else."

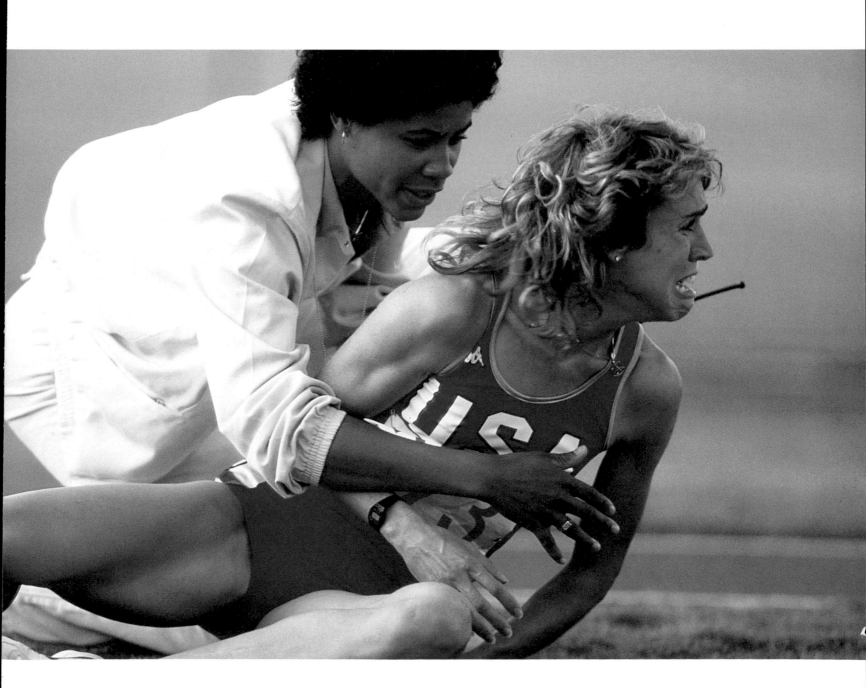

The Little Girl from Armero

© Frank Fournier/Contact Press Images

FRANK FOURNIER

"It was one of the most distressing moments of my career."

Omayra

→ TIMELINE

Wednesday 13 November 1985: at 22.00, the Colombian volcano Nevada Ruiz began to erupt. Twenty million cubic metres of incandescent ash and rock poured over the glaciers, melting enormous volumes of water that flooded into the valley. Bridges, roads, villages: nothing could withstand the torrent that, two hours later, engulfed the little town of Armero. For lack of an evacuation plan, 24,000 people died and tens of thousands were left homeless. This was one of the most lethal volcanic eruptions of the century.

"THIS LITTLE GIRL paid for the politicians' irresponsibility with her life. If I had to do it again, I would still take this photo." His voice choked with emotion, Frank Fournier finds it difficult to talk about Omayra, the little Colombian girl from Armero, whose picture shocked the entire world. On the Saturday after the catastrophe, at 06.00, the photographer met a peasant who took him to a pool of filthy water. A little girl's head emerged from the debris-filled cesspool. Holding tight to a piece of wood, Omayra Sánchez, aged 12, had spent two days and three nights submerged in mud, her legs trapped under the roof of her house. To save her would require a crane to lift the rubble and a pump to remove the water. The crane never came; the pump arrived too late. "I almost didn't take a photo, it was so unbearable. Then I told myself my function was to bear witness and that her courage in the face of death should be an example to me." Omayra had translucent skin, eyes red with exhaustion; her hands were white. Several times she smiled. She said she had to go back to school. She asked the paramedics to pray with her. Around 09.00 she suffered a cardiac arrest. The paramedics tried heart massage, but to no avail. "At 09.16, her head went back, and she was gone." ∎

084

The moment it was published, the photo of Omayra sparked off a bitter international controversy. Its target: the photographer, who was accused of mercenary voyeurism. "People reacted as violently to the photo as I did to the situation," says Frank Fournier. "I was the ready-made scapegoat for what masqueraded as an ethical debate. It was an outlet for the collective guilt people felt at being unable to organise help." In Colombia, the photo caused "an immense wave of solidarity for Omayra's mother," says journalist Germán Santamaría. María Sánchez was not in Armero when the tragedy happened. On holiday in Bogotá, she found out about her daughter's ordeal on TV. Following a press campaign, a group of industrialists offered her an apartment in the capital. The photo also raised national awareness,

resulting in a programme of emergency and safety measures that are still in operation today. As to the ethical debate, Colombia passed a law prohibiting publication of photos of prisoners or disaster-victims below the age of maturity. "In practice," says Germán Santamaría, "if a catastrophe of this magnitude were to happen again, I think the journalists of my country would disregard the law. Little Omayra was a national heroine: those who saw her battle for survival will never forget her. Since then, they are stronger, wiser and humbler."

Germán Santamaría

"Omayra was a national heroine."

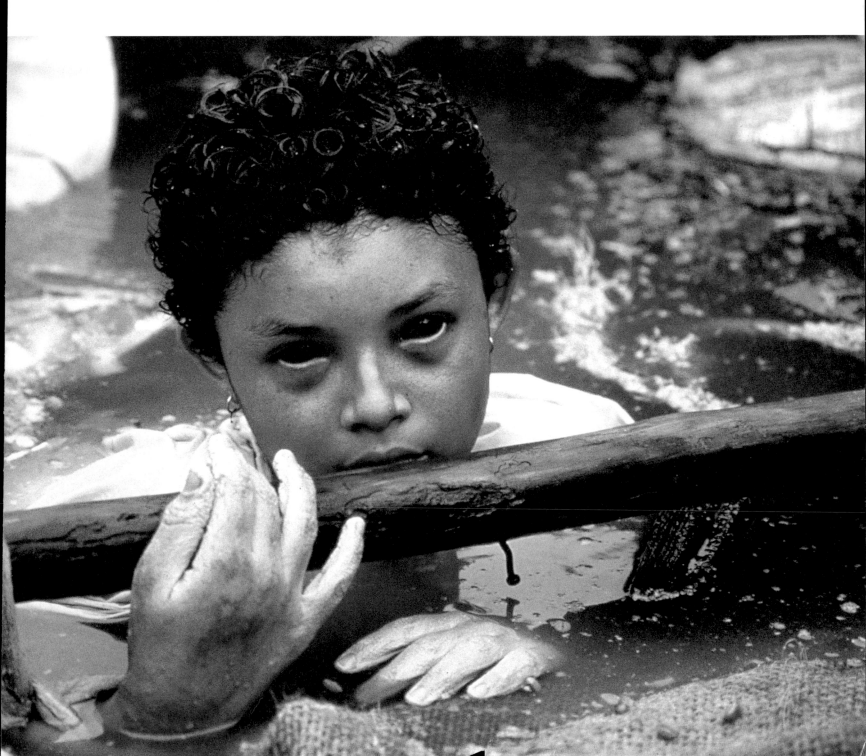

Aids

© Alon Reininger/Contact Press Images

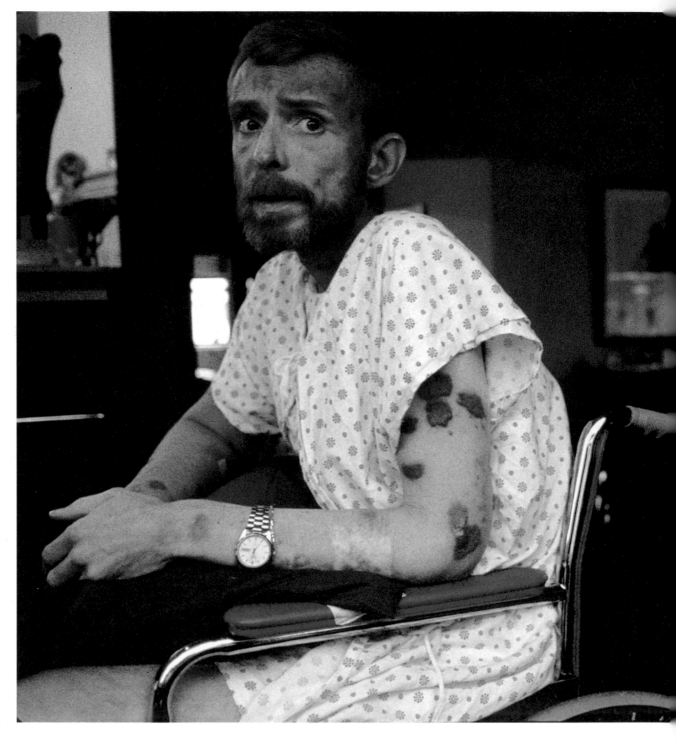

→ TIMELINE

1981. A strange disease, the 'gay cancer', began to strike down male homosexuals in Los Angeles and New York. The American gay community immediately started a crusade against what has become one of the century's worst pandemics. The virus was identified in 1983. Fear of contagion was at first confined to the gay community; now all social categories are at risk. By 1997, Aids had claimed twelve million lives and infected thirty million people, largely in developing countries.

"It was essential to break the visual taboo."

One of the first gay activists, writer Larry Kramer is the figurehead of the American anti-Aids movement. Founder of Act Up, he persuaded Alon Reininger to work on this subject. "In the early 1980s, Aids was a shameful disease, both for the public and for the sufferers, who died without assistance and in complete isolation. People were panic-stricken, although no one had ever seen an Aids sufferer. It was essential to break the visual taboo weighing on Aids. Reininger met great resistance within the gay community, which had been alienated by the sensationalist or moralising tone unanimously adopted by the press. He had one big advantage; he wasn't in a hurry. He took the time to forge real links with the homosexual community before starting work. This photograph enabled Aids sufferers to throw off their shame and become human beings again. Alon Reininger has done more for the fight against Aids than a thousand speeches."

Larry Kramer

Life and Death

ALON REININGER
"I didn't need to ask to take the photo. Ken was ready."

THIS IS THE STORY of a photo that shocked the whole world, even China, where it was used in preventative campaigns. It shows a painfully thin Aids sufferer, his arms covered in dreadful lesions: Kaposi's sarcoma, the skin cancer characteristic of Aids in its terminal stage. The man's name was Ken Meaks. He was the first American sufferer to agree to show his face, owing to the perseverance of Alon Reininger who, since 1981, has taken a keen interest in this "strange disease". "At that time, the US was in the throes of mass hysteria, which resulted in virulent homophobic campaigns." Reininger met Ken, a teacher in San Francisco, and his partner, Jack, both deeply committed to the fight against Aids. Demonstrations, hospital stays, the couple's wedding: day after day, Reininger photographed their life. Then, on Christmas night, 1985, "for the first time, Ken showed me the lesions caused by Kaposi's sarcoma. It was a nightmare sight. I said to him: don't you think people should know about this? But he refused to be photographed." Not until autumn 1986 could Reininger take the photo. Ken knew his time was near and he called Alon in New York. "I took the first plane; I realised this was the end. He was sitting near the kitchen window. I didn't need to ask. Ken was ready." ∎

The Chernobyl Disaster
© Igor Kostin

→ TIMELINE

26 April 1986. Reactor Unit 4 of the Chernobyl nuclear power station exploded. An enormous radioactive cloud spread across the USSR, contaminating mainly the Ukraine and Belarus. After two days of silence, the Soviet authorities evacuated 350,000 people. Nicknamed "the liquidators", 600,000 soldiers were sacrificed to clean up the site and cover the reactor's remains with a concrete sarcophagus. The official death toll for the explosion was thirty-one, but, twelve years later, radiation victims are in their thousands.

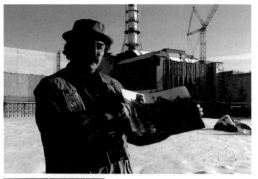

IGOR KOSTIN

"The sacrifice made by those men should *never* be forgotten."

JULY 1987. A photographer with the Novosti agency, Igor Kostin decided to accompany a group of liquidators onto the roof of Unit 3, next to the reactor ripped apart by the explosion: "There were vast fields of radiation. I would never have been able to find my way through without a guide with a Geiger counter. We groped around trying to protect ourselves from the fatal but invisible danger." On the roof, teams of eight liquidators rotated every forty seconds. Wearing lead overalls, the men rushed out, shovel in hand, as soon as the siren sounded. Just time to throw a shovelful of nuclear debris into the crater made by the explosion. The photographer returned to the roof five times in a week for two to three minutes at a time. "All the films I developed were black. So I shielded my Nikons with lead plates and cut my films into 20 cm strips varying the exposure time. Four of my cameras are now buried in the radioactive waste dump." The photo of Chernobyl shows three liquidators in an apocalyptic landscape. At the bottom of the picture, white streaks are rising. "They are streams of radioactivity. The sacrifice made by those men should *never* be forgotten." ∎

"I record everything," says Igor Kostin. "Then it's up to the scientists."

The Liquidators

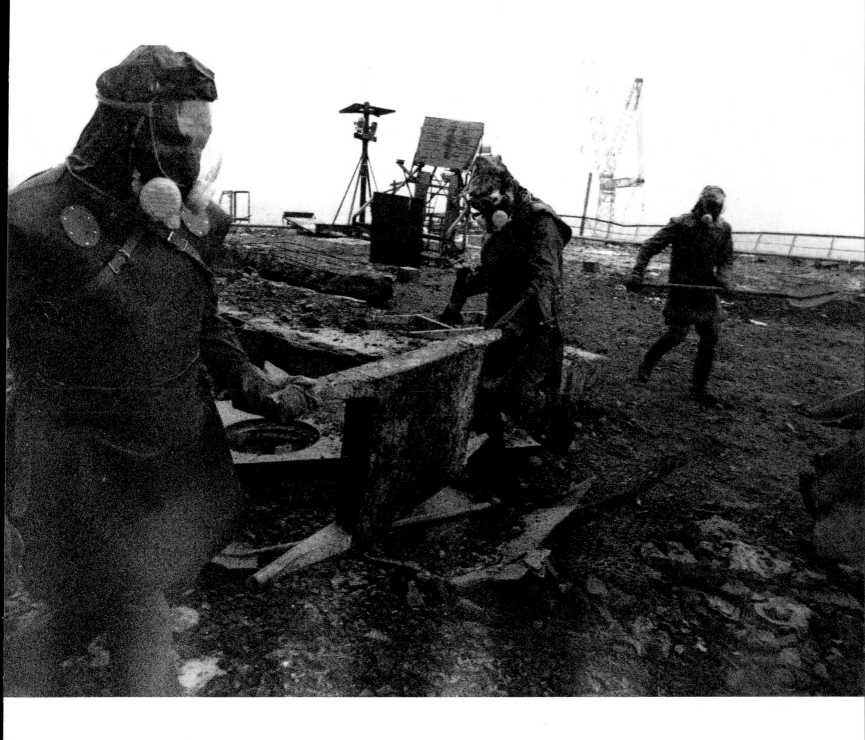

He says that Chernobyl is his "drug", pouring his umpteenth glass of chilled vodka. Then, voluble in his anger, he brandishes the scores of photos laid out in front of him. At his side, Alla, his young wife, listens in silence. "I hope my work will spare future generations this horror." Igor Kostin took his first photo of the disaster several hours after the explosion. Flying over the wreckage of the reactor, he opened the helicopter door and literally grilled several photos. His "madness" earned him a World Press Photo award in 1987. Since then, he has "photographed everything" with an obsessive eye for detail: eight-legged colts, mutated apples

or trees, stillborn babies with webbed fingers emerging from shoulders, babies without arms or legs, children with thyroid cancer (800 cases recorded), liquidators suffering from leukaemia (60,000 already dead) and "post-traumatic stress". "I record everything," says Kostin. "Then it's up to the scientists." Hospitalised on several occasions, including a month in Hiroshima "for a thyroid problem", he is evasive about his state of health. "I received five times the accepted dose, but Moldavians live to be a hundred!" His plans? "To find a publisher for a book and have a child with Alla ... We have had three miscarriages already," he murmurs.

"I hope my work will spare future generations this horror."

Igor Kostin has had several thyroid operations.

The Fall of the Berlin Wall

© Raymond Depardon/Magnum Photos

→ TIMELINE

1989. Perestroika swept through the countries of Eastern Europe. Hungary led the process of liberalisation, opening its borders with Austria. Thousands of East Germans immediately poured through the gap to reach the Federal Republic. In East Germany, escalating demonstrations brought Erich Honecker's resignation. With Mikhail Gorbachev's encouragement, the Berlin wall came down on 9 November 1989, speeding up the collapse of the communist regimes of Czechoslovakia, Bulgaria and Romania. One year later, Germany was re-unified.

RAYMOND DEPARDON

"I wanted a show of anger to symbolise the end of the greatest idiocy of the century."

"IN THIS JOB, you have to be like a cowboy, pistol always loaded, ready to shoot!" A man with timid, blue eyes, Raymond Depardon is no gunslinger. "There were a thousand reasons to miss this photo," he says, "everything happened in a matter of seconds." It was 10 November 1989. During the night, the news spread through the world: the wall of shame had fallen, like a ripe fruit. There had been no deaths or injuries. Depardon found himself in the midst of a tide of humanity. He had never seen the like in Berlin. "I knew the city well and its incredible gift for living in the present. I'd been there for the construction of the wall, for the visits by Kennedy and Queen Elizabeth, but I'd never previously felt that I was experiencing a historic moment." There were hundreds of thousands of onlookers from Checkpoint Charlie to the Brandenburg Gate; subdued jubilation from East Germans in "fake denims and dark anoraks", exuberant joy from West Germans "in furs or leather jackets". Kisses, tears, bewildered smiles; frenzied pickaxes attacking the concrete under the incredulous eyes of the police. "Everything was almost too conventional, too nice," says Depardon. "Where was the anger to symbolise the end of greatest idiocy of the century?" The "miracle" took place a stone's throw from Potsdam Square. A "great shout" ripped through the blue sky: "It could have been a bird, an extraterrestrial, or the howl of an exorcised man. I spun round and pressed the shutter release. I wound the film on, but it was over. I had what I had been waiting for and I went back to Paris." ■

The Exorcist

"I'm a fierce defender of photographic expression because it's one of the bases of democracy; its absence marks the beginning of silence and totalitarianism." Sitting in his Parisian loft, Raymond Depardon is a man of quiet but firm convictions. A photographer and freelance film-maker, he has roamed "in search of the Other". "I like this photo," he says, "because it's like me: I'm a loner and I've never been able to photograph crowds. Here I managed to isolate someone who symbolised the crowds around him. I'll say it right out: I have no desire to meet that young man. It would be demagogy if I said I did. It's important we don't lose the right to take photos of strangers in public places because the most authentic photos, the most realistic ones, are snapshots, stolen photos. Of course, people have the right to their image, but only when photos are manipulated or used dishonestly. Photography is an important witness of history. It celebrates reality and the present. It is a cry that must not be stifled."

"Photography is a cry that must not be stifled."

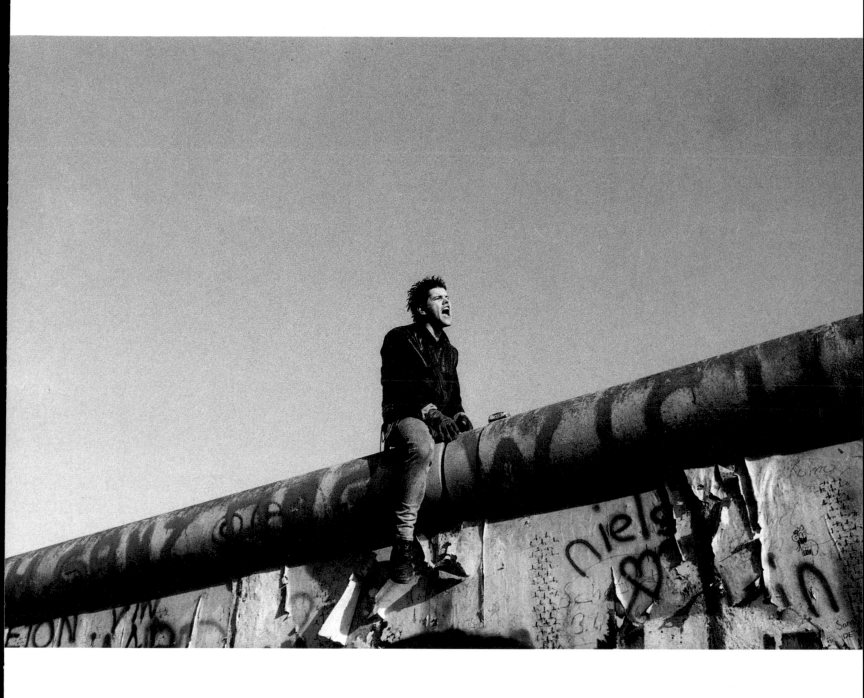

"Up there, I shouted 'Revolution!'"

He no longer has a punk haircut, but a scarf around his head, an earring and a nose ring. A warm-hearted dropout, Armin Strauch has moved from Berlin to south Bavaria. Trained as a gardener, his main interest is making collages. "My favourite,"

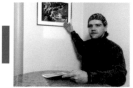

Armin Strauch

he says, sitting in a café that exhibits his works, "is the one I made with *my* photo! I'll never forget that moment. A mate and I wanted to hack off a bit of the wall, but the cops confiscated our hammer. So, my pal gave me a leg-up, and I got a real kick out of doing something which, the night before, would've got me killed! Up there, I saw Vopos ordering me to get down because the wall was the property of the GDR, and I

shouted 'REVOLU-TION!' I came across the photo, six months later, when a friend sent me a postcard from New York. Since then, I've left Berlin; the city isn't the same anymore. With the wall, there was more understanding and solidarity between the people from East and West Berlin. The concrete has disappeared, leaving an invisible wall, which is even more perverse; you can't sit on that wall."

Tiananmen Square
© **Stuart Franklin**/Magnum Photos

STUART FRANKLIN
"Television *made* this photo."

Totem

→ TIMELINE

May 1989. Emboldened by Mikhail Gorbachev's visit, hundreds of thousands of Chinese citizens demonstrated for greater democracy and a clampdown on corruption. The movement was headed by students, who occupied Tiananmen Square in Peking and began a hunger strike. The regime, divided between hardliners and those who sought dialogue, hesitated. On the night of 3 June, Deng Xiaoping ordered tanks to clear the square. A ferocious crackdown followed: more than 1,000 people died and there were countless arrests.

"WITHOUT TELEVISION, this photo wouldn't have made history." Sitting on a terrace overlooking Shanghai Avenue in Peking, Stuart Franklin stands by his opinion. "It really isn't a great picture, because I was much too far away." And for good reason: it was the morning of 4 June 1989, just after the massacre in Tiananmen Square. While the People's Liberation Army stamped out the people's hopes, the press was incarcerated in the Beijing Hotel. "The security forces had the whole building under surveillance and stopped us leaving," says Franklin, who had cleverly positioned himself on a balcony overlooking Tiananmen Square. "I actually saw the soldiers firing at a line of unarmed students. It was extremely frustrating not to be able to get nearer and bear witness. Then the tanks headed east out of the square. I watched as a young man blocked the way of the column of armoured tanks. He talked to the drivers for at least fifteen minutes. It was an act of incredible courage and a very dramatic moment: I was expecting him to be crushed by the tanks at any moment. I took four or five rolls, with the telephoto lens, afraid something would happen while I was changing films. In the end, some demonstrators came to get the stranger and he disappeared into the crowd." The photo reached Paris in a canister of tea, which a French student took back in her luggage. ∎

088

He was 20 and one of the heroes of Tiananmen Square. The photos show him with a red headband and a megaphone in his hand, haranguing the crowds. Founder of the Independent Students' Association in Peking, Wang Dan spent seven years in prison before being expelled to the United States in April 1998. Sitting in his Human Rights Watch office on the thirty-fourth floor of the Empire State Building in New York, Wang Dan is shy and disconcerted by the attention; he gives interview after interview. "My dissident friends and I did our very best to find the man in the photo, but to no avail. I really wanted to meet him; he was such a perfect symbol of our cause. He was probably a worker. If he'd been a student, our networks would have found him. One rumour has it that his name was Wang Wei Min and he came from Hunan Province, but there's nothing to confirm it. When it comes down to it, it's just as well he was photographed from the back. That protected him. The worst of it is, the government used this photo to say: 'You see, there was no repression. The proof is, the tank didn't crush this man'."

Wang Dan

"We never found the man in the photo."

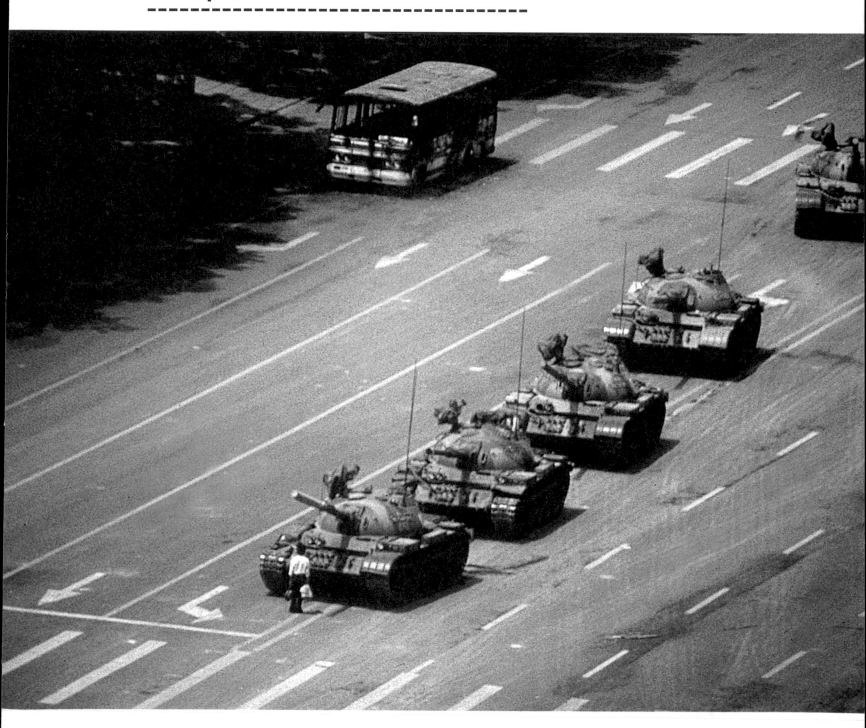

The Highway of Death

© Jacques Langevin/Sygma

JACQUES LANGEVIN

"Fuck the pool!"

Mavericks

→ **TIMELINE**

2 August 1990. Iraq invaded Kuwait. On 16 January 1991, Operation Desert Storm began. The United States sent 500,000 soldiers to the Persian Gulf and headed a coalition of thirty-two countries, mandated by the United Nations. Seven hundred and fifty international journalists were accredited by the Pentagon, which supervised and organised all press activities. During the forty-seven days of the Gulf War, 80,000 tons of bombs were dropped on Kuwait and Iraq. The death toll: 300,000 Iraqis and 200 Allies.

"I SPENT SIX MONTHS COVERING the Gulf War, but I only realised it was a real war at the end." A photographer with Sygma, Jacques Langevin witnessed the liberation of Kuwait City on 27 February 1991. That very day, he decided to head for the motorway leading to the Iraqi border. There was an atmosphere of solar eclipse: before retreating, Saddam Hussein had ordered the oil wells to be sabotaged, and the sky was engulfed by black clouds of smoke that allowed only the occasional ray of sunlight to filter through. "I came across a chaotic jumble of cars. Everything was there: ambulances, tanks, cars containing fridges and washing machines. I heard radios still playing, engines running, as if the occupants had been magicked away." Several hours earlier, the American airforce had bombed the convoy of Iraqis fleeing to Baghdad. Civilians and soldiers had taken to this trunk road, which went down in history as the 'highway of death'. "I was very upset when I discovered the charred body of this man. It's the only image of the Gulf War that will stay with me. A real paradox: this was the most widely mediatised war of the century, with a fleet of journalists armed with the most sophisticated equipment, but there are virtually no pictures to show for it. It was like World War One: the propaganda machine showed us a clean, soulless war. That's why I say: 'Fuck the pool!'" ∎

Jacques Langevin

He has the impish expression of a kid who has just played a joke on someone. "You really want to see my disguise?" he asks, opening a wardrobe. He takes out an American army uniform, bought in Paris, and a helmet, ordered from New York. "This outfit enabled us to pass roadblocks effortlessly, the Saudi soldiers all but stood to attention for us!" Jacques Langevin arrived in Dhahran, ten days after the Iraqi invasion. He watched the "unpacking of the US armada. It was impressive, but it was very difficult to do any work. The journalists were grouped in pools by Pentagon officers, who organised pre-planned coach tours." When Operation Desert Storm began, Jacques Langevin was within a hair's breadth of giving up. "European journalists were systematically relegated to a waiting list. Every morning, I queued up in the hope that there would be a desertion from one of the pools. It was unbearable." Some ten journalists organised a rebellion. Their slogan: 'Fuck the pool', the hard-core version of 'Franctireur [maverick] photographer' or 'FTP'. "Our disguises enabled us to make fools of the Americans and disappear into the desert!" This is what the army calls 'immersion technique'. The group took up position in a service station near the Kuwaiti border. Their plan was to enter the Emirate with the vanguard, as soon as the land war began.

"Our disguises enabled us to make fools of the Americans"

On 24 February, everything went as planned. Preceding the column of Saudi and American tanks heading for Kuwait City, the FTPs photographed the rout of the Iraqi troops, who were surrendering in their thousands. Then, at dawn on 27 February, they watched the liberation of the capital. By the time the press pools arrived at the end of the day, they had already flooded the world with their photos. A fine scoop, washed down with satisfaction "after months of alcohol-deprivation in Saudi Arabia".

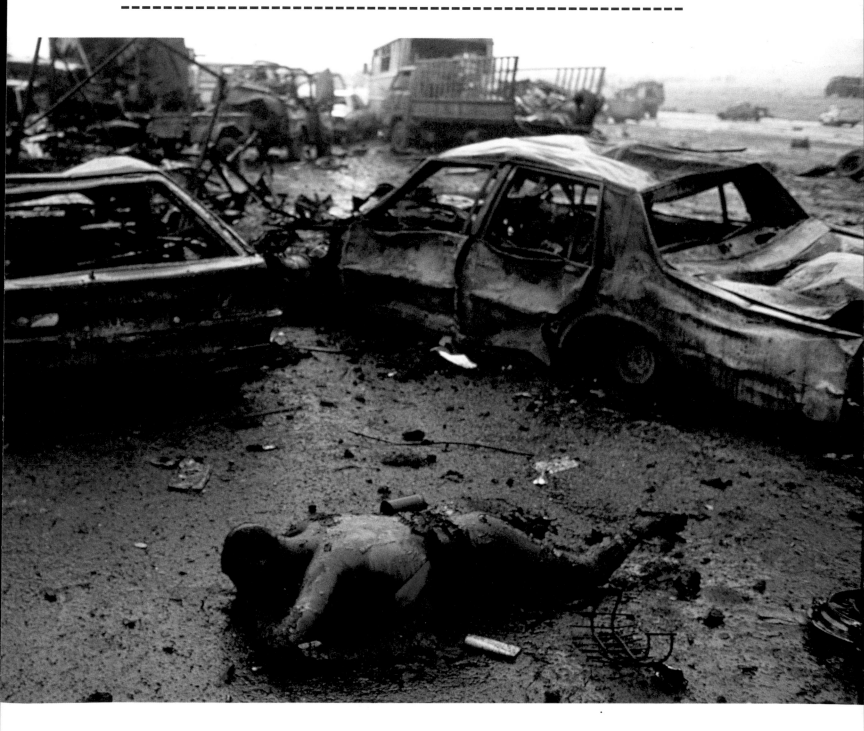

Oil Slick in the Gulf

© Sebastião Salgado/Amazonas/Contact Press Images

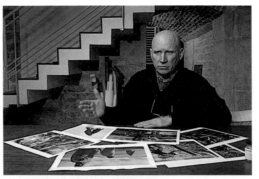

SEBASTIÃO SALGADO

"I was fascinated by the superhuman efforts of the fire fighters."

→ TIMELINE

It was the largest oil slick of the century. Before withdrawing from Kuwait, in February 1991, Saddam Hussein ordered the oil wells to be sabotaged. Over 650 oil wells were set alight, pouring 70,000 tonnes of oil into the Gulf. Fire fighters worked day and night for eleven months to put out the flames. The Kuwait Oil Company gave this 2 billion dollar contract to the best in the profession: the Texan fire fighters of Red Adair, Well Contril and Poots and Coot. The last well was extinguished in October 1991, but the region's ecosystem will be polluted for many years to come.

"IT WAS THE TOUGHEST JOB of my career but, by the end, the grotesque inferno of the oil wells had become my home." His eyes glued to his slide table, Sebastiao Salgado continued: "It was raining oil. Sometimes you didn't see daylight for forty-eight hours. I was working with ultra-sensitive films with a speed of 3,200 ASA – sparingly, because it was impossible to change film without getting it covered in oil. In the evening, I washed with petrol: after several days, my skin was coming off in strips. I was fascinated by the superhuman efforts of the fire fighters, who were risking their lives to fight the flames." Sheathed in asbestos protective clothing, the Fire Fighters used bulldozers to remove the metal debris piled round the well heads. They worked under tonnes of water to protect them from the heat: 1,200 degrees, near the flames. They then had to dynamite the wells and extinguish the flames, knowing that a spark could cause an explosion at any moment. Returning across the oil field at Al-Ahmadi, south of Kuwait City, Salgado came across a "magnificent red lorry" belonging to the Canadian company Safety Boss. Supervised by Mike Miller, the fire fighters were endeavouring to seal off a well head with a new valve. "They were virtually exhausted," recalled the photographer. "Some of were fainting, intoxicated by the persistent oil fumes, one of them went completely off his head. I photographed like mad until I had THE photo." ■

Inferno

"I look like I'm praying?" The question amuses Mike Miller, the boss of the Canadian fire fighters (on the right in the photo). For eight months, his men had worked in rotation to avoid exhaustion: a team of twelve men every thirty days. Mike Miller saw the photo when strolling through the streets of Amsterdam. "There was an enormous poster in a shop window. I went up to it and said to myself: 'My God, that's me!' The first thing I remembered was the deafening noise, then the furnace raging around the wells. It was tough, very tough, but since then, whenever I see this photo, I feel a huge nostalgia: it was the most important event in my life."

"It was the most important event in my life."

Mike Miller

– – – – – – – – – –

090

A bald man with frank, blue eyes, Sebastião Salgado came to photography as one comes to religion. The Brazilian economist discovered his vocation working at the International Coffee Organisation in London. "I immersed myself in the problems of the Third World," he says thirty years later, "and I realised that to solve them, I would have to bear witness." Since when he has travelled the length and breadth of the world to record the life of ordinary people who, day after day, are making history. His credo: to work on the sidelines of current events, where "by definition, nothing happens". In 1987, he began a monumental project on the development of the manual industries. This global saga ended in his award-winning work: *Workers: An Archaeology of the Industrial Age*. "I was working on the history of oil in Venezuela, when the Gulf War broke out," he recalls. "When it was over, I was in the tea plantations of Rwanda. I rushed to Kuwait to record the saga of the fire fighters." Almost all in black and white, Salgado's work marries ethics and aesthetics. The photo of the fire fighters is akin to a religious icon. "I want to pay homage to humanity", says Salgado simply.

"A homage to humanity."

Liz Taylor's Wedding
© Phil Ramey/Ramey Photo Agency

→ TIMELINE

6 October 1991. Liz Taylor married builder Larry Fortensky. It was the star's seventh marriage, attended by one hundred and sixty guests, including former presidents Ford and Reagan. It was a godsend for the 'paparazzi'. Fellini coined the term in 1959. Since then, these image-poachers have conquered the world. Methodical research, telephoto lenses with a range of 500 m, networks of informers in hotels and travel agencies have created a profitable business that feeds a thriving press industry. Meanwhile the number of lawyers specialising in the defence of celebrities is on the rise.

091

PHIL RAMEY
"It isn't a good photo, but it's the only one!"

Paparazzo

H E'S SMART and proud of it: "In this job," he says, "the smarter you are, the better you do". And the more you earn. Gazing at Hollywood Hill, Phil Ramey continues: "When I found out Liz Taylor was getting married again, I looked up and saw hundred-dollar bills raining down from the sky!" He immediately alerted his "information services". The star was to be married on Michael Jackson's ranch, six hundred hectares nestling in the Californian countryside. "Inaccessible to the press", in short. "We're going to play 'chopper weddings'." An "informant" sold him a tip: a rehearsal had been organised three days before the ceremony. Ramey rushed to the helicopter with a video camera. "I filmed it all," he sniggered, "on D-day, I was able to thumb my nose at all my competitors." National and local television channels, press people, were all there from 16.00, flying over the ranch "like flies over a trash can". "There were around fifteen choppers, as well as a strange type of flying machine that crashed on the lawn!" Phil Ramey arrived at the last moment: "Liz has always been late, starting the day she was born!" The ceremony began at 18.15. Wearing a 16,000-dollar sunflower dress, the bride advanced on the arm of the groom, followed by Michael Jackson in a black overcoat. "I had seven seconds to shoot between the moment she stepped out of the tent and disappeared into the trees." Failing light, 1,000 mm lens at an altitude of 1,500 m. "It isn't a great photo, but it's the only one." Jackpot! ■

Phil Ramey had set aside the entire day, bar two hours. "Monica Lewinsky goes jogging at midday in Beverley Hills, and she's very popular just now." A few weeks before Clinton's impeachment, Lewinsky photos were lucrative. The law of the market: "If Liz Taylor remarries tomorrow, I'll hit the jackpot again. She is a safe bet: I followed her to Hong Kong, the Great Wall of China, her detoxification centre and the clinic where she had her tumour removed." A mercenary with a zoom lens, Phil Ramey started the 'chopper weddings' fashion with Madonna's wedding in Malibu. Some thirty marriages later, he owns three helicopters and has no qualms about what he does. "Why don't celebrities stop being such hypocrites: they need photographers just as much as we need them. Besides, when you stop hounding them, they get worried and give you a call. I do show business, not photojournalism: it pays well and that's the only reason for doing it. Would I have photographed Princess Di after the crash? Of course. I'd have taken the photo, then called the emergency services. And I wouldn't have hung around until the police arrived to confiscate my film."

Phil Ramey and Liz Taylor

"I do show business."

"It wasn't a wedding but a circus."

He lives in a spacious villa with a swimming pool, not far from San Diego. "Alimony", say the malicious, citing his recent divorce. In a shy, smoky voice, Larry Fortensky speaks disparagingly of the "animals" who ruined his wedding. "It was a real circus: there was one guy who literally parachuted in! The security agents were very tough on him and I think the shape of his face is still imprinted in Michael's lawn. Liz had permitted just one photographer inside the ranch. The proceeds from the rights were to go to her Aids foundation. The paparazzi infuriated her. As for me, Phil Ramey followed me for weeks: at 06.00 in the morning he was above my house in a helicopter ready to follow me to the building site. I got up earlier, he was there. I slept at friends' houses, and he was still there. He and his stooges really wrecked my life, but now they're not so interested in me."

Larry Fortensky

Rape Campaign in Bosnia
© Andrée Kaiser/G.A.F.F./Sipa Press

→ TIMELINE

1991. Croatia and Slovenia declared their independence from the Federal Republic of Yugoslavia. A four-year war ensued, completely altering the country's ethnic map. The Serb nationalists carried out a policy of 'ethnic cleansing' – genocide – against the Bosnian Muslims: thousands were massacred, their cultural heritage was destroyed and their women systematically raped. In 1993, the UN established an international court at The Hague to try war criminals from former Yugoslavia. Its statutes recognised rape as a war crime.

ANDRÉE KAISER
"We wept with them."

A 35-YEAR-OLD with a shy, youthful expression, Andrée Kaiser doesn't look like a scoop-hunter. Sitting in his photo agency in East Berlin, he insists: "Without Roy Gutman, I would never have been able to do this report". Kaiser met the New York journalist when the Berlin wall was opened. In 1992, they left to cover the war in Yugoslavia together. Their destination: Bosnia, where they were the first to report on the Serbian concentration camps. "According to a persistent rumour, the militias were using the systematic rape of Muslim women as a weapon of war. We decided to explore this further in Tuzla." To reach the surrounded village, the two reporters joined a supply convoy that covered 150 km in two nights. They were taken to a gymnasium used as a refuge by two hundred Bosnian women, teenage girls, mothers and old women. "They were wandering around the gymnasium, silent and drawn, in a complete state of shock. Only the sound of children crying broke the silence. For the first two days, I didn't touch my camera. We talked for a long time to a small group of women who described the torture they'd been subjected to and the unbearable shame that they felt. One day, one of them (Sena, aged 17) said: 'I'm ready to be photographed, because I want the world to know the truth about us'. I took the first group photo, in which the victims were holding their mothers' hands. Then, suddenly, they began weeping and hugging each other. We wept with them." ■

Evidence

Roy Gutman's report appeared on 23 August 1992 in the New York newspaper *Newsday*, with Andrée Kaiser's photos. The report won a Pulitzer Prize. "It's very unusual for a journalist to have a relationship like the one I had with Andrée. He trusted my ability to judge what was a crime, and I trusted his ability to document it. We worked in the same spirit. For me, it was a matter of collating and crosschecking the facts that showed that rape had been used as a means of ethnic purification. But pictures were needed to convince the public. Andrée's photos provided proof. And the photos were what made the international community take action. After my investigation, other journalists worked on the subject but, since André's photos were the only ones, they were published everywhere: they acquired a life of their own, becoming hard evidence of a new crime against humanity."

"The photos provided proof."

Roy Gutman

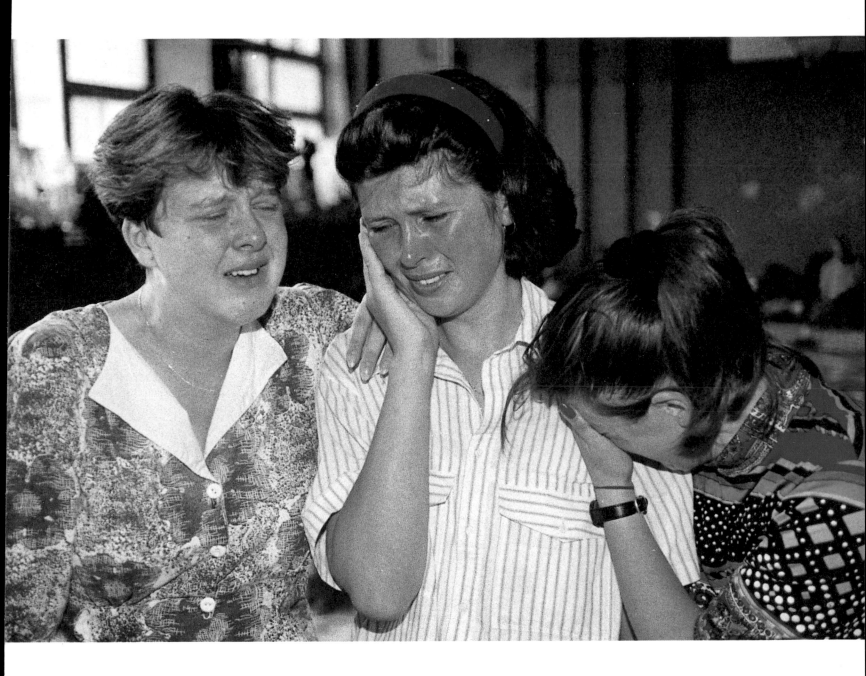

He had decided to be a photographer to "denounce injustice". After the worldwide success of his work in Bosnia, Andrée Kaiser found it difficult to return to normality. "I suffered from depression for two or three years. I continually asked myself: how can you continue to work at that level? In fact, this experience was holding me back. I was lucky; my wife was very supportive. I rediscovered my will to go on when I realised that you can also do your job far from the battlefields, by recording everyday life on your doorstep. Most of the work I do now is centred around the social problems experienced in reunified Germany."

Roy Gutman and
ANDRÉE KAISER

"That experience inhibited me for two or three years."

Sendero Luminoso Defeated

© Wesley Bocxe/*Sipa Press*

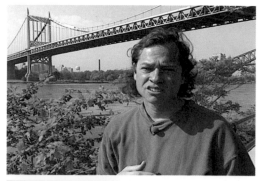

WESLEY BOCXE

"The press had been manipulated and I wanted to show that."

Set-Up

→ TIMELINE

September 1992. Abimael Guzman was arrested in Lima. An admirer of Pol Pot, 'Comrade Gonzalo' led the Sendero Luminoso guerrilla movement, founded in 1978 after a split in the Peruvian Communist Party. Relying on the Indian population, he advocated an uncompromising Maoism that degenerated into a terrorist war. Massacres of villagers, murders of left-wing leaders, clashes with the army: in fifteen years, this reign of violence claimed 15,000 lives. In 1990, Alberto Fujimori was elected President, after a campaign centred on the fight against terrorism.

WESLEY BOCXE, an American photographer, was working in El Salvador when he heard on the BBC that Guzman had been arrested. He immediately flew to Peru where, after a ten-day wait, he was summoned to a former police station in the suburb of Lima by the President's press office. "Two hundred journalists were queuing up to gain entrance to a rectangular courtyard dominated by a press stand, which stood opposite a tarpaulin-covered cage. We didn't know what was going to happen; there was a rumour that Guzman was dead. Then, the soldiers pulled off the tarpaulin. He was sitting on a chair, in a convict's uniform, with a sign round his neck. There was a long silence: he looked at us, we looked at him and we couldn't believe it was really him. It was like seeing a caged wild animal at the circus." Standing on the walls around the courtyard, soldiers armed with machine guns watched the scene, which was carefully orchestrated by plain-clothes policeman. "In suit and tie, they mingled with the journalists and started to insult Guzman." He wasted no time in replying, launching into a violent diatribe in defence of armed combat. Insults flowed copiously, punctuated by Guzman's howls of anger, his voice choked with hatred. Bocxe took several long-focus photos of the yelling prisoner, then seized his wide-angle lens. "I suddenly realised that the real photo was the one that showed the entire set-up. We were being manipulated and I wanted people to know that." ∎

093

"This photo demoralised the guerrillas."

Western magazines published Wesley Bocxe's photo; the Peruvian newspapers printed only close-ups of the "leader of the worldwide revolution". But the propaganda worked. "The guerrillas of the Shining Path were demoralised by the picture of their leader under lock and key," says Carlos Tapía, a journalist and parliamentarian who is no admirer of Fujimori. "One year after Guzman's capture, more than 1,200 regional members had given themselves up to the police. If Sendero Luminoso still exists today, it only has 10% of its former numbers. And the vast majority reject it. That's very important."

Carlos Tapía

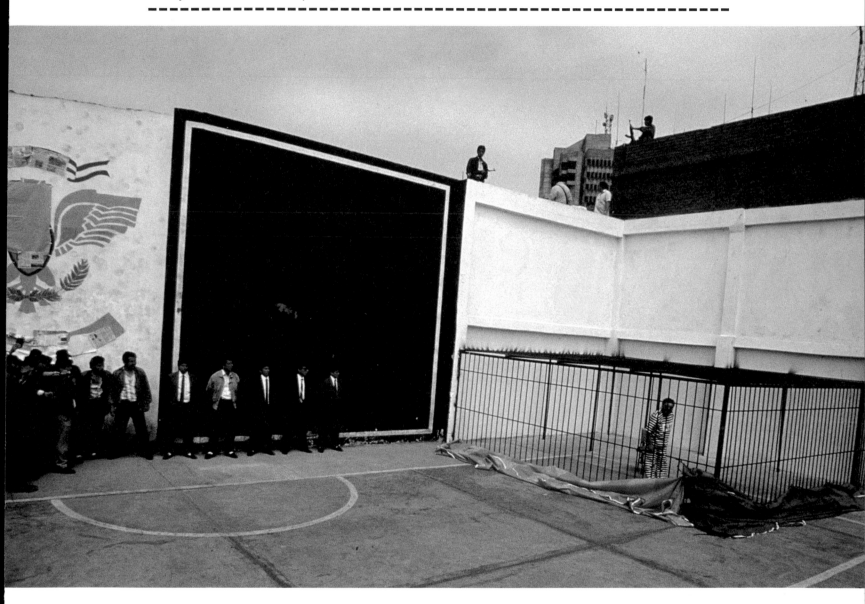

"I designed that cage with a metalworker who built the palace railings. It wasn't expensive: two hundred and seventy dollars, although he worked all night!" Sitting very straight in his presidential chair, Alberto Fujimori does not hide his satisfaction. The Peruvian flag at his side, he is unstoppable when talking about the biggest success of his career. "I also chose the horizontal stripes on Guzman's costume: I knew they'd make an excellent contrast with the vertical bars of the cage!" And he adds, his smile betraying his Japanese origins: "As for the venue, I visited several before I chose the former police station: I wanted as many journalists there as possible so the event would be indelibly printed on people's minds."

"I wanted the event to be indelibly printed on people's minds."

Alberto Fujimori

Genocide in Rwanda
© James Nachtwey/Magnum Photos

→ TIMELINE

6 April 1994. The President of Rwanda was shot down. The country was immediately plunged into a state of chaos: in several weeks, nearly one million Tutsi were massacred by the Hutu militias, who perpetrated a genocide. Their weapon: the machete. The international community made no move to intervene until the end of June when, fleeing the advance of the Tutsi army, hundreds of thousands of Hutu took refuge in Zaire. Acknowledging, finally, that genocide had taken place, the UN established an international court to bring the leaders to trial in November 1994.

JAMES NACHTWEY

"This photo was taken too late."

"THIS PHOTO WAS taken too late, it didn't save anyone. I hope it will remain in the collective memory and help us to act if another genocide is looming." His voice quavers as he searches the New York night for the right words. A photographer with Magnum, James Nachtwey arrived in Rwanda in mid-May 1994, after covering Nelson Mandela's election to the South African presidency. Nearly 500,000 Tutsi had already been massacred. "It was very hard to work: the Hutu militia as well as the Tutsi army (the RPF) restricted press access." After protracted negotiations, the RPF allowed a small group of journalists to travel to the region of Nayensa, which had just been liberated. This was how Nachtwey found himself in an international Red Cross hospital for the victims of the evacuated Tangai death camp. He caught sight of a "dreadfully mutilated" man sitting alone in the corner. His face was seamed with long scars: a Hutu, he had refused to take part in the genocide and the militia had exacted their revenge with a machete. Due to a wound in the throat, he could no longer talk. "I looked him in the eyes and he looked me in the eyes. He was very weak, but I understood from his look that he was giving me permission to take photographs of him. He turned his head so that I could see his scars more clearly, as if, through me, he could show the world what he had suffered, he, and all the others. The fact that I had his tacit consent gave great intensity to my work." ∎

Silence, Men Killing

After taking the photo, James Nachtwey stayed on for many long weeks. He described how he "wanted to run away" when, entering a village church, he found hundreds of corpses with their throats slit, including children still slung across their mothers' backs. He also described his disquiet when he saw the arrival of the hundreds of journalists who had come to cover the Hutu flight to Zaire. 700,000 refugees flooded into the camps at Goma, where 50,000 died of cholera or dysentery. "Of course, it was important to cover the international humanitarian operation but, having made the front page of the newspapers, the butchers all of a sudden became the victims and the genocide was conveniently forgotten." He describes his dismay when he began to photograph the refugees: "Their exodus was almost biblical, it was as if they were paying for their crimes. In the end, you no longer have the strength to judge, you can only sympathise with the human tragedy." He described, finally, the difficulty of "the aftermath": "I've never recovered from what I saw in Rwanda. I'm still haunted by feelings of shame and guilt."

"I've never recovered from what I saw in Rwanda."

JAMES NACHTWEY

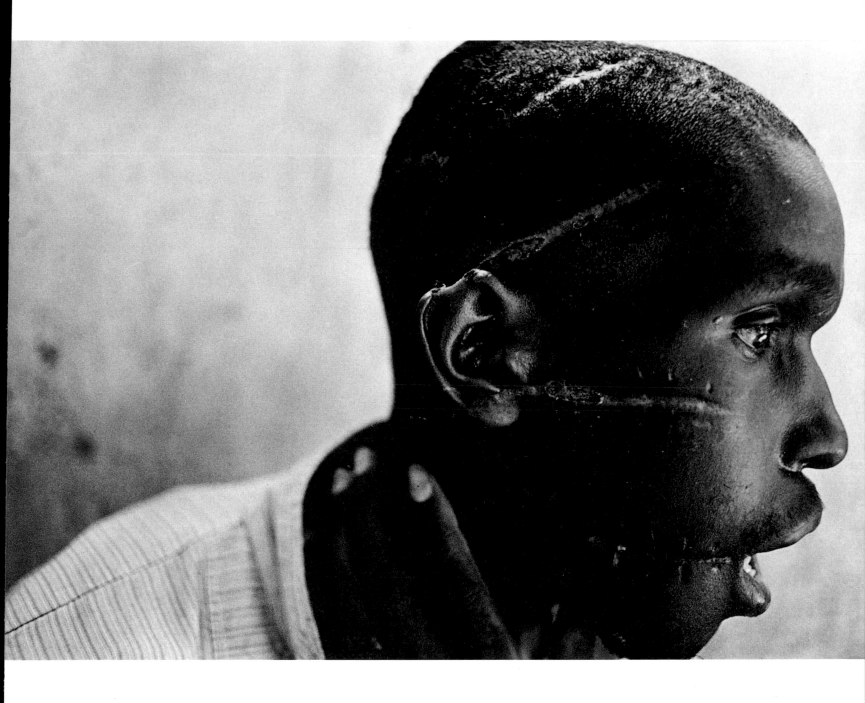

"This man's scars challenge our collective sense of responsibility."

"We were instructed not to use the word genocide because, according to the Convention of 9 December 1948, we should have been obliged to intervene," reports Boutros Boutros-Ghali, who was then Secretary-General of the UN. "Unfortunately, a war taking place in a remote part of Africa where, what's more, there is no oil, was of no interest to anyone." And he adds, brandishing Nachtwey's photo: "This picture represents the greatest failure of my career". The international community closed its eyes while, in Rwanda, entire villages were being massacred. At the end of April, at the height of the massacres, the UN decided to withdraw most of its troops from Rwanda, while a handful of photographers tried in vain to get their photos published in the international newspapers. "A living person bearing the scars of his wounds is more symbolic than a dead person, the dead can't speak. This man's scars are a challenge to our collective sense of responsibility, now and forever."

Boutros Boutros-Ghali

The Peace Process in Washington

© **Barbara Kinney**/The White House

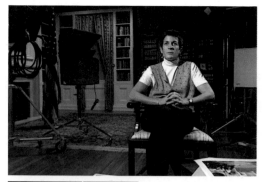

BARBARA KINNEY

"I could think of only one thing: was Arafat wearing a tie?"

→ TIMELINE

13 September 1993. After secret negotiations in Norway, Yitzhak Rabin and Yasser Arafat came to Washington to sign the Oslo Accords, which established Palestinian self-rule in the Gaza Strip and the withdrawal of Israeli troops. In July 1994, the leader of the PLO returned to Palestine after an exile of forty years. On 4 November 1995, Yitzhak Rabin was assassinated, while Islamic extremists stepped up their bomb-attacks on Israel. The election of Benjamin Netanyahu in May 1996 blocked the enforcement of the Oslo Accords, endangering the peace process in the Middle East.

SHE TOOK THE PHOTO, because her boss had better things to do that day. The result: a World Press Photo award in the Spot News category. "Barbara Kinney didn't win the main prize," said a jury-member, "because she was on the White House staff and had no press card. But everyone agreed hers was best." She still finds it amusing today: "On 28 September 1995, I came to work in the morning as usual, and they told me to stick close to President Clinton. It was a special day because all the Middle East leaders had come to the White House." At their head: Yasser Arafat and Yitzhak Rabin. With them: King Hussein of Jordan and the Egyptian President, Hosni Mubarak. On the agenda: signing the Oslo II Accords, extending Palestinian self-rule on the West Bank. "This photo was taken in the Red Room, just as the group were being ushered into the room where the Accords were to be signed. President Clinton was about to go through the door, when his assistant spotted that his tie was badly knotted. With my right eye, in the viewfinder, I saw the President adjusting his tie, and with my left I saw they were all doing the same thing. I took three photos very quickly, and they left the room. Immediately afterwards, I could think of only one thing: was Arafat wearing a tie? I was very excited when I saw the photo, I said to myself: 'Wow! Did I take that? It's really good!'" ■

Humanity

"I made war as long as there was no possibility of making peace", said Prime Minister Yitzhak Rabin, in front of 100,000 Israelis, before he was shot and killed by fundamentalist Igal Amir. Today, Lea Rabin, his wife of more than forty years, has taken up the fight. Sitting in her office in Tel Aviv, she has not forgotten 28 September 1995, when peace seemed within reach. "While they were adjusting their ties, I was with the wives of the heads of state, on the second floor of the White House, where Mrs Clinton was giving a guided tour. The atmosphere was very relaxed: it was a time of reconciliation in the Middle East and we were full of confidence and hope. That comes over very well in this photo, which shows their rapport and profound mutual respect. Unfortunately, the peace process had powerful enemies on both sides. Looking at this picture, I can't help thinking that my husband was sacrificed on the altar of peace."

Lea Rabin

"My husband was sacrificed on the altar of peace."

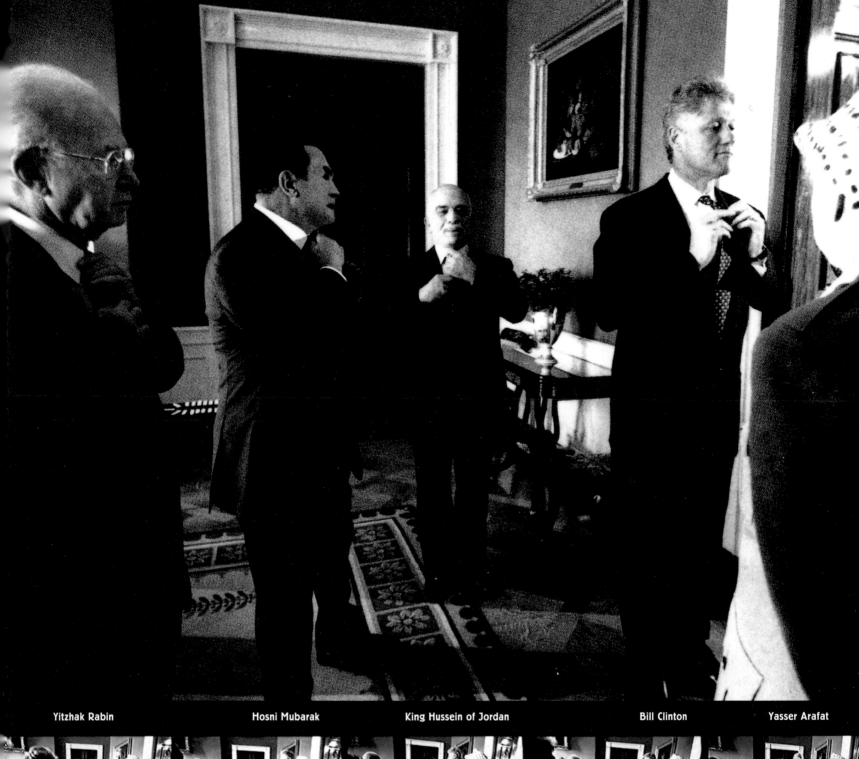

Yitzhak Rabin Hosni Mubarak King Hussein of Jordan Bill Clinton Yasser Arafat

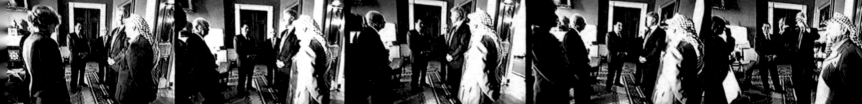

The Orphans of Rwanda

© Reza/Imax

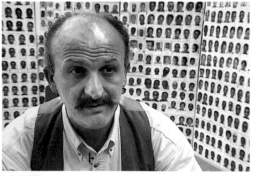

REZA
"For once, photography did some good."

Missing Persons

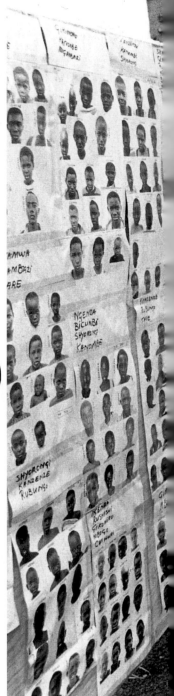

→ **TIMELINE**

It was the greatest exodus of the century. In July 1994, more than a million Hutus fled Rwanda, where the Tutsi rebels had just seized power. The refugees took up residence in five camps at Goma and Bukavu in eastern Zaire, where 50,000 died from disease. During this frantic flight, nearly 30,000 children lost their parents. They were called "unaccompanied children", because they were not necessarily orphans. By the end of 1994, two million Rwandans had gone into self-imposed exile in the lake region, including 100,000 "unaccompanied" children.

096

'PHOTO TRACING', reads the sign at the entrance to the tent. Inside, 12,000 pairs of eyes compete for attention. Stony-faced, smiling or frightened, they are all children. "It was the most moving experience of my life," says Reza. "For once, photography was really doing some good!" It was in 1995. Working on the theme of childhood, Reza moved into the camp at Goma. Here he discovered the story of the "unaccompanied" Rwandan children taken care of by UNICEF and the International Red Cross. For the past year, both organisations, held back by lack of human and logistical resources, had been trying to get a project off the ground: to exhibit portraits of the young refugees so that their families could reclaim them. Reza appealed to manufacturers for cameras and films. Then he taught five Zaireans how to take photographs. The studio was a wooden frame, a chair and a white sheet. Twenty-five Zaireans were in charge of sorting and ordering the photos and fixing them on display panels. The result: an exhibition organised simultaneously in the five Rwandan refugee camps. Announced by vehicles and megaphones, the news spread like wildfire. "Some parents walked scores of kilometres to see the exhibition," says Reza. "And like these pregnant women, they sometimes stayed for hours looking at the photos. They came back once or twice, or visited all five exhibitions. It was no use telling them that all five were the same, some of them found their children at the fifth." ∎

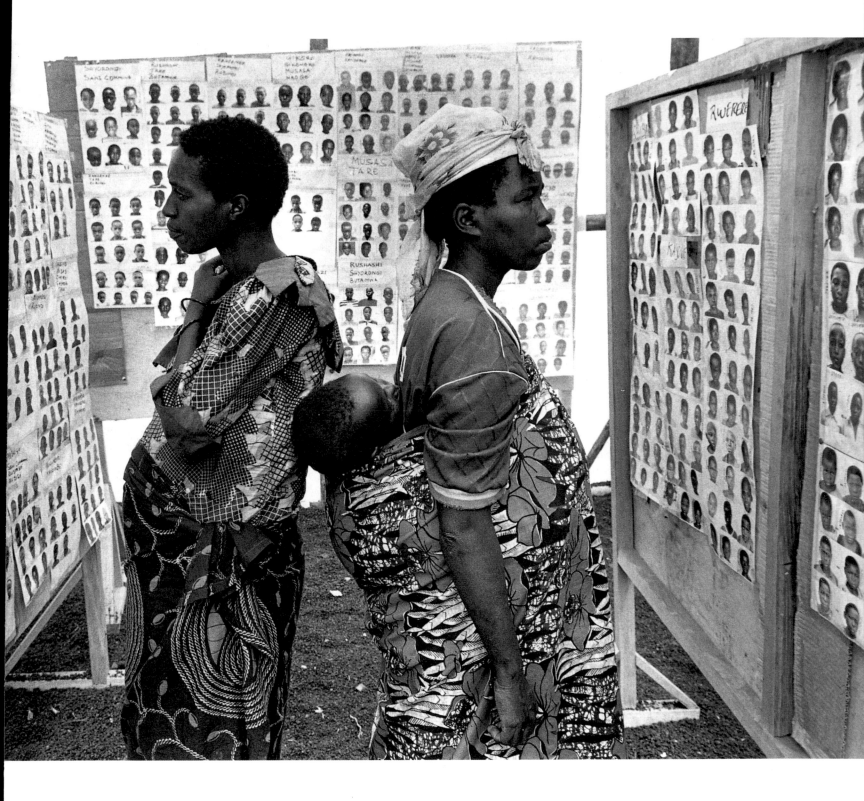

"Some parents had never seen a photo in their life."

"I will never forget the moment when the children saw their parents again," says Philippe Duamelle, the UNICEF representative in charge of the camps in Zaire. "Suddenly the fixed expressions on film came to life." The technique of 'photo-tracing' had been used at the end of World War Two to identify 250,000 German orphans, and subsequently in Biafra and in Thailand. But UNICEF had never used it to reunite families on such a wide scale. For months, UN repre- sentatives had interviewed the children using a form with twenty-six questions: name, age, number of brothers and sisters, father's profession. Each little refugee received an identification number noted on the photo so as to allow cross- checking. "Our main difficulty was the absence of a picture culture in peoples where oral tradition predominates," says Philippe Duamelle. "Some adults had never seen a photo in their life. I remember one woman who burst into tears in front of her child's photo, be- cause she thought his head had been cut off. We trained guides who helped the parents to read the photos. Finally, out of the 27,000 children re- corded in the camps, 14,600 found their parents, 2,600 of them through the photos."

Philippe Duamelle

The Argentine Mafia

→ TIMELINE

March 1976. Military coup in Argentina. The dictatorship waged a dirty war claiming 30,000 victims in six years. On 30 October 1983, Raúl Alfonsín was elected President: he announced plans to prosecute the leaders of the dictatorship. Five high-ranking officials were convicted, but mutinies forced the government to pass a law pardoning other lower-ranking officers. In 1990, Carlos Menem succeeded Alfonsín. Privatisation, free-market economy: his ultraliberal policy exacerbated the poverty of the working classes, while some made huge fortunes.

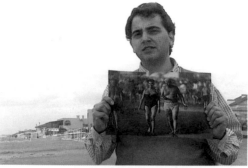

Gabriel Michi: When I learned of José Luis' murder, I immediately thought of that photo."

Fatal Photo

I T IS AN UNREMARKABLE photo; it shows a man in swimming trunks walking with his wife on an Argentinean beach. His name was Alfredo Yabrán and he ran the largest financial empire in the country. In August 1995, Domingo Cavallo, the Finance Minister, publicly denounced him as the "Mafia boss". Yabrán, a businessman, had profitable connections with the henchmen of the military dictatorship; he was worth two billion dollars. "His name was well-known, but not his face," says journalist Gabriel Michi. "In an interview given to my newspaper in 1994, he said that taking his photo was tantamount to putting a bullet through his head. We didn't take that threat seriously." "We" means Michi and the photographer José Luis Cabezas, whizz-kids with the magazine *Noticias*. Renowned for his professionalism, Michi was investigating the elusive Yabrán and his men of straw, all in positions of power. But they needed a photo. In February 1996, they stationed themselves in Pinamar, a smart seaside resort frequented by the Mafioso. "At one point, he left his private beach to walk along the shore. We were about 100 metres away. José Luis asked his wife to pretend to pose. Then he took pictures with his zoom." The photo appeared on the cover of *Noticias* on 3 March 1996. On 25 January 1997, the photographer disappeared when leaving a party in Pinamar: his charred body was found, with a bullet through the head, in the burnt-out shell of his car near the ill-fated beach. ■

"José Luis would not have died if the murderers of the 30,000 people killed during the dictatorship had been convicted and imprisoned!" Brandishing placards with the photographer's portrait, the crowd cheers the speaker. In January 1997, eight hundred reporters sprang into action. Thousands of Argentines demonstrated to prevent the investigation being closed. A policeman who confessed to the crime was arrested. Evidence was stacking up against Yabrán; when he was charged with taking out the contract, he committed suicide. Since then, on the 25th of every month, there are demonstrations by photographers and townspeople. "This photo haunts me, it fills me with grief and a feeling of powerlessness," says María Cristina Robledo, Cabezas' widow. "How can it have killed him? What kind of world is this when such a simple, ordinary photo can cause the death of its photographer? That's what the whole of Argentina wants to know."

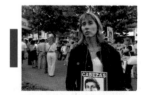

María Cristina Robledo

"How could this photo have killed him?"

During the 1990s, over six hundred journalists were killed worldwide, most of them photographers. But the death of a photographer had never before provoked such strong feelings. "This was the first time a photographer had been murdered because of a photo," says Robert Mesnard, the founder of Reporters Sans Frontières. "Which is why this case has been taken up outside Argentina. In Latin America, where people were celebrating the return of democracy, this was one death too many; it brought back the spectre of the dic-

Robert Mesnard

tatorships, when we thought they were a thing of the past. So Reporters Sans Frontières launched an initiative to support those fighting to bring the perpetrators of this crime to justice. We created a website, asking photographers throughout the world to send us a photo. We received hundreds of replies, from Henri Cartier-Bresson to local correspondents. For all of them, José Luis is a symbol of the honest, courageous photographer fighting for democracy and freedom."

"One death too many."

Cabezas' death prompted unprecedented popular mobilisation in Argentina.

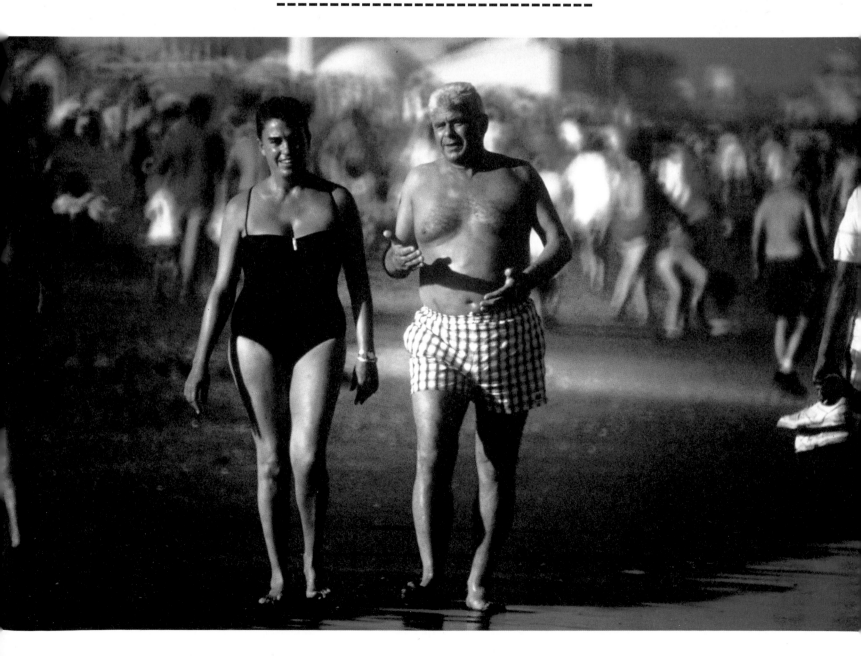

Massacre in Algeria
© Hocine/AFP

→ TIMELINE

1962. After eight years of war with France, Algeria attained independence. The National Liberation Front established a socialist regime. In the 1980s, economic depression and the corruption of the country's leaders led to rioting throughout the country. In December 1991, the Islamic Salvation Front won the elections, but the poll was cancelled. A state of near civil war resulted: armed Islamist groups murdered intellectuals and foreigners, and massacred villagers. The final toll: at least 80,000 deaths by 1998.

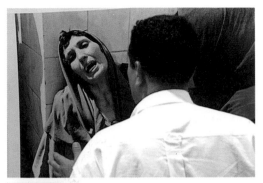

HOCINE

To protect his identity, he was filmed back-to-the-camera.

Malek Chebel: "This picture reassured the West."

"FRANKLY, I DON'T understand: seven prizes in a year, including the World Press Photo award! And I thought I'd never taken a good photo." A shy man with a timid voice, Hocine has been a photographer with AFP since 1993. On 23 September 1997, the word in the street was that a fresh massacre had been carried out in Bentalha, south of Algiers. The news spread like wildfire. It was said that two hundred people had been killed – men, women, and children – their throats slit by Islamic extremists a stone's throw from an army barracks. The scene of the slaughter had been sealed off by the police, so Hocine retreated to the Zmirli hospital, where the corpses of the victims had been taken. Outside, faces racked with anxiety, families gathered to wait for news. "I saw a woman crying and screaming after identifying her loved ones. A friend was trying to comfort her. I sent my five photos to AFP that evening, without great hopes." The very next day, the photo appeared on the front page of hundreds of international newspapers. In Western editorials, the grief-stricken mother, said in the caption to have "lost her eight children", was dubbed 'The Madonna'. "Algeria was a faceless war and therefore incomprehensible," explains Algerian anthropologist Malek Chebel. "This photo reassured the West because, like Michelangelo's *Pietà*, she fitted into the Judaeo-Christian visual tradition. She symbolised the suffering of the Algerian people without revealing the horrific nature of the reality." ∎

The 'Madonna'

Contrary to AFP's initial caption, Oum Saad did not lose eight children, but her brother, sister-in-law and nephew. Not a resident of Bentalha, she had rushed to the Zmirli hospital as soon as she found out about the massacre. The reluctant heroine was interviewed by Algerian journalists: "When I found my dead family, I was extremely upset and I was asked to leave. Outside, I fainted. That was when the photo was taken. I'm an Algerian woman, a Muslim, the daughter of a martyr. I don't want to be compared to the Madonna, who was Christian, not Muslim. Even at weddings, I don't like to have my photograph taken. I want the Algerian government to stop the publication of this photo. I don't want it to appear all over the world, I want it to stay in Algeria."

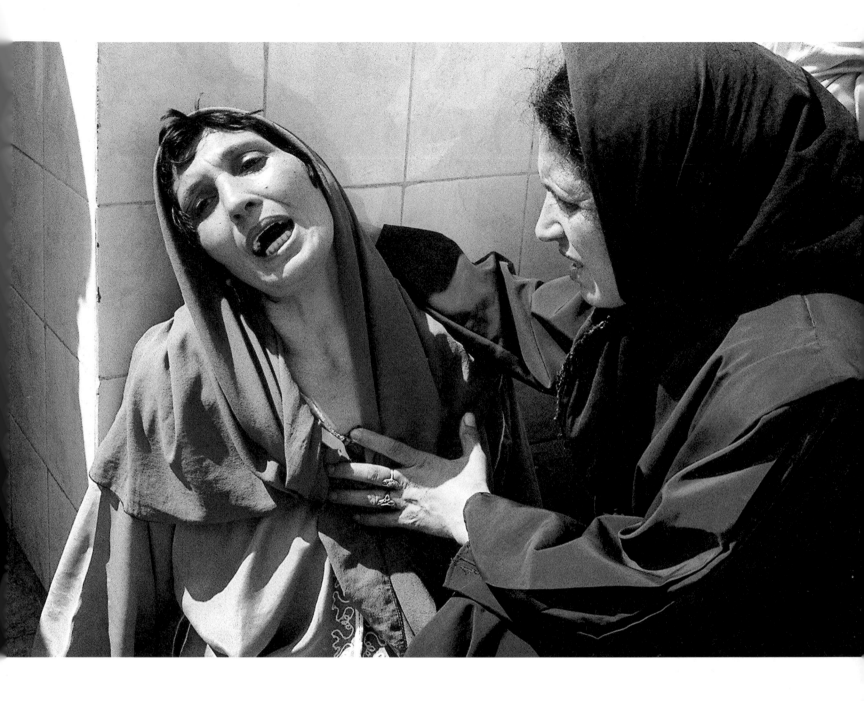

No photo has ever been so controversial or aroused so much passion. The rumour, started by a jealous colleague on an Algerian newspaper, asserted that the picture was actually an "archive photo". In fact, a photo by Hocine's colleagues shows him from behind as he took the famous photo. The rumour gained credibility when the caption-error was discovered. The headlines of the government newspaper *Horizons* condemned this "crude manipulation", insinuating that the woman had never existed. Then Oum Saad appeared on TV: "I'm not a fiction", she said, while, at

"People who criticise this photo are playing into the hands of the terrorists."

the National Assembly, the Prime Minister launched a vituperative attack on the AFP agency. After the World Press Photo award, there were new developments: represented by *Horizons'* lawyer, Oum Saad brought a libel action against AFP and the photographer. "It is no coincidence," says Hocine, "that for months people have been manipulated into criticising my photo and, through it, AFP's work. This just plays into the hands of the terrorists. If I had my time again,

I would still take the photo. I prefer to photograph the living rather than a mutilated corpse. And, despite the threats, I'm staying in Algeria; it's my home. This is my way of fighting back."

On the front page worldwide

59 REPORTERS HAVE BEEN KILLED IN ALGERIA SINCE 1993.

Dolly
© Rémi Benali and Stephen Ferry/Gamma

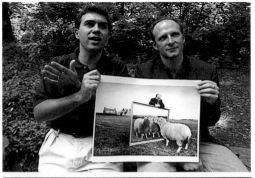

RÉMI BENALI AND STEPHEN FERRY

"We wanted to create a completely novel picture to illustrate the issues that Dolly represented."

Brave New World

→ TIMELINE

This is the most widely photographed animal of the century: the first clone of an adult mammal. Dolly is the identical copy of a six-year-old sheep. The controversy has raged since she was shown in February 1997: should cloning be allowed? Various laboratories are working on the manufacture of transgenic animals capable of supplying human organs, proteins and medicines. But the real controversy concerns the cloning of human beings. The ethical implications are profound. Here science and life intersect. Dolly, the sheep, has opened Pandora's box.

ONE IS FRENCH, the other American. They were working for Gamma when they read about Dolly in the press. "We spent the evening fantasising about the photo we would take to illustrate this incredible subject," recalls Stephen Ferry. After a quick phone call to *Life*, the commission was in the bag. When the two friends flew to Scotland, they had already come up with the idea: to photograph Dolly contemplating herself in a mirror held up by her creator, using a computer to duplicate the reflection. "It captured the very essence of the story," says Rémi Benali. Their first step: to win over the biologist, who had two hundred requests for interviews. "The originality of their proposal intrigued me," says Professor Wilmut. Their second step: to find the right accessories and location. "We wanted an antique mirror and a field, with an old stone farm, to suggest the tension between past and future." In the end, the session took place behind the Roslin Institute where Dolly was created: "While Rémi took the photo of the professor holding the mirror, I was on all fours supporting the frame!" recalls Stephen, laughing. They then had to photograph the sheep looking in the glass. Confined to her sheepfold, where she was under round-the-clock protection, Dolly kept moving around. They shook a pail of grain to lure her towards the mirror. "Suddenly, she stood still," says Stephen, "and I started to shoot!" The final picture was digitally assembled in New York by Steve Walkowiak, "*Life's* computer wizard". ∎

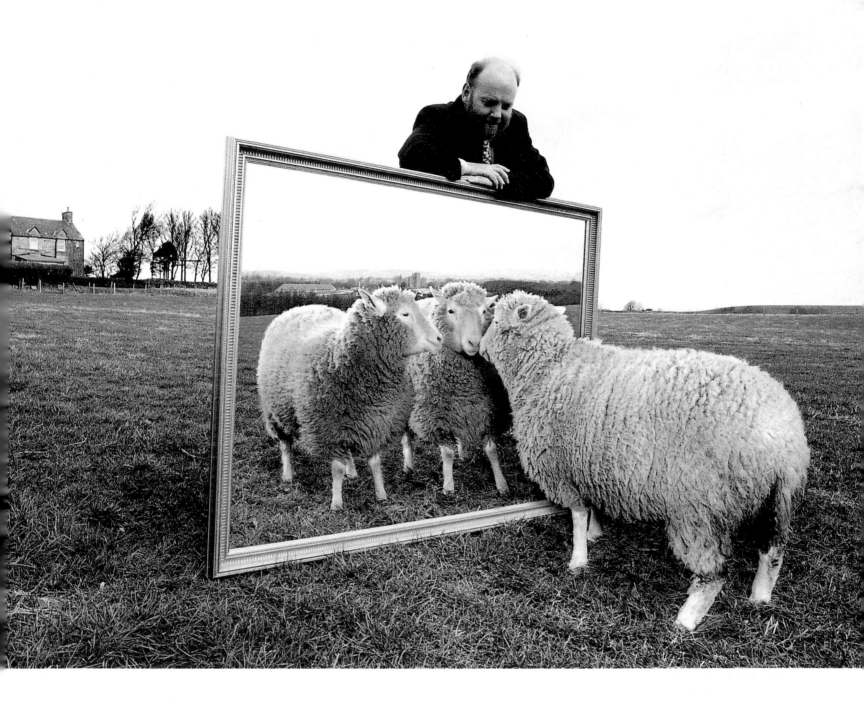

"This photo goes about as far as you can in our profession."

Created on computer, Dolly's photo raises two important issues: the ethics of science, under fire because of genetic engineering, and the ethics of photojournalism, revolutionised by new technology which makes it possible to manipulate images. Rémi Benali and Stephen Ferry think alike about the latter. "The first time we saw Dolly, it was a strange sensation. On the one hand, she looked like a perfectly normal sheep, perhaps a little fat! On the other, this was a com-

pletely new, fatherless creature. This was the aspect we wanted to show: the world is the same and yet something extraordinary has happened. By choosing to put the picture together on computer, we knew we were approaching the limits of what could or could not be done in our profession. And we insisted it be published with a caption stating "digitally assembled by Steve Walkowiak". This photo didn't win any prizes because you can't enter manipulated pictures in

the major photographic competitions. We agree with that: digital manipulation can lead to serious abuse, like the retouching of the Stalinist period. Photographers must be vigilant: their credibility and, therefore their future, is at stake."

The three photos that were used to create the final picture.

The Planet Mars

Image reproduced by Olivier de Goursac

Matthew Golombek: "This is not a photo, but a mosaic of pixels."

Image of the Future

→ TIMELINE

The end of the Cold War prompted cutbacks in space and military budgets. "Faster, smaller, cheaper", was the slogan coined by Daniel Goldin, the new head of NASA. Replaced by unmanned space programmes using probes and interactive robots, manned space flights have become a thing of the past. Costing 260 million dollars, the Mars Pathfinder mission in 1997 was typical of the new trend. Twenty-one years after the Viking programme, which enabled scientists to chart the terrain of the red planet, NASA has announced plans to despatch new probes early in the third millennium.

A RELAXED FORTY, Matthew Golombek is a communications professional. Sitting in his office at Jet Propulsion Laboratory (JPL) in Pasadena, he talks passionately about his "most beautiful baby": the Mars Pathfinder mission. "Everything went exactly as planned," he says, grinning. "On 4 July 1997, at 10.07'25" Californian time, the vessel landed with its shock-absorbing air bag system on the uneven site of Ares Vallis, whose craters were caused three billion years ago by torrential floods. It immediately deployed the 1.80 m extendible mast surmounted by the IMP (Imager for Pathfinder) camera: this is a stereo imaging system, operated from the control room at JPL, with two eyes and some twelve filters scanning between 0.4 and 1.1 microns. The system then released Sojourner, the robot explorer, also equipped with three cameras. This photo is a section from a 360° panoramic view. On the horizon are the Twin Peaks, 30-metre high hills; then, to the right, the striae of the North Peak, furrowed by torrents of liquid mud; and, finally, Sojourner, which is probing Yogi rock. This photo is a mosaic formed of hundreds of pixels, digital images beamed back to earth by the IMP camera: there is no film, no paper: the image was assembled by computer." ■

100

"An absolute record in the history of the web."

"Do you want to see a sunset on Mars?" Olivier de Goursac clicked on the mouse of his computer: "Look! Isn't it fabulous?" Overflowing with enthusiasm, the man is a mine of scientific information. After working for several years at NASA, he became a banker, but his passion has never waned: he processed the thousands of pixels transmitted by the Pathfinder system. "When we received the first images, we were very emotional. So emotional, in fact, that the following Sunday we all went to church or temple! This chaotic site with its rocks, rounded pebbles and deep caverns, provides evidence that water once flowed on the surface of Mars, as certain scientific theories suggested. In a major worldwide first, all these images were immediately accessible to members of the public via the Internet. Once upon a time, you had to have a written medium, but now everything comes direct to your home! On Sunday 6 July, the JPL site recorded 400,000 million visits, an absolute record in the history of the web!"

Olivier de Goursac

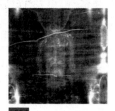

The Turin Shroud
© Secondo Pia
Museo del Sindone 001

Why did I choose a photo taken in 1898 as one of the great photos of the 20th century? Quite simply because its widespread publication began with the new century. In 1898, the European newspapers had reported Secondo Pia's discovery, but without the photo: printing techniques were not up to the challenge. In 1901, Paul Vignon, Professor of Biology at the Catholic Institute in Paris, published the photo in the first scientific work devoted to the image revealed by Pia.

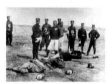

The Boxer Rebellion
© Bildarchiv Preussischer
Kulturbesitz 002

This picture was 'anonymous' until the arrival of a letter from a TV viewer in Saint-Dié, who saw the report on ARTE: "I was very surprised when the programme showed a photo whose original I thought I possessed (copy attached). My grandmother's first husband did his military service in China. He brought back forty-four photos, taken by himself or a friend, including this one. My relative brought back the pigtail belonging to one of the four men executed, which I burned some years ago. He died in Strasbourg in 1915."

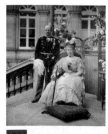

Autochrome
© L'illustration/Sygma 003

The magazine *L'Illustration* presented the Danish King with a print of

this photo. It is still kept in the royal family archives, but the Queen of Denmark refused our request for an interview.

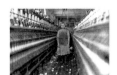

Child Labour
© Lewis W. Hine
Courtesy George
Eastman House 004

It was impossible to discover the identity of this little girl. In the notes for his report, Lewis Hine jotted down only the first name of the children he photographed, after their age, the place and a description of the work they were doing. Born around the turn of the century, the little girl probably has descendants somewhere in the United States. But would they have recognised their grandmother if the photo had been published? We gave up.

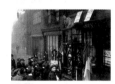

The Suffragettes
© Hulton Getty/
Fotogram Stone Images 005

We chose this photo in tandem with Richard Pankhurst, Sylvia's son, the reluctant witness of a family rift. In 1914, Sylvia, the socialist, accused Emmeline and Christabel of selling out to the right when they campaigned for the recruitment of soldiers during World War One. After their mother's death in 1928, Christabel joined an American fundamentalist sect, while Sylvia became a journalist, denouncing the rise of fascism in Europe. The two sisters never saw each other again.

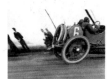

The Distorted Racing Car
© Jacques-Henri Lartigue
Ministère de la culture/
France/AAJHL 006

Some of the illustrations for this book are 'stills' taken from interviews filmed for the TV series. They were all realised by Marc de Banville, Capa's computer wizard, who spent long nights putting the finishing touches to these images. Florette Lartigue, Jacques-Henri Lartigue's wife and companion of more than forty years, refused to be depicted like this: "I don't like it at all", she said, and sent us a photo of herself.

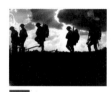

World War One: Propaganda
© Ernest Brooks
Imperial War Museum 007

World War One: Reality 008
© L'Illustration/Sygma

Choosing a photo to illustrate the 'Great War' was an impossible task: there is no one widely published, representative photo from during or after the war; each of the belligerent countries has its own collective (photographic) memory. On the other hand, two approaches to photography were evident at that time: photos taken by official army photographers (propaganda) and snapshots taken by soldiers on the front (reality). We focused on this distinction.

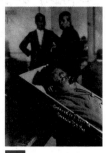

Zapata: Death of a Hero
© Agustín Víctor Casasola 009
INAH

Which photo were we to use for Zapata? Three are extremely well known. The one taken by Miguel Casasola, Agustín's brother, in 1914, in Mexico, is the most famous portrait of Zapata alive. Famous photos of the dead man were taken by Jesús Mora, just after Zapata's murder, and by Agustín Casasola, showing Zapata's body laid out in state. Because Agustín Casasola was one of the greatest Latin-American photographers, we decided to use his.

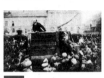

Lenin and Trotsky
© G.P. Goldstein 010
David King Collection

Who should receive the fee for this photo? The historic archives in Moscow? Or David King, who has spent thirty years of his life tracking down the originals of the photos retouched by Stalin's henchmen? The quality of the documents provided by the British collector tipped the balance in his favour.

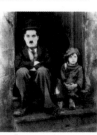

The Kid
© Roy Export
Company Establishment 011

Whoever says 'Chaplin' immediately thinks of his daughter Geraldine. However, she charges FF 70,000 for an interview. Jane, her touchingly sincere younger sister, was an excellent alternative.

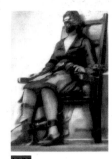

The Death Penalty
© Thomas Howard
Daily News, L.P. 012

In the name of common decency, we did not try to find Lorraine Snyder, who was nine when her mother was executed.

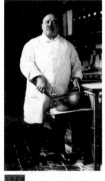

The Pastrycook
© August Sander-
Archiv, Köln/
ADAGP Paris 1999 013

August Sander's archives are managed by the Cologne Art League. We are indebted to the work of Gabriele Conrath-Scholl, who spent years trying to find figures from his *Man of the 20th Century*. Her investigations enabled us to interview the delightful Lili, the pastrycook's daughter-in-law.

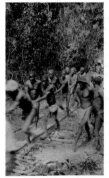

Land of Ebony
© Albert Londres 014
SCAM

The name of Albert Londres has inspired generations of French-speaking journalists; as does the prize that carries his name, founded in 1933, shortly after his mysterious death on the *George Phillipar*. But how many people

knew that the man who "embodied the honour of his profession", was also a photographer? Without Didier Folléas' *Putain d'Afrique!*, we should never have known.

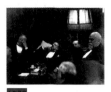

The Hague Conference, 01.00
© Erich Salomon
Bildarchiv Preussischer
Kulturbesitz 015

The meeting with Peter Hunter, Erich Salomon's son, in The Hague, was sheer luck. This unassuming and erudite polyglot was also a photographer, having founded his own agency in London. But he did not want to talk about that: he has dedicated his life to his father's memory. "As the only survivor of my family," he said, "I had no other choice. I felt it was my duty to restore the identity of at least one of Hitler's six million victims."

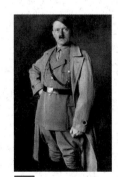

Hitler
© Heinrich Hoffmann
Fotografarchiv
Hans Döring 016

After long deliberation, this courageous woman received us in Düsseldorf. "I wouldn't want people to think I was a Nazi", she explained, tremulously. Gisela Twer need have no fears: we never believed that for an instant and we know how difficult it was for her to talk about "the misfortune that befell Germany and the rest of the world". We would like to thank her for her courage and the quality of her narrative.

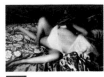

Mexico 1934
© Henri Cartier-Bresson
Magnum Photos 17

At first, he said "No": "I don't like being photographed", he insisted in his outspoken manner, softened by a hint of flirtatious charm. It was the text by André-Pieyre de Mandiargues that saved the day. "If we talk about love, that's OK! But I want you to film me from the back!" The 'chat' started with him in profile, opposite his assistant Marie-Thérèse, then gradually he turned towards us. We were fortunate indeed. What would Henri Cartier-Bresson be without his eyes?

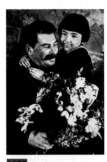

Stalin and Guelia
© Kalashnikov
David King Collection 18

When Dacha Tolstoy, our correspondent in Moscow, announced she had found 'little' Guelia, we were on cloud nine. Her story had been told in the press, in 1996, when Guelia Markizova had consulted her mother's file in the KGB archives.

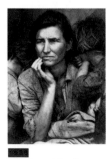

Migrant Mother
© The Dorothea Lange Collection/
The Oakland Museum of California/
City of Oakland/
Gift of Paul S. Taylor 19

Nathalie Bourdon, a journalist with Capa, had to search long and hard to find Kathleen McIntosh, the little girl hiding her face on her mother's left. The vital clue: the publication

of the photo, on 24 August 1983, in the *New York Times*, when Florence Thompson's children launched an appeal for money to help their mother, who was suffering from cancer. This was how we learned that the 'Migrant Mother' was living in Modesto, California, where Kathleen McIntosh also lived.

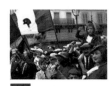

Front Populaire
© Willy Ronis
Rapho 20

They had written to each other before but had never met. Susanne Trompette first wrote to Willy Ronis in May 1996, on the sixtieth anniversary of the Front Populaire: she had seen the photo in a publication by *La Vie Ouvrière* and asked for two prints. Two more letters preceded their 'reunion' in a Paris café.

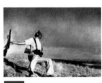

Death of a Spanish Republican
© Robert Capa
Magnum Photos 21

We would have loved to meet Cornell Capa, Robert's brother, also one of Magnum's leading photographers, and the founder of the International Centre for Photography in New York. Unfortunately, it was not possible: "Cornell is very tired", his friend John Morris said.

Death of a Zeppelin
© Sam Shere
Keystone 22

None of the descendants of Count Ferdinand de Zeppelin would agree to talk about this photo. At a time when the com-

pany was announcing crossings of the Alps by dirigible, it may have considered that an interview on this subject would in impolitic.

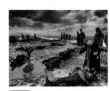

Grief in the Crimea
© Dmitri Baltermants
Tatiana Baltermants 23

Tatiana Baltermants is clearly a strong-willed woman of firm convictions. And so much the better: without her iron will, who knows what would have become of the greatest photo archive of the Soviet era. Her father's daughter, she defends him tooth and nail in her picturesque dacha in the vicinity of Moscow, while in the United States her agent keeps a weather eye open…

Child of the Ghetto
© Rights reserved 24

Is he really the little boy who will forever embody the tragedy of the Warsaw Ghetto? A Scandinavian documentary confirmed our belief that he was Tsvi Nusbaum. There were two decisive factors. One: contrary to the wording of the caption, the photo was not taken in the Ghetto as, by 1943, all the children had already died. Two: a computer-generated morphological comparison revealed more than a passing resemblance between the little boy in the photo and the portrait of 10-year-old Tsvi Nusbaum. And this New York doctor is clearly not a pathological liar.

The Normandy Landings
© Robert Capa
Magnum Photos 25

We never dreamed that we might find the hero of this "slightly out-of-focus" photo! It was Cornell Capa, Robert's brother, who passed his details on to me. For many years, Edward Regan had kept the page from *Life* in which his mother had recognised him. Until it fell to bits: he then contacted Cornell to ask for a print. Edward Regan died not long after our interview.

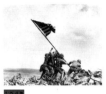

Iwo Jima
© Joe Rosenthal
Associated Press 26

We have one huge regret: we were not able to meet Joe Rosenthal, who fell seriously ill in 1997. In 1995, he was interviewed by a team at the Visa Festival in Perpignan. It was the only filmed interview ever given by this discreet, unassuming man, who took the most famous photo in the history of the United States.

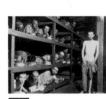

The Death Camps
© H. Miller
National Archives/
Courtesy of USHMM
Photo Archives 27

We moved heaven and earth to track down Henry Miller, the soldier who took this photo. But to no avail. Military archives, World War Two veterans' associations: no-one knew what had become of him.

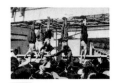

Death of Il Duce
© Vincenzo Carrese
Publifoto Olympia 28

This photo was taken by Vincenzo Carrese, who founded the first Italian photo agency with Fidele Toscani, the father of Benetton's artistic director. Several years earlier, Toscani had been responsible for a fine scoop: he had caught Mussolini urinating by the roadside in Sicily. This photo, an absolute gold mine, was sold in Switzerland, unleashing the fury of the fascist thugs, who were never able to identify the photographer. Oliviero Toscani refused to give us an interview.

The Red Flag
© Evgenii Khaldei
Ana Khaldei/Corbis/
Sipa Press 29

We arranged the meeting for 13 November 1997 at his home in the suburbs of Moscow. We were there, but he was not. On 6 October, Evgenii Khaldei died at the age of 80. It was a great shame: he was the kind of man one longs to meet. "Before talking", said his daughter Ana, "we must drink to his health." And she raised a glass of vodka to the memory of that photographic prodigy, who ended his life on a monthly pension of FF 200.

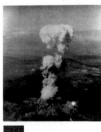

Hiroshima
© George Caron
Rights reserved 30

It was impossible to meet survivors of the Enola Gay mission because it was hard to

find out what had happened to them: photographer George Caron was dead and his wife refused to talk to us. As for the pilot Paul Tibbetts, he had hired an agent to negotiate a ridiculous price for his interviews. We would like to say a big thank you to Vicki Goldberg, author of the remarkable *The Power of Photography*, who agreed to share her knowledge of three photos, including this one.

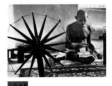

Mahatma
© Margaret Bourke-White
Life Magazine/
PPCM 31

This was one of our favourite brain-teasers: who could we find to give us the 'story' or background information behind this photo. Margaret Bourke-White died childless, and those who knew her well were either dead or too old to talk to us. Sean Callahan, the author of a book on the photographer, made it possible for us to include this important photo in the book. It was also a way to pay homage to *Life* magazine.

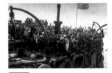

Exodus
© Rights reserved 32

We would like to thank the Parisian magazine *L'Arche* for its help in finding eyewitnesses. Without its co-operation we would not have been able to publish the photo: negatives and prints had disappeared.

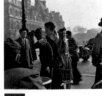

Le Baiser de L'Hôtel de Ville
© Robert Doisneau
Rapho 33

Finding the lovers who exchanged the most famous kiss of the century was child's play! A loyal supporter of Doisneau, Jacques

Carteaud had stood witness at the case brought by a French couple. The photographer and his 'subject' have since met several times, and once, in the south of France, with the actress, Sabine Azéma.

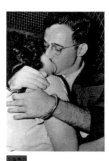

The Rosenberg's Kiss
© Rights reserved

34

No-one knows who took this photo, the emblem of the most important politico-judicial case in post-war years. It was also impossible to obtain a clean print: the negative had disappeared.

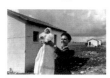

Birth on the Kibbutz
© David Seymour
Magnum Photos

35

We felt that this book had to include a photo by David Seymour, one of the founders of the Magnum agency. But which one? When Ariel Cohen, in Israel, confirmed he had found Eliezer Trito, we did not hesitate: the birth of Israel was widely covered by the Magnum photographers, who were profoundly traumatised by the Shoah.

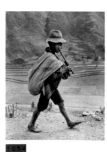

The Cuzco Trail
© Werner Bischof
Magnum Photos

36

We tried absolutely everything to find the little Indian boy with the pipe: the photo was published in a

Cuzco newspaper: Olinda Celestino, a Peruvian anthropologist, distributed copies in the vicinity of the Sacred Valley. But to no avail: no one came forward. "In this remote region of the Andes, photography is not a widespread medium," said Olinda. "The absence of a picture culture means that people do not know how to recognise a loved one in a photo."

Che
© Alberto Korda

37

What can we say about the most widely published photo of the century? Perhaps this short sentence by Ernesto Guevara March, Che's youngest son, who, after a trip to Rome, told us: "This photo has become unbearable: I've seen it printed on T-shirts produced by the MSI, the Italian Fascist Party!"

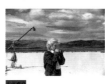

Marilyn
© Eve Arnold
Magnum Photos

38

Why did we choose this photo and not that of Marilyn in a billowing dress standing over a subway-grating with the actor Tom Ewell? No actress has ever used the medium of photography with such skill; and no one tells her story better than Eve Arnold.

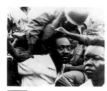

Lumumba
© Dietrich Mummendey
Corbis/
Sipa Press

39

This photo might easily not have appeared. The day that the forerunner of African independence was arrested, two photographers were present: Horst Faas, from the Associated Press agency, and Dietrich Mummendey, from United Press International. AP had lost everything, negatives and prints. Idem for UPI, which no longer exists. We finally obtained a copy of Mummendey's photo from the photographic department of the Belgian newspaper *Le Soir*, which has published it four times.

The Wall of Shame
© Peter Leibing

40

Finding the two protagonists of this photo was very simple: Peter Leibing was still in Hamburg, and had been in contact with Konrad Schuman since they had met on a TV set in 1986. We were sad to learn that the man who "was proud to be a symbol of liberty" died in 1998.

Lei Pheng
© Zhou Jun
Xinhua/Sipa Press

41

Anne Loussouarn, our correspondent in Peking, enabled us to interview Zhou Jun, the photographer of the Maoist icon. As for the little soldier, he was run over by a lorry on 15 August 1962; this was one part of his story that

had (clearly) not been falsified.

Cuban Missiles
© CIA

42

One worked in the photographic department of the CIA, the other was a KGB colonel and Soviet Ambassador in Cuba at the time of the Cuban Missile Crisis. We met Dino Brugioni in the United States and Alexander Alexeyev in Russia. They had contrasting views about the photo, but both agreed that it had "saved humanity from a nuclear war".

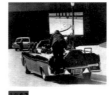

JFK Assassinated
© James W. Altgens
Associated Press

43

We initially wanted to tell the story of the film taken by Abraham Zapruder: six short seconds of Super-8 film that the Dallas tailor sold for 150,000 dollars to *Life Magazine*, which published a selection of frames. The story seems incredible: the American government had just decided not to buy the film, which was in any case in the public domain, since the copyright holders wanted *twenty million dollars* for it. Oliver Stone paid 40,000 dollars for the right to use the six seconds in his film *JFK*.

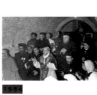

Paul VI in the Holy Land
© Georges Ménager
Paris Match

44

Why did we choose this photo? Firstly, to pay tribute to a friend from the Capa agency, the producer of the TV series on which this book is based, and then to pay homage to *Paris Match*, which was, with *Life Magazine*, the greatest illus-

trated magazine of the century.

The Mysteries of Life
© Lennart Nilsson
Life Magazine/PPCM

45

We are not ashamed to admit it: we wanted to interview the adult who had once been the delightful baby in this photo. Then we found out that the foetus had been aborted due to an ectopic pregnancy. This is why we found it so difficult to obtain an interview with Lennart Nilsson. But he should not worry: his photo will remain in the collective imagination and that is something to be proud of.

Mao Swims
© Quian Sije
Xinhua/Sipa Press

46

This is genuinely a photo from another world. Thirty years later, who could imagine a similar situation with Bill Clinton or Tony Blair? It was Anne Loussouarn, our correspondent in Peking, who found Quian Sije, the photographer of the shot, published so widely in the West. China might have preferred another photo, taken a few minutes later, showing Mao in a bathing robe, waving to the crowd.

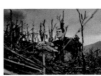

Hill 881
© Catherine Leroy

47

When we arrived at his cabin in the backwoods of Arizona, he was immersed in his macramé. He beamed with delight when he saw Catherine Leroy, his 'soul sister', the woman who had immortalised his grief when he was a marine in the Vietnam war. "She was so brave," Vernon Wike said sim-

ply. They smiled at each other and we realised that this photo would unite them forever.

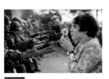

Demonstration for Peace in Vietnam
© Marc Riboud
Magnum Photos

48

This was the finest achievement of our two-year investigation! In 1992,'the girl with the flower' wrote to Marc Riboud. She signed her letter 'Jane Rose Kasmir'. Five years later she no longer lived at that address. We looked in the US phone directory: there were forty-one Kasmirs, but no Jane Rose. In her letter, the pretty brunette had provided a clue: at the age of 42, she had given birth to a little girl 'Lisa Ann', and L. A. Kasmir was the ninth entry on the list. "Why not?" said Delphine de la Salle, the journalist from Capa. Bingo! We passed on the details for Jane Rose to Marc Riboud who lost no time in calling Annick Cojean from the French newspaper *Le Monde*. Shame on him!

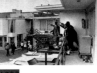

Martin Luther King Assassinated
© Joseph Louw
Life Magazine/PPCM

49

Interviewing Martin Luther King's children was out of the question, unless we wanted to pay a great deal of money. It would have cost so much, in fact, that we had to give up the idea of using an extract from King's "I have a dream" speech in the TV series. All of which is very, very disappointing.

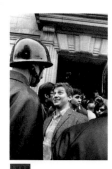

May '68
© Gilles Caron
Contact Press Images [50]

We failed to identify the implacable policeman shown in the photo. We explored all the available channels, notably the police archives in Paris and organisations of retired policemen. We were left with the impression that the gentleman did not want to be found – unless he had died, carrying his secret with him to the grave.

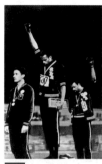

Clenched Fists in Mexico
© John Dominis
Life Magazine/PPCM [51]

Annick Cojean, who wanted to pay back the debt she owed (see above), enabled us to find Tommy Smith. Cut down in his prime, the athlete who once held eleven world records had disappeared from the annals of American athletics.

The End of the Prague Spring
© Ladislav Bielik
Agentura Oko [52]

To be honest, we would have preferred to use the photo of this event by Joseph Koudelka. Alas, Koudelka prohibited broadcast of our interview with him. No matter. Ladislav Bielik's picture was the most widely published at the time of the events, and we

are happy to pay tribute to a photographer whose talent was stifled by the Soviet authorities.

De Gaulle
© Jean-Pierre Bonnotte
Gamma [53]

We had a lot of fun with Jean-Pierre Bonnotte, which made a refreshing change in this rather sombre series. The location for the filming: Colombey-les-deux-Eglises, and particularly the thicket where Jean-Pierre Bonnotte spent two hours, opposite the home of Charles de Gaulle. All that was missing was the sheets of plastic and the beer!

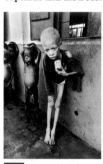

Biafra
© Don McCullin
Contact Press Images [54]

This was one of the most memorable meetings of our trip around the world. On that particular day, storms raged over the south of England, and we were very late for our meeting. Don McCullin, who lives in the heart of Somerset, had said, "I'll give you four hours". We looked deep into his penetrating blue eyes and forgot most of our English as a result. But it didn't matter: all we had to do was listen.

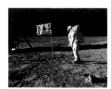

Man Sets Foot on the Moon
© Neil Armstrong
NASA [55]

It was impossible to contact Neil Armstrong, the man who took this photo: NASA refused to disclose his address, saying he was "extremely ill". Rumour has it that he has never recovered from the moon mission.

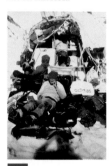

The Survivors of the Century
© Jean-Pierre Laffont
Sygma [56]

Why did we choose this photo? Firstly, because it marked one of the great adventures of the century. We also thought it would be interesting to describe the popular practice of finding and using amateur photographs. All photo agencies do this, but few professionals are willing to talk about it.

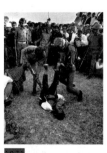

Massacre in Dhaka
© Christian Simonpietri
Sygma [57]

Should this photo have been taken or not? This question goes straight to the heart of a crucial debate: the ethics of photojournalism. Christian Simonpietri decided to record the event, Marc Riboud chose not to: contrasting views of an extreme situation.

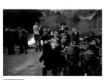

War in Northern Ireland
© Christine Spengler [58]

3 February 1999: the newspaper *Irish News* published Christine Spengler's photograph on the first page with the caption "Where are these children? Please contact us". The next day, its switchboard was flooded with calls, including one from Canada! There were fifteen people in the photo; nine of them met Christine Spengler in this Londonderry street, which was a centre of resistance to the 'British occupation'.

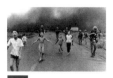

Napalm
© Nick Ut
Associated Press [59]

Without her, *The Photos of the Century* would never have seen the light of day. In 1989, while in Cuba, we learned that Kim Phuc was a student in Havana. Four years later, we tried to find her, but she had gone into self-imposed exile in Canada. During an editorial meeting at Capa, we put forward the idea of a series that would chart the history of the century through the use of outstanding photos illustrating key events "OK, go for it!" said Hervé Chabalier, the head of the agency. We met Kim Phuc in 1998.

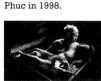

Tomoko in her Bath
© Eugene Smith
Magnum Photos [60]

It was not possible to interview Tomoko's parents, who have refused to talk about this photo since the death of their daughter. When, in 1972, they agreed to denounce the Minamata disease publicly, it never occurred to them that the photo would take on a life of its own.

The Last Picture of Allende
© New York Times [61]

After some genuine detective work, which led us to from Santiago, Chile, to Miami, via New York and Madrid, we were no closer to identifying the photographer who took this photo, the anonymous winner of the World Press Photo award in 1973. According to our latest information, his name was Chiruco Bravo and he had recently died. One theory is that a soldier (still alive) may have confiscated Bravo's films as he was coming out of the Moneda, and then sold them as if they were his own.

The Streaker
© Ian Bradshaw
Mirror Syndication International [62]

"Stop hounding me about that naked man business, I'm fed to the teeth with it!" barked the retired policeman, and hung up. He was one of the reluctant heroes of this extremely famous photo. His colleague Bruce Perry – the man who was holding the helmet so tactfully and effectively – told us that the poor man had snapped when the photo appeared on London bus shelters.

Muhammad Ali
© Howard Bingham [63]

This is not *the* photo of the legendary boxing match. But Muhammad Ali's photographer was Howard Bingham: when Ali was celebrat-

ing, brandishing his gloved fist above his victim, Bingham had forgotten to press the shutter release. Instead, overjoyed, he was hugging everyone around him.

Carlos the Jackal
© Nik Wheeler
Sipa Press [64]

We received no answer to our request for an interview with Abdelaziz Boutelfika, the former Algerian Minister of Foreign Affairs, who appears in the photo. As for Carlos, the French Ministry of Justice categorically refuses to allow the press to meet him in the prison where he is serving his sentence.

Massacre in Lebanon
© Françoise de Mulder [65]

We set up our cameras where this photo was taken. Marc de Banville was filming Fuad Abu Nadar, one of the Phalangist militiamen who took part in that night's events. On that occasion, an old Palestinian man kept pointing to the woman in the centre of the photo. The two men were visibly disagreeing. "What is he saying?" asked Marc. Fuad Abu Nadar's translation: "He says all the civilians were spared". "Liar!" said our Arab interpreter in Paris indignantly. "He said: 'That woman was my cousin! She was killed just afterwards'."

Bob Marley
© Kate Simon [66]

We would have liked to interview Rita Marley, the star's widow, about the history of this photo, which greets visitors to the

museum that she has opened in Jamaica. But Roger Steffens advised us to take up residence on the island if we wanted to be sure of an appointment...

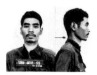

The Victims of Pol Pot
© Nhem Ein
067

Whether these photos of the victims of Tuol Sleng arouse fascination or disgust, we felt that they had to be included in this illustrated history of the century. Marie-Christine Courtès found Nhem Ein, the photographer of so many thousands of portraits, in Phnom Penh. We chose the one of Vann Nath, one of the death camp's seven survivors; he speaks for all those who died.

The Murder of Aldo Moro
© Gianni Giansanti
Sygma
068

Can you publish a photo like this today without running the risk of being sued for infringing a person's right to their image? There are no guarantees: in the United States, as in Europe, photojournalism too has been affected by the legalisation of social relations. More and more frequently, the person photographed or their family takes legal action, claiming damages. "In the case of my father," said Giovanni Moro, "the right to know was more important than the right to his image".

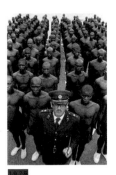

South Africa
© Abbas
Magnum Photos
069

It was thanks to the hard work of the South African Embassy in Paris that we were able to meet General Malan, the white hero of this image, symbol of apartheid. Clear proof, if any were needed, that things have changed in South Africa.

Revolution in Nicaragua
© Susan Meiselas
Magnum Photos
070

In 1991, Susan Meiselas returned to Nicaragua to find the people in the photos she took in 1978 and 1979. Her search gave rise to a remarkable documentary entitled *Images of a Revolution*. During this journey to the land of the Sandinistas, Meiselas renewed her friendship with Justo, one of the guerrillas in this photo.

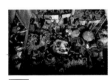

The Boat People
© Alain Dejean
Sygma
071

Geneviève de Montgolfier, a journalist at Capa, worked long and hard to identify the passengers on the *Hai Hong*. The files of the High Commission for Refugees merely contained the names of the thousands of boat people assisted, giving their country of asylum as their only address. The photo was published in the newsletter of an American society of Vietnamese refugees, and this made it possible to contact the Phu family.

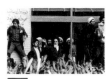

Ayatollah Khomeini
© Michel Setboun
072

Khomeini's return to Iran was widely covered by photojournalists, particularly this scene at the Alavi school. David Burnett, a reporter with the Contact agency, took a very similar photo. But as we had already chosen his photo of the Olympic Games in Los Angeles, we opted for this one by his illustrious colleague, Michel Setboun. Choices of this kind were another factor in our illustrated patchwork of the century.

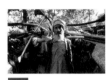

War in Afghanistan
© Alain Mingam
Gamma
073

Mingam's photos received a World Press Photo award. But there were rumours; scandalmongers believed that the photos had been staged for the photographers. This was cleared up by Mehrabodin Masstan. A former mujaheddin, he placed things in their proper perspective. In the early days of the Afghan resistance, plagued by Soviet penetration of the movement, executions of 'traitors', or people assumed to be such, were extremely widespread, and they were carried out in public to discourage potential enemies.

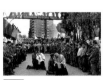

Strike in Gdańsk
© Alain Keler
Sygma
074

After this photo, Alain Keler tried to go back to Poland. But for Jaruzelski's secret services he was a marked man. Arrested on his arrival in Warsaw, he was interrogated, then offered a deal. "They wanted me to give them the names of col-

leagues who were trying to return with tourist visas and of those whom they called 'irresponsible elements' of Solidarity. I refused and was expelled. I was unable to return to Poland until the fall of the regime."

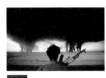

The Iran-Iraq War
© Henri Bureau
Sygma
075

The photo was posed, and Henri Bureau has the honesty to admit it. This is extremely rare; in photography, trade secrets are not willingly shared.

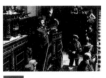

Putsch in Madrid
© M. Perez Barriopedro
Agencia Efe/Sipa Press
076

Franck Duprat, our correspondent in Barcelona, was astonished when the press office of the Spanish parliament informed him that he was not allowed to film Manuel Barriopedro at the Cortes, because the photo concerned "a mere detail" in Spanish history! Franck related this to two journalists, who instantly replied "If they confirm that officially, we'll write an article about it!" Franck obtained authorisation to film without further ado.

Attempt on President Reagan's Life
© Ron Edmonds
Associated Press
077

A case that illustrates the different status enjoyed by members of the profession. On the one hand, Ron Edmonds, an employee at the Associated Press agency; on the other, Sebastião Salgado, a member of the Magnum co-operative.

The former has no say in the jobs he is given, but is free of financial anxiety; the latter chooses his jobs and pays half the expenses incurred. Edmonds always earns the same; Salgado's income varies enormously. NB: Agency photographers have short memories; few of them remember how much they earned from a particular scoop.

Princess Di's Kiss
© Douglas Kirkland
Contact Press Images
078

We would have liked to know how much this photo earned its photographer, but the question is often unwelcome...

François Mitterrand
© Guy Le Querrec
Magnum Photos
079

"May I publish these photos?" asked Guy Le Querrec after the ten sittings. "I'd rather you didn't", replied President Mitterrand. The photographer waited six years before publishing the series. After seeing a Pancho cartoon in *Le Monde* that drew on the Mitterrand series, he decided to disregard the President's wishes. The photo appeared all over the world, just as François Mitterrand was standing for a second term of office.

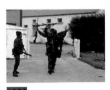

The Falklands War
© Rafael Wollman
Gamma
080

As soon as the Falklands War broke out, Margaret Thatcher's government imposed strict controls on the press. Only a few hand-picked photographers were allowed on board the ships of the British task force. In his memoirs, Don McCullin, one of the greatest war reporters

of the century, explains how he was ejected. Which is how Rafael Wollman managed to get his exclusive scoop.

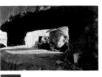

Arafat in his Bunker
© Reza
Sipa Press
081

This was another of the series' frustrations: for a year and a half, we explored every imaginable avenue to obtain an interview with the leader of the Palestinian Authority, but to no avail.

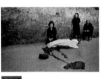

Sicilian Chronicles
© Franco Zecchin
082

When, in 1992, the Benetton group launched their campaign 'The Shock of Reality', using photos taken by photojournalists, including the colourised one by Franco Zecchin, the women in the photo took legal action. They won their case and obtained damages in the name of the 'right to one's own image'. The judges justified their decision by invoking the commercial nature of the publicity campaign.

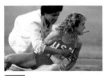

The Los Angeles Olympics
© David Burnett
Contact Press Images
083

When the photo appeared in a leading American weekly, David Burnett discovered with surprise that it had been retouched: the antenna of the nurse's walkie-talkie had been erased. Ten years before the introduction of computerised techniques for manipulating images, the affair sparked off a lively debate about the ethics of photojournalism.

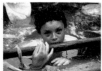

The Little Girl from Armero
© Frank Fournier
Contact Press Images
084

"I can find Omayra's mother," said journalist Germán Santamaría. "She has always refused to talk about it. Should I try to persuade her?" The question provoked an intense debate among the team. In the end we decided that we would do nothing to persuade her to talk. Sometimes disaster victims decide to take on the role of a mouthpiece, but this was obviously not the case with the young martyr's mother; we had to respect her choice.

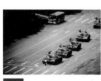

Aids
© Alon Reininger
Contact Press Images
085

This is the story of another photo that has outlived its main protagonist; something which the survivor, who can be glimpsed in the background, finds very difficult to accept. As was the case for 'Tomoko in her Bath' by Eugene Smith, the photo's autonomy has muddied the relationship between photographer and 'subject'.

Chernobyl Disaster
© Igor Kostin
086

It was very difficult to 'negotiate' with Igor Kostin, as he had recently been the victim of some highly dishonest behaviour. Invited to exhibit his photos in Italy, he discovered, shortly afterwards, that an agency had taken advantage of this to make some prints and distribute them without telling him and, therefore, without paying him.

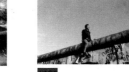

The Fall of the Berlin Wall
© Raymond Depardon
Magnum Photos
087

Because of a snow-storm, we arrived very late at the hotel where we had arranged to meet him. "Is he still a punk?" we asked the receptionist. "Punk? No, Rasta!" We were on the verge of panic: what if he were an impostor! We had published the photo in a German newspaper and, one day, Armin Strauch had phoned us: "That's me, I live in Bavaria!" And it really was him: not Rasta at all, he just had a pig-tail, tied in a scarf. But, in Bavaria, that was outlandish enough…

Tiananmen Square
© Stuart Franklin
Magnum Photos
088

We followed up the rumour for months: people said he came from Hunan Province, his name was Wang Wei Min, he had gone into exile in Paris, then the United States. All these avenues proved to be dead-ends or at least unverifiable. The rumour was started by a Hong Kong newspaper article, in which a witness allegedly identified the mysterious stranger in Tiananmen Square.

The Highway of Death
© Jacques Langevin
Sygma
089

This is not the most widely published photo of the Gulf War, but the one that illustrates its most striking paradox: no war has ever been the subject of so much media coverage and yet left such a dearth of striking pictures. Looking through the hundreds of photos produced on this war, one might (almost) forget that it claimed at least 300,000 lives.

Oil Slick in the Gulf
© Sebastião Salgado
Amazonas/
Contact Press Images
090

Sebastião Salgado made it possible for us to interview Mike Miller, one of the fire fighters in the photo. Miller still runs the Canadian company Safety Boss, whose work the photographer documented for a month.

Liz Taylor's Wedding
© Phil Ramey
Ramey Photo Agency
091

Who would believe it? This blurred, underexposed photo has appeared in all the international celebrity magazines. Its photographer: one of the leading paparazzi, who is honest enough to admit he is merely a picture hunter and quite happy to talk about it. Frankly, after Princess Di's tragic accident, this was an unexpected bonus.

Rape campaign in Bosnia
© Andrée Kaiser
G.A.F.F./Sipa Press
092

With the help of the journalist Roy Gutman, we tried to find one of the women in this photo. In Tuzla, the gynaecologist who had treated the women in the town's hospital contacted one of them. At first, she agreed, but then changed her mind: we did not press her any further.

Sendero Luminoso Defeated
© Wesley Bocxe
Sipa Press
093

We chose this photo at the suggestion of our correspondent in Barcelona, Franck Duprat. The idea originally came from Hector Mata, who covered Abimael Guzman's caged appearance for the Agence France Presse. "We were all confined to the press stand when I glimpsed Wesley Bocxe, who had managed to clamber to the topmost tier. I thought to myself: he's right, *the* photo is the one that shows the entire *mise en scène*."

Genocide in Rwanda
© James Nachtwey
Magnum Photos
094

A very elusive character and an inveterate traveller, James Nachtwey caused us quite a few headaches. We finally managed to pin him down in New York. "A veritable monk of a reporter", as one colleague put it, the most acclaimed photographer of his generation carries the world on his shoulders with admirable self-abnegation.

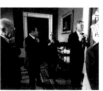

The Peace Process in Washington
© Barbara Kinney
The White House
095

King Hussein of Jordan had agreed to an interview, which was continually postponed for reasons of health. It never took place …

The Orphans of Rwanda
© Reza
Imax
096

Why did we choose this photo? Because apart from the tragedy it symbolises, it also illustrates the history of a small part of humanity. Photography has not yet penetrated far-flung regions where the oral is far more important than the written tradition. In Rwanda, many parents had never seen a photo before they visited the exhibition mounted to help them find their children.

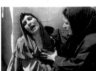

The Argentine Mafia
© José Luís Cabezas
Rights reserved
097

September 1998, the Visa Festival in Perpignan. The Argentine photographers arrived with a free ticket from an airline company, accommodation organised by Jean-François Leroy, the festival director, and one common desire: to tell the whole world about José Luis Cabezas, murdered for taking a photo on an up-market beach. This photo, exemplifying as it does some key issues, fell naturally into a series that also pays homage to photojournalism and the freedom of the press.

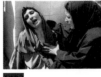

Massacre in Algeria
© Hocine
AFP
098

Did we have the right to publish this photo, when Oum Saad, its main subject, was asking that it be suppressed? After long consideration, we decided that we did, in the name of the 'right to know'. Our investigation made it clear that Oum Saad had been the victim of political manipulation intended to bury an embarrassing picture. If this type of pressure is not resisted, it will erode a hard-won principle, one of the pillars of democracy: the freedom of the press.

Dolly
© Rémi Benali and Stephen Ferry
Gamma
099

To clone or not to clone? To manipulate images or not? Rarely has a photo been so close in spirit to the event that generated it. Food for thought …

The Planet Mars
© Image reprocessed by Olivier de Goursac/NASA/JPL/Caltech/SAF (Société Astronomique de France, 75016 Paris)
100

This was the last photo in the series, and one that heralds fundamental developments in communications techniques on the threshold of the 21st century. Does this spell the end for photos printed on a paper medium and held in the hands or hung on the wall? We doubt it.